Picture Theory

Essays
on
Verbal
and
Visual
Representation

W.J.T. Mitchell

PICTURE
THEORY

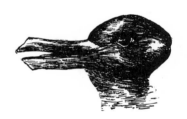

THE UNIVERSITY OF CHICAGO
PRESS
Chicago & London 135879

W. J. T. MITCHELL is the Gaylord Donnelley Distinguished Service
Professor in the Department of English Language and Literature and the
Department of Art at the University of Chicago. He is the author or editor
of several books, including *The Language of Images, On Narrative, The
Politics of Interpretation, Against Theory, Iconology, Art and the Public
Sphere,* and *Landscape and Power,* all published by the University of
Chicago Press. He is also the editor of the journal *Critical Inquiry.*

The University of Chicago Press, Chicago 60637
The University of Chicago Press, Ltd., London
© 1994 by The University of Chicago
All rights reserved. Published 1994
Printed in the United States of America
03 02 01 00 99 98 97 96 95 94 1 2 3 4 5

ISBN: 0–226–53231–3 (cloth)

Library of Congress Cataloging-in-Publication Data

Mitchell, W. J. Thomas, 1942–
 Picture theory: Essays on verbal and visual representation /
W. J. T. Mitchell.
 p. cm
 Includes bibliographical references and index.
 1. Ut pictura poesis (Aesthetics) 2. Arts, Modern.
3. Postmodernism. I. Title.
NX170.M58 1994
700′.1—dc20 93-34057
 CIP

♾ The paper used in this publication meets the minimum requirements of the
American National Standard for Information Sciences—Permanence of Paper for
Printed Library Materials, ANSI Z39.48-1984.

for Janice Misurell Mitchell

Contents

135879

Illustrations

Acknowledgments

S o many conversations have found their way into these pages, it is difficult to know where to begin acknowledging them. Certainly the book feels (for better or worse) very much like a product of the University of Chicago and of a number of collegial groups in the humanities and social sciences, specifically, the editorial group of *Critical Inquiry*, the Committee on Critical Practice, and the (now dormant) Laocoon Group for the discussion of art, literature, and theory. The essays are inseparable from several unforgettable (for me) teaching occasions, in which the various drafts served as supplementary reading and whipping boy. I'm especially grateful to my research assistants, David Grubbs, John O'Brien, and Jessica Burstein; to the staff of *Critical Inquiry*, Jay Williams and David Schabes; to members of seminars convened at the School of Criticism and Theory ("Iconology" at Northwestern University in 1983 and "Image and Text" at Dartmouth College in 1990); to the NEH Summer Seminar in "Verbal and Visual Representation" at Chicago in 1989; to the Mellon Faculty Seminar in Critical Theory at Tulane University in the summer of 1989; to my students and colleagues at Beijing Foreign Studies University in the spring of 1988; to the faithful interlocutors who attended my lectures on "Image and Text" at Canterbury University, New Zealand in July of 1988; to the University of Alberta, whose Henry J. Kreisel Lectureship on Literature and the Visual Arts gave me a unique opportunity to put these topics together; to the scholars at the universities of Turku, Abo Akademi, and Helsinki, Finland; and the researchers at TEMA Kommunikation, the University of Linköping, Sweden, who gave me a last chance to put them in order; to the Fairchild Distinguished Scholar program at California Institute of Technology, which give me the precious months to apply the finishing touches.

It would be impossible to name all the individuals whose intelligent suggestions have been ignored, ruthlessly distorted, or silently appropriated for this book. The late Louis Marin read the book shortly before his death and was extraordinarily generous with advice and encouragement. Charles Altieri, Michael Fried, and Edward Said provided detailed, incisive readings that saved me from uncountable blunders. Miriam Hansen has helped to keep me conscious of what I don't know about film and critical theory; Lauren Berlant has tried

to make me smarter about cultural politics; Arnold Davidson and
Nelson Goodman have been patient with my attempts at philosophy;
Rob Nelson has found work for me in an art history department;
Hortense Spillers has been an inspiring colleague; Robert Morris has
given me his friendship; and Joel Snyder has, as always, been there.
Though they may be slightly surprised to find their names taken in
vain here (was it something they said?), I have learned in various ways
from David Antin, Houston Baker, Susan Bazargan, Linda Beard,
Diane Brentari, Bill Brown, Laurie Brown, Bob Byer, Michael Camille,
Elizabeth O'Connor Chandler, James Chandler, Ted Cohen, Katherine Elgin, Timothy Erwin, Ellen Esrock, Henry Louis Gates, Jr., Joseph Grigely, Bob Kaster, Jean Hagstrum, Charles Harrison, Geoffrey
Harpham, Paul Hernadi, James Heffernan, Elizabeth Helsinger, Kathryn Kraynik, Zhou Jueliang, Norman Klein, Jan-Erik Lundström,
Françoise Meltzer, Leonard Linsky, Stephen Paul Miller, Margaret
Olin, Ronald Paulson, Randy Petilos, Harry Polkinhorn, Catherine
Rainwater, Franco Ricci, Julia Robling Griest, Richard Rorty, Larry
Rothfield, Jay Schleusener, Joshua Scodel, Linda Scott, Linda Seidel,
Bruce Shapiro, Virginia Whatley Smith, Victor Sorell, Daniel Soutif,
Wendy Steiner, Daniel Tiffany, Alan Thomas, Blaise Tobia, Alan
Trachtenberg, Jean Tsien, Auli Viikari, Denis Walker, Martha Ward,
and Tina Yarborough.

Several chapters are based on journal articles that have been reprinted in various places, sometimes with slightly different titles. "The
Pictorial Turn" first appeared in *ArtForum* 30:7 (March 1992); "Beyond Comparison" is based on a much shorter essay, "Against Comparison" in *Teaching Literature and the Other Arts,* edited by Jean-Pierre Barricelli, Joseph Gibaldi, and Estelle Lauter (New York: MLA
Publications, 1990); "Visible Language: Blake's Art of Writing" first
appeared in *Romanticism and Contemporary Criticism,* edited by
Morris Eaves and Michael Fischer (Ithaca, NY: Cornell University
Press, 1986; copyright by Cornell University, used by permission of
the publisher); "*Ut Pictura Theoria*" was first published in *Critical
Inquiry* 15:2 (Winter 1989; copyright 1989 by The University of Chicago; all rights reserved) and subsequently appeared in French translation in *Cahiers du l'art moderne;* a slightly different version of "Word,
Image, and Object" was published in the catalog of the Guggenheim
Museum's retrospective on Robert Morris (New York: The Solomon
R. Guggenheim Foundation, 1994); "The Photographic Essay" appeared as "The Ethics of Form in the Photographic Essay" in *AfterImage* 16:6 (January 1989); "Illusion" appeared in *Aesthetic Illusion,*
edited by Fred Burwick and Walter Pape (Berlin: De Gruyter, 1991);

Acknowledgments

"Realism, Irrealism, and Ideology," *The Journal of Aesthetic Education* 25:1 (Spring 1991); "The Violence of Public Art," *Critical Inquiry* 16:4 (Summer 1990; copyright 1990 by The University of Chicago; all rights reserved); "From CNN to *JFK*" appeared under the title of "Culture Wars" in the *London Review of Books,* 24 April 1992, and in an expanded form in *AfterImage* 19:10 (May 1992). I am grateful to the various editors and publishers for their permission to use the materials that first appeared in their pages.

Above all, I must thank my wife, Janice Misurell Mitchell, who has been the unseen musical presence inspiring all these verbal and visual representations for twenty-five years, and to whom this book is dedicated.

Introduction

n 1988, the National Endowment for the Humanities issued a report entitled *Humanities in America*.[1] The section of this report on "The Scholar and Society" attracted considerable attention with its charges that the humanities in higher education had become overly specialized and politicized. The report argued that the basic values and texts of "the Western tradition" were either being ignored or reduced to a catalog of "political horrors": "Truth and beauty and excellence are regarded as irrelevant," in the academic humanities today, the report lamented. "The key questions" about literature and culture "are thought to be about gender, race, and class" (p. 12). Although the report was a bit short on logic (arguing that academic humanists are too "isolated" from society at the same time it claimed that they are far too engaged and politically militant), and even shorter on documentation, it left little doubt that Western culture was in deep trouble, threatened by the very institutions of learning that are supposed to cultivate it.

A much less publicized section of the NEH report was called "Word and Image." It consisted mainly of uncontroversial (though alarming) statistics about the vast number of hours Americans spend in front of television sets, noting that "our common culture seems increasingly a product of what we watch rather than what we read" (p. 17). Balanced by some reassuring statistics about increased book sales of "classic" novels that had been the subject of television dramatization, this section of the report concludes on a note of optimism about the ability of television to transmit cultural—i.e., literary— values. When the report turns to the "future" of the image (the book has a "fate") it insists that images "compose a medium quite distinct from print, one that communicates differently, one that achieves excellence differently" (p. 20). It was hard to resist the conclusion that, if advanced research in the humanities was a clear and present danger

1. Lynne V. Cheney, *Humanities in America: A Report to the President, the Congress, and the American People* (Washington, DC: National Endowment for the Humanities, 1988). Page references cited in text hereafter.

1

to literacy and Western culture, television was in a position to be its savior, perhaps even its replacement. The section on "Word and Image" closes with the words of E. B. White: "television . . . should be our Lyceum, our Chautauqua, our Minsky's, and our Camelot" (p. 22).

It is not difficult to understand why the principal bureaucrats of the humanities during the Reagan-Bush era regarded critical, revisionist accounts of cultural history as dangerous. "Truth, beauty, and excellence" have always been more to the taste of cultural *apparatchiks* than "political horrors," which are, as the saying goes, best put behind us. And it's not totally surprising to find these same bureaucrats so cheery about the prospects for a culture of images and spectators. The common wisdom has it that spectators are easily manipulated by images, that a clever use of images can deaden them to political horrors and condition them to accept racism, sexism, and deepening class divisions as natural, necessary conditions of existence.

W. E. B. Du Bois said "the problem of the Twentieth Century is the problem of the color line."[2] As we move into an era in which "color" and "line" (and the identities they designate) have become potently manipulable elements in pervasive technologies of simulation and mass mediation, we may find that the problem of the twenty-first century is the problem of the image. Certainly I would not be the first to suggest that we live in a culture dominated by pictures, visual simulations, stereotypes, illusions, copies, reproductions, imitations, and fantasies. Anxieties about the power of visual culture are not just the province of critical intellectuals. Everyone knows that television is bad for you and that its badness has something to do with the passivity and fixation of the spectator. But then people have always known, at least since Moses denounced the Golden Calf, that images were dangerous, that they can captivate the onlooker and steal the soul. Iconoclastic jeremiads that trace the cause of our problems to "images" aren't the answer, nor is the updating of iconoclasm to underwrite notions of aesthetic "purity" or ideological critique.[3] What

2. W. E. B. Du Bois, *The Souls of Black Folk* (first published 1903; New York: Bantam Books, 1989), p. xxxi.

3. See my essay, "The Rhetoric of Iconoclasm: Marxism, Ideology, and Fetishism," in *Iconology: Image, Text, Ideology* (Chicago: University of Chicago Press, 1986), and the discussion of Panofsky and Althusser in chapter 1, below, for a critique of the incorporation of iconoclastic rhetoric into ideological criticism.

we need is a critique of visual culture that is alert to the power of images for good and evil and that is capable of discriminating the variety and historical specificity of their uses. This book is a contribution to that effort. It grows out of a cluster of related interdisciplinary initiatives in literary criticism and theory, the philosophical critique of representation, and new directions in the study of visual art, film, and mass media.

The specific point of emphasis in this study is what the NEH report calls the problem of "Word and Image." It is written in the conviction that the tensions between visual and verbal representations are inseparable from struggles in cultural politics and political culture. It argues that issues like "gender, race, and class," the production of "political horrors," and the production of "truth, beauty, and excellence" all converge on questions of representation. The basic contradictions of cultural politics and of "Word and Image" are mutually symptomatic of deeply felt shifts in culture and representation: anxieties, on the one hand, about the centrality and homogeneity of such notions as "Western civilization" and "American culture" and, on the other, about the sense that changing modes of representation and communication are altering the very structure of human experience. Culture, whether the advanced research carried on in university seminars, the diverse ideologies propagated in "liberal arts" curricula, or the dissemination of images, texts, and sounds to a mass public, is inseparable from questions of representation. Politics, especially in a society that aspires to democratic values, is also deeply connected with issues of representation and mediation, not only the formal linkages between "representatives" and constituencies, but also the production of political power through the use of media.

"Word and Image" is the name of a commonplace distinction between types of representation, a shorthand way of dividing, mapping, and organizing the field of representation. It is also the name of a kind of basic cultural trope, replete with connotations that go beyond merely formal or structural differences. The difference between a culture of reading and a culture of spectatorship, for instance, is not *only* a formal issue (though it is certainly that); it has implications for the very forms that sociability and subjectivity take, for the kinds of individuals and institutions formed by a culture. This is not quite so simple a matter as dividing the terrain of "Word and Image," as the NEH report does, between "television" and "the book." Books have incorporated images into their pages since time immemorial, and television, far from being a purely "visual" or "imagistic" medium, is more aptly described as a medium in which images, sounds, and

words "flow" into one another.[4] This doesn't mean that there is no difference between the media, or between words and images: only that the differences are much more complex than they might seem at first glance, that they crop up *within* as well as *between* media, and they can change over time as modes of representation and cultures change.

"Word and Image" is a deceptively simple label, then, not only for two different kinds of representation, but for deeply contested cultural values. In the NEH report, for example, their difference is associated with the differences between mass and elite culture, between the professional, academic humanities and the "public" humanities, with the difference between a cultural past dominated by the book, and a cultural future in which the image threatens to take over.

The NEH report suggests something of the contemporary situation in which this book was written. This is a book, however, that attempts to put the relation of "word and image" and cultural politics in a larger perspective than contemporary anxieties about television and literacy. It is basically a sequel and companion volume to another book, *Iconology*, which I published in 1986. *Iconology* asked what images are, how they differ from words, and why it matters even to raise these questions. *Picture Theory* raises the same questions with regard to pictures, the concrete, representational objects in which images appear.[5] It asks what a picture is and finds that the answer cannot be thought without extended reflection on texts, particularly on the ways in which texts act like pictures or "incorporate" pictorial practices and vice versa. This text may be regarded as a practical companion to *Iconology*, a kind of "applied iconology." It investigates the

4. See Raymond Williams, *Television: Technology and Cultural Form* (London: Fontana, 1974), p. 92.

5. In common parlance, "picture" and "image" are often used interchangeably to designate visual representations on two-dimensional surfaces, and I will sometimes fall into this usage. In general, however, I think it is useful to play upon distinctions between the two terms: the difference between a constructed concrete object or ensemble (frame, support, materials, pigments, facture) and the virtual, phenomenal appearance that it provides for a beholder; the difference between a deliberate act of representation ("to *picture* or depict") and a less voluntary, perhaps even passive or automatic act ("to *image* or imagine"); the differance between a specific kind of visual representation (the "pictorial" image) and the whole realm of iconicity (verbal, acoustic, mental images). See "What Is an Image?"—chapter 1 of *Iconology*—for further discussion of these distinctions.

interactions of visual and verbal representation in a variety of media, principally literature and the visual arts. One polemical claim of *Picture Theory* is that the interaction of pictures and texts is constitutive of representation as such: all media are mixed media, and all representations are heterogeneous; there are no "purely" visual or verbal arts, though the impulse to purify media is one of the central utopian gestures of modernism.

The book's major aim, however, is not merely to describe these interactions, but to trace their linkages to issues of power, value, and human interest. Foucault's claim that "the relation of language to painting is an infinite relation"[6] seems to me true, not just because the "signs" or "media" of visual and verbal expression are formally incommensurable, but because this fault-line in representation is deeply linked with fundamental ideological divisions. The "differences" between images and language are not merely formal matters: they are, in practice, linked to things like the difference between the (speaking) self and the (seen) other; between telling and showing; between "hearsay" and "eyewitness" testimony; between words (heard, quoted, inscribed) and objects or actions (seen, depicted, described); between sensory channels, traditions of representation, and modes of experience. We might adopt Michel de Certeau's terminology and call the attempt to describe these differences a "heterology of representation."[7]

This book has all the vices of sequels and supplements. It is a collection, a progress report on an incomplete project, the record of numerous attempts to "picture theory," not a "theory of pictures." It is a product of many conversations and occasions, some fugitive reading, and an obsession with three basic questions about pictures: What are they? What is their relation to language? Why are these questions of any importance? That is, why does it matter what pictures are, how they relate to language?

For anyone who is skeptical about the need for/to picture theory, I simply ask them to reflect on the commonplace notion that we live in a culture of images, a society of the spectacle, a world of semblances and simulacra. We are surrounded by pictures; we have an abundance

6. Michel Foucault, *Les Mots et les choses* (1966) translated as *The Order of Things: An Archaeology of the Human Sciences* (New York: Random House, 1973), p. 9.

7. Michel de Certeau, *Heterologies: Discourse on the Other*, translated by Brian Massumi (Minneapolis: University of Minnesota Press, 1986).

of theories about them, but it doesn't seem to do us any good. Knowing what pictures are doing, understanding them, doesn't seem necessarily to give us power over them. I'm far from sanguine that this book, or any book, can change this situation. Perhaps its principal function is disillusionment, the opening of a negative critical space that would reveal how little we understand about pictures and how little difference mere "understanding" alone is likely to make. Images, like histories and technologies, are our creations, yet also commonly thought to be "out of our control"—or at least out of "someone's" control, the question of agency and power being central to the way images work. That's why a book that begins by asking how to picture theory ends with reflections on the relation of pictures and power: the powers of realism and illusion, of mass publicity and propaganda. In between, it attempts to specify the relation between pictures and discourse understood, among other things, as a relation of power.

The educational function of this book is twofold. First, on the practical side, it attempts to suggest some questions, problems, and methods for a curriculum that would stress the importance of visual culture and literacy in its relations to language and literature. Recent developments in art history, film theory, and what is loosely called "cultural studies" make the notion of a purely verbal literacy increasingly problematic. A bureaucratic answer to this problem would insist that students take a "double major" in the textual and visual disciplines. The clear separation of "faculties" (corporeal and collegial) on the basis of sensory and semiotic divisions is becoming obsolete and is now being replaced by a notion of humanistic or liberal education as centrally concerned with the whole field of representations and representational activity. I use "representation" as the master-term for this field, not because I believe in any general, homogeneous, or abstractable concept of representation, but because it has a long tradition in the critique of culture, and it activates a set of linkages between political, semiotic/aesthetic, and even economic notions of "standing or acting for." Like all key words, it has its limitations, but it also has the virtue of simultaneously linking the visual and verbal disciplines within the field of their differences and connecting them with issues of knowledge (true representations), ethics (responsible representations), and power (effective representations).

On the theoretical side, by contrast, this is a relentlessly negative book. My aim has not been to produce a "picture theory" (much less a theory of pictures), but *to picture theory* as a practical activity in the formation of representations. I have not wanted to settle the questions of what pictures are, how they relate to words, and why the

relationship matters. I've been more interested in showing how the received answers to these questions work in practice and why settled answers of a systematic kind may be impossible. This may well be an introduction to a discipline (the general study of representations) that does not exist and never will. If its only accomplishment is as a de-disciplinary exercise to make the segregation of the disciplines more difficult, that will be enough.

This book has been the byproduct of numerous seminars called at various times "Image and Text," "Verbal and Visual Representation," or simply "Picture Theory." It is meant, therefore, as a pedagogical primer or prompt-book for classroom experiments. For teachers interested in a way of addressing the confluences of visual and verbal culture in the classroom, the chapter ("Beyond Comparison") on comparative studies in literature and the visual arts lays out some methodological suggestions, both positive and negative. Those interested chiefly in the literary and textual side of picture theory, the places of images, space, ekphrasis, description, schemata, and figures in the text, should go to the section on "Textual Pictures." Conversely, art historians and students of the visual field will find the section entitled "Pictorial Texts" most directly addressed to their concerns. Finally, for those concerned with what representations *do,* the final sections on pictures, power, and the public sphere are recommended.

Since this is intended as a practical companion to the comparative study of verbal and visual representation, I've tried to make the essays as accessible as possible, keeping technical language to a minimum. Some repetition in the arguments has seemed unavoidable, and there is no use trying to deny that this is a collection of essays in a very uneven state of development, reflective of a highly diverse set of occasions.

I'm also conscious that this is a book whose reach far outstrips its grasp. I've attempted to open up what I call the "image/text problematic" in fields ranging across media and modes of representation from antiquity to the present day. I've had to rely heavily on the work of others, to speculate where certainty seemed impossible, and to be content with raising questions whose answers are beyond my competence. This is a book, therefore, that is likely to offend a lot of specialists: art historians, because it doesn't believe that the history of Western painting as a fine art is the unique key to understanding pictures; film scholars, because it will seem that many of its problems have already been worked through in cinema studies; philosophers, because it tends to read philosophy for the pictures; literary scholars, because

it takes a bit too literally the desire for sensuous, bodily presence in literary representation; radical or "critical" critics, because it is too ahistorical and formalistic; formalists, because it is too interested in history and ideology. My hope is that some specialists will take the unanswered questions as provocative rather than merely provoking and regard the speculations as worthy of closer testing and refinement. For the more general reader, my hope is that a book that figures out a way to connect William Blake, Wittgenstein, and Spike Lee will not be totally lacking in interest.

I····Picture·Theory

Although we have thousands of words about pictures, we do not yet have a satisfactory theory of them. What we do have is a motley array of disciplines—semiotics, philosophical inquiries into art and representation, studies in cinema and mass media, comparative studies in the arts—all converging on the problem of pictorial representation and visual culture.

Perhaps the problem is not just with pictures, but with theory and, more specifically, with a certain picture of theory. The very notion of a theory of pictures suggests an attempt to master the field of visual representation with a verbal discourse. But suppose we reversed the power relations of "discourse" and "field" and attempted to *picture theory*? The following trio of essays attempts this from three different angles. "The Pictorial Turn" looks at the way modern thought has re-oriented itself around visual paradigms that seem to threaten and overwhelm any possibility of discursive mastery. It looks at pictures "in" theory and at theory itself as a form of picturing. "Metapictures," on the other hand, looks at pictures "as" theory, as second-order reflections on the practices of pictorial representation; it asks what pictures tell us when they theorize (or depict) themselves. "Beyond Comparison" looks at the relation of pictures and discourse and tries to replace the predominantly binary theory of that relation with a dialectical picture, the figure of the "imagetext."

THE PICTORIAL TURN

All the impulses of the media were fed into the circuitry of my dreams. One thinks of echoes. One thinks of an image made in the image and likeness of images. It was that complex.

—Don DeLillo, *Americana* (1971)

Richard Rorty has characterized the history of philosophy as a series of "turns" in which "a new set of problems emerges and the old ones begin to fade away":

> The picture of ancient and medieval philosophy as concerned with *things,* the philosophy of the seventeenth through the nineteenth century as concerned with *ideas,* and the enlightened contemporary philosophical scene with *words* has considerable plausibility.

The final stage in Rorty's history of philosophy is what he calls "the linguistic turn," a development that has complex resonances in other disciplines in the human sciences. Linguistics, semiotics, rhetoric, and various models of "textuality" have become the lingua franca for critical reflections on the arts, the media, and cultural forms. Society is a text. Nature and its scientific representations are "discourses." Even the unconscious is structured like a language.[1]

What these shifts in intellectual and academic discourse have to do with each other, much less with everyday life and ordinary language is not especially self-evident. But it does seem clear that another shift in what philosophers talk about is happening, and that once again a complexly related transformation is occurring in other disciplines of the human sciences and in the sphere of public culture. I want to call this shift "the pictorial turn." In Anglo-American philosophy,

1. See Richard Rorty, *Philosophy and the Mirror of Nature* (Princeton: Princeton University Press, 1979), p. 263, and the earlier collection of essays edited by Rorty, *The Linguistic Turn: Recent Essays in Philosophical Method* (Chicago: University of Chicago Press, 1967).

11

variations on this turn could be traced early on in Charles Peirce's semiotics and later in Nelson Goodman's "languages of art," both of which explore the conventions and codes that underlie nonlinguistic symbol systems and (more important) do not begin with the assumption that language is paradigmatic for meaning.[2] In Europe one might identify it with phenomenology's inquiry into imagination and visual experience; or with Derrida's "grammatology," which de-centers the "phonocentric" model of language by shifting attention to the visible, material traces of writing; or with the Frankfurt School's investigations of modernity, mass culture, and visual media; or with Michel Foucault's insistence on a history and theory of power/knowledge that exposes the rift between the discursive and the "visible," the seeable and the sayable, as the crucial fault-line in "scopic regimes" of modernity.[3] Above all, I would locate the philosophical enactment of the pictorial turn in the thought of Ludwig Wittgenstein, particularly in the apparent paradox of a philosophical career that began with a "picture theory" of meaning and ended with the appearance of a kind of iconoclasm, a critique of imagery that led him to renounce his earlier pictorialism and say "A *picture* held us captive. And we could not get outside it, for it lay in our language and language seemed to repeat itself to us inexorably."[4] Rorty's determination to "get the visual, and in particular the mirroring, metaphor out of our speech altogether"[5] echoes Wittgenstein's iconophobia and the general anxiety of linguistic philosophy about visual representation. This anxiety,

2. Another important line of development would be Stanley Cavell's attempt in *The World Viewed: Reflections on the Ontology of Film* (Cambridge, MA: Harvard University Press, 1980) to address American film and modern painting within the philosophical framework of Anglo-American romanticism.

3. I echo here the analysis of Foucault's method in Gilles Deleuze *Foucault,* translated by Sean Hand (Minneapolis: University of Minnesota Press, 1988). See especially the chapter on "Strata or Historical Formations: The Visible and the Articulable (Knowledge)," pp. 47–69. On the notion of a "scopic regime," see Martin Jay's "Scopic Regimes of Modernity," in *Vision and Visuality,* edited by Hal Foster (Seattle: Bay Press, 1988), pp. 3–27. Jean-François Lyotard, *Discourse/Figure* (Paris: Klincksieck, 1971).

4. Ludwig Wittgenstein, *Philosophical Investigations,* translated by G. E. M. Anscombe (New York: Macmillan, 1953), I:115. For a fuller account of this issue, see my essay, "Wittgenstein's Imagery and What It Tells Us," *New Literary History* 19:2 (Winter 1988): 361–70.

5. Rorty, *Mirror of Nature,* p. 371.

this need to defend "our speech" against "the visual" is, I want to suggest, a sure sign that a pictorial turn is taking place.[6]

I am not saying, of course, that all these different encounters with visual representation can be reduced to some single thesis or that all the anxieties about "the visual" come to the same thing. Rorty's concern is to get philosophy over its infatuation with epistemology, and particularly its obsession with the model of the image as a figure of representational transparency and realism. For him, the "mirror" is the temptation to scientism and positivism. For the Frankfurt School, by contrast, the regime of the visual is associated with mass media and the threat of a culture of fascism.[7] What makes for the sense of a pictorial turn, then, is not that we have some powerful account of visual representation that is dictating the terms of cultural theory, but that pictures form a point of peculiar friction and discomfort across a broad range of intellectual inquiry. The picture now has a status somewhere between what Thomas Kuhn called a "paradigm" and an "anomaly," emerging as a central topic of discussion in the human sciences in the way that language did: that is, as a kind of model or figure for other things (including figuration itself), and as an unsolved problem, perhaps even the object of its own "science," what Erwin Panofsky called an "iconology." The simplest way to put this is to say that, in what is often characterized as an age of "spectacle" (Guy Debord), "surveillance" (Foucault), and all-pervasive image-making, we still do not know exactly what pictures are, what their relation to language is, how they operate on observers and on the world, how their history is to be understood, and what is to be done with or about them.

The study of the visual arts has not been exempt from these developments, but it has not exactly been in the vanguard, either. Anglo-American art history, in particular, has just begun to awaken to the implications of the linguistic turn. While French scholars like Louis Marin and Hubert Damisch were pioneering a structuralist art his-

6. Charles Altieri suggests that the "anxiety" here lies in Wittgenstein's realization that "analytic philosophy was itself based on a radically pictorial notion of self-evidence and representability." Correspondence with author, October 1992.

7. The closest thing to a philosophical synthesis of Rorty and the Frankfurt School on the regime of the visual is, ironically enough, Martin Heidegger's *"Die Zeit des Weltbildes,"* translated as "The Age of the World Picture" by William Lovitt, in Heidegger, *The Question Concerning Technology and Other Essays* (New York: Harper & Row, 1977), pp. 115–54.

tory, Anglo-American art history continued to focus on sociological issues (notably patronage studies) and to avoid theory like the plague.[8] It took the work of a renegade literary scholar like Norman Bryson to bring the latest news from France and shake art history out of its dogmatic slumber.[9]

Now that art history is awake, at least to the linguistic turn, what will it do? The predictable alternatives are already flooding the learned journals in the form of discoveries that the visual arts are "sign systems" informed by "conventions," that paintings, photographs, sculptural objects, and architectural monuments are fraught with "textuality" and "discourse."[10] A more interesting alternative, however, is

8. Damisch noted almost twenty years ago that after "the great period of Riegl, Dvorak, Wölfflin and others," art history "has shown itself to be totally incapable of renovating its method, and above all of taking any account of the potential contribution from the most advanced lines of research." The first "line" of research that Damisch mentions is linguistics. See "Semiotics and Iconography," in *The Tell-Tale Sign,* edited by Thomas Sebeok (Netherlands: Peter de Ridder, 1975), p. 29.

9. In this sense, Bryson has done for Anglo-American art history something like the service Jonathan Culler provided for Anglo-American literary criticism some ten years earlier. I should stress, however, that this is my sense of the *institutional* shape of recent developments in American art history in the academy. A more broadly conceived account would have to reckon with the path-breaking work (and the often equivocal academic reception) of Anglo-American scholars like Svetlana Alpers, Michael Baxandall, Rosalind Krauss, Ronald Paulson, and Leo Steinberg. I should also mention here the far-reaching work of T. J. Clark and Michael Fried, who have, in very different ways, put the theoretical languages of art history under the most intense pressure since the sixties and early seventies. See my remarks on the Clark/Fried debate in chapter 7.

10. For an authoritative survey of these developments, see Mieke Bal and Norman Bryson, "Semiotics and Art History," *Art Bulletin* 73:2 (June 1991): 174–208. Bal and Bryson argue that semiotics goes beyond the linguistic turn to achieve a "transdisciplinary theory" that will "avoid the bias of privileging language" in accounts of visual culture: "rather than a linguistic turn, we will propose a semiotic turn for art history" (p. 175). As will become clear in what follows (and in chapter 3, "Beyond Comparison"), I am skeptical about the possibility both of transdisciplinary theory and of avoiding "bias" or achieving neutrality in the metalanguages of representation. Although I have great respect for the achievements of semiotics, and draw upon it frequently, I'm convinced that the best terms for describing representations, artistic or otherwise, are to be found in the immanent vernaculars of represen-

suggested by the very resistance of the visual arts to the linguistic turn. If a pictorial turn is indeed occurring in the human sciences, art history could very well find its theoretical marginality transformed into a position of intellectual centrality, in the form of a challenge to offer an account of its principal theoretical object—visual representation—that will be usable by other disciplines in the human sciences. Tending to the masterpieces of Western painting will clearly not be enough. A broad, interdisciplinary critique will be required, one that takes into account parallel efforts such as the long struggle of film studies to come up with an adequate mediation of linguistic and imagistic models for cinema and to situate the film medium in the larger context of visual culture.

If we ask ourselves why a pictorial turn seems to be happening now, in what is often characterized as a "postmodern" era, the second half of the twentieth century, we encounter a paradox. On the one hand, it seems overwhelmingly obvious that the era of video and cybernetic technology, the age of electronic reproduction, has developed new forms of visual simulation and illusionism with unprecedented powers. On the other hand, the fear of the image, the anxiety that the "power of images" may finally destroy even their creators and manipulators, is as old as image-making itself.[11] Idolatry, iconoclasm, iconophilia, and fetishism are not uniquely "postmodern" phenomena. What is specific to our moment is exactly this paradox. The fantasy of a pictorial turn, of a culture totally dominated by images, has now become a real technical possibility on a global scale. Marshall McLuhan's "global village" is now a fact and not an especially comforting one. CNN has shown us that a supposedly alert, educated population (for instance, the American electorate) can witness the mass destruction of an Arab nation as little more than a spectacular television melodrama, complete with a simple narrative of good triumphing over evil and a rapid erasure from public memory. Even

tational practices themselves. Sometimes, of course, the language of semiotics intersects with these vernaculars (consider the loaded notion of the "icon"). These intersections only make it clearer that the technical metalanguages of semiotics don't offer us a scientific, transdisciplinary, or unbiased vocabulary, but only a host of new figures or theoretical pictures that must themselves be interpreted.

11. For further discussion of traditional versions of these anxieties, see my *Iconology* (Chicago: University of Chicago Press, 1986), and David Freedberg's *The Power of Images: Studies in the History and Theory of Response* (Chicago: University of Chicago Press, 1989).

more notable than the power of the media to allow a "kinder, gentler nation" to accept the destruction of innocent people without guilt or remorse was its ability to use the spectacle of that destruction to exorcise and erase all guilt or memory of a *previous* spectacular war. As George Bush so aptly put it: "the specter of Vietnam has been buried forever in the desert sands of the Arabian Peninsula." Or perhaps the moral was put more pointedly by Dan Rather, as he juxtaposed file footage of the last U.S. helicopter rising from the American embassy in Saigon with live footage of a helicopter landing at our embassy in Kuwait City: "Of course," Rather said, "an image doesn't tell us everything. . . ."[12]

Whatever the pictorial turn is, then, it should be clear that it is not a return to naive mimesis, copy or correspondence theories of representation, or a renewed metaphysics of pictorial "presence": it is rather a postlinguistic, postsemiotic rediscovery of the picture as a complex interplay between visuality, apparatus, institutions, discourse, bodies, and figurality. It is the realization that *spectatorship* (the look, the gaze, the glance, the practices of observation, surveillance, and visual pleasure) may be as deep a problem as various forms of *reading* (decipherment, decoding, interpretation, etc.) and that visual experience or "visual literacy" might not be fully explicable on the model of textuality.[13] Most important, it is the realization that while the problem of pictorial representation has always been with us, it presses inescapably now, and with unprecedented force, on every level of culture, from the most refined philosophical speculations to the most vulgar productions of the mass media. Traditional strategies of containment no longer seem adequate, and the need for a global critique of visual culture seems inescapable.

The current revival of interest in Panofsky is surely a symptom of the pictorial turn. Panofsky's magisterial range, his ability to move with authority from ancient to modern art, to borrow provocative and telling insights from philosophy, optics, theology, psychology, and philology, make him an inevitable model and starting point for any general account of what is now called "visual culture." More

12. For more on this subject, see chapter 13, "From CNN to *JFK.*"

13. This negative version of the pictorial turn was already latent in the realization that a semiotics constructed on the model of the linguistic sign might find itself incapable of dealing with the icon, the sign by resemblance, precisely because (as Damisch notes) "the icon is not necessarily a sign" (Sebeok, *Tell-Tale Sign,* p. 35).

significant, perhaps, is that Panofsky's early theoretical work is not just the subject of inert reverence, but of some rather hot arguments in art history. Is he really "the Saussure of art history," as Giulio Argan once claimed? Or merely a "quaint early modern episode" in the "lugubrious labyrinth" of German neo-Kantian art history, as Donald Preziosi suggests? Has Panofsky's iconology amounted to anything more than a "rote cryptography" that reinforces the insularity of one of the most retrograde disciplines in the humanities? Or did he, as the enthusiastic editors of Zone Books suggest, anticipate Foucault by producing an "'archaeology' of Western representation that far surpasses the usual scope of art historical studies"?[14]

All these claims have some partial truth. Panofsky has no doubt been appropriated for all sorts of stultifying disciplinary routines; the intellectual contexts of his thought could no doubt be understood much better than they are; his iconology would no doubt have been improved by acquaintance with Mukarovský's semiology; and he will no doubt be more to contemporary taste after Preziosi manages to "grill him through the grid of Nietzsche."[15] All the same, it is quite remarkable how much power remains in his classic 1924 essay, "Perspective as Symbolic Form," now available in a clear, elegant translation and authoritative introduction by Christopher Wood. This essay remains a crucial paradigm for any ambitious attempt at a general critique of pictorial representation. Panofsky's grand synthetic history of space, visual perception, and pictorial construction remains unmatched in both its sweep and its nuanced detail. We are reminded once again that this is not just a story of the invention of perspective in the Renaissance, but an account of pictorial space that goes from antiquity to the present, that embraces Euclid and Vitruvius at one end and El Lissitzky and Ernst Mach at the other. Panofsky manages to tell a multidimensional story of Western religious, scientific, and

14. Dust jacket copy from the Zone Books edition of Erwin Panofsky's *Perspective as Symbolic Form,* edited by Sanford Kwinter and translated by Christopher S. Wood (Cambridge, MA: Zone Books, 1991); subsequent page references will be cited in the text. See Argan in *The Language of Images,* edited by W. J. T. Mitchell (Chicago: University of Chicago Press, 1980), and Donald Preziosi, *Rethinking Art History: Meditations on a Coy Science* (New Haven, CT: Yale University Press, 1989), p. 112. Preziosi's blast in this book against Michael Ann Holly's *Panofsky and the Foundations of Art History* (Ithaca, NY: Cornell University Press, 1984) was the opening salvo in the current controversy over Panofsky.

15. See Preziosi, *Rethinking Art History,* p. 121.

philosophical thought entirely around the figure of the picture, under-
stood as the concrete symbol of a complex cultural field of what
Foucault might have called the "visible and the articulable." This
history is grounded, moreover, in what was for Panofsky's time the
most up-to-date psychophysiological accounts of visual experience.
Panofsky argued that Renaissance perspective did not correspond to
"actual visual experience" either as it was understood scientifically in
the early twentieth century or intuitively in the sixteenth century or
antiquity. He calls perspective a "systematic abstraction from the
structure of . . . psychophysiological space" (p. 3) and suggests a
link between "the most modern insights of psychology" into visual
perception and the pictorial experiments of Mondrian and Malevich.

The unfinished business in Panofsky's perspective essay, as in his
iconological method more generally, is the question of the spectator.
Panofsky is routinely ambiguous about just what the subject of his
history is.[16] Practices and precepts for pictorial representation are reg-
ularly elided in his argument with claims about transformations in
"subjective visual impressions" (p. 33) and phrases about the "percep-
tion" of an "epoch"—as if a historical period were something that
could be visually perceived or could itself be described as a perceiving
subject (p. 6). Sometimes Panofsky will talk as if visual perception
has a history that can be read directly from the pictorial conventions
that express it in "symbolic forms." Other times he will treat visuality
as a natural, physiological mechanism that lies outside history, a
mechanism intuitively grasped by ancient optics and on the way to
a scientific understanding in modern psychophysiology. Panofsky's
philosophical language of "subject" and "object" (as distinct, say,
from "individual" and "world" or "self" and "other") only com-
pounds the difficulty by replicating the optical figures of perspective
as the fundamental terms of epistemology.[17] The "subject" is para-

16. The best critique of Panofsky's argument in the perspective essay is
Joel Snyder's "Picturing Vision," in Mitchell, *The Language of Images*.

17. It is in this sense that I've argued along the same lines as Michael
Podro, that at some very fundamental level of discursive figuration, Panofsky
does believe in the universality of perspective. See Podro's discussion of the
correspondence between Panofsky's perspective and Kantian epistemology in
The Critical Historians of Art (New Haven, CT: Yale University Press, 1982),
pp. 188–89, and my essay, "Iconology and Ideology: Panofsky, Althusser,
and the Scene of Recognition," in *Works & Days* 11/12 (Spring–Fall 1988)
and reprinted in *Image and Ideology in Modern/Postmodern Discourse*, ed-
ited by David Downing and Susan Bazargan (Albany, NY: State University

digmatically a *spectator,* the "object" a visual image. Vision, space, world-pictures, and art-pictures all weave together as a grand tapestry of "symbolic forms" that synthesize the *kunstwollen* of each historical period. If the pictorial turn is to accomplish Panofsky's ambitions for a critical iconology, however, it seems clear that we will need to *unweave* this tapestry, not just elaborate it.

A notable attempt to disentangle the spectatorial thread from art history's master-narrative is offered by Jonathan Crary's *Techniques of the Observer.* I want to discuss this book at some length for several reasons. First, it is quite consciously situated in relation to the general problems raised by Panofsky's iconology, and to the particular issues of the perspective essay, with its interweaving of questions about visual representation and scientific accounts of visual perception as a bodily and mental activity. Second, it positions itself in a critical relation to traditional art history, insisting on the importance of a broader critique of visual culture that places models of the spectator at a central location. Finally, in some of its limitations and excesses, Crary's book illustrates certain chronic difficulties in the very notion of historicizing and theorizing spectatorship, showing just how difficult it is to break out of the specular totalities of Panofsky's iconology. I offer this critique, not because I think I've solved every problem encountered by Crary, but in the spirit of a cooperative endeavor, one that strikes me as being in its very early, exploratory stages.

Crary wants to write a book about "vision and its historical construction" (p. 1), but he wants to detach that history to some extent from "an account of shifts in representational practices" (p. 5). Bypassing what he calls the "core narrative" of art history—the shift from the "Renaissance, perspectival, or normative" model of vision signaled by the arrival of artistic modernism in the 1870s and 1880s—Crary turns our attention to earlier "systemic shifts" in the discourses of psychology, physiology, and optical technology. The central argument of the book is that "a new kind of observer took shape in Europe" during the first few decades of the nineteenth century. The observer of the seventeenth and eighteenth centuries, according to Crary, was a disembodied figure whose visual experience was modeled on the "incorporeal relations of the camera obscura." In the nine-

of New York Press, 1991), pp. 321–30. Christopher Wood's excellent introduction to Panofsky's essay also provides an account of Panofsky's "double entendres" between "art and worldview" and shows that "perspective . . . makes possible the metaphor of a *Weltanschauung,* a worldview, in the first place" (Panofsky, *Perspective as Symbolic Form,* pp. 21, 13).

teenth century, this observer is given a body. Psychophysiological phenomena like afterimages replace the paradigms of physical optics, and new optical devices like the stereoscope and the phenakistoscope grow out of "a radical abstraction and reconstruction of optical experience" (p. 9).

Crary adduces some striking examples to illustrate the shift in the scientific understanding of visual experience: typical of these are his discussion of Goethe's *closing off* of the opening into the camera obscura in order to contemplate the "physiological" colors that float and transform themselves in the ensuing darkness and his acute description of the stereoscope as a kind of transition between the (ob)-scene space of the theater and the Euclidean fragments of "Riemann space" (pp. 126–27). Crary also offers some important admonitions about theory and method. He warns against the tendency (characteristic of early film studies) to simply "read off" an account of the spectator from optical apparatuses in a kind of technological determinism. He notes that "the position and function of a technique is historically variable" (p. 8) and that the camera obscura may not occupy the same position in eighteenth-century accounts of vision that the stereoscope does in the nineteenth century. He seems aware, above all, that the whole concept of "the observer" and of a "history of vision" is fraught with deep theoretical problems: there may not actually *be* any "nineteenth century observer," only "an *effect* of an irreducibly heterogeneous system of discursive, social, technological, and institutional relations" (p. 6). There may not be any "true history" of this subject, only a rhetoric that mobilizes certain materials from the past in order to have an effect in the present (p. 7).

Crary also strays, however, into some of the familiar occupational hazards of iconology, failing to heed many of his own warnings about overgeneralization and categorical truth-claims. His modest and interesting account of optical devices and physiological experiments rapidly gets inflated into "a sweeping transformation in the way in which an observer was figured," a "hegemonic set of discourses and practices in which vision took shape," a "dominant model of what an observer was in the nineteenth century" (p. 7). Dominant for whom? Hegemonic in what sphere? Sweeping across what social boundaries? Crary cannot even ask, much less answer, these questions because he shows no interest in the empirical history of spectatorship, in the study of visuality as a cultural practice of everyday life, or in the observer/ spectator's body as marked by gender, class, or ethnicity. "Obviously," he says, "there was no single nineteenth century observer, no example that can be located empirically" (p. 7). The first half of the

sentence *is* obvious and true; the second half is quite false, if by it Crary means that we can have no access to examples of spectatorship—what people liked to look at, how they described what they saw, how they understood visual experience, whether in pictures or the spectacles of daily life. Crary's skepticism about the "single nineteenth century observer" leads him, against all logic, to conclude that there is *no* observer, except in the "dominant model" he has extracted from physiological optics and optical technology.[18]

Even more curious is the determining historical function attributed to this very specialized "shift" in spectatorship. The transformed observer who is described on one page as merely an "effect" becomes, in the twinkling of an eye, the fundamental *cause* of massive historical developments: "Modernist painting in the 1870s and 1880s and the development of photography after 1839 can be seen as later symptoms or consequences of this crucial systemic shift which was well under way by 1820" (p. 7). When Crary talks about these "systemic shifts," "gaps," and "ruptures," he sounds most conventional, most firmly in the grip of received ideas. The rhetoric of rupture and discontinuity forces him to make arguments that *appear* in the guise of historical particularity and resistance to "homogeneity" and "totality" but actually wind up producing exactly what they want to avoid. Typical is his claim that the "similarities" between photographs and other, older kinds of pictures are only apparent: "the vast systemic rupture of which photography is a part renders such similarities insignificant. Photography is an element of a new and homogeneous terrain . . . in which an observer becomes lodged" (p. 13).

18. Jonathan Crary, *Techniques of the Observer: On Vision and Modernity in the Nineteenth Century* (Cambridge, MA: MIT Press, 1990); further page references will be cited in the text. Crary does note that there are "practices of vision" that lie beyond the scope of his study, but he relentlessly assimilates them to his "dominant model" by characterizing them as "marginal and local forms by which dominant practices of vision were resisted, deflected, or imperfectly constituted" (p. 7). The problem with this formulation is that all heterogeneity in visual experience is preordained to fit a "dominant/resistant" or "universal/local" model and (more fundamentally) that the case for Crary's observer as a "dominant model" is never really argued. His account of the nineteenth-century observer would surely have benefitted from some of the recent work being done on the audiences of early cinema, particularly Charles Musser's *History of the American Cinema*, volume 1, *The Emergence of Cinema: The American Screen to 1907* (New York: Macmillan, 1990) and Miriam Hansen's *Babel and Babylon: Spectatorship in American Silent Film* (Cambridge, MA: Harvard University Press, 1991).

Although the vocabulary is from Foucault, the tendency toward a totalizing master narrative that cuts across all strata, exerting its force on "a single social surface" sounds more like the German idealist history that informs Panofsky's perspective essay—exactly the sort of thing Foucault was trying to leave behind. But then Crary's Foucault, in a remarkable act of reverse historical leapfrogging, turns out to have influenced the principal philosophical influence on Panofsky: "Ernst Cassirer's reading of the Enlightenment, though unfashionable now, more than echoes certain parts of Foucault's construction of 'classical thought'" (p. 56). It is telling that Crary opens by situating his own historical position precisely in the terms provided by Panofsky's perspective essay, that is, "in the midst of a transformation in the nature of visuality probably more profound than the break that separates medieval imagery from Renaissance perspective" (p. 1). It is equally telling that his "systemic shift" turns for a supporting analogy to the master-narrative of M. H. Abrams's *The Mirror and the Lamp*, a straightforward idealist literary history of English and German romanticism that is generally regarded in literary studies as an important museum piece—a history to be criticized and rewritten, not to be cited as a confirming authority. The clincher comes when Crary starts describing the eighteenth-century "camera obscura" observer in terms of "objectivity" and the "suppression of subjectivity" and (predictably) characterizes the nineteenth-century observer as one in which subjectivity is running rampant (see p. 9). These ready-made subject-object binarisms lead us, then, to a familiar story of the "abstraction" of visual experience from a "human observer" whose vision is progressively "alienated" and "reified" (see p. 11). The surest sign that the well-worn paths of idealist history are being retraced in this book is the way it absorbs all possible theories and histories of the observer into a single-minded, nonempirical account of a purely hypothetical observer. Foucault, Adorno, Baudrillard, Benjamin, Debord, Deleuze, and other critics all co-exist happily in the construction of this specular history; their disagreements and discrepancies disappear in the blinding light of a "dominant model" illuminating a "homogeneous terrain."

In Crary's defense it must be said that it is a lot harder to get away from idealist histories of visual culture than we might imagine, and it's not clear that Foucault himself completely avoided their temptations. Any interesting theoretical reflection on visual culture will have to work out an account of its historicality, and that will necessarily involve some form of abstraction and generality about spectators and visual regimes. And there are important pleasures and rewards in

22

these overgeneralized master-narratives, especially when they are told by a master like Panofsky who knew more about the history of visual culture than Crary and I and several others put together. Panofsky's story still feels fresh and challenging because it is so multidimensional, so densely realized, and so complexly comprehensive. It covers four distinct epochs (ancient, medieval, Renaissance, and modern) with a discursive grid that includes religion, philosophy, science, psychology, physiology, and of course art history. It aims at nothing less than a critical iconology, a self-theorizing account of visual culture.

It's not fair, then, to compare Crary's book and its two-stage "Romanticist/Modernist" history with Panofsky's epic of visuality. The standard is impossibly high. It is a standard we will have to interrogate, however, if we are going to develop a critical art history or an understanding of contemporary visual culture. Could it be, as Christopher Wood suggests, that "iconology, in the end, has not proved an especially useful hermeneutic of culture" precisely because its *object* (the visual image) entraps its discourse and method in tautological "likenesses" between visual images and historical totalities? Is iconology, in contrast to its "disintegrative" methodological cousin, philology, incapable of registering the "faults" in culture, the fractures in representation, and the resistance of spectators? Crary is certainly right to identify the historicizing of vision and spectatorship as the deep puzzle of a critical iconology. And he may, after all, be right in saying that we "are in the midst of a transformation in the nature of visuality . . . more profound than the break that separates medieval imagery from Renaissance perspective." This is not what his book is about (*Techniques of the Observer* is only a "prehistory" to contemporary visuality), and he makes no argument for it, except to assert that "computer-generated imagery" is "relocating vision to a plane severed from a human observer" (p. 1). Since this "relocation" and severing of vision from the "human" has, in Crary's account, been going on since 1820, and since it echoes Panofsky's narrative of the "rationalization of the visual image" by Renaissance perspective, it doesn't feel like big news.

At the same time, it is not so different from the paradoxical narrative I have tacitly subscribed to in locating a "pictorial turn" in contemporary thought and culture that replays the most archaic iconomachias on the screens of a global electronic visual culture. Crary's technological symptoms of this turn—"computer-aided design, synthetic holography, flight simulators, computer animation, robotic image recognition, ray tracing, texture mapping, motion control, virtual environment helmets, magnetic resonance imaging, and multi-spectral

sensors"—may not be best described as severing vision from "the human," but it is certainly the case that they are altering the conditions under which human vision articulates itself, and it is easy to sympathize with the moral/political anxiety in Crary's nostalgic invocation of "the human." Crary's list of cybervisual technologies could be a catalog of the special effects in Arnold Schwarzenegger's *Predator* or *Terminator,* an inventory of the devices that made a spectacle like Operation Desert Storm possible. The power/knowledge quotient of contemporary visual culture, of nondiscursive orders of representation, is too palpable, too deeply embedded in technologies of desire, domination, and violence, too saturated with reminders of neofascism and global corporate culture to be ignored. The pictorial turn is not the answer to anything. It is merely a way of stating the question.

Whether some revised version of Panofsky's iconology is the best way of answering the question is far from clear. The problem is suggested by the root meanings of the very word "iconology." On the one hand, we are promised a discursive science of images, a mastering of the icon by the logos; on the other hand (as Wood notes), certain persistent images and likenesses insinuate themselves into that discourse, leading it into totalizing "world-pictures" and "world-views." The icon in iconology is like a repressed memory that keeps returning as an uncontrollable symptom.

One way of dealing with this problem would be to give up the notion of a metalanguage or discourse that could control the understanding of pictures and to explore the way that pictures attempt to represent themselves—an "iconography" in a sense rather different from the traditional one. I will return to this notion in the next chapter. In the meantime, I want to recall two of the basic claims of my argument in *Iconology.* The first is that the key move in the reconstruction of iconology is to resign the hope for a scientific theory and to stage the encounter between the "icon" and "logos" in relation to topics such as the *paragone* of painting and literature and the Sister Arts tradition. This move, in my view, takes iconology well beyond the comparative study of verbal and visual art and into the basic construction of the human subject as a being constituted by both language and imaging. There is an ancient tradition, of course, which argues that language is the essential human attribute: "man" is the "speaking animal." The image is the medium of the subhuman, the savage, the "dumb" animal, the child, the woman, the masses. These associations are all too familiar, as is the disturbing countertradition, that "man" is created *in the image* of his maker. One basic argument of *Iconology* was that the very name of this "science of images" bears

the scars of an ancient division and a fundamental paradox that cannot be erased from its workings.

The other key move for a revived iconology is, as I've suggested, a mutually critical encounter with the discourse of ideology.[19] I attempted to stage such an encounter in the final chapter of *Iconology* by working through the constitutive figures (*camera obscura* and fetish) in Marx's account of ideology and commodity. I want now to extend that discussion here by shifting from the "apparatus" of ideology (especially its figures of optical assemblages) to its *theatrical* figures, what I will call (following Geoffrey Hartman) "the recognition scene of criticism."[20]

Panofsky gives us the "primal scene" of his own iconological science in the introductory essay to his *Studies in Iconology:* "When an acquaintance greets me on the street by removing his hat, what I see from a *formal* point of view is nothing but the change of certain details within a configuration forming part of the general pattern of colour, lines and volumes which constitutes my world of vision."[21] Panofsky's subsequent elaboration of this scene as a hierarchy of ever more complex and refined perceptions is familiar to all art historians: the "formal" perception gives way to (or is "overstepped" by) a "sphere of subject matter or meaning," the "factual" identification of the formal pattern as an *"object* (gentleman)"—that is, a thing that has a *name*. This level of "Natural" or "practical experience" Panofsky associates anthropologically with savages (the Australian Bushman), and it gives way, in turn, to a secondary level of "conventional subject matter," or meaning. The "realization that the lifting of the hat stands for a greeting belongs in an altogether different realm of interpretation." Finally, the greeting reaches the level of global cultural symbol: "besides constituting a natural event in space and time,

19. The remainder of this essay is based largely on my article, "Iconology and Ideology: Panofsky, Althusser, and the Scene of Recognition," cited in footnote 17. These pages were initially written in response to Tim Erwin's very stimulating critique of *Iconology* in the special issue on "Image and Ideology."

20. Geoffrey Hartman, *Criticism in the Wilderness* (New Haven, CT: Yale University Press, 1980), pp. 253–64.

21. Erwin Panofsky, "Iconography and Iconology," in *Studies in Iconology* (New York: Harper & Row, 1962), p. 3. See Joan Hart's discussion of Panofsky's modeling of this scene on a similar one in the writings of Karl Mannheim ("Erwin Panofsky and Karl Mannheim: A Dialogue on Interpretation," *Critical Inquiry* 19:3 [Spring 1993]: 534–66).

besides naturally indicating moods or feelings, besides conveying a conventional greeting, the action of my acquaintance can reveal to an experienced observer all that goes to make up his 'personality,'" a reading that takes this gesture as "symptomatic" of a "philosophy," a "national, social, and educational background."

These four terms—form, motif, image, and symbol—are overlapped to construct a three-dimensional model of interpretation that moves from "pre-iconographical description" of "primary or natural subject matter," to "iconographical analysis" of "secondary or conventional subject matter," to "iconographical interpretation" of the "intrinsic meaning or content," to the (iconological) world of "symbolical values" (p. 14). The movement is from surface to depth, from sensations to ideas, from immediate particulars to an insight into the way "*essential tendencies of the human mind* were expressed by specific *themes* and *concepts*" (p. 15; emphasis Panofsky's).

There are plenty of reasons to accept the naturalness of the scene of greeting as a starting place for the explanation of painting. The silent, visual encounter, the gesture of raising the hat, the motif of "gesturality" as such may seem simply inevitable as a basic example, since it captures one of the central features of Western history painting, the language of the human body as a vehicle for narrative, dramatic, and allegorical signification. We might also look forward to Michael Fried's accounts of gesture in modernist painting and sculpture to reinforce a sense of Panofsky's scene as inevitable and natural.[22] But suppose we resisted these natural inevitabilities and questioned the scene itself? What might we notice?

First, the banality and minimal interest of the scene, its empty typicality as an emblem of something like "bourgeois civility," the mutually *passing* recognition of subjects who take no interest in one another, *say nothing* to one another, and go on with their business. The example is not important, of course; it *exemplifies*, stages, even flaunts its insignificance, its lack of importance. It does not deserve harsh, picky scrutiny or judgment. It is not dignified enough to be the subject of a painting—no great history, epic, or allegory is being enacted. It is just there to exemplify the *minimal* features of visual communication and representation; it provides a baseline from which to measure more complex, more important forms of visual representation.

Second, the transformation of this simple, social encounter (the

22. See Michael Fried, "Art and Objecthood," *ArtForum* 5 (Summer 1967): 12–23.

men passing in the street) into the encounter between a subject and an object (the perception and "reading" of an image, a painting) and finally into the encounter between two "objects" of representation (the two passing figures—"gentlemen"—staged for us in Panofsky's own "theoretical scene"). "Transferring the results of this analysis from every-day life to a work of art" (p. 5) we find the "same three strata"—forms as objects; objects as images; and images as symbols. Panofsky on the street greeting an acquaintance becomes a figure for his encounter with the individual painting; the "scene" of greeting between iconologist and icon becomes the paradigm for a science of iconology.

Third, the construction of a hierarchical structure deployed as a narrative sequence from simple to complex, trivial to important, natural to conventional, "practical" to "literary" or "philosophical" knowledge, analytic to synthetic understanding, primitive, savage confrontation to civilized intersubjective encounter. Early stages are "automatic" (p. 3), later ones are reflective, deliberative. In our inability to recognize the subject of a painting "all of us are Australian bushmen."

Fourth, the opposition between "iconography" and "iconology" deployed as a reverse narrative, in which the higher level precedes the lower in a hierarchy of control. Thus, "our practical experience had to be controlled by an insight into the manner in which objects and events were expressed by forms . . . " (p. 15); the fact "that we grasp these qualities in the fraction of a second and almost automatically, must not induce us to believe that we could ever give a correct pre-iconographical description of a work of art without having divined, as it were, its historical '*locus*'" (p. 11).

Fifth, the privileging of literary painting, in which "images" of the human body and its gestures are the principal bearers of meaning, and the marginalizing of nonliterary forms ("landscape painting, still-life, and genre") as "exceptional phenomena, which mark the later, oversophisticated phases of a long development" (p. 8). No mention of abstract art or other forms "in which the whole sphere of secondary or conventional subject matter" (namely, literary images) is "eliminated." No mention of pictorial traditions that impose severe constraints (including prohibitions) on the representation of the human form.

Sixth, a homogenizing of these oppositions and hierarchies into an "organic whole"—the "essential tendencies of the human mind" accessible to the "synthetic intuition" of the iconologist.

Simply to list these features is probably sufficient to demarcate

the outlines of a critique that would question the homogeneity of the iconological process. The "control" of lower levels of perception by higher levels immediately suggests the possibility of resistance; modernism becomes intelligible, for instance, precisely as a resistance to Panofsky's iconology and its romantic hermeneutic, its literary/figural basis, and its familiar array of analytic/synthetic oppositions. Panofsky's is an iconology in which the "icon" is thoroughly absorbed by the "logos," understood as a rhetorical, literary, or even (less convincingly) a scientific discourse.

But there is more to do here than simply to note the way Panofsky's method reproduces nineteenth-century conventions or undermines its own logic in the play of its figurative language. We need to ask (1) what stands between this scene, its extrapolation, and the hoped-for "science" of iconology; why is this scene inconvenient for that goal, and what other scenes might serve it better? This question will take us ultimately back to Panofsky's essay on perspective; (2) what can we learn from Panofsky's canny choice of the primal scene of greeting? How might this scene be revisited by a postmodern iconology, or (as I should prefer to label it) a *critical* iconology?

One thing a critical iconology would surely note is the resistance of the icon to the logos. Indeed, the cliche of postmodernism is that it is an epoch of the absorption of all language into images and "simulacra," a semiotic hall of mirrors. If traditional iconology repressed the image, postmodern iconology represses language. This is not so much a "history" as a kernel narrative embedded in the very grammar of "iconology" as a fractured concept, a suturing of image and text. One must precede the other, dominate, resist, supplement the other. This otherness or alterity of image and text is not just a matter of analogous structure, as if images just happened to be the "other" to texts. It is, as Daniel Tiffany has shown, the very terms in which alterity *as such* is expressed in phenomenological reflection, especially in the relation of speaking Self and seen Other.[23]

Critical iconology, then, is what brings us back to the men greeting one another silently in the street, the constitutive figure or "theoretical scene" of the science of iconology—what I have called the "hypericon."[24] It would be all too easy to subject this scene (as I

23. Daniel Tiffany, "Cryptesthesia: Visions of the Other," *American Journal of Semiotics* 6:2/3 (1989): 209–19.

24. See *Iconology*, pp. 5–6, 158, and the related concept of the "metapicture" in chapter 2 of this volume.

have partly done) to ideological analysis, to treat it as an allegory of bourgeois civility built, as Panofsky reminds us, upon a "residue of medieval chivalry; armed men used to remove their helmets to make clear their peaceful intentions" (p. 4). Instead, let us subject a different scene—an explicitly ideological one—to an iconological analysis.

The scene is Althusser's description of ideology as a process which "hails or interpellates concrete individuals as concrete subjects."[25] Ideology is a "*(mis)recognition* function" exemplified by several of what Althusser calls "theoretical scenes" (p. 174). The first scene:

> To take a highly 'concrete' example, we all have friends who, when they knock on our door and we ask, through the door, the question 'Who's there?', answer (since 'it's obvious') 'It's me'. And we recognize that 'it is him', or 'her'. We open the door, and 'it's true, it really was she who was there'. (p. 172)

This scene immediately coupled with another—a move into the street:

> To take another example, when we recognize somebody of our (previous) acquaintance ((re)-connaissance) in the street, we show him that we have recognized him (and have recognized that he has recognized us) by saying to him "Hello, my friend," and shaking his hand (a material ritual practice of ideological recognition in everyday life—in France, at least; elsewhere there are other rituals). (p. 172)

How do we "read" these scenes of greeting in comparison with Panofsky's? First, they are slightly more detailed, more "concrete," as Althusser puts it—in quotation marks. The social encounter, similarly, is slightly more intimate and consequential—a mutual greeting of acquaintances, friends, gendered persons, not a one-way token of civility that could as well pass between anonymous strangers. Althusser's scene is a prelude to a narrative or dramatic encounter, a dialogue of which these are the opening words; it brackets the visual and privileges the blind, oral exchange—the greeting through the closed door, the "Hey, you there!" of an unseen caller in the street—"the most commonplace everyday police (or other) hailing" (p. 174). Panofsky's is a purely visual scene; no words are exchanged, only gestures, and we are led to expect nothing further from the passing acquaintances. Panofsky never tips his hat in return; he withdraws into

25. Althusser, "Ideology and Ideological State Apparatuses (Notes Toward an Investigation)," in *Lenin and Philosophy* translated by Ben Brewster (New York: Monthly Review Press, 1971), pp. 127–86. Further page references will be cited in the text.

an anatomy of his own perceptual and interpretive activity, the three-dimensional interpretation of an object in visual/hermeneutic space.

These are the constitutive "theoretical scenes" of two sciences, Panofsky's science of images (iconology) and Althusser's science of (false) consciousness (ideology). The symmetry is imperfect, of course. Iconology is the science; ideology is supposed to be the object of a science. Ideology is a theoretical object, not a theory; it is the bad symptom that has to be diagnosed. Iconology is the "diagnostician" (p. 15) according to Panofsky; the (good) "symptoms" are the cultural symbols he interprets with his "synthetic intuition"—those theoretical objects (other men, paintings) encountered in the primal scene of visual recognition and greeting.

Let us now stage a recognition scene (as opposed to a mere comparison) between Panofsky's iconology and Althusser's ideology by asking each to recognize and "greet" itself in the other. Iconology recognizes itself as an ideology, that is, as a system of naturalization, a homogenizing discourse that effaces conflict and difference with figures of "organic unity" and "synthetic intuition." Ideology recognizes itself as an iconology, a putative science, not just the object of a science. It makes this discovery most simply by re-cognizing and acknowledging its origins (etymological and historical) as a "science of ideas" in which "ideas" are understood as images—the "science" of Destutt de Tracy and the original "ideologues" of the French Revolution.[26]

The point of this greeting, then, is not simply to make iconology "ideologically aware" or self-critical, but to make the ideological critique iconologically aware. Ideological critique cannot simply enter the discussion of the image, or the text-image difference, as a super-method. It intervenes and is itself subjected to intervention by its object. That is why I've called this notion of iconology critical and dialectical. It does not rest in a master-code, an ultimate horizon of History, Language, Mind, Nature, Being or any other abstract principle, but asks us to return to the scene of the crime, the scene of greeting between Subjects—between the speaking and the seeing Subject, the ideologist and the iconologist.

What we learn from this greeting is that the *temptation to science*, understood as the panoptic surveillance and mastery of the object/ "other" (individual or image) is the "crime" imbedded in these scenes.

26. See my discussion of the French ideologues and the history of ideology in *Iconology*, pp. 165–66.

It is not staged directly for us; the figures merely engage in more or less conventional social greetings. To "see" the crime, we need to remove the figures from the stage and examine the stage itself, the space of vision and recognition, the very ground which allows the figures to appear.

The presentation of this empty stage, the foundational image of all possible visual-spatial culture, is precisely what Panofsky offers in the perspective essay.[27] This paper, as Michael Podro has argued, makes a double (and contradictory) argument about Renaissance perspective: first, that "it has no unique authority as a way of organizing the depiction of spatial relations, that it is simply part of one particular culture and has the same status as other modes of spatial depiction developed within other cultures"; second, that it "provides an absolute viewpoint for interpreting other constructions."[28] Perspective is a figure for what we would call ideology—a historical, cultural formation that masquerades as a universal, natural code. The continuum of "homogeneous infinite space" (p. 187) and the bipolar reduction to a single viewpoint/vanishing point at the "subjective" and "objective" ends of visual/pictorial space provide the structure or space in which Panofsky's three-dimensional iconology makes sense. Perspective is thus both a mere symptom and the diagnostic synthesis which allows interpretation to be scientific and symptoms to be made intelligible.[29]

27. Panofsky's essay was first published as "Die Perspective als 'symbolische Form,'" in *Aufsatze,* (1927) pp. 99–167.

28. Podro, *The Critical Historians of Art,* p. 186; further page references will be cited in the text.

29. Joel Snyder urges caution on this point, arguing that Podro "misunderstands an implicit inner/outer distinction made by Panofsky." "The painters," claims Snyder, "believed that perspective provided an 'absolute standpoint.' But the understanding of perspective from the standpoint of a neo-Kantian, twentieth-century art historian shows that it does not have a special privileged, natural claim upon us. Panofsky takes the latter to be his contribution to the study of perspective and the inner view to be the prevailing, uninformed position" (correspondence with author). I agree that Panofsky believes in some such distinction between the painter's and the iconologist's "perspective," but I think Panofsky's practice, choice of examples, and model of analysis undermines it. It isn't that Panofsky believes that pictorial perspective, literally understood, is a universal, ahistorical norm, but that this model, with all its figural and conceptual furniture (surface-depth, three-dimensionality, the "subject/object" paradigm for the relation of beholder and beheld) is embedded in the rhetoric of Kantian epistemology.

Panofsky comes close to saying this explicitly in the concluding remarks of "Iconography and Iconology":

> Just as it was impossible for the Middle Ages to elaborate the modern system of perspective which is based on the realization of a fixed distance between the eye and the object and thus enables the artist to build up comprehensive and consistent images of visible things; just as impossible was it for them to evolve the modern idea of history, which is based on the realization of an intellectual distance between the present and the past, and thus enables the scholar to build up comprehensive and consistent concepts of bygone periods. (p. 51)

Panofsky's iconology takes perspective as one of its historical/theoretical objects at the same time that it regards "the modern idea of history" as itself modeled on the perspective system. The history of pictorial representation turns out to be intelligible only inside a theoretical picture that is itself supposed to be "inside" that history.

The equivalent stage in Althusser's notion of ideology is unveiled when he moves to "the formal structure of ideology" which, he informs us, "is always the same" (p. 177). Althusser's example for the universal structure of ideology (which he says could be replaced by any number of others, "ethical, legal, political, aesthetic ideology, etc.") is "Christian religious ideology." Specifically, he invokes the theological greeting or "interpellation of individuals as subjects" by a "Unique and central Other Subject" (p. 178), namely, God. The relation established in this greeting is one of mirroring and subjection or dominance: "God is thus the Subject, and Moses and the innumerable subjects of God's people, the Subject's interlocutor-interpellates: his *mirrors*, his *reflections*. Were not men made *in the image* of God?" (p. 179). The stage on which the ideological greeting of individuals occurs, then, is something like a hall of mirrors:

> We observe that the structure of all ideology, interpellating individuals as subjects in the name of a Unique and Absolute Subject is *speculary*, i.e., a mirror-structure, and *doubly* speculary: this mirror duplication is constitutive of ideology and ensures its functioning. Which means that all ideology is *centred*, that the Absolute Subject occupies the unique place of the Centre, and interpellates around it the infinity of individuals into subjects in a double mirror-connexion such that it *subjects* the subjects to the Subject, while giving them in the Subject in which each subject can contemplate its own image . . . the guarantee that this really concerns them and Him. (p. 180)

It should be noted that this is the moment when Althusser's ideological "scenes" give way to the possibility of a "science," a general account of "the formal structure of all ideology." It is hard to ignore the irony, however, in grounding a scientific theory of ideology in a model drawn from theology. Of course, Althusser stands outside this model; he views it from afar, puts it, as Panofsky might say, "in perspective" for us. If we can see that ideology is a hall of mirrors, perhaps we can smash the mirrors and rescue the oppressed subjects from the all-powerful Subject. Or can we? Is this "formal structure of all ideology," like Panofsky's perspective, a peculiar historical formation which will pass when relations of production, reproduction, and the social relations deriving from them are transformed? Or is it (also like Panofsky's perspective) a universal, natural structure which absorbs social forms, all historical epochs in its purview? If Althusser takes the first alternative (the model as specific historical formation) he forsakes his claim to science and universality; the structure of Christian religious ideology might *not* be replicated exactly in "ethical, legal political, aesthetic ideology, etc." The "etc." might include formations quite different from the religious, and religious ideology itself might vary with history and culture. If Althusser takes the second alternative and insists on the universal, scientific generality of the specular model, he becomes, like Panofsky, an iconologist who has an ideology and doesn't know it.

How can we stage a greeting of Panofsky and Althusser that is anything more than an impasse between science and history, a fatal mirroring of ideology and iconology? What can the French Marxist philosopher and the German Kantian art historian do for each other besides tip their hats in the street? Can they "hail" each other, as Althusser dramatizes it, from the opposite sides of a closed door, and expect any recognition, any acknowledgment other than the misrecognition of the "everyday police" suspect? Perhaps not, except insofar as we map out the common space they occupy, which is simply the placement of the recognition scene at the center of their reflections. The main importance of *recognition* as the link between ideology and iconology is that it shifts both "sciences" from an epistemological "cognitive" ground (the knowledge of objects by subjects) to an ethical, political, and hermeneutic ground (the knowledge of subjects by subjects, perhaps even Subjects by Subjects). The categories of judgment shift from terms of cognition to terms of re-cognition, from epistemological categories of knowledge to social categories like "acknowledgment." Althusser reminds us that Panofsky's relation to pic-

tures begins with a social encounter with an Other and that iconology is a science for the absorption of that other into a homogeneous, unified "perspective." Panofsky reminds us that Althusser's local instances of ideology, the greeting of subject with subject (s/s), are all staged within a hall of mirrors constructed by the sovereign Subject (S/s) and that the ideological critique is in danger of being nothing more than another iconology. These reminders do not get us out of the problem, but they may help us to recognize it when we see it.

METAPICTURES

I worry about images. Images are what things mean. Take the word image. It connotes soft, sheer flesh shimmering on the air, like the rainbowed slick of a bubble. Image connotes images, the multiplicity of being an image. Images break with a small ping, their destruction is as wonderful as their being, they are essentially instruments of torture exploding through the individual's calloused capacity to feel powerful undifferentiated emotions full of longing and dissatisfaction and monumentality. They serve no social purpose.

 —E. L. Doctorow, *The Book of Daniel*

This is an essay on pictures about pictures—that is, pictures that refer to themselves or to other pictures, pictures that are used to show what a picture is.[1] It is not exactly an unprecedented subject. Self-reference is a central issue in modernist aesthetics and its various postmodern revisions. On the side of modernism, one thinks of Clement Greenberg's claim that modern art aims to explore and present the essential nature of its own medium or Michael Fried's characterization of the self-referential "absorption" and antitheatricality of modern painting.[2] With postmodernism, one thinks of

1. I am grateful to Akeel Bilgrami, Arnold Davidson, Leonard Linsky, and Joel Snyder for reading and criticizing, if not totally approving of, this essay. I also want to thank the Center for Twentieth Century Studies at the University of Wisconsin, Milwaukee, especially Katherine Woodward, Herbert Blau, and Jane Gallop, for an extraordinarily stimulating discussion of this paper in its earliest stages.

2. See Clement Greenberg's "Avant Garde and Kitsch" and "Towards a Newer Laocoon" in vol. 1, edited by John O'Brian, of *The Collected Essays and Criticism*, 4 vols. (Chicago: University of Chicago Press, 1986 and 1993); and Michael Fried's "Art and Objecthood," *ArtForum 5* (Summer 1967): 12–23.

Thierry de Duve's claim that "the work of art is self-analytic." This self-analysis is directed, not only at the medium, but at the determining conditions of the work—its institutional setting, its historical positionality, its address to beholders. As John Rajchman puts it:

> To say 'the work of art is self-analytic' is . . . to say that it consists in the crises it goes through, that it is punctuated by moments of breakthrough or 'revelation,' which require that one question one's conception of who one is or how one has invested oneself in it. It is to say that a work is constituted through those events that arrest the self-evidence of one's identity and that open other possibilities that retroactively reinterpret it.[3]

From a sufficiently embracing perspective these versions of the fundamental task of modernism may not seem opposed; that is, what Fried means by a "medium" could be understood to *include* all those determining conditions.[4] My point here is only to suggest that self-reference is the uniting theme for accounts of modern art that might seem, at first glance, to be radically opposed. This point would hardly come as a surprise to anyone who attended the Whitney Museum's 1978 exhibition, "Art about Art," which ranges freely from ancient gems to Jasper Johns and Andy Warhol, or read Leo Steinberg's catalog essay with its argument that "all art is infested by other art."[5]

This is not an essay, however, on "art about art," but on the related but distinct topic of "pictures about pictures." I want to separate, at least provisionally, the problem of pictorial self-reference from the polemics of modern and postmodern aesthetics, the battles to determine what is "authentic" or "good" or "powerful" in twentieth-century art, and resituate the issue in a rather different context. We might call this context the "ordinary language" view of pictures and images, a treatment of representation as a vernacular phenomenon. The disciplinary name of this context is "iconology," the study of the general field of images and their relation to discourse. The debates over modern art need not disappear or lose their identity in this larger

3. John Rajchman, from the foreword to Thierry de Duve, *Pictorial Nominalism,* translated by Dana Polan (Minneapolis: University of Minnesota Press, 1991), p. xvi.

4. This, I take it, is the point of Stanley Cavell's analysis of the concept of a medium in *The World Viewed: Reflections on the Ontology of Film* (Cambridge, MA: Harvard University Press, 1980).

5. Jean Lipman and Richard Marshall, *Art About Art,* introduction by Leo Steinberg (New York: Dutton, 1976), p. 9.

context. My hope is that their stakes will be clarified by being juxtaposed with an account of pictorial self-reference that starts outside the institutions of art and cuts across the debates about modernism.

Another road not taken in this essay would lead us toward the rich literature on self-reference in logic and the philosophy of language. This approach would lead us into the whole question of "metalanguages," second-order discourses that attempt to reflect on first-order discourses. It would lead us into the knotty philosophical literature on self-referentiality, circularity, and paradox.[6] Above all, it would analyze the use of that whole class of verbal expressions typified by "I" and "this," the use of deictic terms, indices, and what are called "shifters" to establish reference—and especially self-reference—to the medium and the users of language.[7] But this is an

6. The index to Jon Barwise and John Etchemendy's important book on this subject, *The Liar: An Essay on Truth and Circularity* (New York: Oxford University Press, 1989), illustrates the connection between the semantic issue of self-reference and the geometrical figure of circularity quite nicely. If you look up the word "self-reference," you will be told to "see *circular argument*." When you turn to "circular argument," you are told to "see *self-reference*." Nevertheless, no one to my knowledge has been able to demonstrate that there is a *necessary* relation between self-reference and paradox. I am grateful to Leonard Linsky for coaching a very dull pupil on this subject.

7. See Elisabeth Anscombe, "The First Person," in *Mind and Language*, edited by Samuel Guttenplan (New York: Oxford University Press, 1975), pp. 45–65. An ordinary language account of pictorial self-reference that started with language might start with two distinct forms of self-reference in language: (1) in metalanguages, words about words, sentences that refer to themselves, propositions about propositions; (2) in linguistic expressions that refer to their producer, the use of words to point to their originating agent, the "first person" or "I" of an utterance. We might think of this as the difference between "this" and "I," the shifters or indices whose meaning shifts radically according to context: "this" only means in relation to a specific context of pointing; "I" only means in relation to a context of utterance. Is it a mistake to even think of these expressions as "referential" in the same sense? Does "I" actually "refer" to the speaker? The two versions of the Liar's Paradox illustrate the limits of these two forms of self-reference: "The Sentence between these quotation marks is false," and "I always lie." Self-reference in the first statement takes the form of metalanguage; it refers to "the sentence," its own existence as a piece of language. The "self" referred to in the second expression is the producer of the expression, the speaker. This is like the difference between something that shows "itself," versus something that shows "oneself," the difference between showing *showing,* and showing the shower. We might picture the two forms of self-reference by

essay on pictures about pictures, not on words about words. Its aim is not to derive a model for pictorial self-reference from art or language, but to see if pictures provide their own metalanguage. I want to experiment with the notion that pictures might be capable of reflection on themselves, capable of providing a second-order discourse that tells us—or at least shows us—something about pictures. My procedure, therefore, will be ekphrastic.[8] That is, I'm simply going to attempt faithful descriptions of a series of pictures that seem to be self-referential in various ways. This raises some obvious problems about the whole claim implicit in the concept of the "metapicture," which would seem, on the face of it, to be an attempt to construct a second-order discourse about pictures *without* recourse to language, without resorting to ekphrasis. But this is an essay *about* pictures about pictures; it is not an essay *in* pictures, but in words. I will return to the problem of "words about pictures" (and what metapictures say about them) in my conclusion. In the meantime, I'm not going to claim that these words are free of special knowledge or interpretation or speculation, nor are they to be seen as innocent about related issues of self-reference in art and language. I also make no claim that the pictures are artistically important or philosophically profound; they are only presented to illustrate the ways pictures reflect on themselves. Each example should be understood, then, as a kind of specimen that is to be explored for what it tells us about itself and for what it might suggest about other metapictures.

The Picture Itself

An important part of the "psychoanalysis" of the painting is conducted by the painting itself.
—Thierry de Duve, *Pictorial Nominalism*

A rather ordinary gentleman in a cutaway coat is drawing a picture (figure 1). He is close to the end; the available space is almost filled,

imagining two portraits, one of a sitter in profile pointing to herself, the other of a face staring directly at us. The first picture says "she is there"; the second "I am here." Meyer Schapiro makes this point about frontal/profile images in *Words and Pictures: On the Literal and the Symbolic in the Illustration of a Text* (Hague: Mouton, 1973), pp. 38–39.

8. See chapter 5, "Ekphrasis and the Other," for an extended account of this verbal strategy.

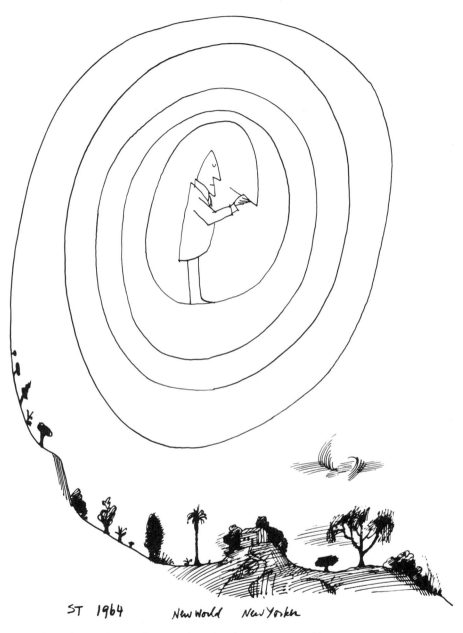

ST 1964 New World New Yorker

1. Saul Steinberg, *The Spiral* (1964), from Steinberg's *New World* series. Drawing
by Saul Steinberg; © 1963, 1991 The New Yorker Magazine, Inc.

and the drawing has nowhere to go but into the draughtsman's own body, for the man is in his own picture, standing in the center of the spiral he has drawn, a spiral whose outer ring has been elaborated as a rural landscape with trees, a wisp of cloud, and a cottage on a hill. The gentleman dominates this landscape; he stands above it like a sky-god in a whirlwind above his creation. Yet he looks indifferent to it, his attention (if any) confined to the point where his pen touches the line it is inscribing, or withdrawn inward, veiled under his hooded eyelids and impassive mouth. He is serene and poised in just a hint of contrapposto with his weight slightly forward. Everything in his world, including himself, has been created by himself. Even the signature, title, and credit line at the bottom ("ST 1964 New World New Yorker") is the product of his pen.[9]

This is the fiction of the drawing. Seen as fact, as the trace of a real event, an act of drawing by Saul Steinberg, we may read its narrative in the opposite direction, and the temporal line will run from inside to outside, from center to circumference. Seen as fact, we do not look at the scene of the drawing, but imagine the activity of the artist. We see him beginning with a drawing of a man in the center of an empty sheet of paper, drawing the pen in the man's hand, drawing the widening spiral outward from the pen until it begins to fill the page, elaborating the outer sweep of the line with landscape features, and then adding the signature, title, and destination of the drawing. Read clockwise, the drawing could be taken as an allegory of a familiar history of modern painting, one which begins with representation of the external world and moves toward pure abstraction. Read counterclockwise, the drawing shows another history, one that has moved from the figure to abstraction to landscape to the writing at the bottom—to a "New World" that lies beyond the circumference of the drawing.

Saul Steinberg has described this as "a frightening drawing," one which "gets narrower and narrower," like "the life of the artist who lives by his own essence. He becomes the line itself and finally, when the spiral is closed, he becomes nature."[10] Steinberg gives us an artist's

9. The actual title of Steinberg's drawing is *The Spiral*, but it first appeared in *The New Yorker* with the title *New World*. This title established the drawing as the exemplar of a whole series of drawings on the theme of the artist as world-maker.

10. Quoted in Harold Rosenberg's text for the Whitney Museum catalog, *Saul Steinberg* (New York: Knopf, 1978), p. 19.

reading of the drawing, a reading from inside. He sees this as a terrifying, sublime image of the danger in self-reflexive art. But there is another view of the drawing which comes at it from the outside. From this angle, the drawing is not "art," but a *New Yorker* cartoon; it is not sublime but ridiculous. This view notices that the drawing is not a portrait of the artist as expressive individual creating a world from nothing, but of the bourgeois gentleman doodling aimlessly on his scratchpad. This is certainly not the modern stereotype of the bohemian artist. It is more like an image of a possible viewer of the picture, perhaps a "New Yorker," an average reader of the *New Yorker,* a comfortable, affluent, urbane man of business enjoying a moment of leisure. If Matisse created an art for the tired businessman, Steinberg seems to be showing us the art *of* the tired businessman. The "New World" designated by the title is not the abstracted world of the autonomous, alienated artist, but *our* world ("America" or "1964," as the caption puts it), a world that is not merely represented by pictures, but actually constituted and brought into being by picturemaking. It is a perfect illustration of what I have called the "pictorial turn" in postmodern culture, the sense that we live in a world of images, a world in which, to paraphrase Derrida, there is nothing outside the picture.[11]

This view of the drawing may finally be as frightening as Steinberg's view from the inside. We spectators can defend ourselves against it by differentiating ourselves from the figure (not everyone is a white male in a formal cutaway suit) or removing ourselves from its time (we can say that the "New World" of "1964," the drawing's date, is not our world of 1993). But both of these defenses are easily breached by a recognition of the way the picture reaches out to us, lays a claim on us. "I" the spectator may not be a well-to-do bourgeois, but this "I" knows that she or he lives in a world dominated by business. The "New World" constituted by pictures may be old news at the end of the twentieth century, a cliché of postmodernism, but it is still our world. In a post–Cold War era of the final victory of capitalism, of global culture of images and simulation, the drawing has a feeling of prophetic realism. Steinberg's drawing is a metapicture, a self-referential image; it is quite strictly and formally a drawing that is "about itself." That doesn't prevent it from being about a great many other things and, even more fundamentally, from calling into question

11. See chapter 1, "The Pictorial Turn," for further discussion of this claim.

the basic issues of reference that determine what a picture is about and constitute the "selves" referred to in its structure of self-reference.

Perhaps the most obvious thing called into question by this meta-picture is the structure of "inside and outside," first- and second-order representation, on which the whole concept of "meta-" is based. An image of nested, concentric spaces and levels is required to stabilize a metapicture, or any second-order discourse, to separate it cleanly from the first-order object-language it describes. Thus, most metapictures depict a picture-within-a-picture that is simply one among the many objects represented. Even a picture-within-a-picture that duplicates its framing image (the effect of the *mise en abîme*) can, in principle, keep its levels, boundaries, and frames distinct. Consider a drawing that shows a man painting a picture of a man painting a picture of a man . . . etc. The infinite regress of simulation, duplication, and repetition does not blur the distinctness of levels, except at the vanishing point; one simply has *n*-levels of nested representation, each level clearly distinguished as an outside to another inside. Steinberg's drawing is a kind of deliberate evocation and transgression of this clearly demarcated "nesting" structure. The spiral form constructs an inside-outside structure that is continuous, without breaks or demarcations or duplications. It is a metapicture in a strict or formal sense, a picture about itself, a picture that refers to its own making, yet one that dissolves the boundary between inside and outside, first- and second-order representation, on which the metapictorial structure depends.[12]

Other Pictures

It is a subversive operation, hidden by and within a limpid discourse, a Trojan horse, a panoptical fiction, using clarity for inserting an otherness into our "epistemè."
—Michel de Certeau, *Heterologies*

Alain's well-known cartoon (figure 2) from the *New Yorker* (1955) is a metapicture that refers, not to itself, but to a class of pictures that are generally understood to be different in kind from itself. Alain shows us a class of Egyptian art students "drawing from the life,"

12. See Roland Barthes, *All Except You* (Galerie Maeght, 1983) for further reflections on *"le représentant d'un représentant"* in Steinberg's drawings.

42

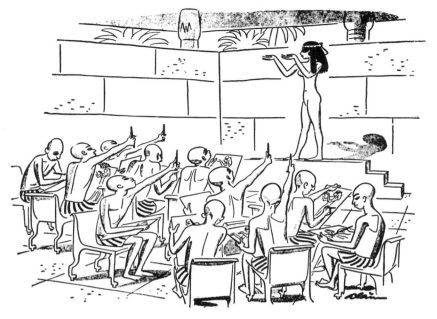

2. Alain, "Egyptian Life Class." Drawing by Alain; © 1955, 1983 by The New Yorker Magazine, Inc.

rendering the figure of a nude model who stands in a stiff, flat pose remarkably similar to those flat, stiff figures we find in Egyptian painting. In contrast to Steinberg, whose artist-gentleman's eyes are closed in a kind of parody of modernist "absorption," Alain's artists are clearly involved in the traditional problem of representing the visible world. If Steinberg shows us a modernist narrative of art history embedded inside a postmodern counternarrative, Alain depicts a classical narrative of art history as the progress of visual representation from the ancients to the present day.

Ernst Gombrich employs this picture as the opening illustration to *Art and Illusion*, arguing that it provides a key to the "riddle of style" in the history of art, the puzzling fact that ways of picturing the world are different in different times and places.[13] "Egypt" is

13. Ernst Gombrich, *Art and Illusion: A Study in the Psychology of Pictorial Representation* (Princeton: Princeton University Press, 1960), p. 2. Further page references will be cited in the text.

Gombrich's figure for the most radical form of this difference: it stands for both historical and racial otherness, for a static, stereo-typed, repetitious Oriental art, the "prehistory" of art before the "Greek revolution" introduces the dynamic progression of "schema and correction" into the development of visual representation. For Gombrich, Alain's cartoon "hints that they [the Egyptians] perceived nature in a different way" (p. 3) or, even more fundamentally, that they did not see nature at all, but merely copied the same formulas they already knew: "We have often looked back to the Egyptians," says Gombrich, "and their method of representing in a picture all they knew rather than all they saw" (p. 394).

Gombrich's reading of Alain's cartoon is curious, if only for its failure to say anything about what makes this cartoon funny, much less anything about the details of the picture. One is almost tempted to say that he brings his schema or stereotype of "Egypt" to the picture and sees in it only what he is prepared to see. The most con-spicuous problem in Gombrich's reading is his suggestion that the cartoon shows the Egyptians "perceived nature in a different way." In fact, the whole point of the cartoon is that the Egyptian art students are not shown as "different" at all, but behave just as modern, West-ern art students do in a traditional life-class. They sight along their thumbs to "put the model in perspective" and establish proportions, and the drawings they produce seem to duplicate quite faithfully the contours of the model. They are shown drawing exactly what they see, not some "stereotype" or conceptual schema. What is funny about the cartoon, I take it, is not that ancient Egyptians are shown (as we might expect) to be exotic, alien, and different from us, but that they are shown (against all expectation) to be just like us.[14]

The point of the cartoon may be clarified further by asking our-selves just who the joke is on. Gombrich, I take it, thinks it is on the myopic Egyptians who cannot see (much less depict) nature because they are trapped in their stereotyped conventions. From this stand-point, all Egyptian art and artists "look alike," in both the relevant senses. The art of the other continues to be relevant to us, in Gom-brich's view, because it is a "beginning" to a history of pictorial prog-ress that must always be repeated, in the way children must go through the drawing of basic shapes before they can begin to "cor-rect" them against visual reality. As Gombrich puts it: "The 'Egyp-tian' in *us* [emphasis mine] can be suppressed, but he can never be quite defeated" (p. 395). In the alternate reading, the joke is on us,

14. I am grateful to Joel Snyder for explaining this joke to me.

on modern beholders who expect a picture of an alien, exotic way of picture-making and who come to realize that this is really a picture of the way we make pictures. The stereotypical "sameness" we project on the Egyptians is actually a reflection of our own conventions; our "dynamic" and "progressive" exploration of "nature" in the "life-class" is revealed by Alain to be as deeply entrenched in sameness and repetition as were the paintings of the Egyptians.

I'm not suggesting, however, that this second reading is simply "right" in contrast to Gombrich's "wrong" reading. In a very real sense, the second reading depends upon the first: it is the expectation of insight into difference that sets up the deflating revelation of sameness, like finding out too soon that the secret of Polish humor is—timing. Gombrich's reading is, as it were, the necessary straight man or straw man for the joke of Alain's cartoon. The two readings of Alain, like the two readings of Steinberg's "New World," stand in a dialectical relationship, by which I mean that they contradict one another, oppose one another, and yet they also require, give life to, one another. Whatever these cartoons amount to as totalities, as meta-pictures, is not reducible to one reading or the other but is constituted in the argument or dialogue between them.

Dialectical Images

Ambiguity is the pictorial image of dialectics, the law of dialectics
seen at a standstill.
—Walter Benjamin, *Reflections*

I want to consider next a class of pictures whose primary function is to illustrate the co-existence of contrary or simply different readings in the single image, a phenomenon sometimes called "multistability."[15] Ambiguous drawings and diagrams such as the Necker cube (figure 4), the "Double Cross" (figure 5), and "My Wife or My Mother-in-law," (figure 6) have been, along with the classic "Duck-Rabbit" (figure 3), a familiar feature of textbooks on the psychology of vision since the late nineteenth century. Multistable images are also a staple feature in anthropological studies of so-called "primitive art." Masks, shields, architectural ornaments, and ritual objects often display visual para-doxes conjoining human and animal forms, profiles and frontal views,

15. See Tsili Doleve-Gandelman and Claude Gandelman, "The Metasta-bility of Primitive Artefacts," *Semiotica* 75, no. 3/4 (1989): 191–213.

3. Joseph Jastrow, "The Duck-Rabbit," from *Fact and Fable in Psychology* (New York: Houghton Mifflin, 1900).

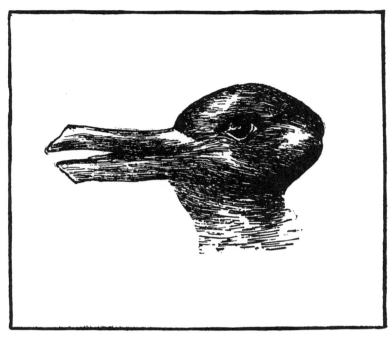

Do you see a duck or a rabbit, or either ? (From *Harper's Weekly*, originally in *Fliegende Blätter*.)

or faces and genitals. The "fort-da" or "peek-a-boo" effect of these images is sometimes associated with forms of "savage thought," rites of passage, and "liminal" or threshold experiences in which time and space, figure and ground, subject and object play an endless game of "see-saw."[16]

The appearance of multistable images in studies of both the "savage" and the "modern" mind, quite aside from their recurrence in

16. On "split representations," see Claude Lévi-Strauss, *The Way of Masks* (Chicago: University of Chicago Press, 1982), and Franz Boas, *Primitive Art* (New York: Dover, 1955); on the "fort-da" game, see Sigmund Freud, "Beyond the Pleasure Principle," in *The Standard Edition of the Complete Psychological Works*, vol. 18, p. 271; on the use of the multistable image to provoke "liminal" or "threshold" experiences, see Arnold Van Gennep, *The Rites of Passage* (London: Routledge, 1960).

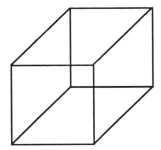

4. Necker cube.

5. "Double Cross," in Ludwig
Wittgenstein's *Philosophical In-
vestigations* (Cambridge, MA:
Blackwell Publishers, 1958).

6. *My Wife and My Mother-in-Law.*
Reprinted from Norma Scheidemann,
Experiments in General Psychology
(Chicago: University of Chicago
Press, 1939).

MY WIFE AND MY MOTHER-IN-LAW

Boring considers this cartoon the best puzzle-picture
in the sense that neither figure is favored over the other.
(From *American Journal of Psychology*, XLII [1930],
444–45.)

artistic practices of all ages, ought to make us skeptical of any attempt to think of these images as uniquely "primitive" in any anthropological sense. They may be primitive in a rather different sense, however, in their function as reflections on the basic nature of pictures, places where pictorial representation displays itself for inspection rather than effacing itself in the service of transparent representation of something else. Metapictures are pictures that show themselves in order to *know* themselves: they stage the "self-knowledge" of pictures.

Most multistable images are not metapictures in the formally explicit way the Steinberg and Alain cartoons are. They display the phenomenon of "nesting," presenting one image concealed inside another image, but, like the Steinberg, they tend to make the boundary between first- and second-order representation ambiguous. They do not refer to themselves, or to a class of pictures, but employ a single gestalt to shift from one reference to another. The ambiguity of their referentiality produces a kind of secondary effect of auto-reference to the drawing as drawing, an invitation to the spectator to return with fascination to the mysterious object whose identity seems so mutable and yet so absolutely singular and definite.

If self-reference is elicited by the multistable image, then, it has as much to do with the self of the observer as with the metapicture itself. We might think of the multistable image as a device for educing self-knowledge, a kind of mirror for the beholder, or a screen for self-projection like the Rorschach test. The observer's identity may emerge in a dialogue with specific cultural stereotypes—for instance, Alain's "Egyptian" or Steinberg's "Gentleman"—that carry a whole set of explicitly ideological associations. Or it may locate itself in something as simple (and apparently neutral) as the position of the observer's body. The multistable aspects of the Necker cube (see figure 4), for instance, are best activated by imagining oneself alternately looking up and looking down at the image. If the multistable image always asks, "what am I?" or "how do I look?", the answer depends on the observer asking the same questions.

These questions and answers—the observer's dialogue with the metapicture—do not occur in some disembodied realm outside of history but are embedded in specific discourses, disciplines, and regimes of knowledge. Metapictures may be employed as ritual objects in a cultural practice, or as examples and illustrations in an anthropological model of such a practice; they may appear as occasions of middle-brow leisure and amusement in magazines like *The New Yorker* or *Fliegende Blätter,* or as illustrations to treatises on philosophy and psychology. Most notable, perhaps, is their ability to move

across the boundaries of popular and professional discourses. The metapicture is a piece of moveable cultural apparatus, one which may serve a marginal role as illustrative device or a central role as a kind of summary image, what I have called a "hypericon" that encapsulates an entire episteme, a theory of knowledge.[17] Gombrich employs Alain's "Egyptian Life Class" to summarize his entire argument about the history of pictorial representation, placing it at the beginning and end of his book. Panofsky and Althusser employ the scene of civil greeting to inaugurate and epitomize the sciences of iconology and ideology. Discursive hypericons such as the camera obscura, the *tabula rasa,* and the Platonic Cave epitomize the tendency of the technologies of visual representation to acquire a figurative centrality in theories of the self and its knowledges—of objects, of others, and of itself. They are not merely epistemological models, but ethical, political, and aesthetic "assemblages" that allow us to observe observers.[18] In their strongest forms, they don't merely serve as illustrations to theory; they picture theory.

Wittgenstein worried about these theoretical pictures. He could see their value from a pedagogical standpoint: the "advantage" of a concrete, visual model is "that it can be taken in at a glance and easily held in the mind."[19] This "advantage" is, however, from another standpoint a disadvantage. It may be *too* easy to "take in" the hypericon, which may "hold" the mind in the paralysis of a misleading analogy, a beguiling metaphor: "a picture held us captive, and we could not get outside it."[20] Wittgenstein seems, at times, to prefer the possibility of a "naked theory" that would be articulated "in sentences or equations" and that would dispense with the "model" or "symbolism" that "dresses up the pure theory" and allows us to picture it.

Yet Wittgenstein's own resort to the figure of the naked and clothed body of theory reveals the impossibility of getting outside the picture, except into another picture. I suspect that Wittgenstein's

17. See *Iconology,* pp. 5–6, 158.

18. Jonathan Crary's *Techniques of the Observer* (Cambridge, MA: MIT Press, 1990) discusses the fortunes of the camera obscura as apparatus, metaphor, and cultural assemblage in eighteenth- and nineteenth-century optics and optical physiology. See my critique of Crary in chapter 1.

19. Ludwig Wittgenstein, *The Blue and Brown Books* (New York: Harper, 1958), p. 6.

20. Ludwig Wittgenstein, *Philosophical Investigations,* translated by G. E. M. Anscombe (New York: Macmillan, 1953).

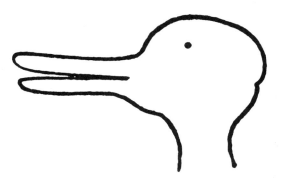

7. Wittgenstein's Duck-Rabbit, in *Philosophical Investigations* (Cambridge, MA: Blackwell Publishers, 1958).

obsession with the Duck-Rabbit, arguably one of the most famous multistable metapictures in modern psychology, is traceable to this anxiety about the fixation of discourse on certain images, especially pictures of/in the mind, visual analogies, etc. The advantage of the Duck-Rabbit is twofold: (1) it is a weak or peripheral hypericon; it doesn't serve as a model of the mind, for instance, but as a kind of decoy or bait to attract the mind, to flush it out of hiding; (2) its central "effect" is at odds with the stabilization of an image to be "taken in at a glance and easily held in the mind." The Duck-Rabbit is the ideal hypericon for Wittgenstein because it cannot explain anything (it remains always to be explained), and if it has a "doctrine" or message, it is only as an emblem of resistance to stable interpretation, to being taken in at a glance. Wittgenstein's own drawing of the Duck-Rabbit in *Philosophical Investigations* (figure 7) eliminates all the features of realism (shading and modeling) that would facilitate such a glance, reducing the image to a schematic, minimal abstraction that "looks like" *neither* a duck nor a rabbit.

Some day a proper history of the Duck-Rabbit will be written, tracing its migration from the pages of a nineteenth-century German humor magazine that was a favorite of Freud's, to its long sojourn in Gestalt and American cognitive psychology; from its thoroughly canonical and stabilized role in Gombrich's *Art and Illusion* to its surprise appearance in a painting by Jackson Pollock, to its apotheosis in the pages of *Philosophical Investigations*. Wittgenstein's immediate aim with the Duck-Rabbit seems to have been a negative one: the image served to unsettle the psychological explanations that had stabilized the Duck-Rabbit with models of mental picturing in the beholder. For Joseph Jastrow, whose *Fact and Fable in Psychology* first subjected the Duck-Rabbit to scientific discipline, the spectatorial

model was explicitly based in photography: "The eye may be compared to a photographic camera, with its eyelid cap, its iris shutter, its lens, and its sensitive plate,—the retina."[21] This model of the eye then generates a familiar model of the mind: "The pictures that are developed are stacked up, like the negatives in the photographer's shop, in the pigeon-holes of our mental storerooms." The Duck-Rabbit, and multistable images in general, reveal the presence of a "mind's eye" roving around this storeroom, interpreting the pictures, seeing different aspects in them. The bodily eye simply transmits information: "the image on the retina does not change" (p. 282), and the identity of the observer, his "difference" from other viewers, is located in the mental eye: "physical eyes see alike, but . . . mental eyes reflect their own individualities" (p. 277).[22] When I see the duck, my mind's eye interprets the Duck-Rabbit as a duck; when I see a rabbit, my mind's eye interprets it as a rabbit.

It is easy to see why this explanation explains nothing. Saul Steinberg shows us a picture of its absurdity in his wonderful cartoon of the scared rabbit inside the head of the businessman, looking out through the windows of the eyes (figure 8). This is a kind of literalization of Jastrow's notion of the "identity" of the spectator in the "mind's eye": if the spectator sees the rabbit, it doesn't mean that he has a picture of the rabbit in his head, but that there *is* a rabbit in there looking out for its kin. Wittgenstein is impatient, vexed with this fable. He warns repeatedly against thinking about seeing in terms of "internal mechanisms" ("the concept of the 'inner picture' is misleading, for this concept uses the *'outer'* picture as a model" [*Philosophical Investigations,* p. 196]). He shifts the inquiry from speculation on inner visual mechanisms to observations on what we might call the "grammar of vision," the language games employed in things like interpretations, descriptive reports, and exclamations prompted by visual experiences. He compares the experience of "noticing an aspect" to the application of captions or textual labels to a book illustration (p. 193) and, in general, replaces the causal linkages of the "mental" and "bodily" eye with the interplay of the visual and

21. Joseph Jastrow, *Fact and Fable in Psychology* (New York: Houghton-Mifflin, 1900), p. 276; further page references will be cited in the text. Jastrow is cited by Wittgenstein as his source for the Duck-Rabbit in *Investigations.*

22. I am grateful to Ruth Leys for her help with the psychological literature on identity and spectatorship that would have been relevant to Wittgenstein. See her article, "Mead's Voices: Imitation as Foundation, or the Struggle Against Mimesis," *Critical Inquiry* 19:2 (Winter 1993): 277–307.

8. Saul Steinberg, *The Rabbit.*
Drawing by Saul Steinberg;
© 1958, 1986 The New Yorker
Magazine, Inc.

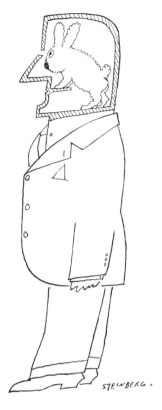

the verbal. This doesn't mean that he replaces the model of the inner eye with "inner speech" or writing. The point is rather to *flatten out* the field of inquiry, to replace the model of deep, inner causes explaining surface effects with a surface description of complex intersections between different codes and conventions. Instead of "looking inside ourselves" to find a mechanical explanation, we ask ourselves what different kinds of *sense* can be made of expressions like "I see a rabbit," or "*Now* I see a duck," or "It's a duck-rabbit," or "a rabbit!"

Even the familiar negative "doctrine" of the Duck-Rabbit, that "we cannot experience alternate readings" of the figure "at the same time" (Gombrich, p. 5), is unsettled by Wittgenstein's suggestion that we can in fact experience it as a composite, synthetic figure: "I *may* say 'It's a duck-rabbit' . . . The answer that it is a duck-rabbit is again the report of a perception" (p. 195). Anyone who has spent hours

52

looking through the pages of *Fliegende Blätter* for the image will know that Wittgenstein is right, that the search is neither for a duck nor a rabbit, but for a curious hybrid that looks like nothing else but itself.[23] Wittgenstein uses this strange creature to make us see "that we find certain things about seeing puzzling, because we do not find the whole business of seeing puzzling enough." The Duck-Rabbit is not just a puzzle that emerges against a background of stable, ordinary visual experience, but a figure, like Steinberg's "New World," of the "whole business."

Wittgenstein restores the "wildness" of the Duck-Rabbit by freeing it from its domestication by psychology and by photographic models of the psyche. Another way to recover that wildness would be to go back to the "flying leaves" of *Fliegende Blätter,* to track the Duck-Rabbit into its original habitat (see figures 9, 10). There we find a forest of signs, a heterogeneous image-text field in which human and animal figures freely interact in cartoons and anecdotes. The Duck-Rabbit is not alone in this world, but is juxtaposed textually to the beast-fable that precedes it and graphically to the illustration of this story, particularly to the pair of laughing rabbits shown eavesdropping on the scene of narration. The story is "The Bear in the Eagle's Nest," translated from the tall-tale language of *Jäger-lateinischen* ("Hunter's Latin") a fable about the ability of different animals to "pass" for one another and to co-exist in a "friendship pact" (*Freundschaftsbund*). The hunter who discovers the fat bear cub in the eagle's nest contrives a story in which the young eagles agree to co-exist with the bear cub and let him eat the food brought by their parent as long as he agrees not to eat them. This *realpolitik* arrangement persists until the hunter arrives and shoots them all.

The Duck-Rabbit's "native habitat," then, is a world of beast fables and animal cartoons where questions of representation, appearance, and identity abound (the previous page of this issue of *Fliegende Blätter* shows a skeptical observer thrusting his head into the mouth of a painted lion). The specific placement of the Duck-Rabbit may well be accidental, a mere whim of the layout editor, or it may serve as a pictorial answer—a kind of coda or colophon—to the narrative of the "Bear-Eagle." It is difficult without this context to get the point of the question that accompanies the figure labeled *Kaninchen und Ente: "Welche Thiere gleichen einander am meisten"* ("which animals

23. On the relation of this "hybrid" image to the figure of the mulatto, see footnote 39. I want to thank my research assistant, John O'Brien, for tracking down this creature.

Welche Thiere gleichen einander am meiſten?

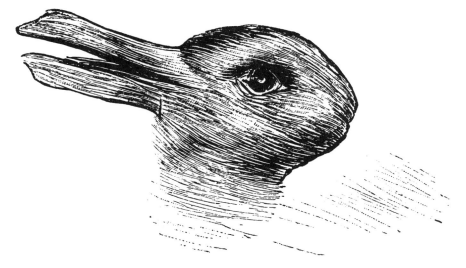

Kaninchen und Ente.

9. Duck-Rabbit, detail from page in *Fliegende Blätter* (1892).

Der Bär im Adlerhorst.
(Aus dem Jäger-Lateinischen.)

Bär gefressen hatte, und alsbald machte er sich wieder auf, um Beute zu holen. Natürlich ließ sich auch diese wieder der junge Bär vortrefflich schmecken, und so kam es, daß er jeden Tag stärker und größer wurde, während die jungen Adler, über deren Appetit sich der Alte nicht genug wundern konnte, in der Entwickelung sehr zurückblieben. Die jungen Adler fürchteten sich, von dem Bären gefressen zu werden, und buldeten ihn darum in ihrem Neste, ohne ihn dem Alten zu verrathen; der Bär aber sah wohl ein, daß für ihn ein Entrinnen aus dem Felsenneste unmöglich sei und daß, wenn er die jungen Adler einen um den andern verspeisen wollte, der Alte es merken und keine Nahrung mehr zutragen würde. Darum entstand zwischen dem Bären und den jungen Adlern eine Art Freundschaftsbund, der so lange währte, bis ich eines Tages, nachdem ich den alten Adler mit einer sicheren Kugel getödtet, das Nest ausnehmen will und bei den ziemlich mageren Adlerjungen den fetten Bären im Horste fand und erlegte . . . Sehen Sie, meine Herren, so kann es gehen!""

Welche Thiere gleichen einander am meisten?

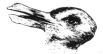

Kaninchen und Ente.

A Leb'n.

Beim Wirth is iaßa g'rad a' Leb'n,
So werd's es net glei' wieder geb'n.
Dös is a' Gaudi und a' Freud,
Und Alles juchzt, singt und schreit;
A' Jeder schnack'lt*), draaht an Huat
Und stampft vor lauter Uebermuath.
„Was gibt's denn?" frag i', wia i' 's
 g'hört.
„„Geh' eina!" ruafa i', „„an'zapft
*) Mit der Zunge schnalzen. werd!""
 Leinr. Zeller

Das genügt.

„. . . Spricht Ihre Tochter fremde Sprachen?" „Nicht fertig jedoch kann sie in fünf Sprachen „Ja" sagen, falls ein anständiger Mann sie an halten sollte!"

„„Wie? Ein Bär im Adlerhorst! Und den wollen Sie selbst gesehen und geschossen haben?!" „„Eigenhändig"", entgegnete der Graf mit aller Gemüthsruhe. „„Die Geschichte klingt allerdings unglaublich, aber sie ist wahr und darum die Erklärung sehr einfach!""

Allen stand der Verstand stille, aber der Graf erzählte mit ernster Miene weiter:

„Der alte Adler sieht drei junge Bären, die in einem unbewachten Momente sich auf einer baumfreien Lichtung herumtummeln. Alle drei zugleich zu fassen und mit in die Lüfte zu nehmen, ist ihm unmöglich. Er packt also den jüngsten beim Fell und bringt ihn seinen Jungen zum Adlerhorst. Statt ihn aber zu tödten, setzt er ihn lebendig in's Nest und fliegt rasch wieder fort, um den zweiten Bären zu holen. Der junge Bär, nachdem er sich vom ersten Schrecken erholt, benützt die Abwesenheit des alten Adlers, um den jungen Adlern zu imponiren, indem er einen derselben frißt. Wie er den alten Adler, diesmal ohne Beute, wiederkommen sieht, versteckt der junge Bär sich in eine Felsenspalte; der alte Adler aber meint, seine Jungen hätten mittlerweile den Bären gefressen und wundert sich nur, daß sie noch Hunger haben. Da er nicht bis fünf zählen konnte, entging ihm der Verlust des einen Adlers, den der

resemble each other the most?"). Certainly the rabbit and the duck don't "resemble" each other: like the Bear and Eagle they are "nested" together—that is, located, imagined, or pictured *in the same gestalt,* the one a narrative representation or fable, the other an equivocal picture.[24] The Duck-Rabbit is about difference and similitude, the shifting of names and identities—that is, metaphoricity—in the field of vision: it solicits the self-knowledge of the human eye by aligning it with the eye of the animal, depicted as a still center across which waves of shifting identity may be seen to flow.[25]

This trio of images, the Duck-Rabbit, Alain's Cartoon, and Steinberg's "New World," will serve, I hope, to map out a rough, preliminary typology of the metapicture, exemplified in three distinct forms of pictorial self-referentiality. Steinberg's "New World" exemplifies strict or formal self-reference, the picture that represents *itself,* creating a referential circle or *mise en abîme.* Alain's cartoon is *generically* self-referential; it exemplifies the sort of picture that represents pictures as a class, the picture about picture*s* (cp. here the genre of studio, atelier, gallery, museum, and collector's cabinet pictures). The Duck-Rabbit, finally, involves discursive or contextual self-reference; its reflexivity depends upon its insertion into a reflection on the nature of visual representation. In principle, this means that any picture or visible mark no matter how simple, from the Necker cube to the single stroke which served as the signature of Apelles, is capable of becoming a metapicture. Pictorial self-reference is, in other words, not exclu-

24. In its original context, the rabbit would seem to be the dominant figure, the one we see first, the one whose name appears first. He resembles the neighboring rabbits in the picture of the storyteller and his audience that accompanies the story; the rabbits, in fact, are depicted outside the central circle of the hunters. The duck-rabbit's position at the end of the story suggests a moral for the hunted as well as the hunters. If the story of the bear who passed for an eagle shows the logic of a *freundschaftsbund* of mutual fear and respect between feathered and furry predators, the Duck-Rabbit transposes this moral into the realm of the animals preyed upon, a bond of mutual *camouflage* in which Duck and Rabbit disguise themselves as one another. The evident futility of these reciprocal disguises (both duck and rabbit being "fair game" for hunters and predators) darkens the joke even further.

25. See chapter 10, "Illusion: Looking at Animals Looking," for further thoughts on the animal as object and spectator of pictures.

sively a formal, internal feature that distinguishes some pictures, but a pragmatic, functional feature, a matter of use and context. Any picture that is used to reflect on the nature of pictures is a metapicture.

These three examples should also suggest some of the basic features of metapictures, their typical uses, effects, and status as a genre. The principle use of the metapicture is, obviously, to explain what pictures are—to stage, as it were, the "self-knowledge" of pictures. We may want to say that self-knowledge is "only a metaphor" when applied to pictures that are, after all, nothing but lines and shapes and colors on flat surfaces. But we also know that pictures have always been more than that: they have also been idols, fetishes, magic mirrors—objects that seem not only to have a presence, but a "life" of their own, talking and looking back at us.[26] That is why the use of metapictures as instruments in the understanding of pictures seems inevitably to call into question the self-understanding of the observer. This destabilizing of identity is to some extent a phenomenological issue, a transaction between pictures and observers activated by the internal structural effects of multistability: the shifting of figure and ground, the switching of aspects, the display of pictorial paradox and forms of nonsense. We might call this the "wildness" of the metapicture, its resistance to domestication, and its associations with primitivism, savagery, and animal behavior.

But the question of "effects" and "identity" does not merely reside in the encounter between an image and an eye: it also engages the *status* of the metapicture in a wider cultural field, its positioning with respect to disciplines, discourses, and institutions. Here we also find what I can only describe as a another form of wildness in the ways metapictures tend to resist fixed cultural status. Metapictures are notoriously migratory, moving from popular culture to science, philosophy or art history, shifting from marginal positions as illustrations or ornaments to centrality and canonicity. They don't just illustrate theories of picturing and vision: they show us what vision is, and picture theory.

26. For a comprehensive survey of this phenomenon, see David Freedberg, *The Power of Images: Studies in the History and Theory of Response* (Chicago: University of Chicago Press, 1989).

A Meta-metapicture

Man is then able to include the world in the sovereignty of a discourse that has the power to represent its representation.
—Michel Foucault, *The Order of Things*

The metapicture that summarizes all these features of the genre most fully is Velázquez's *Las Meninas* (figure 11). From a formal standpoint, *Las Meninas* equivocates between the strict self-reference of Steinberg's "New World" and the generic self-reference of Alain's cartoon. It represents Velázquez painting a picture, but we will never know whether it is *this* picture or some other, since he shows us only its back. The formal structure of *Las Meninas* is an encyclopedic labyrinth of pictorial self-reference, representing the interplay between the beholder, the producer, and the object or model of representation as a complex cycle of exchanges and substitutions. Like "New World" and Alain's cartoon, it offers a totalizing historical image: Foucault calls it a "representation, as it were, of Classical representation,"[27] a comprehensive figure not only of a painterly style, but of an *episteme*, an entire system of knowledge/power relations. We might amend this slightly to say that it is a *classical* representation of classical representation, to contrast it with the kind of apocalyptic and historicizing self-reference we find in Alain and Steinberg: Alain's Egyptian life-class shows archaic representation within the frame of classical representation; Steinberg shows modernist representation (as "abstraction") within the frame of a "New World" we might want to call postmodernism.

The status of *Las Meninas,* however, may seem radically different from the metapictures we have examined, and I suspect there will be some resistance to thinking of it as belonging to the same genre, much less the same essay, with the Duck-Rabbit. The two pictures are about as unlike one another as one could imagine. *Las Meninas* is a canonical masterpiece of Western painting and the subject of a massive art-historical literature. The Duck-Rabbit is a trivial, anonymous drawing from a humor magazine that became a key illustration in psychological literature. *Las Meninas* is an endlessly fascinating labyrinth of reflections on the relations of painting, painter, model, and beholder. The Duck-Rabbit has been employed to establish a kind of degree zero in the interpretability of the multistable or ambiguous image: it is not generally taken to be paradoxical, allegorical, or (in itself)

27. Michel Foucault, *The Order of Things: An Archaeology of the Human Sciences* (New York: Vintage, 1973), p. 16.

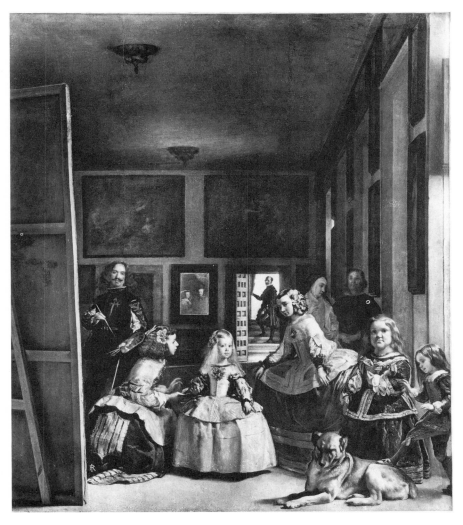

11. Diego Rodríguez de Silva Velázquez, *Las Meninas*. Courtesy of Museo del Prado; © Museo del Prado, Madrid. Photo: Alinari/Art Resource, NY.

self-reflexive. If *Las Meninas* exemplifies the metapicture in its most complex, articulate, and exalted status, the Duck-Rabbit is the simplest and humblest member of the genre, inhabiting a site where human and animal perception seem to intersect, a place where popular culture enters into the basement of psychological and philosophical discourse. If Wittgenstein had not written about the Duck-Rabbit, it would scarcely be remembered, and it would not qualify as a metapicture. On the other hand, if Foucault had not written about *Las Meninas*, it would still be a great masterpiece, but it too would not be a metapicture.[28] Svetlana Alpers implied as much when she asked "why should it be that the major study, the most serious and sustained piece of writing on this work in our time, is by Michel Foucault?" Alpers answer was that the "interpretive procedures of the discipline itself . . . made a picture such as *Las Meninas* literally unthinkable under the rubric of art history."[29] I would put this a slightly different way. The problem with the art historical writing about *Las Meninas* was like the problem with the psychological literature on the Duck-Rabbit: it made the picture far too *thinkable*. Like Wittgenstein, Foucault sprung his metapicture loose from a professional discourse where it had an assured status and meaning into another way of speaking. This "way of speaking" is by now hardening into a disciplinary formation in its own right (that is, a set of clichés or rigid hypericons), one which sometimes forgets that the peculiar language-games Foucault and Wittgenstein brought to their images were designed to make them harder, not easier to talk about.

That is why calling this way of speaking "philosophy" would simply beg the question of Foucault and Wittgenstein's very problematic relations to their respective philosophical traditions and the curious sort of language they bring to the metapicture. The key features of this language are (1) its refusal of explanation and closure, its preference for surface description; (2) its application of a highly general vocabulary to pictures (Foucault confesses to his own use of "vague, rather abstract designations"); and (3) its strange passivity before the image, as if the point were to achieve a state of receptivity that would allow the image to speak for itself. Wittgenstein urges us

28. See Svetlana Alpers, "Interpretation without Representation, or The Viewing of *Las Meninas*," *Representations* 1 (February 1983): 31–42, for argument about the revolutionary character of Foucault's essay. See also Leo Steinberg, "Velázquez' *Las Meninas*," in *October* 19 (Winter 1981): 45–54.

29. Alpers, "Interpretation without Representation," p. 31.

not to explain the Duck-Rabbit, but to listen to what comes out of our mouths and to ponder its relation to our visual experience, as if the automatisms to be discovered were not "in our heads" but in expressions of body language, tone of voice, and grammatical inflection. Foucault argues that "we must . . . pretend not to know" who the figures are in *Las Meninas*. We must forego the "adequate" language of the anecdote and the proper name, the language that tells us who's who and what's what in *Las Meninas* and confine ourselves to a language that knows its inadequacy to the "visible fact." "It is perhaps through the medium of this grey, anonymous language . . . that the painting may, little by little, release its illuminations" (p. 10).

These "illuminations" are the by now familiar and canonical readings by which Foucault transforms *Las Meninas* from an art historical masterpiece into a metapicture, a picture about picturing, a "representation, as it were, of Classical representation" (p. 16). I won't rehearse the extensive literature that has been generated by this insight with any further reading of the intricacies of self-reference in *Las Meninas*. Suffice it to say that, like the other metapictures we have examined, it deploys its self-knowledge of representation to activate the beholder's self-knowledge by questioning the identity of the spectator position. In *Las Meninas,* this questioning has centrally to do with power and representation-the power of painting and the painter, and the power of the sovereign who is the implied observer. Velázquez portrays himself as a court servant, simply another member of the household, at the same time he insinuates a kind of mastery for himself, a sovereignty over representation, with a wit and discretion that makes the hint of usurpation acceptable. Sovereigns, after all, had to go to school like anyone else, had to subordinate themselves to the discipline of tutors and advisors. The discipline of the eye and control of visual representation is central to the technology of sovereignty, including those techniques of self-discipline adumbrated in the optical figure of "the mirror for princes."[30] *Las Meninas* portrays a political and representational power so pervasive that it need not display itself; it can afford to be discreet, even invisible, to disseminate itself in this scene of the courtly interior made public spectacle, and even to permit itself to be upstaged by the discreet master of courtly spectacle, Velázquez himself. Exactly how this speaks to the self-knowledge of modern observers, how it continues to astonish "sover-

30. See Joel Snyder, "*Las Meninas* and the Mirror of the Prince," *Critical Inquiry* 11:4 (June 1985): 539–72.

eign subjects" in a radically different social order, is precisely the question that makes this painting so endlessly fascinating.

Las Meninas' self-reflexivity is directed at its own *kind* of painting, at an entire institution of and discourse on painting which Velázquez epitomizes and masters. It is not strictly auto-referential and self-constituting like Steinberg's "New World," unless we imagine the painting with its back to us to be *Las Meninas* itself. And it does not refer, as Alain's cartoon does, to an*other* kind of painting. *Las Meninas* aims, like "New World," to give us a total picture of representation, one which, unlike Steinberg's, does not pretend to ignore its beholder, but solicits and even represents the spectator position. Foucault traces this totalizing gesture in *Las Meninas* as a "spiral shell" that "presents us with the entire cycle of representation" (p. 11)—the painter, his tools and materials, the completed paintings on the walls, the illuminated rectangle of the door, and, above all, the mirror on the back wall which seems to reflect dimly the beholders of this scene, who are themselves the implied spectacle for the gazes of the figures in the scene.

To enter into this cycle is something like "switching on" the ambiguous aspects of the Duck-Rabbit. In *Las Meninas,* however, the aspects are (at least) triple rather than binary, and they are located in an imaginary site of projection in front of the painting, the space occupied (1) by the painter as he worked on this canvas; (2) by the figures (presumably reflected in the mirror) who are modeling for the painter and addressed by the gazes of the figures; (3) by the beholder. These three projected beholders can be matched up with Leo Steinberg's three "vanishing points": (1) the "real" (geometrical) vanishing point by the man in the doorway (the keeper of tapestries, also named "Velázquez"); (2) the "false" or "symbolic" vanishing point in the mirror (whose figures may be the King and Queen beholding the scene or, if Joel Snyder is correct, the reflected images of their painted images on Velázquez's hidden canvas; (3) the little Infanta, who is the conventional "subject" of the picture and who is, as the royal child, the "image" of her parent-beholders.

There is no vulgar playing with illusion as in the Duck-Rabbit, no tricks on the senses. The only figure in the painting who lies outside the cycle of gazes and visual exchange is, appropriately enough, the one closest to the surface: the drowsy dog in the foreground. If the "aspects" of *Las Meninas* shimmer and shift, they do so in an invisible, unrepresentable space where the spectator's subjectivity is constituted. As Foucault puts it: "no gaze is stable, or rather, in the neutral furrow of the gaze piercing at a right angle through the canvas, subject

and object, the spectator and model, reverse their roles to infinity. . . . Because we see only that reverse side [of the canvas in the painting] we do not know who we are, or what we are doing. Seen or seeing?" (p. 5). It is the painting's ability to destabilize the position of the observer, engaging our fantasies of sovereign subjectivity—the mastery of space, light, and design we attribute to the painter, the mastery of people we attribute to the historical sovereigns, and the mastery of our own visual/imaginal field, its look and meaning, that we attribute to ourselves as modern observers, rulers of our private "mental kingdoms."

To summarize: our four theoretical pictures constitute an array, by no means exhaustive, of some of the key moments of force in the representation of representation. They show us four contrasting pictures of the producers, models, and spectators of pictures: Steinberg shows us the draughtsman as demiurge, creating a universe casually, almost as a byproduct of doodling, working abstractly, without a model, in indifference to a beholder who is simultaneously "sucked in" and repelled by the composition. Velázquez gives us a portrait of the artist as clever servant, holding up a seductive mirror to a beholder who is at once the sovereign, the painter himself, and any passing observer. Alain gives us a picture of the artist as servile copyist of an equally servile model; the beholder, meanwhile, is placed in a position of superior visual mastery, beholding the whole scene of pictorial production as a historical moment, an archaic, alien convention from a position (apparently) beyond history, beyond style and convention. The Duck-Rabbit, finally, is addressed to the beholder as experimental subject, the sort of psycho-physiological being constructed by optical illusion tests. The "artist" of this drawing is not the draughtsman, but the scientist who puts it to use, and the model is neither a duck nor a rabbit, but a set of hypotheses about visualization and visual perception.

I want to return now to the question of the "grey anonymous language" by which Foucault transforms *Las Meninas* from an object of art historical interpretation into a metapicture. Foucault notes that this way of talking about pictures risks

embroiling ourselves forever in those vague, rather abstract designations, so constantly prone to misunderstanding and duplication, 'the painter,' 'the characters,' 'the models', 'the spectators', 'the images'. Rather than pursue to infinity a language inevitably inadequate to the visible fact, it would be better to say that Velázquez composed a picture; that in this picture he represented himself, in his studio or in a room

of the Escurial, in the act of painting two figures whom the Infanta Margarita has come there to watch, together with an entourage of Duennas, etc.

"Proper names," Foucault notes, would "avoid ambiguous designations," and bring the chain of explanations, the stream of descriptive phrases to an end. Why, then, do we not take this obvious road to certainty and closure? Foucault's answer is an assertion about the nature of the relation between words and images:

> the relation of language to painting is an infinite relation. It is not that words are imperfect, or that, when confronted by the visible, they prove insuperably inadequate. Neither can be reduced to the other's terms: it is in vain that we say what we see; what we see never resides in what we say. And it is in vain that we attempt to show, by the use of images, metaphors, or similes, what we are saying; the space where they achieve their splendour is not that deployed by our eyes but that defined by the sequential elements of syntax. (p. 9)

It is important to stress here that Foucault is not pronouncing what Wittgenstein would call a metaphysical law about the incommensurability of language and vision; it may be "in vain" that we "say what we see" (and vice versa) but no vanity is more common. The assigning of proper names to images, for instance, "gives us a finger to point with . . . to pass surreptitiously from the space where one speaks to the space where one looks; in other words, to fold one over the other as though they were equivalents." This search for proper equivalents, for closure of explanation, is the normal task of art history, perhaps even of the theory of representation. But it is not Foucault's goal, as he goes on to explain: "if one wishes to keep the relation of language to vision open, if one wishes to treat their incompatibility as starting-point for speech instead of an obstacle to be avoided, so as to stay as close as possible to both, then one must erase those proper names and preserve the infinity of the task" (pp. 9–10).

Talking Metapictures

Words are not, then, proof against a relapse into images.
—Jean-François Lyotard, "Figure Foreclosed"

Foucault's strategy of holding open the gap between language and image allows the representation to be seen as a dialectical field of

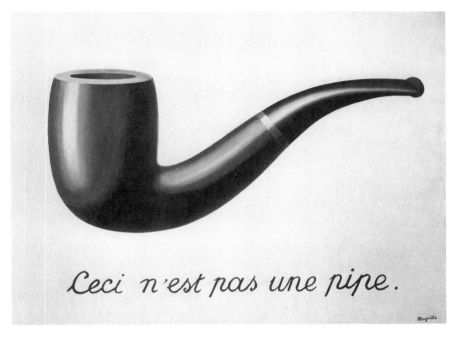

12. René Magritte, *Les trahison des images* (1929). © 1993 C. Herscovici/ARS, New York.

forces, rather than a determinate "message" or referential sign. So far, although we have noted the embedding of each metapicture in discourse, we have not yet seen a picture of this relationship as such, a representation of the relation between discourse and representation, a picture about the gap between words and pictures. Magritte's *Les trahison des images* provides a picture of just this relationship (figure 12). The self-reflexivity of this picture depends, in fact, upon its introjection of language inside the frame. The indexical "this" in "this is not a pipe" refers, we suppose, to the pictured pipe (though it could also refer to itself, that is, to the string of words, or to the entire ensemble of words and image). The structure of our third kind of metapicture, the one that depends on the "insertion of the picture into a discourse on vision and representation," is here internalized within the frame. We might want to object that this isn't really a metapicture, not really *pictorial* self-reference, in that it "cheats" by using words to achieve self-reference. The objection presumes that words cannot properly signify in a picture, that they remain alien to

its semiotic order no matter how firmly they are located in its pictorial space. Nevertheless, I take the point. Let us think of this as a "cheating" metapicture, slightly illegitimate, whose real purpose is to reflect, not on pictures, but on the relation of pictures and words, both the way we speak of pictures and the way pictures "speak" to us.

What image could be simpler, more calculated to let a whole theory of the relation between words and images "be taken in at a glance and easily held in the mind"? There are no optical illusions, no puns, no labyrinth of gazes, reflections, and self-reflexive references. We are shown a simple pipe, carefully rendered in a realist style, with modeling, shading, and highlights, accompanied by the straightforward statement: "Ceci n'est pas une pipe." If this is a puzzle, it is one that is decoded so quickly that all the pleasure of decipherment goes up in smoke immediately: of course it is not a pipe; it is only a picture of a pipe. The apparent contradiction dissolves in a moment, erasing even the slim pleasure of a double reading, the equivocal play provided by the two (or three) equally true perceptions of the Duck-Rabbit. The statement, "this is not a pipe," is just literally true: if there is a contest here between the statement and the image, it is clear that discourse has the final say.

And yet, what discourse is it that can only use language literally? As Foucault notes, there also is "a convention of language," the custom we have of talking about the images of things as if they were the things themselves. This custom makes the legend "this is not a pipe" literally true, but figuratively false. Moreover, insofar as the verbal figure is customary and conventional, it is no longer a figure at all, but a dead metaphor, like the leg of a table or the arm of a chair. The proposition which seems to deny the authority of the image winds up having its own authority called into question, not only by the picture, but by something internal to the conventions of language.

Magritte's pipe doesn't aim to astonish like *Las Meninas,* to beguile and divert like Steinberg's *New World,* to destabilize our knowledge of the other like Alain's life-class, or to activate the body's visual apparatus like the Duck-Rabbit. It is designed, rather, with all the connotations of pedantry and utility: it is a teaching aid, a piece of classroom apparatus, a point which is made explicit in a later version of the pipe motif, *Les deux mystères* (figure 13), which shows the same composition on a blackboard mounted on an easel. Its proper site is not the museum or gallery, but the classroom, and its function is as a pedagogical primer. It is like one of those illustrated elementary textbooks that teach reading by correlating words with pictures. Its purpose, however, is a negative lesson, an exercise in unlearning or

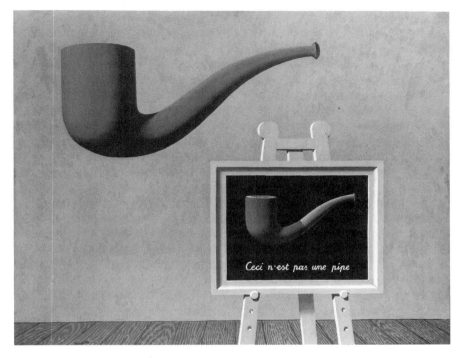

13. René Magritte, *Les deux mystères*. © C. Herscovici/ARS, New York.

deprogramming a set of habits which are second nature. It is not possible to gauge the effect of this negative lesson, therefore, without a patient working through of the forms of verbal and visual discipline that it seeks to overturn. A subversion of the "natural attitude" toward pictures is the least important of its objectives.[31] The picture is not aimed at people who believe that pictures transparently represent objects, much less those who are "taken in" by pictorial illusions. It addresses the much more fundamental issue of the relation between pictures and texts and those who believe they know what that relation is, who think they know what to say about pictures, what pictures say.

Magritte's pipe is a demonstration (to recall Foucault's words

31. On the notion of a "natural attitude" toward pictures, see Norman Bryson, *Vision and Painting: The Logic of the Gaze* (New Haven, CT: Yale University Press, 1983), chapter 1.

about *Las Meninas*) that "the relation of language to painting is an infinite relation." This doesn't mean the relation is indefinite or indeterminate or perhaps even quantitatively large: it isn't that there are fifty or fifty thousand "readings" (or "viewings") of Magritte's composition. Two readings are quite sufficient to open out the infinite relation, just as the duality (and the significance of the duality) of the Duck-Rabbit suffices to "switch on" its multistable circuit of signification. Metapictures elicit, not just a double vision, but a double voice, and a double relation between language and visual experience. If every picture only makes sense inside a discursive frame, an "outside" of descriptive, interpretive language, metapictures call into question the relation of language to image as an inside-outside structure. They interrogate the authority of the speaking subject over the seen image. Magritte's pipe is a third-order metapicture, depicting and deconstructing the relation between the first-order image and the second-order discourse that is fundamental to the intelligibility of all pictures, and perhaps of all words. It isn't simply that the words contradict the image, and vice versa, but that the very identities of words and images, the sayable and the seeable, begin to shimmer and shift in the composition, as if the image could speak and the words were on display.

The best way to see this effect is to give voice to the silent dialogue of the painting by amplifying the arguments that might be mustered in support of its contrary readings. The first reading we already have: the text tells us that the drawing is not a pipe, and the drawing assents, declaring (silently, of course) that it is only a drawing and not a pipe; the argument is over. The second reading is more difficult to specify. It is only implicit, hesitant, like a murmur or demurral beginning "and yet. . . . " Perhaps it is only an echo of the beholder's voice saying,

and yet it is, after all, a picture of a pipe. It represents a pipe. We could use it to pick out a real pipe from a pile of miscellaneous objects. We could even use it to pick out a particular pipe, one with just this specific shape and lustre, from a rack full of pipes. Surely it makes sense to say, 'This is a pipe,' so long as we understand ourselves to mean 'this is what a pipe looks like,' or 'this represents a pipe.' To write 'this is not a pipe' under this simple drawing is a perverse sort of pedantry. It tells us something we already know, tries to correct us and prevent us from making a mistake we were in no danger of making. If there is any "mistake" here, in fact, it is that of some overly-docile student, whose subjection to the rote discipline of penmanship is revealed in the mechanical handwriting of the legend. It takes no skill, learning, or imagi-

nation to write "this is not a pipe" under a drawing of a pipe; it is like a defacement of the drawing, something one could write under any drawing whatsoever. The drawing, by contrast, shows a mastery of draughtsmanship in its modelling, shading, and lustrous highlights. It shows us something about pipes, is a real aid to learning, whereas these words are merely a hindrance to knowledge.

I imagine this monologue to illustrate how quickly and abundantly a series of counterstatements to "this is not a pipe" can be generated in defense of the drawing and how readily they escalate into a counter-attack. If the drawing could speak, we can readily imagine its quiet demurral turning into a tirade. The text, for its part, is not left silent. It never tires of repeating itself, and mobilizing support from readers who will say,

> and yet it is simply a literal truth that the drawing is not a pipe. How can the truth be a hindrance to knowledge? Why should this lesson be dismissed as elementary or perverse? Why do you want to cling to what you yourself concede is a mere figure of speech? Are you quite sure that you haven't fallen, by habit, convention, or ideology, under the spell of images? Doesn't your excessive defensiveness suggest that the simple truth is something you can't bear to hear? Why can't we just make peace and co-exist in the same space?

The problem is that Magritte's drawing exists precisely to question whether such a common space can be found. Magritte shows everything that can be shown: written words, a visible object. But his real aim is to show what cannot be pictured or made readable, the fissure in representation itself, the bands, layers, and fault-lines of discourse, the blank space between the text and the image.

Foucault calls attention to this gap in his commentary on Magritte's pipe:

> On the page of an illustrated book, we seldom pay attention to the small space running above the words and below the drawings, forever serving them as a common frontier. It is there, on these few millimeters of white, the calm sand of the page, that are established all the relations of designation, nomination, description, classification.[32]

The double-coding of the illustrated book, its suturing of discourse and representation, the sayable and the seeable, across an unobtrusive,

32. Michel Foucault, *This Is Not a Pipe,* translated by James Harkness (Berkeley: University of California Press, 1982), p. 28.

invisible frontier, exemplifies the conditions that make it possible to say "this is that" (designation), to assign proper names, to describe, to place in grids, strata, or genealogies. The dialectic of discourse and vision, in short, is a fundamental figure of knowledge as such. The collaboration of word and image engenders what Foucault calls a "calligram," a composite text-image that "brings a text and a shape as close together as possible" (pp. 20–21). The calligram is a figure of knowledge as power, aiming at a utopia of representation in which "things" are trapped in a "double cipher," an alliance between the shapes and meanings of words. Word and image are like two hunters "pursuing its quarry by two paths. . . . By its double function, it guarantees capture, as neither discourse alone nor a pure drawing could do" (p. 22). They are like the two jaws of a trap set for the real. But then Magritte

> reopened the trap the calligram had sprung on the thing it described.
> . . . The trap shattered on emptiness: image and text fall each to its
> own side, of their own weight. No longer do they have a common
> ground nor a place where they can meet. . . . The slender, colorless,
> neutral strip, which in Magritte's drawing separates the text and the
> figure, must be seen as a crevasse—an uncertain, foggy region. . . . Still
> it is too much to claim that there is a blank or lacuna: instead, it is an
> absence of space, an effacement of the "common place" between the
> signs of writing and the lines of the image. (pp. 28–29)

Foucault performs for us the impossibility of designating, describing, naming, perhaps even classifying this curious region between the word and image. One moment it is nearly abstract and geometrical (a "colorless neutral strip"); the next it is a sublime landscape ("an uncertain foggy region") or the margin of a seashore; the next a pure negation, an "absence of space." At other times he will describe it in terms reminiscent of Lessing's account of painting and poetry, as something like a frontier separating two armies:[33] "between the figure

33. Lessing, *Laocoon* (1766), translated by Ellen Frothingham (New York: Farrar, Straus, and Giroux, 1969), p. 110; further page references will be cited in the text. As Lessing puts it in *Laocoon*: "Painting and poetry should be like two just and friendly neighbors, neither of whom indeed is allowed to take unseemly liberties in the heart of the other's domain, but who exercise mutual forbearance on the borders, and effect a peaceful settlement for all the petty encroachments which circumstance may compel either to make in haste on the rights of the other" (p. 110). See *Iconology*, chapter 3, on Lessing and the battle of the temporal and spatial arts.

and the text a whole series of intersections—or rather attacks launched by one against the other, arrows shot at the enemy target, enterprises of subversion and destruction, lance blows and wounds, a battle" (p. 26).

Whatever we call the No Man's Land between image and text in Magritte's drawing, it seems clear that, for Foucault, it is foundational for both the structures of power/knowledge that are the object of his genealogies and for his own practice as a writer. I think it is no exaggeration to say that the little essay on Magritte, and the hypericon of "Ceci n'est pas une pipe," provides a picture of Foucault's way of writing and his whole theory of the stratification of knowledge and the relations of power in the dialectic of the visible and the sayable. Michel de Certeau has commented on Foucault's "optical style," with its scenes, tables, figures, and illustrations:

> Actually, these images institute the text. . . . Forgotten systems of reason stir in these mirrors. On the level of the paragraph or phrase, quotes function in the same way; each of them is embedded there like a fragment of a mirror, having the value not of a proof but of an astonishment—a sparkle of other. The entire discourse proceeds in this fashion from vision to vision.[34]

Gilles Deleuze argues further that this interplay between "seeing and speaking," the "visible and the sayable," is not merely a matter of style or rhetoric, a way to seduce the reader, but a constitutive feature of Foucault's epistemology. Knowledge itself is a system of archaeological strata "made from things and words . . . from bands of visibility and bands of readability." Foucault's "visual style" is built, then, upon the most venerable oppositions of rhetoric and epistemology, the traditional interplay between *res* and *verba,* words and things, *les mots et les choses,* arguments and examples, discourse and image. (Deleuze remarks that "Foucault enters into a logical tradition that is already well established, one which claims that there is a difference in nature between statements and descriptions . . . the description-scene is the regulation unique to visibilities, just as the statement-curve is the regulation unique to readabilities."[35]) Foucault's characteristic procedure might be described, then, as his identification of the visual-

34. Michel de Certeau, *Heterologies: Discourse on the Other,* translated by Brian Massumi (Minneapolis: University of Minnesota Press, 1986), p. 196.

35. Gilles Deleuze, *Foucault* (Minneapolis: University of Minnesota Press, 1988), p. 80.

verbal dialectic as a kind of "historical a priori" which serves, not merely as one of the structures of knowledge and power, but a key to the relation of theory and history. The dialectic of the visible and the sayable is the closest Foucault comes to a set of foundational Kantian categories; they even play something like the role that time and space serve in Kant's epistemology. But Foucault refuses the phenomenological account of visual perception, insisting on the historicality of the senses and perceptual fields. *Ceci n'est pas une pipe* is his closest brush with a transcendental a priori, a moment whose abstractness and generality is undone by its reliance on this particular, concrete example. It is only, after all, a reading of a picture, and only a picture of a theory.

To return to the picture, and to the most obvious, banal question, one that is rarely asked about this drawing: Why a pipe? Why wouldn't any other object—a hat, a shoe, a glove—do as well? The answer is that they would do as well to illustrate the abstract "theme" of the composition, but they would completely lose the specific force of the image. Foucault finds a hidden calligram in the similarity of the shape of the "p" in "pipe" to the pictured pipe. (To this one might add the hint of a physical motivation in the link between the plosive lip-action required to pronounce a "p" and the act of puffing on a pipe.) But there is an even more obvious and naively literal connotation to the depicted object, in its reminder of the "effect/affect" of metapictures on beholders. Metapictures are all like pipes: they are instruments of reverie, provocations to idle conversation, pipe-dreams, and abstruse speculations. Like pipes, metapictures are "smoked" or "smoked out" and then put back in the rack. They encourage introspection, reflection, meditations on visual experience. Their connection to history, politics, contemporaneity is equivocal, for they clearly serve (like puzzles, anagrams, conundrums, paradoxes) the purposes of escapist leisure, consumptive and sumptuary pleasure, a kind of visual orality in which the eyes "drink" in and savor the scopic field. Indeed, as some of Magritte's other "pipe" drawings make clear (figure 14), the pipe is an instrument of autofellatio, a device to link the pleasures of masturbation and orality.[36]

36. Dawn Ades and Terry Ann Neff, "Addendum: It Certainly Was Not a Pipe!" in *In the Mind's Eye: Dada and Surrealism*, catalog for an exhibition at the Museum of Contemporary Art, Chicago, 1984. Louis Scutenaire also points out the pun in French on the pipe and the penis. See *Avec Magritte* (Brussels: Le Fil Rouge, Editions Lebeer Hossman, 1977), p. 31. I'm grateful to John Ricco and Alison Pearlman for calling these matters to my attention.

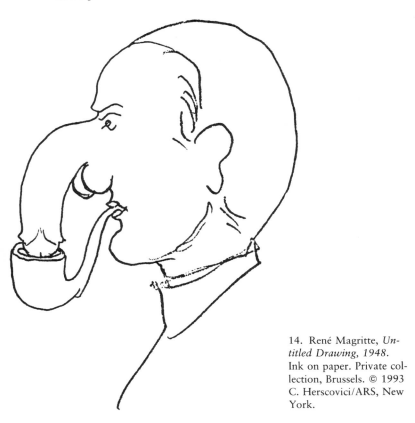

14. René Magritte, *Untitled Drawing, 1948*. Ink on paper. Private collection, Brussels. © 1993 C. Herscovici/ARS, New York.

The pipe's function in smoking rituals—for peace, worship, exchange of gifts, and festivals, associates it with utopian social practices as well as with solitary introspection and narcissism. It also has (as the shadows of Magritte's drawing indicate) darker sides: excess, addiction, narcosis, habituation to self-destructive pleasures. Even the festive, utopian aspects of the pipe are linked with death and sacrifice— the burnt offering, the spectacular destruction of wealth in potlatch rituals.[37]

37. See Marcel Mauss, *The Gift: The Form and Reason for Exchange in Archaic Societies* (1950), translated by W. D. Halls (New York: Norton, 1990), pp. 70–71.

These readings of the public and private symbolism of the pipe might seem incompatible at first glance with my earlier remarks about the pedantic, pedagogical character of the drawing. I would argue, however, that the idleness and reverie connoted by the pipe are not incompatible with disciplinary pedagogies, especially the sort that involve initiation rituals and exercises in self-understanding. I would also want to stress that these interpretations involve a seeing of the picture that forgets about the legend, or replaces it freely with other legends, such as "this is a pipe," or "why is this a pipe?" Magritte's pipe does not "symbolize" these things, of course. It has been snatched away from these uses into the space of abstraction: it has become a philosopher's example, illustrating a simple negative lesson about pictures, statements, and objects. But we can put it back into touch with the world simply by erasing the legend (which is clearly the sort of writing that is meant to be erased)[38] and substituting something else, or by returning it to its probable "origin" in the real world, as a self-sufficient indexical, a sign-board over the entrance of a tobacconists' shop.

The *effect* of the metapicture, in short, shouldn't be confused with themes or topoi. I take the theme of "This Is Not a Pipe" to be the relation of statements and pictures but the effect to be a certain infinite reverie activated by the density of the image and the legend, how they are drawn and inscribed. Let us call this the "Pipe Effect." There are other effects that seem more or less "programmed" into the hypericons we have considered. The Duck-Rabbit has, according to some phenomenological theories, a mechanical effect on perception; it activates a potential for the "switching" of aspects, one which Gombrich believes is "wired in" as an inability to see both aspects simultaneously. Wittgenstein hinted at some skepticism about this supposed inability, suggesting that it's possible to see the drawing as "the Duck-Rabbit," a form which is neither one nor the other, but both or neither.[39] In any event, let us call this the "multistability

38. Even more so in *Les deux mystères,* where the writing is shown as chalk on a blackboard.

39. This point was brought forcibly home during a discussion of the Duck-Rabbit at the seminar on "Image and Text" at the 1990 School of Criticism and Theory, when Linda Beard of Michigan State University pointed out that the problem of the Duck-Rabbit is exactly analogous to the question of the mulatto, the ambiguous visual/verbal coding of race in the binary system of black and white "identity." The possibility of a third term, an image of

effect,"[40] noting that it too seems to be a recurrent feature of the metapicture. We noted that the "time-line" of Steinberg's drawing can be read in two opposite directions; Magritte's Pipe requires two contrary and symmetrical readings; *Las Meninas* is a veritable whirlpool of interpretative "aspects," switching and alternating the places of painter, beholder, and model, the viewer and the viewed, with dazzling complexity.

The figure of the "whirlpool" suggests a way of specifying (or picturing) the multistability effect in a graphic form. We might call this the "Vortex Effect," locating its most explicit rendering in Steinberg's "New World," where the graphic abstraction of reverie finds its appropriate icon in the spiraling doodle. Versions of the vortex are implied in our other examples as well—in the rotation of the Duck-Rabbit around the axis of the eye, in the cyclical scanning of Magritte's text/image composite, and in the "cycle of representation" that Foucault compares to a "spiral shell" in *Las Meninas*.[41] All these effects are mobilized in the service of an overarching effect that is most vividly realized in *Las Meninas,* and that is what we might call (following Althusser) the "Effect of Interpellation," the sense that the image greets or hails or addresses us, that it takes the beholder into the game, enfolds the observer as object for the "gaze" of the picture. This is true even when no figure in the image looks out at the beholder. Magritte's pipe addresses, even lectures the beholder, broadcasting two contradictory messages (the legend: "This is not a pipe"; the picture: "this is a pipe") simultaneously. Steinberg's "New World" challenges the beholder to find a position outside it. The Duck-Rabbit addresses us across the gulf between animal and human perception, between mechanical illusion and interpretive "seeing-as."[42] That may be why this particular example, rather than the numerous multistable

both-or-neither, is what makes sense of the original question that accompanied the Duck-Rabbit: "Which animals resemble each other the most?"

40. See Gandelman's discussion in "The Metastability of Primitive Artefacts," pp. 191–213.

41. See Foucault, *Order of Things*, p. 11. See my essay, "Metamorphoses of the Vortex: Hogarth, Turner, and Blake," in *Articulate Images: The Sister Arts from Hogarth to Tennyson,* edited by Richard Wendorf (Minneapolis: University of Minnesota Press, 1983), pp. 125–68.

42. See chapter 10, "Illusion: Looking at Animals Looking," for more on this issue.

geometric diagrams that appear in psychology textbooks, has emerged as the canonical example for philosophical reflection. The Duck-Rabbit, like the pipe, is not a neutral motif. It brings all the associations of game, hunting, decoys, and the linkage of the visual field with power, entrapment, and violence. What does it mean that the key shift in the Duck-Rabbit is the flashing between ears and a mouth: does the picture alternately "listen" for its observer, like a rabbit trembling in the weeds? Or does it quack at us insistently?[43] Alain's Egyptian life-class seems to "capture" the geographical and historical "other" in the net of "our" gaze. More typical of the strong hypericon, however, is the interpellative return, the multistable vortex that brings the net itself to our notice, or tears holes in it. Recall Foucault's comparison of Magritte's pipe to a "double trap, unavoidable snare" that falls open, allowing the object to escape (*Pipe*, pp. 22, 28).

I want to conclude these reflections, not with generalizations but with a pair of final examples that might suggest further directions of inquiry. The first is Poussin's Arcadian Shepherds (figure 15), the subject of a large scholarly literature that includes classic essays by Erwin Panofsky and Louis Marin.[44] I hope it is clear by now how we might proceed with this example. It is clearly a representation of representation, but with the poles of Magritte's pipe reversed: here, instead of a text surrounding or commenting on a picture, we have an array of pictured figures surrounding a text inscribed on a cenotaph—a picture of textuality and reading. If Magritte shows us the relation of a declarative statement to a picture, Poussin is concerned with picturing the *narrative* statement, the classic problem of Western history painting. I won't try to reconstruct the multistable aspects of the painting in detail, except to say that it "puts on stage" another generic feature of the metapicture: its role as a *scene of interpretation.* The shepherds have discovered the cenotaph with the ambiguous inscription, "I too was (or am) in Arcadia." Like the ambiguous deictic "this" in Magritte's pipe, the "I" may be a dead shepherd speaking

43. Note that the scene of the hunter's story in *Fliegende Blätter* is framed by a pair of listening rabbits whose toothy grins suggest they are about to burst out laughing at the absurd scene.

44. Marin, "Toward a Theory of Reading in the Visual Arts," in *Calligram: Essays in New Art History from France,* edited by Norman Bryson (Cambridge: Cambridge University Press, 1988), pp. 63–90; Panofsky, "*Et in Arcadia Ego:* Poussin and the Elegiac Tradition," in *Meaning in the Visual Arts* (New York: Doubleday, 1955), pp. 295–320.

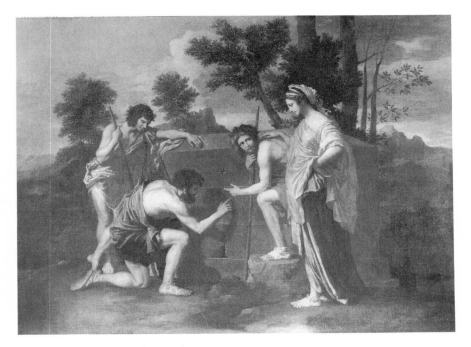

15. Nicolas Poussin, *Et in Arcadia Ego*. Reproduced courtesy of Musée du Louvre; photograph courtesy of Musées Nationaux—Paris.

from the past, or Death himself, speaking ominously in the eternal present. The painting stages a double vortex of interpretation. The first is explicitly represented by the complex drama of the shepherds' gestures and interwoven gazes, the sense that they represent stages in a process of encounter, apprehension, puzzlement, and discussion, culminating in the calm comprehension/recognition of the sibylline shepherdess at the right. The second is the implied vortex of the implied beholders' colloquy in front of this picture. I have in mind a secondary image, one in which a somewhat reduced copy of the Arcadian Shepherds is placed on display in some academic pastoral setting and is photographed surrounded by curious students and a wise instructor to show us something about the continuing function of the metapicture as teaching aid—a scene of sublime instruction that contrasts sharply with the hilarious anarchy Foucault imagines in Magritte's pipe-ridden classroom.

My final example comes from well outside the canon, not just of art history, but of philosophical reflection as well. It comes from the

popular culture of the adolescent white American male in the second half of the twentieth century, a whole realm of pubescent transgression that has marked the maturation of boys in this country since the 1950s. I'm speaking, of course, of *MAD* magazine,[45] and I have in mind a particular cover that brings the metapicture into the territory of sexuality, voyeurism, gender difference, pornography, and the pictured body (figure 16). It does this, not by showing a representation of representation, but a representation of *pre*sentation, a picture about the body as spectacle.

The picture shows us a scene at a nude beach. The nudists are discreetly screened from our view by a board fence with the words "nude beach" painted on it. Beyond the fence we see the faces and upper bodies of the nudists reacting in horror to a spectacle that confronts them atop the fence, where we see from behind a figure standing on the fence, his legs spread wide, holding open a trench coat to expose himself to the nudists. We recognize the flasher, of course, by his knobby knees, shock of red hair, and distinctively large ears. It is Alfred E. Neumann, the crazy, perverted nerd who is the closest thing *MAD* magazine ever had to a hero. Exactly what Neumann is exposing to the nudists to cause such consternation is withheld from us behind the open trench coat. It is clear that he is showing them something that causes women to cover their mouths in horror and cover their children's eyes; it leaves men gaping in amazement, even managing to distract a distant volleyball player who is transfixed in midair. The picture leaves us asking what it is that could arouse such horror and astonishment.

I will spare you a comprehensive set of speculations on what it is that Alfred E. Neumann is exposing to the nudists. The facial expressions all evoke a determinate genre of presentational imagery that might be summed up as the "Medusa Effect." Whatever Neumann is exposing evokes a set of responses that cycles between repulsion and attraction, disgust and fascination. The figures seem paralyzed by the awful spectacle, their faces registering a sequence of emotions that range from terror to puzzlement to gaping amazement. The only "articulate" signs and conventional gestures in the crowd are those of the man at the left, who points toward the hidden monstrosity and calls others to come and see. We recognize, in short, the classic responses to what Gombrich calls the "apotropaic" image, the danger-

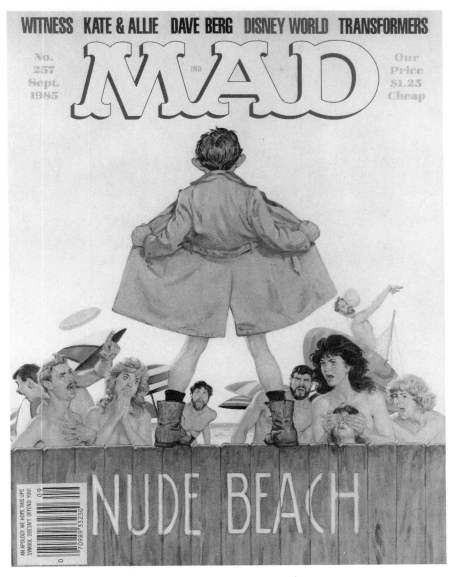

16. Front cover of *MAD* Magazine #257, painted by Richard Williams and used with permission. © 1985 by E. C. Publications, Inc.

ous representation. (These were often multistable images of faces, genitalia, and dangerous animals, all summed up in the snaky locks of Medusa.) As in traditional representations of Medusa, we are protected from a direct view of the paralyzing spectacle; it is mediated by the expressions of the pictured beholders.

Medusa, of course, is not quite appropriate to what I suppose is our first surmise about the displayed object. But then anyone who knows Alfred E. Neumann should have already suspected that he is not to be imagined as being well endowed. He is a nerd, a weirdo, a crazy, witty pervert. The suspicion begins to dawn that what Neumann is showing the nudists is not a prodigious phallus, but exactly its opposite, a prodigious absence, a gaping wound (the empty cleavage at the tail end of his trench coat already suggests far too much empty blue sky between his legs). Perhaps Neumann is a castrato, a hermaphrodite, a sexual monster with snaky scales on his genitals.

The truth, alas, is much more prosaic, a veritable anticlimax. To guess at it we need to ask what form of visual transgression would be most threatening in a world defined by the free visual access to the naked body, the open, illuminated world of nudism? The answer: not merely a lack of visible genitalia, a wounding absence, but a positive prohibition, an interdiction on display, a form of negation possible only in language. Neumann's secret (figure 17) turns out to be nothing but some words, the slogan "Flashers Against Nudity" printed on his tee-shirt. It's hard to imagine a clearer illustration of what Foucault calls "the repressive hypothesis" concerning sexuality. Exhibitionism doesn't simply violate the law against a certain kind of visual display; it relies on that law for its very effect. Nudism is the deadly enemy of exhibitionism, for it offers the possibility of bodily display without sex, secrecy, or transgression; it threatens the regime of concealment and surveillance, and overturns the alliance between voyeurism and exhibitionism. Alfred E. Neumann "assumes the position" here of the classic figures of patriarchal repression and the law, maintaining their hold on visibility and sex "through language, or rather through that act of discourse that creates . . . a rule of law,"[46] which in turn constitutes desire as lack.

If the *MAD* cover pictures a theory of sexuality, its more fundamental mission is to picture the relation between the visible and the

46. Michel Foucault, *The History of Sexuality: An Introduction*, vol. 1, translated by Robert Hurley (New York: Vintage, 1990), p. 83. Further page references will be cited in the text.

17. Back cover of *MAD* Magazine #257, painted by Richard Williams and used with permission. © 1985 by E. C. Publications, Inc.

readable in the intersections of power, desire, and knowledge. Like our other "wild" metapictures, it doesn't merely illustrate the repressive hypothesis, but undermines it, holds it up to ridicule, revealing the law itself as mad and perverse. Like Magritte's pipe, it reveals the relation of the visible and the readable to be one of negation and interdiction, a site where power, desire, and knowledge converge in strategies of representation. Like *Las Meninas,* it interpellates its beholder in a scene of recognition and spectacular power, replacing the sovereignty of painter/monarch with the contemporary figure of the walking billboard, speaking in the body language of the tee-shirt. Like the Duck-Rabbit, it opens up contrary readings with infinite possibilities: on the one hand, a mysterious sexuality that circulates through discourse and representation, requiring an intricate *scientia sexualis* to trace what Foucault calls its "perpetual spirals of power and pleasure" (*HS,* p. 45); on the other hand, an *ars erotica* that would have its own forms of visibility and concealment, "a different economy of bodies and pleasures" (p. 159), and a different nexus of the seeable and the sayable.

It will be objected that I am comparing apples and oranges (not to mention neglecting history) in juxtaposing such disparate examples—*New Yorker* cartoons, gestalt images, surrealist conundrums, Renaissance masterpieces, and juvenile comic books. I hope it is clear that this miscellaneous and heterogeneous array is fundamental to the claims of this essay. The study of metapictures is not a special problem in art history, but an issue in a much larger field theory of representation, the hybrid discipline of "iconology." The metapicture is not a subgenre within the fine arts but a fundamental potentiality inherent in pictorial representation as such: it is the place where pictures reveal and "know" themselves, where they reflect on the intersections of visuality, language, and similitude, where they engage in speculation and theorizing on their own nature and history. As the words "reflection," "speculation," and "theory," indicate, there is more than a casual relation between visual representation and the practice called theorizing (*theoria* comes from the Greek word "to see"). We tend to think of "theory" as something that is primarily conducted in linear discourse, in language and logic, with pictures playing the passive role of illustrations, or (in the case of a "theory of pictures") serving as the passive objects of description and explanation. But if there is such a thing as a metalanguage, it should hardly surprise us that there is such a thing as a metapicture. Our search for a theory of pictures may best be advanced by turning the problem upside-down to look at pictures of theory.

BEYOND COMPARISON: PICTURE, TEXT, AND METHOD

There is no link that could move from the visible to the statement, or from the statement to the visible. But there is a continual relinking which takes place over the irrational break or crack.

—Gilles Deleuze, *Foucault*

W hat implications do these theoretical pictures have for questions of method in the study of images and texts? Perhaps the most important lessons are negative ones. Metapictures make visible the impossibility of a strict metalanguage, a second-order representation that stands free of its first-order target. They also reveal the inextricable weaving together of representation and discourse, the imbrication of visual and verbal experience. If the relation of the visible and the readable is (as Foucault thought) an infinite one, that is, if "word and image" is simply the unsatisfactory name for an unstable dialectic that constantly shifts its location in representational practices, breaking both pictorial and discursive frames and undermining the assumptions that underwrite the separation of the verbal and visual disciplines, then theoretical pictures may be mainly useful as de-disciplinary exercises. The working through of their formal specificity and historical functioning may leave us with nothing more than a pragmatics loosely grounded in tradition. That is, the problem of the "imagetext" (whether understood as a composite, synthetic form or as a gap or fissure in representation) may simply be a symptom of the impossibility of a "theory of pictures" or a "science of representation."

It is easy, then, to be persuaded by Deleuze's suggestion that the antinomy of word and image is something like a historical *a priori*,[1]

1. Gilles Deleuze, *Foucault* (Minneapolis: University of Minnesota Press, 1988), p. 60: "Speaking and seeing, or rather statements and visibilities, are

cropping up like an unruly weed whenever some attempt is made to stabilize and unify the field of representation and discourse under a single master-code (mimesis, semiosis, communication, etc.). One traditional answer to this problem in the (American) academic study of the representational arts has been the comparative method. The tradition of "Sister Arts" criticism, and the pedagogy of "literature and the visual arts," has been the dominant model for the interdisciplinary study of verbal and visual representation. In its ambitious forms "interartistic comparison" has argued for the existence of extended formal analogies across the arts, revealing structural homologies between texts and images united by dominant historical styles such as the baroque, the classical, or the modern.[2] In its more cautious versions it has been content with tracing the role of specific comparisons between visual and verbal art in poetics and rhetoric and examining the consequences of these comparisons in literary and artistic practice.[3]

Although these methods have been mainly associated with the work of literary scholars moonlighting in the visual arts, they have a certain hidden institutional presence in art history as well, where the

pure Elements, *a priori* conditions under which all ideas are formulated and behavior displayed, at some moment or other."

2. Traditional approaches to the comparative method include Wylie Sypher's, *Rococo to Cubism in Art and Literature* (New York: Random House, 1960); Mario Praz, *Mnemosyne: The Parallel between Literature and the Visual Arts* (Princeton, NJ: Princeton University Press, 1970); and Chauncey Brewster Tinker, *Painter and Poet: Studies in the Literary Relations of English Painting* (1938, reprint: Freeport, NY: Books for Libraries Press, 1969); René Wellek's skeptical critique of the comparative method in his *Theory of Literature* (Orlando, FL: Harcourt, Brace, Jovanovich, 1964, rev. ed.) remains a sensible antidote, but it does not attempt any analysis of the basic intuitions and motives that drove interartistic comparison in the first place. Wendy Steiner's *The Colors of Rhetoric* (Chicago: University of Chicago Press, 1982) is the best example of the application of structuralist and semiotic methods to interartistic comparison in modern literature and visual art. See also Göran Sonneson's *Pictorial Concepts* (Sweden: University of Lund, 1989), discussed below. For a good survey of recent "interart studies," see the special issue "Art and Literature," edited by Wendy Steiner, of *Poetics Today* 10:1 (Spring 1989).

3. Jean Hagstrum, *The Sister Arts: The Tradition of Literary Pictorialism and English Poetry from Dryden to Gray* (Chicago: University of Chicago Press, 1958).

academic legitimation of the field (at least in the United States) has sometimes been grounded in the sense that art history provides a "visual analogue" to the study of literature. Donald Preziosi notes that "one of the earliest formal appearances of art history in the American university system occurred in 1874 when the Harvard Corporation appointed Charles Eliot Norton Lecturer on the History of the Fine Arts as Connected with Literature."[4] The corporate, departmental structure of universities reinforces the sense that verbal and visual media are to be seen as distinct, separate, and parallel spheres that converge only at some higher level of abstraction (aesthetic philosophy; the humanities; the dean's office).

Given this background of tradition and institutional structuring, it's hardly surprising that the comparative method has seemed like the only systematic way to talk about relations of word and image (I lay aside for the moment ad hoc discussions based in historical contingencies such as the friendships of painters and poets). Comparison is the ideal trope for figuring "action at a distance" between different systems. When accompanied by a set of standard and acceptable differentiations between the institutions of "literature" and "visual art" (that is, differentiating figures like the "spatial" and "temporal" arts, the iconic and symbolic, even "the verbal" and "the visual") a conceptual framework for comparative study is established. This framework may then be refined (as Wendy Steiner has shown) by distinguishing three-term ("substantive") from four-term ("relational") analogies. This "structured set of interrelations," according to Steiner,

> has made the comparison of the two arts seem both a possible and a valuable enterprise. It has allowed contemporary theoreticians to discover what they consider 'real' similarities—real because they correspond to structures in other areas of human experience and because they can be discussed in the privileged terms of science.[5]

The next step is to historicize this framework with a master-narrative that can be seen as common to the internal traditions of the disciplines of literature and art history and to their bureaucratic subdivisions. The sequence of "periods" from medieval to postmodern (with its inevitable consequences for the definition of academic

4. Donald Preziosi, *Rethinking Art History: Meditations on a Coy Science* (New Haven, CT: Yale University Press, 1989), p. 9.

5. Steiner, *The Colors of Rhetoric*, p. 19.

"positions") is overlaid on the framework of analogy and one has an interdisciplinary "field"—the comparative study of literature and the visual arts. Why is it worth doing this? "The answer," says Wendy Steiner, "is that the interartistic comparison inevitably reveals the aesthetic norms of the period during which the question is asked."[6] In short, the method will not make any waves: it will simply provide confirmation and elaboration of the dominant historical and conceptual models that already prevail in the discipline, offering the sort of highly general, watered-down historicism that can be extracted to match up visual art and literature.

One might suppose that the scientific and systematic tradition of European semiotics would provide an alternative to the pragmatism of the American "interartistic comparison" model, but in practice the only thing that seems to change is the generality of the claims. A good example is Göran Sonesson's *Pictorial Concepts,* which is the most ambitious recent attempt to synthesize the semiotic analysis of visual representation and verbal discourse. But Sonesson simply replaces the unifying concept of "art" with more general notions of "picturality," "literarity," and "meaning" to produce a higher-level comparative method and a more insistently scientistic rhetoric. The basic task of semiotics, argues Sonneson, is "to render comparable, in their similarities and differences, the results of the different human and social sciences, through the unification of their concepts and methods."[7]

Since the filling in of familiar grids with novel (but unchallenging) detail is what usually passes for "the advancement of learning" in academic research, the practice of interartistic or intersemiotic comparison seems a safe professional option. It is a nice extra in times of budgetary surplus, and it may have a certain survival value in times of retrenchment, when the ability to teach in more than one department could be attractive to a cost-cutting administration. At its best,

6. Ibid., 18.

7. See Sonneson, *Pictorial Concepts,* pp. 19, 16. The situation with the semiotics of cinema and mass culture in the tradition of Roland Barthes is, for the most part, quite different. There a rich body of connections between semiotic structures and ideology has been developed, especially in feminist and psychoanalytic criticism. It would be impossible to do justice to this work in a single footnote. One of my aims is to open up the traditional problems of interartistic comparison to some of the redescriptions made possible by this more self-critical and nonscientistic tradition of semiotic analysis. As a starting point, one might consult the excellent anthology *On Signs,* edited by Marshall Blonsky (Baltimore, MD: Johns Hopkins University Press, 1985).

the comparative method can offer a kind of intellectual housekeeping, sorting out the differences and similarities not only between various kinds of cultural objects, but between the critical languages that are brought to bear on them. It also has the advantage of tradition: there is no question that poetics, rhetoric, semiotics, and aesthetics are riddled with the tropes of interartistic comparison and that these figures, like any other, deserve analysis.

Any such analysis ought to proceed, however, by acknowledging three basic limitations in the comparative method. The first is the presumption of the unifying, homogeneous concept (the sign, the work of art, semiosis, meaning, representation, etc.) and its associated "science" that makes comparative/differentiating propositions possible, even inevitable. The second is the whole strategy of systematic comparison/contrast that ignores other forms of relationship, eliminating the possibility of metonymic juxtapositions, of incommensurability, and of unmediated or non-negotiable forms of alterity. The third is the ritualistic historicism, which always confirms a dominant sequence of historical periods, a canonical master-narrative leading to the present moment, and which seems incapable of registering alternate histories, counter-memories, or resistant practices. "Interartistic comparison" suffers, in short, from comparison, from artiness, and from its inability to do anything but confirm received versions of cultural history. Intersemiotic comparison has the same problem, substituting scientism for artiness.[8]

All the same, the impulse to "interartistic comparison" cannot be totally pointless. It must correspond to some sort of authentic critical desire to connect different aspects and dimensions of cultural experience. The challenge is to redescribe the whole image/text problematic that underwrites the comparative method and to identify critical prac-

8. For a case in point, see the important article by Mieke Bal and Norman Bryson on "Semiotics and Art History," *Art Bulletin* 73, no. 2 (June 1991): 174–208. Bal and Bryson argue that semiotics "challenges the positivist view of knowledge" endemic to art history with an "antirealist" theory of the sign (p. 174). Bal and Bryson seem committed, moreover, to a notion of the semiotic challenge as fundamentally political, allowing questions of gender and power, for instance, to become central to the study of the visual image. Yet they also tend to treat semiotics as a neutral, scientific metalanguage: "since semiotics is fundamentally a transdisciplinary theory, it helps to avoid the bias of privileging language that so often accompanies attempts to make disciplines interact" (p. 175). As should be clear by now, I'm skeptical about the possibility of transdisciplinarity and the avoidance of "bias."

tices that might facilitate a sense of connectedness while working against the homogenizing, anaesthetic tendencies of comparative strategies and semiotic "science." In *Iconology* I tried to show why the prevailing tropes of differentiation between verbal and visual representation (time and space, convention and nature, the ear and the eye) do not provide a stable theoretical foundation for regulating comparative studies of words and images. I also tried to suggest the ways in which these tropes function as "ideologemes," relays between semiotic, aesthetic, and formal boundaries, and figures of social difference. The remainder of this essay maps out some practical and methodological implications of these conclusions for the study of words and images. I'm concerned here particularly with questions of pedagogy. How do we teach literature and textual analysis in the era of "the pictorial turn" and the dominance of visuality? How do we teach "art history" when the distinctiveness and identity of "art" is exactly what cannot be taken for granted? What do we want from a course, a curriculum, and a discipline that seeks to connect and cross the shifting boundaries of verbal and visual representation?

My first goal for a course that connects images and texts has always been to confront this topic only where it is necessary and unavoidable. The historicist course in "comparative arts" that compares (say) cubist painting with the poems of Ezra Pound, or the poems of Donne with the painting of Rembrandt, is exactly the sort of thing that seems unnecessary, or whose necessity is dictated mainly by the administrative structure of knowledge. It may enlarge our knowledge of modernism to study both Pound and the cubists, but it tends also to reduce that knowledge to a set of abstract propositions about the period aesthetic. The real subject of such a course is not the image/text problem, but modernism. There is no good reason to stop with the comparison of painting and poetry; one might as well go on to look at music, science, film, philosophy, and historical writing. That, in fact, is what a densely woven interdisciplinary study of modernism would require, though it would not require a comparative methodology as a starting point, much less a singling out of poetry and painting as the objects for comparison. But if one's subject is not modernism or the baroque, but the problem of the image/text—that is, the heterogeneity of representational structures within the field of the visible and readable—then one is led to rather different starting points. One may want to shed the comfort of the historicist security blanket with its preordained rediscoveries and refinements of the period's aesthetic concept. One may be forced to leave the enclave of "the aesthetic" altogether to engage with vernacular forms of repre-

sentation. One will, above all, be constrained to take on the subject of the image/text, not as a kind of luxury "option" for the amateur, the generalist, or the aesthete, but as a literal, material necessity dictated by the concrete forms of actual representational practices.

Perhaps these starting points seem so obvious to me because I began this sort of work in a rather different place, with the composite art of William Blake, a poet-painter whose illuminated books seem absolutely to demand a reader capable of moving between verbal and visual literacy, and whose relation to the prevailing aesthetic concepts of "romanticism" seems so equivocal. Even with Blake's mixed media, however, I was always struck by the oddness, the arbitrariness of the demand for double literacy. Blake's poetry had been (and still continues to be) taught with only the most cursory attention to his graphic art. I know this for a fact because, despite my commitment to the critical analysis of Blake's composite art, I still find it important occasionally to teach him just as a writer. For certain purposes it might be more important to read Rousseau's *Émile* next to the *Songs of Innocence and Experience* than to look at the illustrations. Blake has always served for me, then, as a kind of exemplar of both the temptation and arbitrariness of comparative studies of verbal and visual art. Blake's illuminated books invite "comparative" analysis, if ever any works of art did; but even they require it only for the specific purpose of confronting the formal materiality and semiotic particularity of Blake's text. If one wants to see Blake's work for what it is, in short, one cannot avoid the problem of the image/text.[9]

One can and must, however, avoid the trap of comparison. The most important lesson one learns from composite works like Blake's (or from mixed vernacular arts like comic strips, illustrated newspapers, and illuminated manuscripts) is that *comparison itself is not a necessary procedure in the study of image-text relations*. The necessary subject matter is, rather, the whole ensemble of *relations* between media, and relations can be many other things besides similarity, resemblance, and analogy. Difference is just as important as similarity, antagonism as crucial as collaboration, dissonance and division of

9. I will employ the typographic convention of the slash to designate "image/text" as a problematic gap, cleavage, or rupture in representation. The term "imagetext" designates composite, synthetic works (or concepts) that combine image and text. "Image-text," with a hyphen, designates *relations* of the visual and verbal. The necessity of a concept such as the "imagetext" was first made clear to me by Robert Nelson in our team-taught seminar on "Image and Text."

labor as interesting as harmony and blending of function. Even the concept of "relations" between media must be kept open to question: is radical incommensurability (cp. Foucault on Magritte's pipe)[10] a relation or a nonrelation? Is a radical synthesis or identity of word and image (the utopian calligram) a relation or a nonrelation? The key thing, in my view, is not to foreclose the inquiry into the image/text problem with presuppositions that it is one kind of thing, appearing in a certain fixed repertoire of situations, and admitting of uniform descriptions or interpretive protocols.

The best preventive to comparative methods is an insistence on literalness and materiality. That is why, rather than comparing this novel or poem with that painting or statue, I find it more helpful to begin with actual conjunctions of words and images in illustrated texts, or mixed media such as film, television, and theatrical performance. With these media, one encounters a concrete set of empirical givens, an image-text structure responsive to prevailing conventions (or resistance to conventions) governing the relation of visual and verbal experience. Some plays (taking their cue from Aristotle) privilege *lexis* over *opsis,* speech over scenery, dialogue over visual spectacle.[11] The film medium has passed through a technological revolution involving a shift from a visual to a verbal paradigm in the shift from silent film to the "talkies," and film theory invariably confronts some version of the image/text problem whenever it attempts to specify the nature of "film language."[12] The relative positioning of visual and verbal representation (or of sight and sound, space and time) in these mixed media is, moreover, never simply a formal issue or a question to be settled by "scientific" semiotics. The relative value, location, and the very *identity* of "the verbal" and "the visual" is exactly what is in question. Ben Jonson denounced the spectacular set designs of

10. See my discussion of Foucault on Magritte in chapter 2, "Metapictures."

11. Aristotle's repudiation of *opsis* is so thorough that he is even willing to jettison performance itself, in favor of a narrative presentation of the action. "The plot should be so constructed that even without seeing the play anyone hearing of the incidents thrills with fear and pity as a result of what occurs. . . . To produce this effect by means of an appeal to the eye is inartistic and needs adventitious aid . . . " (*The Poetics* XIV, translated by W. Hamilton Fyfe, 1927; [Cambridge, MA: Harvard University Press, 1973], p. 49).

12. See Christian Metz, *Film Language: A Semiotics of the Cinema,* translated by Michael Taylor (New York: Oxford University Press, 1974), and footnote 27.

Inigo Jones as degradations of the poetic "soul" of the masque. Erwin Panofsky thought the coming of sound corrupted the pure visuality of silent movies.[13] These are not scientific judgments, but engagements in the theoretical praxis of representation. The image-text relation in film and theater is not a merely technical question, but a site of conflict, a nexus where political, institutional, and social antagonisms play themselves out in the materiality of representation. Artaud's emphasis on mute spectacle and Brecht's deployment of textual projections are not merely "aesthetic" innovations, but precisely motivated interventions in the semio-politics of the stage. Even something as mundane and familiar as the relative proportion of image and text on the front page of the daily newspaper is a direct indicator of the social class of its readership. The real question to ask when confronted with these kinds of image-text relations is not "what is the difference (or similarity) between the words and the images?" but "what difference do the differences (and similarities) make?" That is, why does it matter how words and images are juxtaposed, blended, or separated?

The "matter" of the image-text conjunction matters a great deal in the work of Blake, whose illuminated books seem designed to elicit the full range of relations between visual and verbal literacy. In his illuminated books, Blake constructed image-text combinations that range from the absolutely disjunctive ("illustrations" that have no textual reference) to the absolutely synthetic identification of verbal and visual codes (marks that collapse the distinction between writing and drawing).[14] It's not surprising, of course, that Blake's illuminated books, and the whole related genre of the "artist's book," would tend to exhibit flexible, experimental, and "high-tension" relations between words and images. The "normal" relations of image and word (in the illustrated newspaper or even the cartoon page) follow more traditional formulas involving the clear subordination and suturing of one medium to the other, often with a straightforward division of labor.[15] In the typical comic strip, word is to image as speech

13. Ben Jonson, "An Expostulation with Inigo Jones," in *The Complete Poems*, edited by George Parfitt (New Haven, CT: Yale University Pressss, 1975), pp. 345–47; see Erwin Panofsky on space and time in cinema in "Style and Medium in the Motion Pictures," *Critique* 1:3 (Jan.–Feb. 1947), reprinted in Gerald Mast and Marshall Cohen, eds., *Film Theory and Criticism* (New York: Oxford University Press, 1979), pp. 243–63.

14. See *Blake's Composite Art* (Princeton, NJ: Princeton University Press, 1978) and chapter 4 of this volume, "Visible Language."

15. I am adapting here the concept of "suture" as developed in psychoana-

(or thought) is to action and bodies. Language appears in a speech-balloon emanating from the speaker's mouth, or a thought-cloud emerging from the thinker's head. (In the pre-Cartesian world of the medieval illuminated manuscript, by contrast, speech tends to be represented as a scroll rather than a cloud or bubble, and it emanates from the gesturing hand of the speaker rather than the mouth; language seems to co-exist in the same pictive/scriptive space—hand-writing emanating from hand-gesture—instead of being depicted as a ghostly emanation from an invisible interior).[16] Narrative diegesis (cp. *Prince Valiant*'s "Our Story . . . ") is generally located in the margins of the image, in a position understood to be "outside" the present moment of depicted action, scenes, and bodies.[17]

lytic film theory and am relying principally on Stephen Heath's article, "On Suture," in *Questions of Cinema* (Bloomington: Indiana University Press, 1981), pp. 76–112. Suture might be described most generally in Lacan's words as the "junction of the imaginary and the symbolic" (quoted in Heath, p. 86), the process by which the subject (the "I") is constituted both as a division and a unity. "*I*," as Heath notes, is "the very index of suture." Film theory adapted the notion of suture to describe the construction of the spectator position in cinema (the "I/eye" as it were) and to analyze the specific characteristics of film discourse. Suture might be described as that which "fills in" the gaps between images and shots by constructing a subjective sense of continuity and absent positionality. Shot-reverse-shot, with its interplay of shifting spectatorial positions and self/other identifications, is thus the paradigmatic figure for suture in cinema. My adaptation of this notion to the "image/text" is very rough and preliminary, but not, I hope, completely unfounded. At the root of the idea in both psychoanalysis and film theory is the figure of a heterogeneous field of (self)representation and the process by which its disjunctions are at once concealed and revealed. The specific form of that heterogeneity (for Lacan, the imaginary and the symbolic; for film theory, the transformation of the sequence of film images into a discourse) is already very close in its formulation to the problem of the image/text. Film theory's emphasis, not surprisingly, has been on the suturing of the image sequences and the construction of the subject as spectator. But the question of the image/text suggests, I hope, that the notion of suture might well be extended to include the subject as *reader* and *listener,* as Heath himself notes (pp. 107–8). On the interpellation and suturing of spectatorial subject and image more generally, see chapter 2, "Metapictures."

16. I'm indebted to Michael Camille for this contrast between the medieval and post-Cartesian cartoon.

17. There's nothing to prevent the rearrangement of these conventional spaces, of course. Dialogue need not appear in voice balloons, but can simply

This is not to suggest that "normal" relations of word and image are uninteresting or that vernacular composite forms like the comic strip or the journalistic photo essay are incapable of experimentation and complex deviations from the norm. Gary Trudeau's anti-cinematic, talky cartoon sequences in *Doonesbury* defy the normal privileging of the visual image as the place "where the action is" on the cartoon page. *Doonesbury* is a kind of exercise in visual deprivation, rarely showing bodies in motion, often repeating an identical and empty image (a view of the White House, the back of a television set, a point of light above a presidential seal) in every frame, displacing all movement onto the bodiless voice indicated by the text. Postmodern cartoon novels like *Maus* and *The Dark Knight* employ a wide range of complex and self-reflexive techniques. *Maus* attenuates visual access to its narrative by thickening its frame story (the dialogue of a holocaust survivor and his son is conspicuously uncinematic in its emphasis on speech) and by veiling the human body at all levels of the visual narrative with the figures of animals (Jews are mice, Germans are cats, Poles are pigs).[18] *The Dark Knight,* by contrast, is highly cinematic and televisual, employing the full repertoire of mo-

run along the bottom edge of the frame (the normal convention of the single panel cartoon and of multiple-panel narrative cartoonists like Jules Pfeiffer). For a very useful insider's account of rhetorical and narrative devices in cartoons, see Will Eisner, *Comics & Sequential Art* (Tamarac, FL: Poorhouse Press, 1985).

18. See Art Spiegelman, *Maus I: A Survivor's Tale: My Father Bleeds History* (New York: Pantheon, 1973). The effect of Spiegelman's brilliant animal caricatures is, of course, more complex than a simple "veiling" of the human form. The reduction of the Holocaust to a "Tom and Jerry" iconography is at once shocking in its violation of decorum and absolutely right in its revelation of a fitness and figural realism in the animal imagery. Spiegelman's images insist that the Jews really were "scared mice"; they really were treated as vermin to be hunted down and exterminated; they hid in cellars like and with rats; some of them were traitors and rats, notably when they organized themselves into the collaborationist institution of the *"Judenrat"* (Jewish Council). The Germans really are heartless predators, but feline and unpredictable, luxuriating in the pleasure of absolute power over abject victims. The Poles really are pigs, fattening themselves on the dispossessed goods of the Jews, sometimes goodhearted, but inevitably gross and unrefined. The hyperbole of the animal imagery enforces a mode of critical realism, while defending the viewer against (or preventing) an unbearable (or voyeuristic) access to the banal human forms of evil and abjection. For more on abjection and visual defense, see chapter 6, "Narrative, Memory, and Slavery."

tion picture and video rhetoric while continually breaking frames and foregrounding the apparatus of visual representation.

Similar observations might be made on the mixed medium of the photographic essay. The normal structure of this kind of imagetext involves the straightforward discursive or narrative suturing of the verbal and visual: texts explain, narrate, describe, label, speak for (or to) the photographs; photographs illustrate, exemplify, clarify, ground, and document the text.[19] Given this conventional division of labor, it's hardly surprising that an aggressively modernist experimental deviation like James Agee and Walker Evans's *Let Us Now Praise Famous Men* would come into existence. *Famous Men* is a photo essay whose form resists all suturing of word and image: the photos are physically and symbolically separated from the text; there are also no captions on the photos, and few references to the photos in the text.[20] These deviations, moreover, cannot be fully accounted for by notions of "purifying" visual and verbal media. Or, more precisely, the "purist" strategies of Agee and Evans only make sense in relation to their sense of participating in a hopelessly compromised and *impure* representational practice, one for which the political and ethical conventions need to be challenged at every level.

How do we get from the study of media in which visual-verbal relationships are unavoidable—such as films, plays, newspapers, cartoon strips, illustrated books—to the traditional subjects of "interartistic comparison," the analogies and differences between poems and paintings, novels and statues. In some ways it should be clear that we ought never come back to this subject, that it is a non-subject without a real method or object of investigation. But in another sense it should be obvious that the subject of the image/text is just as unavoidable and necessary with these "unmixed" media as it is with mixed, composite forms. Interartistic comparison has always had an intuition of this fact, without really grasping its implications. The image/text problem is not just something constructed "between" the arts, the media, or different forms of representation, but an unavoidable issue *within* the individual arts and media. In short, all arts are

19. See Jefferson Hunter, *Image and Word: The Interaction of Twentieth-Century Photographs and Texts* (Cambridge, MA: Harvard University Press, 1987), and chapter 10, "Illusion: Looking at Animals Looking."

20. See chapter 9, "The Photographic Essay," for an extended discussion of *Let Us Now Praise Famous Men* (first published in 1939; reprint: Boston: Houghton-Mifflin, 1980) and its relation to the genre of the photographic essay.

"composite" arts (both text and image); all media are mixed media, combining different codes, discursive conventions, channels, sensory and cognitive modes.

This claim may seem counterintuitive at first glance. Surely, the objection will run, there are *purely* visual and verbal media, pictures without words and words without pictures. The extension of the concept of the composite imagetext to unmixed forms such as poetry or painting is surely a kind of figurative excess, extending a model that applies literally to mixed media beyond its proper domain.

There are several answers to this objection. The first focuses on the question of literal and figurative applications of the image/text division. It is certainly true that the division applies literally to mixed media like film, television, and illustrated books. But it is also a fact that "pure" visual representations routinely incorporate textuality in a quite literal way, insofar as writing and other arbitrary marks enter into the field of visual representation. By the same token, "pure" texts incorporate visuality quite literally the moment they are written or printed in visible form. Viewed from either side, from the standpoint of the visual or the verbal, the medium of *writing* deconstructs the possibility of a pure image or pure text, along with the opposition between the "literal" (letters) and the "figurative" (pictures) on which it depends. Writing, in its physical, graphic form, is an inseparable suturing of the visual and the verbal, the "imagetext" incarnate.[21]

But suppose we bracket for the moment the issue of writing. Surely, the objection might continue, there are visual representations in which no writing appears and verbal discourses (especially oral) which need never be written down. How can we deny the merely figurative status of visuality in an oral discourse, or the merely figurative status of textuality in a painting purely composed of shapes and colors, without legible, arbitrary signs? The answer is that there is no need to deny the figurative status of the imagetext, only to dispute the "merely" that is appended to it. To claim that a label only applies metaphorically, notes Nelson Goodman, is not to deny that it has application, only to specify the form of application.[22] Figurative labels

21. I take the equivocal status of writing as image/text to be one of the leading themes of Jacques Derrida's *Of Grammatology,* translated by Gayatri C. Spivak (Baltimore, MD: Johns Hopkins University Press, 1977). See also chapter 4, "Visible Language," for an extended discussion.

22. See Nelson Goodman, *Languages of Art* (Indianapolis, IN: Hackett, 1976), pp. 68–69. See also Derrida's discussion of "literal" and "figurative"

("blue" moods and "warm" colors) apply as firmly and consistently as literal ones and have as much to do with actual experience. That images, pictures, space, and visuality may only be figuratively conjured up in a verbal discourse does not mean that the conjuring fails to occur or that the reader/listener "sees" nothing. That verbal discourse may only be figuratively or indirectly evoked in a picture does not mean that the evocation is impotent, that the viewer "hears" or "reads" nothing in the image.[23]

Perhaps the best answer to the purist who wants images that are only images and texts that are only texts is to turn the tables and examine the rhetoric of purity itself.[24] In painting, for instance, the notion of purity is invariably explicated as a purgation of the visual image from contamination by language and cognate or conventionally associated media: words, sounds, time, narrativity, and arbitrary "allegorical" signification are the "linguistic" or "textual" elements that must be repressed or eliminated in order for the pure, silent, illegible visuality of the visual arts to be achieved. This sort of purity, often associated with modernism and abstract painting, is both impossible and utopian, which isn't to dismiss it, but to identify it as an ideology, a complex of desire and fear, power and interest.[25] It is also to recognize the project of the "pure image," the unmixed medium, as a radical deviation from a norm understood to be impure, mixed, and composite. The purist's objection to the image/text, and to the heterogeneous picture of representation and discourse it suggests,

senses of writing in *Of Grammatology,* p. 15: "the 'literal' meaning of writing as metaphoricity itself."

23. On the psychology of visual response in reading, see Ellen Esrock, *The Reader's Eye* (Baltimore, MD: Johns Hopkins University Press, 1994). Esrock is the first to connect the "senses" (semantic or cognitive) in which readers might be said to visualize with a thorough survey of the psychological literature on the subject.

24. The classic argument for the purification of poetry and painting, and the strict segregation of them according to visual/verbal and spatial/temporal categories, is, of course, Lessing's *Laocoon* (1766), translated by Ellen Frothingham (New York: Farrar, Straus, and Giroux, 1969). For a critique of Lessing, see chapter 4 of *Iconology.*

25. The most notable modernist redaction of the "purity" argument is Clement Greenberg's essay, "Toward a Newer Laocoon" (1940; pp. 23–38 of vol. 1 of *Collected Works*), with its self-conscious evocation of Lessing. For more on the modernist purification of media, see chapter 7, "*Ut Pictura Theoria.*"

turns out to be a moral imperative, not an empirical description. It's not that the claim that all media are mixed media is empirically wrong, but that these mixtures are bad for us and must be resisted in the name of higher aesthetic values.

It would be easy to document a similar kind of resistance to visuality in literary discourse, in the name of a similar kind of utopian purification of language, and in response to a similar intuition about the composite, heterogeneous character of normal discourse.[26] My aim is not to dismiss the purists, but to redescribe the way their utopian projects invoke the metalanguage of the image/text, understood as a body of figures for the irreducible impurity and heterogeneity of media. Christian Metz demonstrated long ago that cinema cannot be reduced to the models of linguistics, that film is *parole* but not *langue*.[27] But suppose that language itself were not *langue,* that its deployment as a medium of expression and discourse inevitably resulted in its contamination by the visible? That is what it means, in my view, to approach language as a medium rather than a system, a heterogeneous field of discursive modes requiring pragmatic, dialectical description rather than a univocally coded scheme open to scientific explanation.

This decentering of the purist's image of media has a number of practical consequences. It clearly obviates the need for comparison, which thrives on the model of clearly distinct systems linked by structural analogies and substantive differentiations. It also permits a critical openness to the actual workings of representation and discourse, their internal dialectics of form understood as pragmatic strategies within the specific institutional history of a medium. There's no compulsion (though there may be occasions) to compare paintings with texts, even if the text happens to be represented directly (or indirectly) in the painting. The starting point is to see what particular form of textuality is elicited (or repressed) by the painting and in the name of what values. An obvious entry to the "text in painting" is the question

26. See my essay, "Tableau and Taboo: The Resistance to Vision in Literary Discourse," *CEA Critic* 51:1 (Fall 1988): 4–10.

27. See Metz, *Film Language*: "When approaching cinema from the linguistic point of view, it is difficult to avoid shuttling back and forth between two positions: the cinema as a language; the cinema as infinitely different from verbal language. Perhaps it is impossible to extricate oneself from this dilemma with impunity" (p. 44). We need not accept Metz's ultimate valorization of narrative as the essence of cinema to see that film can never be explicated fully as a systematic language.

of the title. What sort of title does the painting have, where is it located (inside, outside, or on the frame)? What is its institutional or interpretive relation to the image? Why are so many modern paintings entitled "Untitled"? Why the vigorous, explicit verbal denial of any entitlement of language in painting, the aggressive paradox of the title which denies that it is a title? What is being resisted in the name of labels, legends, and legibility?[28]

The question of the title is a literalist's entry point to a whole series of questions about the ways that words enter pictures. How, for instance, might we sort out the differences among the following kinds of textuality in painting: a picture that represents (among other objects) a text (like an open book in a Dutch painting); a picture that has words and letters, not represented *in,* but inscribed *on* its surface, as in Chinese calligraphic landscape or the large canvases of Anselm Kiefer; a picture in the mode of classical history painting that depicts an episode from a verbal narrative, like a still from a movie or a play; a picture in which the words "speak to" or disrupt the image, occupying an ambiguous location, both in and outside the image (like Dürer's signature monograms inscribed on plaques, or Magritte's inscription in "This Is Not a Pipe"); a picture whose entire composition is designed around a linguistic "character"—a hieroglyphic or ideogram, as in the work of Paul Klee; a picture that eschews all figuration, reference, narrative, or legibility in favor of pure, unreadable visuality. The investigation of these questions doesn't begin with a search for contemporary texts that betray structural analogies in some parallel literary institution or tradition. The starting point is with language's entry into (or exit from) the pictorial field itself, a field understood as a complex medium that is always already mixed and heterogeneous, situated within institutions, histories, and discourses: the image understood, in short, as an imagetext. The appropriate texts for "comparison" with the image need not be fetched from afar with historicist or systemic analogies. They are already inside the image, perhaps most deeply when they seem to be most completely absent, invisible and inaudible. With abstract painting, the appropriate texts may well be, not "literature" or "poetry," but criticism, philosophy, metaphysics—*ut pictura theoria.*[29]

28. On titles, see Gerard Genette, "Structure and Function of the Title in Literature," *Critical Inquiry* 14:4 (Summer 1988): 692–720. For more on the question of the relation of label, object, and image, see chapter 8, "Word, Image, and Object."

29. See chapter 7, "*Ut Pictura Theoria.*"

In a similar way, the visual representations appropriate to a discourse need not be imported: they are already immanent in the words, in the fabric of description, narrative "vision," represented objects and places, metaphor, formal arrangements and distinctions of textual functions, even in typography, paper, binding, or (in the case of oral performance) in the physical immediacy of voice and the speaker's body. If it is hard to keep discourse out of painting, it is equally difficult to keep visuality out of literature, though the impulse to do so is adumbrated in the topos of the blind poet, literature's answer to painting as "mute poesy." Not that the situation of literature and visual art as mutual "significant others" is purely symmetrical. It seems easier for painting to re-present and incorporate textuality in a quite literal way than for the reverse to happen. Language becomes "literally" visible in two ways: in the medium of writing, and in the utterances of gesture language, the visible language of the Deaf.[30]

The most damaging objection to the imagetext model for the analysis of either texts or images might be that, like the comparative method, it simply rearranges the deck chairs and reiterates existing dominant paradigms of analysis in the disciplines of literature and art history. The notion that images may be read as texts is hardly news in art history these days: it is the prevailing wisdom, the latest thing.[31] On the side of literary study, reading texts for the "imagery" is definitely not the prevailing wisdom: it is as old as the hills.[32] It is seen as an outmoded paradigm, a relic of psychologistic approaches to literary experience and of stultifying routines like motif-hunting, image-counting, and a disproportionate attention to figurative and formal analysis, at the expense of real cultural history.

30. For more on gesture language, see chapter 5, "Ekphrasis and the Other."

31. See Mieke Bal and Norman Bryson on "Semiotics and Art History," cited in footnote 8, which argues that the key move in semiotic versions of art history is the treatment of the image as a sign or "visual text" (p. 179): "Considering images as signs, semiotics sheds a particular light on them, focusing on the production of meaning in society. . . . " (p. 176). Although Bal and Bryson insist that they are proposing "a semiotic turn for art history" rather than "a linguistic turn," they underestimate, in my view, the extent to which semiotics privileges textual/linguistic descriptive frameworks. Far from avoiding "the bias of privileging language," semiotics continually reinstates that bias.

32. See *Iconology*, chapter 1, for a discussion of the attacks on the notion of literary imagery.

There is some truth to these charges. The concept of the medium (visual or verbal) as a heterogeneous field of representational practices, as an "image/text," is not recommended here for its novelty, but for its persistence as a theoretical tradition, its survival as an abiding feature of poetics, rhetoric, aesthetics, and semiotics. It is this tradition that gave us the models of interartistic comparison, and that opens the possibility of other relations between texts and visual images, and the de-disciplining of the divisions between visual and verbal culture. It may also seem that, in my zeal to overturn the tedious historicism of the comparative method, I've jettisoned history altogether in favor of a kind of descriptive formalism. This charge is half right. This book is not a history of visual and verbal culture, but a theory. It offers the figure of the image/text as a wedge to pry open the heterogeneity of media and of specific representations. The aim, however, is not to stop with formal description, but to ask what the function of specific forms of heterogeneity might be. Both the formal and functional questions require historical answers: they are not predetermined by any universal science of signs, and their relation to a historical "period concept" is an open question. There's no doubt that a period concept will probably include some general account of image/text relations. It's a commonplace, for instance, that English neoclassical criticism takes the analogy between poetry and painting very seriously, while romantic poetic theory often debunks the *ut pictura poesis* tradition.[33]

But this doesn't mean that every imagetext will inevitably reveal the aesthetic norms of the period or even be describable in the language of those norms. The first place to look for the appropriate description language for analyzing the formal heterogeneity of a representation is in the representation itself, and in the institutional metalanguage—an immanent vernacular, not a transdisciplinary theory— of the medium to which it belongs. As an example, consider the genre of the "backlot" film, which reflects on the movie industry. The members of this genre are more or less self-conscious about the institutional history of the cinematic medium to which they belong; they carry a kind of institutional memory, a myth of the medium, a picture of the theory of the medium itself. Billy Wilder's *Sunset Boulevard,* a

33. Roy Park, "*Ut Pictura Poesis*: The Nineteenth Century Aftermath," *Journal of Aesthetics and Art Criticism* 28 (Winter 1969): 155–69. For a more complex account of this aftermath, see Elizabeth Abel, "Redefining the Sister Arts: Baudelaire's Response to the Art of Delacroix," *Critical Inquiry* 6:3 (Spring 1980): 363–84.

classic instance of the backlot film, takes a version of the image/text (the division between speech and visual representation) as its explicit theme, embodied in the relationship of a young male writer (Joe Gillis, played by William Holden) and an aging female screen idol (Norma Desmond, played by Gloria Swanson). The film allegorizes a number of familiar myths of film history and theory: the two central characters represent, respectively, the New Hollywood of "talking pictures" and the Old Hollywood of silent spectacle; they also incarnate the professional tension between the (invisible) writer and the (visible) star, the split between cinema as a literary and a pictorial institution. The love-hate relationship between Joe and Norma dramatizes the ambivalence of cinema about its own past and parts; Norma's murder of Joe suggests that the dead hand of the past will never allow the institution to escape its grip; Norma's pathetic delusion of a "return" to the movies is no more misguided than Cecil B. DeMille's smug assurance to Norma (conveyed in a scene in which he plays himself on the soundstage of *The Ten Commandments*) that "the movies have changed a lot since your day."

At first sight (and hearing), *Sunset Boulevard* is a film that seems conspicuously experimental and deviant in its formal deployment of voice and visual narration. There is a certain straightforward shock effect in framing the entire story in the voice-over narration of the dead Joe Gillis, whose first visible appearance is as an open-eyed corpse seen from below, floating face-down in Norma Desmond's swimming pool. Once the bizarre premise of the dead narrator is accepted, however, the film settles into a straightforward and conventional suturing of voice and image. Joe's voice addresses the audience in the most ordinary of narrative contracts: he is sardonic, knowing, and sociable, counting on an audience that shares his experience and values ("it was one of those crazy Hollywood houses"; "let's go back six months to where it all started"; "well, this is where you came in"). He is like the narrator of a nineteenth-century novel: "an individual who looks back, all passion spent, the narrator has mastered the world and tells a civilized company of listeners about a series of events which now can be composed and named."[34] The visual narrative seems invariably to illustrate Joe's voice in the most straightforward ways: when he describes something, we see it on the screen; when he narrates an action, it is performed for us; when he recalls a memory

34. Jonathan Culler, *Structuralist Poetics* (Ithaca, NY: Cornell University Press, 1975), p. 195.

or a dream, it is projected in full. The *histoire* is firmly controlled by the *récit*, the visible by the sayable.

If the thematic image/text in *Sunset Boulevard* is the unshakable dominance of the visual over the verbal in the film medium, its formal image/text seems to convey precisely the reverse message: voice seems continually to dominate and control the image. The film's formal perfection is precisely *not* to "mirror" or imitate its theme, unless we take inversion rather than similitude as the chief symptom of mimesis. It is perhaps this perverse form of formal/thematic mirroring that produces the film's overall effect of ideological impasse and paralysis, what one might call the pathological version of the infinite relation between word and image staged by Magritte's pipe.

The "flickering" of this impasse is most visible and readable at the outer edges of the film, its opening and closing sequences. The opening shot shows the words "Sunset Boulevard" painted on the curb of the actual street in Hollywood, the melodramatic theme music giving way to police sirens and the camera eye lifting from the curb to spot the taillights of the cars rushing to Norma Desmond's mansion where William Holden's unidentified voice refers to himself in the third person as some "poor dope" who has been found dead in a swimming pool. The closing sequence is presumably an hour or so later when Norma Desmond descends her staircase, mistaking the news cameras for signs that her fantasy of a "return" to film stardom has been fulfilled. As she says "I'm ready for my close-up, Mr. De-Mille," she advances on the camera until her face fills the screen and dissolves into an illegible blur.

The outer frame of the film, then, stands outside the authority of Joe Gillis's voice: the first word enunciated by the film is an image, the written name of a place, a setting, a street which contains Joe Gillis's voice the way a haunted house contains its spirit; the last words of the film are those of Norma Desmond taking control of her own image, which is an image that defies all optical or textual control. This outer frame, with its subversion of the authority of the voice, is then redoubled by the inner frame with its revelation of the body of the narrator. The image of William Holden's floating corpse seen from the bottom of the swimming pool is without question the most memorable shot in this film. And yet it is precisely the image that has to be forgotten to allow the narrative contract of the film to proceed as if a sociable relation of teller and audience could be assumed. If the audience were to remember this image throughout the film, it would not be able to rely on the authority and security of the spoken narrative, but would continually recall its position at the scene of

narration, looking up from the bottom of a pool, as drowned in images as the narrator himself.

Sunset Boulevard's reflections on the film medium may help us to see why, in Deleuze's words, "the most complete examples of the disjunction between seeing and speaking are to be found in the cinema"[35] and how those disjunctions underlie (indeed, require) the most seamless forms of image/text suturing. The image/text in *Sunset Boulevard* is specified not only by a technical account of the relation between its verbal and visual codes but also by an account of the way it thematizes that relation in the institutional practices of the medium to which it belongs. Joe Gillis's "moral choice" in the film is portrayed as a choice between two women who have two different relations to his screen-writing. Norma Desmond as the fatal female "idol" represents the prostitution of Joe's literary talents, the commodification of his pen (not to mention his penis). Betty Schaefer, the pretty young script-reader from Paramount, is content to remain off-screen and encourage Joe's cultivation of literary authenticity. The impossibility and unreality of this choice is the moral version of the impasse presented by the film's contradictory locations of narrative authority.[36]

The relation of speech to vision in this movie is thus mapped onto ideologemes like the relation of the sexes and generations (the aging female star versus the young male script-writer), as well as the relation of death and life, vice and virtue. It is also a figure for the past-present dialectic of the film's reflection on its medium as a historically evolving (or devolving) institution. This history would, if pursued far enough, situate the film in relation to postwar anxieties about the decline of Hollywood and Cold War paranoia about Hollywood's susceptibility to "foreign" influences. (At one moment in the film, when Joe Gillis is seen by a friend riding in Norma Desmond's car, he is asked if he's "working for a foreign power.") In reflecting on its own medium, *Sunset Boulevard* provides both a description language for and a spe-

35. *Foucault*, p. 64. See also Deleuze's comprehensive discussion of the relation between speech and vision, sound- and image-track in "The Components of the Image," in his *Cinema 2: The Time-Image*, translated by Hugh Tomlinson and Robert Galeta (Minneapolis: University of Minnesota Press, 1989), p. 261.

36. See my article, "Going Too Far with the Sister Arts," in *Space, Time, Image, Sign: Essays on Literature and the Visual Arts*, edited by James Heffernan (New York: Peter Lang, 1987), pp. 1–10, for further discussion of *Sunset Boulevard*'s knowing allusions to the *ut pictura poesis* tradition and its connection with allegories of the "Choice of Hercules."

cific instantiation of the cinematic imagetext. It pictures a theory of film and narrates that theory as an account both of the death of cinema and of cinema as a kind of love affair with death.

I hope it's clear that the answers to the questions put by the image/text problem are both formally descriptive and historical. They try to locate in the specific formal divisions of the film text its own sense of institutional history (the cinema) and its representation of the struggles over power and value that give that history a specific form. The point of the image/text is certainly not simply to reinforce the truism that film is a mixed, divided medium, but to specify the particular sensory and semiotic mixtures and divisions that characterize particular films, specific genres and institutional practices, and to account for their function in historical terms. The image/text is neither a method nor a guarantee of historical discovery; it is more like an aperture or cleavage in representation, a place where history might slip through the cracks.

The openness of the image/text problem to historical issues may best be illustrated by looking at a place where a history has itself been constructed with self-conscious attention to the interplay of visual and verbal experience. I'm thinking of Thucydides' *Peloponnesian War,* which is constructed around the alternation between what Thucydides calls "logoi" and "erga," the representation of set speeches and the actions reported by eyewitness descriptions.[37] Thucydides insists on the distinctness of these two modes of writing, noting especially the different kind of historical authority they carry. The "precise words" of the speeches, Thucydides admits, are "difficult to remember . . . so my method has been, while keeping as closely as possible to the general sense of the words that were actually used, to make the speakers say what, in my opinion, was called for by each situation."[38] Thucydides' text presents the speeches in a form (direct transcription or quotation) that belies their actual status. We are given the illusion of reading and hearing the actual words of Pericles' funeral oration, or the Athenian ambassador's speech to the Spartans. The "reporting of events," on the other hand, is subjected to more constraints, both in the gathering of information and its presentation. Thucydides has "made it a principle not to write down the first story" that comes his

37. For a good discussion of the role of *logoi* and *erga,* see Virginia J. Hunter, *Thucydides: The Artful Reporter* (Toronto: Hakkert, 1973).

38. Thucydides, *The Peloponnesian War,* translated by Rex Warner (New York: Penguin Books, 1954), p. 47; further page references will be cited in the text.

way "and not even to be guided by [his] own general impressions" (p. 48). He claims to have "checked with as much thoroughness as possible" the various eyewitness reports (including his own) and admits that this skepticism will eliminate "the romantic element" of his narrative, both in the facts it admits and in its hesitant form of presentation ("my history will seem less easy to read").

The Peloponnesian War, then, is a radically heterogeneous representation of history, alternating between the illusion of oral immediacy and direct transmission of speech and the presentation of visual experience (eyewitness testimony about events) as highly mediated and unreliable. The "general sense" of words is enough for Thucydides, but his own "general impressions" of events in visual memory are not. The question, of course, is "so what?" Why does Thucydides construct a dialectical representation of history? Where do his assumptions about the relative accuracy of oral and visual memory come from? (It's hard to ignore the fact that they seem precisely counter to modern "rules of evidence" which privilege "eyewitness testimony" and denigrate "hearsay.")

A proper answer to these questions would take us well beyond the limits of this essay. It would involve a reconstruction of Thucydides' theory of memory and its relation to the senses of vision and hearing. It would require attention to the links between the art of memory and contemporary Greek rhetorical theory. Above all, it would lead to an inquiry into the ideological and institutional status of "speech" and (visible) "action" in Athenian political culture during the Periclean age. The verbal/visual division is, as Thucydides himself makes clear, not merely a rhetorical feature of historical writing, but a key to the way history itself is made as a dialectic between "what men did" and "what they said." Thucydides shows us cities being conquered with speeches. He also shows us (in Pericles' funeral oration) a polemic against speech-making and an argument in favor of ceremonial spectacle:

> Many of those who have spoken here in the past have praised the institution of this speech at the close of our ceremony. It seemed to them a mark of honour to our soldiers who have fallen in war that a speech should be made over them. I do not agree. These men have shown themselves valiant in action, and it would be enough, I think, for their glories to be proclaimed in action, as you have just seen it done at this funeral organized by the state. (p. 144)

The adjustment of the dialectic between speech and visible action is, in Pericles' view, not just a question about the proprieties of cere-

monial occasions, but the key issue in the healthy functioning of Athenian democracy: "we do not think that there is an incompatibility between words and deeds; the worst thing is to rush into action before the consequences have been properly debated" (p. 147). The tragedy of Athenian democracy might well be described as the breakdown of this *logos/erga* dialectic in the emergence of demagogues who corrupt the *logos* and the greed of the Athenians who crave instant, visible action and unlimited expansion of the empire. Thucydides' text is an attempt to preserve this fragile dialectic as a way of knowing and showing history and perhaps of making it take a different form. (Pericles' critique of the visible "marks and monuments of our empire," his insistence that "famous men" leave their memorials, "not in any visible form but in people's hearts" [p. 149] is an attempt to resist the craze for spectacular memorials that he himself did so much to foster and which remain as the chief visible sign of Athenian glory.) For Thucydides, the fullness of history doesn't lie either in what men did or what they said, what we could see and describe or what we could hear. It seeps through the cracks between hearing and seeing, speaking and acting.

I've juxtaposed these historically and culturally remote examples (a Hollywood film and a classical history), not in order to "compare" them, but to call attention to the extraordinary generality of the image/text as a figure for the heterogeneity of representation and discourse. I hope it is clear that this sort of generality does not entail any lack of attention to material, formal, and historical specificity. I have not forgotten that *The Peloponnesian War* is nothing but words, and *Sunset Boulevard* is nothing but traces on celluloid. The image/text is not a template to reduce these things to the same form, but a lever to pry them open. It might be best described, not as a concept, but as a theoretical *figure* rather like Derrida's *différance,* a site of dialectical tension, slippage, and transformation. *Sunset Boulevard* and *The Peloponnesian War* employ versions of this figure to reflect on their own heterogeneity and to connect their formal dialectics to ideological and institutional struggles within their own media (cinema, history) and to the cultural contradictions they mediate. They are, as it were, metapictures of their media.

Why are these metapictures coming into focus for us now? Why does the image/text seem to crop up in contemporary criticism and theory like a historical *a priori?* One answer would appeal to the historical situation of contemporary culture, the increasing mediatization of reality in postmodernism, and the phenomenon I have called "the pictorial turn," with its regimes of spectacle and surveillance.

Our readings of ancient texts and images cannot help but be inflected by our experiences with television and cinema. The claim that all media are mixed media, all arts composite arts, may actually sound like common sense to a generation raised on MTV. Another answer, however, would stress that the purification of the media in modernist aesthetics, the attempt to grasp the unitary, homogeneous essences of painting, photography, sculpture, poetry, etc., is the real aberration and that the heterogeneous character of media was well understood in premodern cultures. The essentializing of the media was reinforced by the emergence of professional disciplines and the academic administration of knowledge. "Interartistic comparison" was, in its best moments, a way of resisting this compartmentalization; at its worst, it collaborated in the insularity of the disciplines and the amateurishness of interdisciplinary efforts.

I'm fully aware, though, that I have not come remotely close to demonstrating my claims about the status of the image/text. My hope is that these introductory gestures have provoked enough curiosity to motivate further investigation. In the following chapters, I will try to elaborate these claims by examining two different kinds of verbal/visual conjunctions, the first from the side of language and literature, the second from the field of visual representation: (1) "textual pictures," the evocation of the visual image as a site of difference within language, exemplified in the materiality of writing and typography, in the poetic genre of ekphrasis, and in the curious role of description in narrative; (2) "pictorial texts," the representation and (equally important) the repression of language in the visual field, exemplified in abstract modernist painting, postmodern minimalist sculpture, and a range of twentieth-century photographic texts. After this detour through variations on the image/text, I will return to the fundamental questions of "picture theory" with analyses of illusion and realism and a concluding section on the question of images and the public sphere.

II····Textual·Pictures

The pictorial turn in contemporary culture has not just changed the way visual culture is produced and consumed. It has also raised new questions, and new versions of very old questions, about the place of visuality in language. The following trio of essays examines the text as imagetext in three different forms, focusing on particular cases and genres. First, the question of writing as a visible representation of speech, a "spacing" of the temporal, a materialization of the immaterial: what is at stake in embracing or denying "visible language"? Why does it matter that speech can be represented in writing, or that writing can be represented in graphic art? What is the politics of inscription? Second, the question of ekphrasis, the verbal representation of visual representation, as poetic genre and literary principle: what motivates the desire to construct an entire text as an evocation, incorporation, or substitute for a visual object or experience? Why do texts seem compelled to reach out to their semiotic "others," the objects of visual representation? Third, the question of visual descriptions as ornaments, supplements, and spatial "interludes" in the temporal structure of narrative: what is the significance of description's role as a "servant" of narrative? How does the double coding of narrative in temporal action and spatial description correspond with the double coding of memory as an imagetext? What happens when the servitude of description is enlisted in the description of servitude?

VISIBLE LANGUAGE:
BLAKE'S ART OF WRITING

All agree that it is an admirable invention: To paint speech, and speak
to the eyes, and by tracing out characters in different forms to give col-
our and body to thoughts.

> —Alexander Cruden, *Concordance to the Old and
> New Testament* (1738)

But to show still clearer that it was nature and necessity, not choice and
artifice, which gave birth and continuance to these several species of
hieroglyphic writing, we shall now take a view of the rise and progress
of its sister-art, the art of speech; and having set them together and com-
pared them, we shall see with pleasure how great a lustre they mutually
reflect upon one another; for as St. Austin elegantly expresses it, *Signa
sint VERBA VISIBILIA; verba, SIGNA AUDIBILIA.*

> —William Warburton, *The Divine Legation of
> Moses* (1740)

"Visible language" is a phrase that has primarily a metaphor-
ical meaning for both art historians and literary critics. In
painting we construe "visible language" in the idiom of
Joshua Reynolds or Ernst Gombrich, as the body of con-
ventional syntactic and semantic techniques available to a pictorial
artist. Reynolds called these techniques "the language of art," and
Gombrich promised a "linguistics of the image" that would describe
its syntax (schematisms) and its semantics (iconography).[1] In litera-

1. See Discourse V of Reynolds's *Discourses on Art (1797)*: "This first
degree of proficiency is, in painting, what grammar is in literature. . . . The

ture, conversely, the notion of "visible language" imports the discourse of painting and seeing into our understanding of verbal expression: it tempts us to give terms like imitation, imagination, form, and figuration a strong graphic, iconic sense and to conceive of texts as images in a wide variety of ways.[2] If there is a linguistics of the image, there is also an "iconology of the text" which deals with such matters as the representation of objects, the description of scenes, the construction of figures, likenesses, and allegorical images, and the shaping of texts into determinate formal patterns. An iconology of the text must also consider the problem of reader response, the claim that some readers visualize and that some texts encourage or discourage mental imaging.[3]

Both of these procedures—the "linguistics of the image" and the "iconology of the text"—involve a metaphorical treatment of one of the terms in the phrase "visible language." The treatment of vision and painting in the lingo of linguistics, even in a strong sense like Bishop Berkeley's "visual language" of sight, is commonly understood to be metaphoric.[4] Similarly, the "icons" we find in verbal expressions, whether formal or semantic, are (we suppose) not to be understood literally as pictures or visual spectacles. They are only likenesses of real graphic or visual images—doubly attenuated "images of images" or what I have elsewhere called "hypericons."[5]

power of drawing, modelling and using colours, is very properly called the Language of the Art." Quoted from the Robert Wark edition (New Haven, CT: Yale University Press, 1975), p. 26. Ernst Gombrich discusses the "linguistics of the visual image" in *Art and Illusion* (Princeton, NJ: Princeton University Press, 1956), p. 9.

2. See *The Princeton Encyclopedia of Poetry and Poetics* (Princeton, NJ: Princeton University Press, 1974), s.v. "Imagery." For further discussion of the notion of "text as image," see my "Spatial Form in Literature," in *The Language of Images,* edited by W. J. T. Mitchell (Chicago: University of Chicago Press, 1980), and "What Is an Image?" *New Literary History* 15, no. 3 (Spring 1984): 503–37, revised as chapter 1 of *Iconology.*

3. On visual response in reading, see Ellen Esrock, *The Reader's Eye* (Baltimore, MD: Johns Hopkins University Press, 1994).

4. See Bishop Berkeley, *The Theory of Vision or Visual Language* (1733). In *Works on Vision,* edited by Colin Murray Turbayne (New York: Bobbs-Merrill, 1963), pp. 121–52.

5. In *Iconology: Image, Text, Ideology* (Chicago: University of Chicago Press, 1986).

But suppose we were to take *both* the terms of "visible language" literally? We would encounter, I suggest, the point at which seeing and speaking, painting and printing converge in the medium called "writing." We would grasp the logic that made it possible to change the name of *The Journal of Typographic Research* into the simpler, more evocative *Visible Language*. "Writing," as Plato suggested in the *Phaedrus*, "is very like painting," and painting, in turn, is very like the first form of writing, the pictogram. The history of writing is regularly told as a story of progress from primitive picture-writing and gestural sign language to hieroglyphics to alphabetic writing "proper."[6] Writing is thus the medium in which the interaction of image and text, pictorial and verbal expression, adumbrated in the tropes of *ut pictura poesis* and the "sisterhood" of the arts, seems to be a literal possibility. Writing makes language (in the literal sense) visible (in the literal sense); it is, as Bishop Warburton noted, not just a supplement to speech, but a "sister art" to the spoken word, an art of both language and vision.

There is no use pretending that I come innocently from the sister arts to the topic of writing. We live in an era obsessed with "textuality," when "writing" is a buzzword that is not likely to be confused with the sort of writing promoted by textbooks in composition. We even have what sometimes looks like a "science of writing," a "grammatology" that concerns itself not only with the graphic representation of speech, but with all marks, traces, and signs in whatever medium.[7] This science includes an interpretive method for deconstructing the complex ruses of writing and for tracing the play of differences that both generates and frustrates the possibility of communication and meaning. What I propose to do in the following pages is to come at the topic of writing from the standpoint of what it seems to exclude or displace. In a sense, of course, this is almost a parody of deconstructive strategies, and I suppose one could think of this as an essay written about and "for" Blake, and "against" Derrida, as long as one understands its "Blake" as a complexly de-centered authority figure

6. See, for instance, Ignace J. Gelb's *A Study of Writing* (Chicago: University of Chicago Press, 1952; rev. ed., 1963), which characterizes "writing in its evolution from the earliest stages of *semasiography,* in which pictures convey the desired meaning, to the later stage of *phonography,* in which writing expresses language" (p. 190).

7. Although Jacques Derrida is usually regarded as the founder of grammatology, it may be worth noting that the first book to employ the notion systematically was Ignace J. Gelb's *A Study of Writing,* cited above.

and its "Derrida" as a friendly dialectical contrary rather than an antagonistic negation.[8]

What is it that writing and grammatology exclude or displace? Nothing more or less than the *image*—the picture, likeness, or simulacrum—and the *iconology* that aspires to be its science. If *"différance"* is the key term of grammatology, "similitude" is the central notion of iconology. If writing is the medium of absence and artifice, the image is the medium of presence and nature, sometimes cozening us with illusion, sometimes with powerful recollection and sensory immediacy. Writing is caught between two othernesses, voice and vision, the speaking and the seeing subject. Derrida mainly speaks of the struggle of writing with voice, but the addition of vision and image reveals the writer's dilemma on another flank. How do we say what we see, and how can we make the reader see?

The familiar answer of poets, rhetoricians, and even philosophers has been this: we construct a "visible language," a form that combines sight and sound, picture and speech—that "makes us see" with vivid examples, theatrical gestures, clear descriptions, and striking figures—the devices associated in classical rhetoric with *enargeia*. If we are a painter-poet like William Blake we may even construct a "composite art" of word and image that plays upon all the senses of "visible language" simultaneously. But alongside this tradition of accommodating language to vision is a countertradition, equally powerful, that expresses a deep ambivalence about the lure of visibility. This tradition urges a respect for the generic boundaries between the arts of eye and ear, space and time, image and word. And its theory of language is characteristically oriented toward an aesthetic of invisibility, a conviction that "the deep truth is imageless" and that language is the best available medium for evoking that unseeable, unpicturable essence.

Both of these traditions were alive and well in Blake's time, but I think it is fair to say that the latter, antipictorialist position is the dominant one among the major, canonical romantic poets. For all the talk of "imagination" in theories of romantic poetry, it seems clear that images, pictures, and visual perception were highly problematic issues for many romantic writers. "Imagination," for the romantics, is regularly contrasted to rather than being equated with mental im-

8. I employ here Blake's own distinction between "Contraries" and "Negations," the former associated with progressive, interactive opposition (though not necessarily resolution or Hegelian synthesis), the latter with static binarism or an absolutist, Manichean conflict that requires the destruction of the opposite.

aging: the first lesson we give to students of romanticism is that, for Wordsworth, Coleridge, Shelley, and Keats, "imagination" is a power of consciousness that transcends mere visualization.[9] We may even go on to note that pictures and vision frequently play a negative role in romantic poetic theory. Coleridge dismissed allegory for being a mere "picture language," Keats worried about the temptations of description, and Wordsworth called the eye "the most despotic of our senses."[10] It is a commonplace in intellectual history that the relation of the "sister arts" of poetry and painting underwent a basic shift in the early nineteenth century, a shift in which poetry abandoned its alliances with painting and found new analogies in music.[11] M. H. Abrams's story of romantic poetics as a replacement of the "mirror" (epitomizing passive, empirical models of the mind and of art) by the "lamp" (a type of the active imagination) is simply the most familiar way of schematizing this shift.[12] Coleridge's distinctions between symbol and allegory, imagination and fancy, the "Idea" and the "eidolon," all employ a similar strategy of associating the disparaged terms with pictures and outward, material visibility, the favored term with invisible, intangible "powers" of the mind.

It is tempting to summarize romantic antipictorialism as a kind of "aesthetic iconoclasm" and to see it as a direct reflection of the political, social, and cultural iconoclasm of the French Revolution.

9. I take as exemplary here Coleridge's famous definition of the primary imagination as the "living power and prime agent of all human perception." See chapter 13 of *Biographia Literaria*, vol. 7 of *Collected Works of Samuel T. Coleridge*, edited by James Engell and Walter Jackson Bate (Princeton, NJ: Princeton University Press, 1983), p. 304.

10. Coleridge's comments on allegory as a picture language appear in *The Statesman's Manual* (1816), quoted here from *The Collected Works*, vol. 6: *Lay Sermons*, edited by R. J. White (Princeton, NJ: Princeton University Press, 1972), p. 30. Keats's claim that "descriptions are bad at all times" occurs in his letter to Tom Keats, June 25–27, 1818. Wordsworth's remark on the despotism of the eye comes up in *The Prelude*, both in 1805 (XI. 174) and in 1850 (XII. 129). For further discussion of Wordsworth's ambivalence about imagery, see my "Diagrammatology," *Critical Inquiry* 7, no. 3 (Spring 1981): 622–33.

11. See Roy Park, " 'Ut Pictura Poesis': The Nineteenth-Century Aftermath," *The Journal of Aesthetics and Art Criticism* 28, no. 2 (Winter 1969): 155–64.

12. M. H. Abrams, *The Mirror and the Lamp* (New York: Oxford University Press, 1953).

Tempting, but I think misleading, unless we remind ourselves that the "reflection" of political and social patterns in artistic forms is just as likely to include reactionary reversal and inversion as direct imitation. Our suspicion about a direct connection between aesthetic and political iconoclasm during the French Revolution should be especially aroused when we note that the universally acknowledged father of aesthetic iconoclasm in the romantic era is none other than Edmund Burke, the reactionary politician whose youthful essay on the sublime inaugurated the romantic critique of pictorialist poetics.[13] Burke started his own minor revolution in poetic theory by attacking the neoclassical "picture theory" of poetic language based on a combination of classical rhetoric and associationist psychology. Denying that poetry could or should raise clear, distinct images in the mind of the reader, Burke argued that the proper genius of language was to be found in invisible, even insensible matters of feeling and sympathy. Poetry, in Burke's view, is uniquely fitted for presenting the obscure, the mysterious, the incomprehensible—in a word, the sublime. Two things are worth noting here: the first is that Blake alone among the major romantic poets firmly rejected Burke's doctrine ("Obscurity is Neither the Source of the Sublime nor of any Thing Else").[14] The second is a curious disparity between Burke's aesthetic and political preferences. When Burke confronted a historical event (the French Revolution) that conformed to his concept of sublimity, he could find it only monstrous and disgusting. His notion of the sublime remained safely contained in the realm of aesthetics where it served as a point of departure for writers whose relation to the Revolution was, let us say, obscure.

The battle lines between the aesthetics of visibility and invisibility become clearer if we take the key terms in their literal sense and recast the problem in terms of writing. If writing and speech have the same sort of "sisterhood" as painting and poetry—a sisterhood of radical

13. Edmund Burke, *A Philosophical Enquiry into the Origin of Our Ideas of the Sublime and the Beautiful* (1757). See James T. Boulton's fine introduction to his edition of the *Enquiry* (Notre Dame, IN: University of Notre Dame Press, 1968) for an account of Burke's influence.

14. Annotations to Reynolds's *Discourses. The Complete Poetry and Prose of William Blake*, edited by David Erdman (New York: Doubleday, rev. ed., 1982), p. 658. All references in the text to Blake's writings will be to this edition, indicated in parentheses after the quotation by an "E."

inequality, as Lessing and Burke argued—if writing transforms invisible sounds into a visible language, then it is bound to be a problem for writers who want to be imaginative iconoclasts, who want images that are not pictorial, visions that are not visual, and poetry that need not be written down.[15] Wordsworth's claim that a poet is a man "speaking" (not writing) to men is no casual expression, but a symptom of what Derrida would call the "phonocentric" tendency of romantic poetics. The projects for recovering or impersonating oral, folk traditions in poetry, the regular comparison of poetry with music, and the consistent distaste of the romantic poets for the vulgar necessity of submitting their words to material, printed form—all these patterns of thought reflect a common body of assumptions about the superiority of word to image, ear to eye, and voice to print. When the printed word comes to be a highly controversial political instrument in itself, as it did in the era of the French Revolution, the business of translating speech into the "visible language" of print can take on an ideological character in itself.

This is the context that makes intelligible the peculiar status of visible language and writing in Blake and his contemporaries—that makes it an *issue* rather than a set of neutral facts about language, representation, and the senses. I have previously discussed the relation between word and image in his illuminated books in terms of his commitment to a revolutionary religious and aesthetic sensibility based on dialectical transformation through conflict.[16] But the specifically political character of Blake's commitment to making language visible can best be seen by reflecting on his "graphocentrism," his tendency to treat writing and printing as media capable of full presence, not as mere supplements to speech. These reflections will fall into three sections: first, a look at Blake's "ideology of writing" in the context of romantic hostility to the printed word; second, a consideration of some major "scenes of writing" represented in his art; third, some observations on Blake's calligraphy and typography, the "wond'rous art of writing" which is his "visible language" in what he would call "the litteral sense."

15. On the "unequal sisterhood" of painting and poetry, see my essay, "The Politics of Genre: Time and Space in Lessing's *Laocoon*," in *Representations* 6 (Spring 1984), revised as chapter 4 of *Iconology*.

16. In *Blake's Composite Art: A Study of the Illuminated Poetry* (Princeton, NJ: Princeton University Press, 1978).

Romanticism and the Politics of Writing

He who destroyes a good booke, kills reason it self, kills the Image of God, as it were, in the eye.

Milton, *Areopagitica* (1644)

The source of the romantic animus toward "visible language" in general and writing in particular is not far for the seeking. William Hazlitt put it most succinctly when he suggested that "The French Revolution might be described as a remote but inevitable result of the art of printing."[17] Modern historians like Peter Gay and Elizabeth Eisenstein have echoed Hazlitt in tracing the intellectual roots of the French Revolution to the *philosophes'* "devotion to the art of writing" rather than to any specific philosophical doctrine.[18] The first French Republic, Eisenstein suggests, grew out of a prior "republic of letters," a polity of unrestrained "speculation" in both the philosophical and financial senses of the term.[19] Nor was the visual sense of "speculation" lost on critics of the Revolution. Burke traced revolutionary fanaticism to an excess of "imagination" (in the visual eighteenth-century sense) and to a deficiency in "feeling," the blind, untutored habits that make for a stable society.[20] Coleridge identified this tendency to reify and idolize imaginary conceptions as the peculiar defect of the French people: "Hence the *idolism* of the French . . . even the *conceptions* of a Frenchman, whatever he admits to be conceivable, must be imageable, and the imageable must be fancied tangible."[21] The materialism of the French Enlightenment, the pictorialist psychology of empiricism and rationalism, and the emergence of an economy of unfettered philosophical and financial speculation all add up to a

17. William Hazlitt, *The Life of Napoleon*, 6 vols. (Boston: Napoleon Society, 1895), vol. 1, p. 56.

18. The phrase is used by Gay in his essay, "The Unity of the French Enlightenment," in *The Party of Humanity* (New York: Knopf, 1964), p. 117.

19. See Elizabeth Eisenstein, *The Printing Press as an Agent of Change* (Cambridge: Cambridge University Press, 1979; one volume edition, 1980), pp. 136–38.

20. See Burke's "Appeal from the New to Old Whigs" (1791): "There is a boundary to men's passions when they act from feeling; none when they are under the influence of imagination." Quoted from *The Works of Edmund Burke*, 12 vols., edited by George Nichols (Boston: Little, Brown, 1865–67), 4:192.

21. Coleridge, *The Friend*, vol. 4, part 1, of *Collected Works*, CW 4.i.422.

coherent pathology called "idolism," the tendency to worship our own created images. Carlyle summarized the iconoclastic English re-action to the French Enlightenment most comprehensively:

> shall we call it, what all men thought it, the new Age of Gold? Call it at least of Paper; which in many ways, is the succedaneum of Gold. Bank-paper, wherewith you can still buy when there is no gold left; Book-paper, splendent with Theories, Philosophies, Sensibilities, beauti-ful art, not only of revealing thought, but also of so beautifully hiding from us the want of Thought! Paper is made from the *rags* of things that did once exist; there are endless excellences in Paper. What wisest Philosophe, in this halcyon uneventful period, could prophesy that there was approaching, big with darkness and confusion, the event of events?[22]

This is the context that makes Wordsworth's notorious ambiva-lence about books intelligible.[23] In *The Lyrical Ballads* Wordsworth associates printed books with the sterility of "barren leaves," the life-less knowledge passed "from dead men to their kind," and with the "dull and endless strife" of "meddling intellects" who "murder to dissect."[24] These expressions of bibliophobia have to be taken with some skepticism, of course, coming as they do in a printed book that Wordsworth hoped would be widely read. But no appeals to Wordsworthian "irony" can explain away his anxiety about the printed word. Wordsworth locates the essence of poetry in speech, song, and silent meditation and consistently treats writing as a neces-sary evil, a mere supplement to speech. A book of poetry is a "poor earthly casket of immortal verse,"[25] and true moral or political wis-

22. Thomas Carlyle, *The French Revolution* (1837), 2 vols. (London: Macmillan, 1925), 1:30.

23. For an excellent account of Wordsworth and the ideology of writing, see James K. Chandler, *Wordsworth's Second Nature: A Reading of the Po-etry and Politics* (Chicago: University of Chicago Press, 1984), chapter 7.

24. I quote here from "Expostulation and Reply" and "The Tables Turned," Wordsworth's famous dialogue poems on the merits of "natural lore" versus books. It is worth noting that Matthew, the defender of books, is commonly identified as William Hazlitt, whose claim that the French Revo-lution was caused by the invention of printing was so widely influential.

25. See *The Prelude* (1850) V. 160–65, where Wordsworth describes the "maniac's fond anxiety" that entrances him when he holds a volume (i.e. "casket") of Milton or Shakespeare in his hand.

dom is not to be found in books of "Science and of Art," but in the "natural lore" of oral tradition. Wordsworth and Coleridge seem most sensitive to the visual potential of printed books when their bibliophobia becomes explicitly political. Coleridge describes circulating libraries (which were notorious for disseminating radical opinions to the populace) as "a sort of mental *camera obscura* manufactured at the printing office, which *pro tempore* fixes, reflects, and transmits the moving phantasms of one man's delirium, so as to people the barrenness of a hundred other brains. . . . "[26] Wordsworth expresses a similar contempt for the material version of this popular *camera obscura* in his sonnet on "Illustrated Books and Newspapers"(1846): "Avaunt this vile abuse of pictured page! / Must eyes be all in all, the tongue and ear / Nothing?"[27]

The battle lines between the conservative oral tradition and the radical faith in the demotic power of printing and "visible language" had been clearly drawn in the famous debate between Thomas Paine and Edmund Burke about the nature of the English constitution. For Burke, the essence of law is to be found in the *unwritten* customs and traditions of a people; writing is only a supplement for "polishing" what has been established by immemorial practice. Thus, "the constitution on paper is one thing, and in fact and experience is another."[28] For Burke, the Enlightenment faith in the unlicensed printing of speculative theories and speculative paper currency was bound to produce a host of speculative constitutions. The National Assembly's Declaration of the Rights of Man was, in Burke's view, nothing more than "paltry blurred shreds of paper" in contrast to the immemorial, invisible sinews of the English constitution.[29] Paine's reply was to insist on the primacy of a written, *visible* constitution:

> Can Mr. Burke produce the English Constitution? If he cannot, we may fairly conclude, that although it has been so much talked about, no such thing as a constitution exists. . . . A constitution is not a thing in

26. Coleridge, *Biographia Literaria* (1817), chapter 3, CW 7, p. 48.

27. William Wordsworth, *Poetical Works,* rev. ed. edited by Thomas Hutchinson and Ernest de Selincourt (Oxford: Oxford University Press, 1969), p. 383.

28. Edmund Burke, "Speech on a Bill for Shortening the Duration of Parliament," in *Works* 7:7.

29. Edmund Burke, *Reflections on the Revolution in France* (1790) (New York: Doubleday, 1961), pp. 98–99.

name only, but in fact. It has not an ideal, but a real existence; and wherever it cannot be produced in visible form, there is none.[30]

Where did Blake stand in this dispute over the political significance of writing and "visible language"? Insofar as Blake was a professed ally of radical intellectuals in the 1790s, we expect him to be on the side of Paine, quite apart from his professional self-interest as a printer, engraver, and painter—a technician of "visible languages" in every sense of the phrase. One way of defining Blake's difference from the other romantics is to see his lifelong struggle to unite these languages in a "composite art" of poetry and painting as the aesthetic symptom of his die-hard fidelity to the Revolution. Blake would have agreed with Wordsworth's claim that books are an "endless strife," but (like Hazlitt) he thought of this strife as anything but dull. On the contrary, he regarded the battles of books, the "fierce contentions" fostered by a free, independent press, as the very condition of human freedom. While Coleridge and Wordsworth found themselves arguing for censorship of the "rank and unweeded press"[31] that encouraged the excesses of the Revolution, Blake was busy planting new seeds in the fields of unlicensed printing.[32] Blake never forsook the "republic of letters" for the tranquility of the oral tradition. The underground printshop or "Printing House in Hell" that turned out subversive illuminated books in the 1790s expands into the "Wine Press of Los" in the 1800s, becoming the scene of the "Mental Warfare" that Blake hoped would replace the "Corporeal Warfare" ravaging Europe throughout his maturity. Blake continued, in short, to think of writing as a "wond'rous art" when many of his contemporaries were blaming it for all the evils attendant on modernity.

This contrast between radical writers and reactionary speakers is, of course, a vast oversimplification; I present it as a way of foregrounding a subtle tendency in the rhetorical stances taken by intellectuals in the aftermath of the Revolution (my claim is *not*, obviously, that radicals refused oratory, or that conservatives eschewed the written word). There is a kind of writing (call it "natural hieroglyphics")

30. Thomas Paine, *Rights of Man* (1791–92) (New York: Doubleday, 1989), p. 309.

31. The phrase is Coleridge's. See *A Lay Sermon* (1817). Quoted here from *Collected Works*, edited by R. J. White, vol. 6, p. 151.

32. On Wordsworth's role in the attempt to suppress the anti-Tory *Kendal Chronicle*, see Arthur Aspinall, *Politics and the Press, 1780–1850* (First edition, London, 1949; repr. New York: Barnes and Noble, 1974).

that Wordsworth regularly celebrates, and Blake's encomia on writing are frequently "stained" by irony:

> Piper sit thee down and write
> In a book that all may read.
> So he vanish'd from my sight
> And I plucked a hollow reed.
>
> And I made a rural pen
> And I stain'd the water clear
> And I wrote my happy songs
> Every child may joy to hear.
> —"Introduction" to *Songs of Innocence*

The celebratory emphasis on writing is obvious: Blake's version of the pastoral refuses to keep it in the realm of oral transmission. The hollow reed is not plucked to make the expected flute, but a pen, and the act of writing is immediately identified with the process of publication: "all may read" the books written with this rural pen, and without any loss of the original presence of the speaker: "every child may joy to hear" the voice transmitted in the visible language of writing. No critical reader of this poem, however, has been able to avoid the ironic undertones. The moment of writing is also the moment when the inspiring child vanishes; the hollow reed and the stained water suggest that a kind of emptiness, absence, and loss of innocence accompanies the very attempt to spread the message of innocence. What makes this a song of *innocence,* then, is the speaker's unawareness of these sinister connotations. Indeed, we might say that the most literal version of this innocence is the speaker's blithe assumption that the mere act of writing is equivalent to publication and a universally appreciative readership, a bit of wish-fulfillment that every writer will recognize. The piper sees no difference between the creation of a unique, handwritten manuscript and the creation of a text that can be universally disseminated. He is unaware of both the problems and possibilities of print culture, the culture of mechanical reproduction, what Blake would later call "the Machine of Art."[33]

Blake's struggles with the fearful symmetry of this machine are

33. See Morris Eaves, "Blake and the Artistic Machine: An Essay in Decorum and Technology," *PMLA* 92, no. 5 (October 1977): 907. While Eaves stresses Blake's opposition to mechanical reproduction, my emphasis will be on the evidence for his incorporation of mechanical means into his own expressive project.

evident throughout his writings. From his earliest projects for books in illuminated printing we see a man obsessed with the idea of having it both ways—that is, by producing unique, personal texts that would be widely distributed through a new technology combining the arts of poet, engraver, printer, and painter. We see his awareness of how easily this dream could become a nightmare in the title-page to *The Book of Urizen,* an image that might be labeled "textual man" (figure 18). This image is usually read as a satire on Blake's enemies, as a figure of political, religious, and psychological tyranny—king, priest, and rational censor on the liberating energies of the Revolution. When Urizen is given a more particular historical identity, he is usually equated with English tyrants and reactionaries such as George III, Pitt, or Burke.[34]

But suppose we were to look at this image as a self-portrait of the artist as a solitary reader and writer of texts, a figure of the textual solipsist who insists on doing everything at once—writing his poems with one hand, for instance, while he illustrates them with the other? Or reading the classics and writing commentaries at the same time? Suppose we were to see this, in other words, as a self-parody in which Blake has a bit of fun at his own expense, expressing in a pictorial joke what he cannot quite bring himself to say in print? This reading of the image would also help us, I think, to make a more precise historical identification of the sort of figure Urizen represents in the literary-political battles of the revolutionary era. Instead of representing English reactionaries, Urizen might be seen as a certain kind of French radical, an elder statesman in the republic of letters, a paragon of the "age of paper."

While I know it is heresy to suggest that Blake could have held any reactionary opinions or agreed with Edmund Burke about anything, it seems to me that certain features of the Urizen-figure have to be faced in their historical context.[35] Urizen is no doubt sometimes employed as a figure of English reaction in the late 1790s, but it is also clear that

34. David Erdman equates Urizen with Britain and Luvah/Orc with France in *Blake: Prophet Against Empire* (Princeton, 1954; 3d edition, New York: Doubleday, 1969), p. 309.

35. The orthodox view of Blake's political position is that he remained loyal to the ideals and ideology of the French Revolution throughout his life and only criticized France when it departed from those ideals. Thus, David Erdman: "When Blake reports deteriorative change in Orc-Luvah he is criticizing not 'the French Revolution' but the Bonapartism that followed and in a sense negated it" (*Prophet,* p. 313).

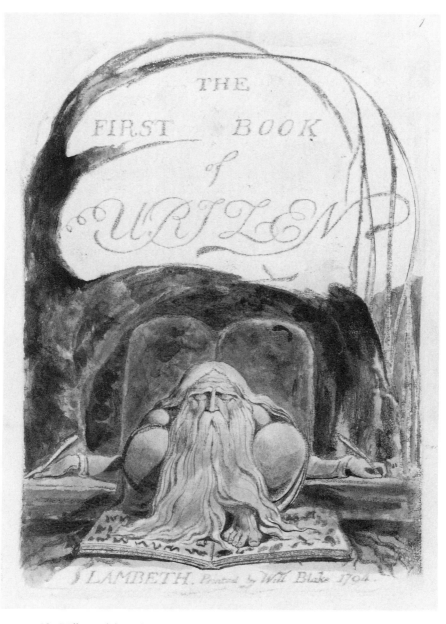

18. William Blake, title page from *The First Book of Urizen*, Bentley plate 1, PML 63139, by permission of the trustees of the Pierpont Morgan Library, New York.

in *The Book of Urizen* (1794) Blake represents him as a revolutionary, utopian reformer who brings new laws, new philosophies, and a new religion of reason. The general prototype for Urizen's "dividing and measuring" is, of course, Edmund Burke's characterization of the "geometrical and arithmetical constitution" of the new French Republic.[36] But Urizen may be identified even more specifically as a composite figure for two French *philosophes* who were much in the news in the early 1790s. The first is Rousseau, the universally acknowledged intellectual father of the Revolution, whose confessions of self-absorption, onanism, and obsession with "pity" must remind us of the drama of Blake's Urizen.[37] The second is Condorcet, who spent much of his life attempting to reduce moral and political questions to problems in mathematics, and who was the principal author of the "Principles of the Constitutional Plan" presented to the National Convention in 1793.[38] Condorcet's constitution, like Urizen's "books of brass," attempted to promulgate one rational law to govern France (his scheme to abolish the traditional geographical divisions of France in favor of a geometrical grid became one of Burke's favorite figures of ridicule). Condorcet's Girondin constitution, like Urizen's "iron laws," immediately produced a reaction: Condorcet was ousted by the Jacobins under the leadership of Robespierre and died in prison; Urizen's "laws of peace, love & unity" are spurned by the fiery eternals, and we last see him imprisoned in the web of his own creation. The new leader of the "sons of Urizen" is a fiery rebel named Fuzon who attempts to kill Urizen and is eventually killed by his own "hungry beam" (the guillotine). David Erdman's suggestion that Fuzon represents Robespierre (who deposed the Girondins and pulled down their statue of Reason in 1794) makes even more sense if Urizen is a figure of Condorcet.[39]

36. Edmund Burke, *Reflections*, p. 67.

37. Urizen must also remind us of Derrida's Rousseau. See *Of Grammatology*, translated by Gayatri Spivak (Baltimore, MD: Johns Hopkins University Press, 1977), pp. 142–52, for Derrida's discussion of Rousseau and writing.

38. Condorcet's most famous publications in this line were his *Essay on the Application of Mathematics to the Theory of Decision-Making* (1785) and *A General View of Social Mathematics* (1793). See *Condorcet: Selected Writings*, edited by Keith Baker (Indianapolis, IN: Bobbs-Merrill, 1976).

39. Erdman, *Prophet Against Empire* (New York: Doubleday, rev. ed., 1969), p. 314. I must add, however, that Erdman has expressed strong reservations about my claim that Urizen has a "French connection."

We need not see Urizen as a political cartoon, unequivocally linked to Rousseau and Condorcet, to see that he makes considerable sense as a neo-Burkean caricature of revolutionary rationalism and the ethos of letters. But even this interpretation tells us only half the story. It helps us see something of Blake's anxieties about the Revolution and his own role in it as technician of "visible languages"; it shows a world in which the "wond'rous art of writing" has become grotesque and obsessive. But seeing this is not quite the same as understanding the position from which Blake could mount his self-parodic critique of writing. The pure negativity in Blake's attack on rationalist writing is scarcely distinguishable from that of Burke, Coleridge, or Carlyle. We still need to ask, then, how Blake could sustain his faith in the printed word, the visible language that seemed to have brought him and his generation into Urizen's abyss.

The answer, I think, is that Blake never did buy into the rationalist version of the Revolution with the same fervor that Coleridge and Wordsworth did.[40] His understanding of it seems to have been mediated, from very early on, by the typology of seventeenth-century English Puritanism rather than the eighteenth-century French Enlightenment. His faith in writing is grounded, not in the brilliance of the modern "republic of letters," but in the tradition of a free English press to be traced back to the English Revolution, Milton's *Areopagitica*, and beyond that, to the religious reformation fostered by Wycliffe's vernacular Bible. More specifically, I suspect that Blake identified himself with the urban guilds of radical printers and engravers whose pamphlets and broadsides helped to bring down

40. In the early days of the Revolution Blake sympathized with Voltaire and Rousseau as presiding spirits in the awakening of France to liberty (see Blake's *The French Revolution* [1791], pp. 14–15; E, pp. 298–99). But Blake's early suspicion of rationalism is expressed clearly in *The Marriage of Heaven and Hell*, and by the 1800s that suspicion had become explicitly linked with Rousseau and Voltaire's attacks on revealed religion (see the address "To the Deists" which introduces chapter 3 of *Jerusalem*). A good index of Blake's ambivalence about the rationalist ideology of the revolution is his willingness to find Tom Paine "a better Christian" than Bishop Watson (whose attack on Paine in his *Apology for the Bible* Blake annotated), at the same time that he notes that neither the Bishop nor his radical deist opponent quite measures up to Blake's "Everlasting Gospel," the tradition of Puritan radicalism (see "Annotations to an Apology for the Bible," E, p. 619: "The Bishop never saw the Everlasting Gospel any more than Tom Paine").

Charles I.[41] Blake was, in short, an *English* (and Christian) revolution-
ary, a radical throwback to the "Good Old Cause" of Cromwell who
was incapable of separating politics from religion, reason from feeling
or imagination.[42] That is why, no matter how mercilessly Blake sati-
rizes the rationalist corruption of writing, he is still able to maintain
the sort of faith in it that he expresses in the "Introduction" to *Songs
of Innocence* and in the much later introduction to his long "song of
experience," *Jerusalem*:

> Reader! lover of books lover of heaven
> And of that God from whom all books are given,
> Who in mysterious Sinais awful cave
> To man the wond'rous art of writing gave,
> Again he speaks in thunder and in fire!
> Thunder of thought and flames of fierce desire:
> Even from the depths of hell his voice I hear,
> Within the unfathomd caverns of my ear.
> Therefore I print; nor vain my types shall be:
> Heaven, Earth & Hell henceforth shall live in harmony.

Blake's affirmation that writing is a divine gift must be understood
here in opposition to two contrary ideologies of writing. Blake count-
ers the conservative hostility to the free press and provides an answer
to poets like Wordsworth who sought an escape from the "dull and
endless strife" of print culture in the traditionalism of oral, rural cul-
ture. If Coleridge could argue that the popular press, especially in the
hands of French writers, was producing a sort of "idolism," Blake's
reply is that there are some kinds of printing (his own, for example)
that generate, not vain, hollow signifiers or "idols," but efficacious
"types" that are anything but vain.

On the other hand, the die-hard radical would have to read
Blake's account of the divine origin of writing as a direct contradiction
of the rationalist position. When Enlightenment *philosophes* like
Warburton, Rousseau, Condillac, or Condorcet reflected (as they in-

41. For the connection between printing and Puritanism in the English
Revolution, see Christopher Hill, *The World Turned Upside Down: Radical
Ideas during the English Revolution* (Harmondsworth, Middlesex, England:
Penguin Books, 1972), pp. 161–62.

42. The basic study of Blake's ties to the Dissenters is still A. L. Morton's
classic *The Everlasting Gospel* (London: Lawrence and Wishart, 1958).

variably did) on the progress of writing as an index to the progress of humanity, they unanimously debunked the notion of divine origin as an outmoded superstition. Bishop Warburton even went so far as to deny that writing had a *human* origin: "it was nature and necessity, not choice and artifice" that produced the evolution of writing from pictogram to hieroglyph to phonetic script.[43]

It's easy to see why Blake, an engraver-printer in the tradition of radical English millenarianism, would want to treat the invention of writing as a divine gift. It is also easy to see why this position could be so readily dismissed as superstition, self-interest, and vanity. Benjamin Disraeli suggested it was a superstition "peculiar" to *English* calligraphers:

> I suspect that this maniacal vanity is peculiar to the writing-masters in England; . . . writing masters or calligraphers, have had their engraved "effigies," with a Fame in flourishes, a pen in one hand, and a trumpet in the other; and fine verses inscribed and their very lives written! They have compared "The nimbly-turning of their silver quill" to the beautiful in art and the sublime in invention; nor is this wonderful since they discover the art of writing, like the invention of language, in a divine original; and from the tablets of stone which the deity himself delivered, they traced their German broad text or their running hand.[44]

Actually, Blake's "maniacal vanity" goes even further, for he is not just claiming a divine origin for writing in the mythic past, but is affirming that his own art of printing, as well as the message it conveys, has been given directly to him as a divine gift in the historical present. Taken literally, Blake's claim is that the writing of *Jerusalem* is on the same level as the writing of the Ten Commandments on Mt. Sinai.

Blake would no doubt answer the charge of vanity by claiming that he, unlike the vain English writing masters, has something important to say. He is not merely playing with empty, ornamental signifiers, but recording a prophecy—that is, speaking his mind on public and private matters. He might answer the charge of superstition by pointing out that the divine origin of writing is synonymous with a

43. Bishop Warburton, *The Divine Legation of Moses Demonstrated* (1738–1841), vol. IV, section 4. Quoted from the three-volume tenth edition (London: T. Tegg, 1846), vol. II. pp. 184–85.

44. Benjamin Disraeli, quoted in Donald M. Anderson, *The Art of Written Forms: The Theory and Practice of Calligraphy* (New York: Holt, Rinehart, and Winston, 1969), p. 148.

human origin, since "All deities reside in the human breast" (*Marriage of Heaven and Hell,* plate 11; E, p. 38). Blake claims for his writing no more and no less authority than that of Moses—the authority of the human imagination. What he disputes is the rationalist reduction of writing to "nature and necessity," on the one hand, and the phobia about idolatrous writing (and its attendant fetishization of orality and invisibility) on the other.

Blake criticizes both the radical and conservative views of writing from a position which looks irrational and even fetishistic from either flank, but which from his own point of view offers a possibility of dialectical struggle and even harmony. He does not single out his own books for unique authority. His writings, like those of Moses (and, presumably, of Warburton, Rousseau, Wordsworth, and even Burke) are gifts of "that God from whom all books are given."[45] And the particular text in question, *Jerusalem,* is presented as a "writing" that unravels all the oppositions that have made books a "dull and endless strife" in Blake's time. "Heaven, Earth & Hell, henceforth shall live in harmony." God speaks in both "thunder" and "fire," a double voice that marries the contraries of thought and desire, reason and energy. This voice is heard both in the "depths of hell," the underground printshop that produced Blake's radical prophecies of the 1790s, and from the mountaintop, the heaven of Urizenic invention that designs the massive symmetries of *Jerusalem.*

We must notice, finally, that Blake's encomium on writing undoes all the semiotic oppositions that were reified by the political conflicts of his time. Writing and speech, for instance, are not at odds in Blake's scenario of imaginative creation. God speaks to Moses, and in the act of speaking also gives man a new art of alphabetic writing. God (the human imagination) speaks to Blake, and in that speaking gives him symbolic or poetic "types" that will transform the invisible voice and message in a visible language of graphic and typographic signifiers. If Blake's visible language heals the split between speech and writing, it is also designed to undo certain oppositions within the world of textuality, most notably the gap between the pictorial and linguistic use of graphic figures. Perhaps less obvious, Blake's composite art is an attempt to fulfill the Piper's fantasy of a "writing" that would preserve the uniqueness of the hand-inscribed manuscript and yet be reproduc-

45. It has to be noted, however, that the crucial phrase, "all books are given," was etched on plate 3 of *Jerusalem* but never printed. This particular message now comes to us "under erasure," thanks to David Erdman's textual reconstructions.

ible so that "all may read" and "joy to hear" the poet's message. Blake is perhaps hinting at this marriage of the values of print and manuscript culture when he has God give Moses a "wond'rous art of *writing*" while reserving for himself an art of printed *"types."*

It's one thing to project the notion of an ideal form of writing that will play across all the semiotic, social, and psychic boundaries that constitute an artistic practice. It is quite another actually to achieve such a goal, much less to recognize what would count as its realization. The remainder of this essay examines the way Blake's utopian concept of writing, his commitment to a divinely given "visible language" that would fulfill the Piper's fantasy of full presence, expresses itself in "scenes of writing" and in his concrete practice as a calligraphic and typographic designer.

The Scribal Scene: Book and Scroll

And all the host of heaven shall be dissolved, and the heavens shall be rolled together as a scroll.
 Isaiah 34:4

If it is accurate to view Blake the way he regarded himself, as a traditional "History Painter" who depicts (contra Reynolds) "The Hero, & not Man in General" (E, p. 652), then it seems clear that the writer is one of Blake's particular heroes. The moment of writing is, for Blake, a "primal scene," a moment of traumatic origin and irrevocable commitment. Inspiration does not come to him from a disembodied spirit into an evanescent voice, later to be recorded in script, but comes directly "into my hand / . . . descending down the Nerves of my right arm / From out the portals of my Brain" (*Milton*, plate 2, lines 4–6). And the "Hand" that wields the pen, burin, or paintbrush is as capable of becoming a rebellious demon as a dutiful servant.[46] Writing, consequently, is not just the technical means of recording epic action: it is itself an activity of world historical significance, worthy of representation in its own right.

The treatment of writing as an epic activity is hardly original with Blake, of course. Ceremonial scenes of writing (the signing of the Declaration of Independence or the Magna Carta) and scenes involving the transmission of sacred texts (the Ten Commandments, the

46. See my discussion of Blake's rebellious "Hand" in *Blake's Composite Art,* p. 202.

Book of Revelation) were the frequent subjects of history painting, and Blake produced his own versions of these themes. Probably the most important model for his image of the "scribe as hero" was Michelangelo's series of prophets and sibyls in the Sistine Chapel.[47] Blake made pencil copies of engravings after these figures and employed their postures frequently in his own art—so frequently that the image of writing takes on a heavily elaborated, obsessively repetitious character in his iconography. His illustrations of Milton, Dante, the Book of Job, Young's *Night Thoughts,* and the Bible regularly feature the figure of the reader or scribe. And his choices of unusual subjects (Newton inscribing his mathematical diagrams, the Angel writing the sevenfold "P" on Dante's forehead with his sword, and Christ writing on the ground to confound the scribes and Pharisees) suggest that the moment of inscription tended to stand out for him as a principal subject for illustration in any narrative. The prominence of these "scribal scenes" is such that it is hard to think of them as metaphors or symbols for something else. We have to say of Blake what Derrida says of Freud: he "is not manipulating metaphors, if to manipulate a metaphor means to make of the known an allusion to the unknown. On the contrary, through the insistence of his metaphoric investment he makes what we believe we know under the name of writing enigmatic."[48]

The clearest indication that writing imposes itself on Blake as enigma rather than simply being deployed as an instrument is its inflationary, universal character. For Blake, anything is capable of becoming a text, that is, of bearing significant marks. The earth, the sky, the elements, natural objects, the human body and its garments, the mind itself are all spaces of inscription, sites in which the imagination renders or receives meaning, marking and being marked. This "pantextualism" looks, at first glance, rather like the medieval notion of the universe as God's text and seems quite alien to the modern sense of universal semiosis as an abyss of indefinitely regressive signifiers. But Blake's consistent identification of God with the human imagination makes this abyss an ever-present possibility. "Writing"

47. For a discussion of Blake's use of these figures, see Jenijoy La Belle, "Blake's Visions and Re-visions of Michelangelo," in *Blake in His Time,* edited by Robert Essick and Donald Pearce (Bloomington: Indiana University Press, 1978), pp. 13–22.

48. Jacques Derrida, "Freud and the Scene of Writing," in *Writing and Difference,* translated by Alan Bass (Chicago: University of Chicago Press, 1978), p. 199.

makes its appearance in Blake's work both as imaginative plenitude and presence and as the void of doubt and nihilism; his pantextualism stands precisely at the hinge between the ancient and modern view of semiosis. (A similar division was, of course, already latent in the medieval division of the universal text into the Book of Nature and the Book of Scripture.)[49]

This hinge in the textual universe is represented emblematically in Blake's art by a formal differentiation between what I will call, for simplicity's sake, the "book" and the "scroll." In the context of romantic textual ideology, the book is the symbol of modern rationalist writing and the cultural economy of mechanical reproduction, while the scroll is the emblem of ancient, revealed wisdom, imagination, and the cultural economy of handcrafted, individually expressive artifacts. We might summarize this contrast as the difference between print culture and manuscript culture.[50] Alongside these quasi-historical differentiations, however, Blake treats book and scroll as synchronic emblems of an abiding division within the world of sacred or "revealed" writing. The book represents writing as *law:* it is usually associated with patriarchal figures like Urizen and Jehovah, and Blake regularly uses the rectangular shape of the closed book and the double-vaulted arch-shape of the open book to suggest formal rhymes with textual objects like gravestones, altars, gateways, and tablets, "books," as it were, of stone and metal. The scroll represents writing as *prophecy:* it is associated with youthful figures of energy, imagination, and rebellion, and its spiraling shape associates it formally with the vortex, the Blakean form of transformation and dialectic.

In the illuminated books, Blake's most monolithic presentation of the book motif is, as we would expect, *The Book of Urizen,* which completely excludes the image of the textual scroll. The only relief from the cave and gridlike shapes of *Urizen* is the scroll-like posture of the guiding sibyl in "The Preludium" plate. The scroll, by contrast, never seems to dominate any of Blake's illuminated books as an explicit motif the way the book does *Urizen.* It appears in the marginal

49. The classic discussion of medieval pantextualism is Ernst Robert Curtius's chapter, "The Book as Symbol," in his *European Literature and the Latin Middle Ages* (First German edition, Bern, 1948; first English edition, New York, 1953).

50. For a stimulating discussion of this difference, see Gerald Bruns's essay, "The Originality of Texts in a Manuscript Culture," in *Inventions: Writing, Textuality, and Understanding in Literary History* (New Haven, CT: Yale University Press, 1982).

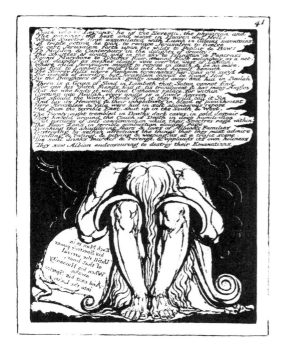

19. William Blake, *Jeru-salem*, 41. Photograph by permission of the Department of Printing and Graphic Arts, The Houghton Library, Harvard University.

designs, as a scarcely perceptible "extra-textual" activity, occasionally to be "blown up" into monumental proportions, as in *Jerusalem* 41 (figure 19). Here Blake depicts himself as an elfin scribe writing what Erdman calls a "merry proverb" in reversed engraver's writing. The Giant Albion (England/Mankind) is too deeply asleep to notice, much less decipher the prophetic message, but Blake's joke seems to be having its effect nonetheless. The scroll is beginning to "grow" on Albion, becoming one with his garments. The picture can't tell us whether this is a good or bad thing, but even without Blake's puckish intervention, it's hard to imagine this sleeping giant staying that way indefinitely. His head is buried so deeply in the center of his book that it seems about to break through the spine (as his flowing locks already have) and wake the sleeper with a jolt.

The most systematic use of the book-scroll opposition in Blake's art occurs in his illustrations to the Book of Job, where it serves as a kind of emblematic gauge of Job's spiritual condition. Blake's opening plate (figure 20) shows Job and his family in a scene of rational, legalistic piety, praying from their books while their musical instruments (several of them shaped like scrolls) hang idle in the tree above their heads. The accompanying text tells us that Job is "perfect &

20. William Blake, *Book of Job*, 1. Reproduced by permission from the collection of Robert N. Essick.

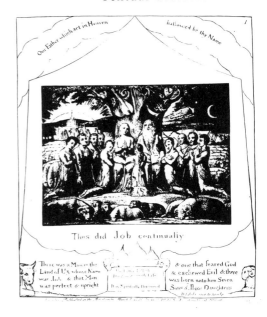

upright"—he conforms to the letter of the law—but it also issues a warning (carved on the stone base of a sacrificial altar) about this sort of perfection: "The letter Killeth The Spirit giveth Life." In the final plate (figure 21) of the Job illustrations, all of these emblematic signals are reversed: the books have been replaced by scrolls,[51] the musical instruments are being played, reading has been replaced by song, and the inscription on the altar repudiates the altar's function: "In burnt Offerings for Sin thou hast no Pleasure." The stress on oral performance in this final plate is, of course, quite in keeping with Blake's consistent association of the scroll/vortex form with the structure of the *ear*.[52]

The emblematic opposition of book and scroll settles quite easily, then, into an allegory of good and evil, a code which could be schematized in the following table of binary oppositions:

51. In the engraved version, one of Job's daughters is holding a book; in the watercolor version (now in the Morgan Library), the scroll has completely taken over. See Butlin, *The Paintings and Drawings of William Blake*, 2 vols. (New Haven, CT: Yale University Press, 1981), vol. 2, pl. 717.

52. See *Blake's Composite Art*, pp. 62–64, for a discussion of Blake's links between graphic form and sensory structure.

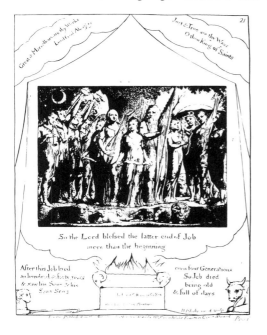

21. William Blake, *Book of Job*, 21. Reproduced by permission from the collection of Robert N. Essick.

Book	Scroll
Mechanical	Handcrafted
Reason	Energy, Imagination
Judgment	Forgiveness
Law	Prophecy
Modern	Ancient
Science	Art
Death	Life
Sleep	Wakefulness
Literal	Spiritual
Writing	Speech/Song

The interesting thing about Blake's use of this iconographic code, however, is not just its symmetrical clarity, but the way it disrupts the very certainties it seems to offer. We have to note, for instance, that the final plate of Job has not completely banished the bad sort of text: one of his daughters seems to be holding a book (albeit a rather limp, flexible one).[53] And what are we to make of Blake's

53. In the engraving, that is. In the watercolor version of this scene, all the texts are scrolls.

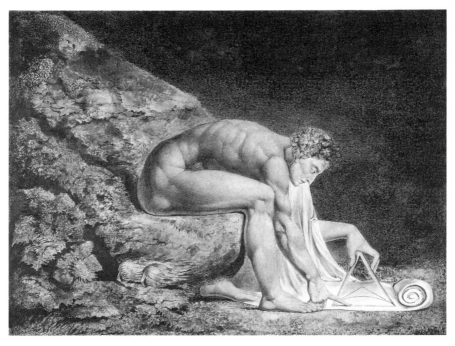

22. William Blake, *Newton*. By permission of the Tate Gallery, London.

depiction of Newton (figure 22) inscribing mathematical diagrams on a parchment scroll? Everything we know about the "doctrinal" Blake would lead us to expect the great codifier of Natural Law and Reason to be presented as a patriarch with his writings inscribed on books and tablets. Blake presents him instead as a youthful, energetic scribe whose writings take the form (perhaps unintentionally) of a prophecy. This is the Newton, not of "single vision" and "sleep," but the "mighty Spirit from the land of Albion, / Nam'd Newton" who "siez'd the Trump, & blow'd the enormous blast!" that awakes the dead to judgment. Or, perhaps more accurately, it is the Newton whose "single vision" is so intensely concentrated that it opens a vortex in his own closed universe, a figure of reason finding its own limit and awakening into imagination.

A similar dialectical reversal occurs in Blake's association of books with sleep, scrolls with wakefulness. We have already remarked on the way the elfin scribe with his prophetic scroll in *Jerusalem* 41 (see figure 19) insinuates his message into the garments of the sleeping giant with his Urizenic law book. Blake disrupts the stability of this

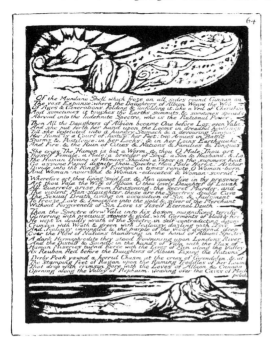

23. William Blake, *Jerusalem*, 64. Photograph by permission of the Department of Printing and Graphic Arts, The Houghton Library, Harvard University.

opposition even further in *Jerusalem* 64 (figure 23), where the sleeping patriarch has become a scribe pillowing his head on a scroll, and the wakeful figure is poring over a book. The joke is further complicated when we notice that the wakeful reader has been distracted from his text by the lively erotic dream of his sleeping colleague, so much so that he makes a gesture of shielding his book from the tempting vision above him. In that vision, a pair of sylphs soar amidst a blast of pollen, unrolling a miniature sexual heaven in the form of a scroll. What is the point of this scene? Are we to take the sleeping writer as a figure of superior imaginative status whose fertile dreams contrast with the barren wakefulness of the inferior reader? (Their position on the page sustains this interpretation, the reader looking up wistfully to the writer, across the gulf of Blake's text.) Or should we take it as a satire on writerly wish-fulfillment, the idle pen of the sleeping writer ironically contrasting with his dream of infinite, pleasurable dissemination of the text, of intellectual radiance (note the aureole around the sleeper's head) combined with sensuous enjoyment (the dream of the unrolling scroll emanates like a giant phallus from the sleeper's loins)? Either way the viewer is confronted with the dilemma of the reader's relation to Blake's authority: Is his work a vision or merely

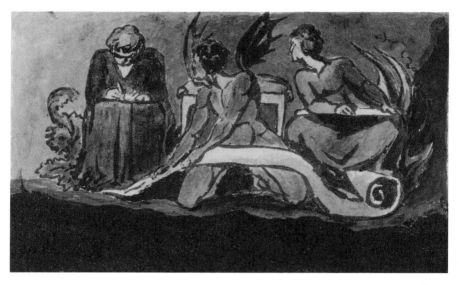

24. William Blake, *The Marriage of Heaven and Hell*, 10 (detail). Courtesy of the Library of Congress.

a dream? A prophecy or an idle fantasy? Is his authority, as he claims, on a par with Moses? Or was he a harmless eccentric who had too many ideas and too little talent?

Blake dramatizes the whole issue of scribal authority in plate 10 of *The Marriage of Heaven and Hell,* a scene which brings the emblems of book and scroll into direct contact (figure 24). The design shows a naked devil kneeling on the ground, dictating from a scroll to two clothed scribes who are copying his words down in books. The devil is looking up from his scroll, keeping his place with his finger while he checks on the progress of the scribe at his right. The scribe on his left (who appears slightly feminine in most copies) seems to have finished her secretarial duties and joins the devil in peering over at the diligent copyist on the left. When viewed in the context of Michelangelo's prophetic and sibylline scribes in the Sistine Chapel, the image reveals itself as a kind of blasphemous joke. Michelangelo placed naked figures or *ignudi* above his prophets and sibyls to represent the inspiring angels who bring them heavenly wisdom. Blake places his naked devil *below* his angelic scribes, a transformation one can read as a parody of Michelangelo or as an appropriation of angelic authority for Blake's "Infernal Wisdom." The basic point of the

design seems to be a conversion of the dialectics of *The Marriage of Heaven and Hell* (Prolific/Devourer; Active/Passive; Energy/Reason; Devil/Angel) into a scene of textual transmission. The devil is the authority figure: he and his scroll represent the primitive original, the "Prolific" source of prophetic sayings like the "Proverbs of Hell" that Blake has been recording in plates 7 through 10. The clothed scribes (who we are tempted to call "angelic" in their modest, dutiful passivity) are, by contrast, the textual "Devourers," mere middlemen (and women) who copy and perhaps interpret the "original derivations of Poetic Genius." In this reading of the image, all scribal authority is reserved for the prophetic scroll and the "Voice of the Devil." The scene may be read, then, as a kind of warning against the transformation of prophetic "sayings" (scroll-writing again associated with oral performance) into the dead, silent form of derivative book-learning.

And yet the image refuses to settle quietly into this "doctrinal" reading of its oppositions. For one thing, the two bookish scribes are themselves divided by an emblematic contrast. Erdman calls them the fast learner and the slow learner, but the sexual differentiation also suggests an allusion to and condensation of Michelangelo's seven (male) prophets and five (female) sibyls, symbols of the distinction between canonical Jewish prophecy, and noncanonical "gentile" prophecy.[54] The quick study on the devil's left (a female Daniel, in Michelangelo's idiom) is the figure of unauthorized, noncanonical textual transmission, and she seems to get the prophetic message sooner than her more reputable brother. But a second moment of unsettling occurs when we notice that even the authority of the Devil's Voice (and scroll) will not survive extended contemplation. He, after all, is no "author," but merely a reciter, reading off "Proverbs of Hell," which, by definition, can have no author, no individual source. They are impersonal, authorless sayings whose authority comes from their repetition, their efficacy in articulating a collective national "character" ("I collected some of their Proverbs: thinking that as the sayings used in a nation. mark its character, so the Proverbs of Hell, shew the nature of Infernal wisdom better than any description of buildings or garments" [*Marriage of Heaven and Hell,* plate 6; E, p. 35]).

We may say, of course, that this guise of impersonality is a transparent fiction, and we know very well that Blake the historical individual was the author of the Proverbs of Hell. And yet we also have to acknowledge that, for Blake, the claim of individual expressive au-

54. See Edgar Wind, "Michelangelo's Prophets and Sibyls," in *Proceedings of the British Academy* LI (London, 1966), p. 74.

thority and the disclaimer of authority ("I dare not pretend to be any other than the Secretary the Authors are in Eternity" [E, p. 730]) involves no contradiction, for the universal poetic genius that is God only acts through individuals. That is why Blake can seem to be both the author of original writings and merely a conduit through which innumerable writings (tradition, historical reality, textual and pictorial influence) transmit themselves. All writings, both books and scrolls, are best described by Blake's oxymoron of "original derivations." The attempt to settle the question of origin and authority, to stabilize it in the Voice of the Devil, the writing of the Blakean scroll, or the voice of the historical individual William Blake, is precisely what reifies prophecy into law, the bounding lines of the scroll into the closed gates of the book.

Blake's vision of a synthetic text that would reconcile the claims of book and scroll is most directly expressed in the illustrations to the Book of Job. If the first and last plates tell the story of Job as a direct movement from legalistic, bookish religion to the musical, celebratory religion associated with the scroll, the intervening plates treat this movement as a complex struggle between these contrary kinds of writing. The second plate in the Job series is the opening engagement in this "battle of books," every figure in the design except Satan holding some sort of text (figure 25). As it happens, this textual war is being conducted on two fronts simultaneously, one on earth, the other in "heaven" (generally taken by commentators to be Job's mind). The war on earth seems to follow directly from the scene of plate 1. Job's allegiance to the letter of his law-books is being challenged by two angels who appear on his right offering their scrolls as an alternative to Job's books. Job resists this offer by facing his open book toward the angels, as if projecting the power of its message toward them. It appears that his allegiance to the book and resistance to the scroll is supported by all his family except his eldest son, whose offered scroll is rejected by Job's turned back. Meanwhile, in heaven, the same event is being played out as a scene of judgment. God, presented as Job's spiritual double, is besieged by six petitioning angels who cast down scrolls at his feet. (S. Foster Damon suggests that these are lists of Job's good deeds.[55]) Below these petitioners are two more angels, one holding a book open before Jehovah, the other *withholding* a closed scroll. Presumably these two figures symbolize the balance of mercy and justice one looks for in representations of

55. S. Foster Damon, *Blake's Job* (New York: Dutton, 1969), p. 14.

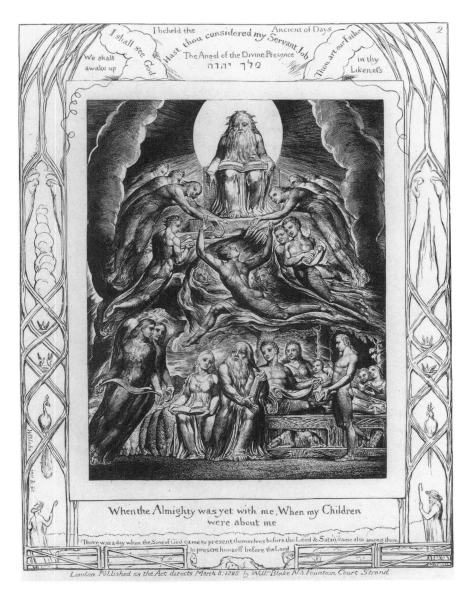

25. William Blake, *Book of Job*, 2. By permission of the Tate Gallery, London.

the Last Judgment; if so, the open book and closed, withdrawn scroll depicts the upsetting of this balance, as does the figure of God himself, who ignores the petitioners' scrolls, consults only his book, and issues the condemning judgment on Job. Amidst all of these textual battles the figure of Satan intrudes as the voice of accusation from beyond the world of writing, disrupting the dialectic between book and scroll, insisting on the unalloyed rule of law. This disruption of the balanced dialectic between book and scroll is re-enacted on plate 5, where Blake shows God himself torn between the two alternatives. Instead of a serene, assured judge, we find God writhing on his throne, his left side and upper body (anchored by the book in his left hand) recoiling from the scene of Job's affliction, his right side drawn down in sympathy by the scroll that trails from his right hand.

These scenes of textual warfare are answered in later plates by images of reconciliation. Blake frames his illustration of the Lord blessing Job and his wife with marginal ornaments that show verses from the Gospel stressing the unity of father and son, the Lord and his people, printed in a display of open books flanking a central scroll (figure 26). The point here seems to be that the messages of law and prophecy, letter and spirit, book and scroll have been harmonized in the Gospel, and this reconciliation extends even to the "senses" in which the world and texts are interpreted. Job has previously *heard* a great deal of advice (from his wife and comforters) about God's ways, but what he has *seen* has not been consistent with that advice. Now he says "I have heard with the hearing of the Ear but now my Eye seeth thee," an experience which, at the level of reading and writing, is something like that of seeing an illuminated book— language made visible—for the first time.

Blake further develops this association between sensory, spiritual, and textual synthesis in his depiction of Job telling his story to his daughters. In the engraved version of this scene (figure 27), Job instructs his daughters in a room lined with murals showing scenes from his own story. The priority of word and image here is strictly undecidable: Job may be using the pictures to illustrate and embellish his narrative, or he may be using the pictures as the starting point and telling a story by way of interpretation. In his earlier watercolor of the same scene (figure 28), Blake made these priorities even more complex: here Job gestures, not toward a series of wall paintings, but toward a cloud-encircled vision that emanates from his head. His daughters do not simply listen passively, but are busy taking down (or taking in) the story in a variety of ways (reading, listening, drawing or writing) and in a variety of media (book, scroll, and a text or

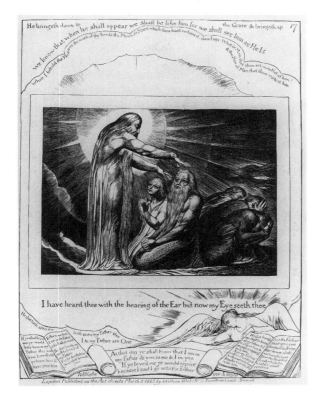

26. William Blake, *Book of Job*, 17. By permission of the Tate Gallery, London.

image) which will make the mental images of Job's story into a visible language in the "litteral sense."

Two things should be clear about the motif of book and scroll in Blake's scenes of writing. One is that it forms a fairly consistent iconographic code, expressing in emblematic form the basic contradictions—voice versus print, ancient versus modern textuality, and imaginative versus rational authority—that wreaked the romantic ideology of writing; the second is that Blake consistently uses this code in ways that unsettle its authority and frustrate the straightforward judgments it seems to offer. For Blake, writing does not move in a straight line toward a single version (or vision) of the story. It traces the clash of contraries and subverts the tendency to settle into the fixed oppositions he calls "Negations," whether these are the moral antitheses of law and prophecy, the sensory divide between eye and ear, or the aesthetic gulf between word and image. But we have still only seen his attempt to create this dialectic at the level of ideology (his intellectual "position" on writing) and representation (his treatment of "scenes

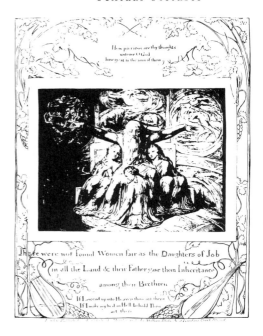

27. William Blake, *Book of Job*, 20. Reproduced by permission from the collection of Robert N. Essick.

of writing"). In order to see Blake's visible language directly, in the "litteral sense," we must turn to the material character of the printed word in his illuminated books.

Human Letters

& every Word & Every Character
Was Human according to the Expansion or Contraction,
 the translucence or
Opakeness of Nervous fibres such was the variation
 of Time & Space
Which vary according as the Organs of Perception vary.
 Jerusalem 98:35–38; E, p. 258

Any attempt to characterize the typography or calligraphy of Blake's illuminated books is frustrated by his subversion of the normal categories into which we sort texts.[56] The distinction between calligraphy

56. I should mention here Nelson Hilton's excellent *Literal Imagination: Blake's Vision of Words* (Berkeley: University of California Press, 1983). Hilton is mainly interested in Blake's typographic techniques at the level of

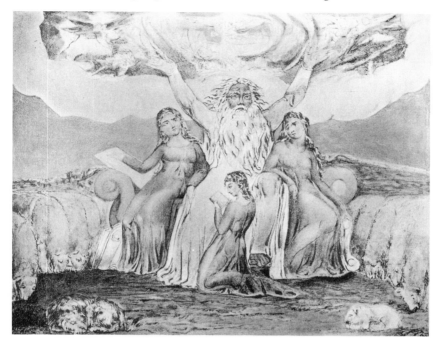

28. William Blake, *Job and His Daughters* (watercolor), III, 45, plate 20, by permission of the trustees of the Pierpont Morgan Library, New York.

and typography, for instance, is impossible to apply to Blake's work, for the art of engraved or etched writing is a composite of the two procedures. It seems odd to think of Blake as a calligrapher, since his texts are not literally autograph manuscripts, written with pen on paper. They are literally books mechanically printed from metal plates on a press. And yet the illuminated books all have the *look* of autograph manuscripts, and the best reconstructions of Blake's reversed writing technique suggests that the letters were traced with a quill or pen on copper, not carved with an engraving tool.[57] It is even more

the *word*, and thus he focuses on aural-visual punning, verbal association, and other modes of polysemic word-play. My aim here is to characterize the style of Blake's *letters* (in a fairly expansive sense) rather than whole words, but I see this project as integrally related to Hilton's work.

57. See Robert Essick's chapter on "The Illuminated Books and Separate Relief Prints," in his *William Blake, Printmaker* (Princeton, NJ: Princeton University Press, 1980).

difficult, on the other hand, to think of Blake as a typographer: although his lettering style sometimes approximates the uniformity of moveable type, it never reaches that stage, aiming instead for a various, flexible look that reminds us continually of its manual, nonmechanical origin. Indeed, one hesitates even to invoke a distinction like the "mechanical" versus the "handcrafted" in describing Blake's books. If Blake's book and scroll symbolize this difference between mechanically reproduced and hand-inscribed texts, it seems clear that his own texts are both book and scroll—or neither.

A second, even more fundamental, distinction that founders on Blake's text is the difference between alphabetic and hieroglyphic or pictographic forms, between writing "proper" and primitive forms or "pre-writing." As we have noted, the history of the evolution from pictorial to alphabetic writing was a central concern of the philosophes in their attempt to trace the growth of human understanding, and it became an especially lively issue in Blake's lifetime with the decipherment of the Rosetta stone. The basic principles that led to decipherment had been laid down in the mid-eighteenth century in Bishop Warburton's famous essay on hieroglyphics.[58] Warburton's theory that the hieroglyphics were not to be read as pictures of objects but as figures of speech involving puns, traditional associations and legends, and metaphoric or metonymic abridgments was repeated by Condillac and Rousseau in their histories of human knowledge and became the basis for Champollion's breakthrough.

There's no question that Blake deliberately violates the boundary between written and pictorial forms; his letters often sprout appendages that are decipherable only in pictorial terms. But the more fundamental problem in viewing Blake's text is deciding just what it means to see something "in pictorial terms." For eighteenth-century aestheticians it usually meant (what it still often means for us) seeing something as a likeness of a previous sense impression, a simulacrum of a "natural" perception. But Blake thought of his pictures in quite different terms, as images of "mental things" or "intellectual vision." They are what is called in the history of writing "ideograms," images which must be construed, not just as representations of objects, but of whole conceptions. The problem may be illustrated by asking ourselves whether we see Urizen "in pictorial terms" when we see him as an old man with a white beard or as a personification of Reason who

58. For an account of Warburton's role in the decoding of hieroglyphics, see Maurice Pope, *The Story of Archaeological Decipherment* (London, 1975).

belongs in a complex myth. For Blake, this distinction between ideo-grammatic seeing and pictorial seeing would be, I suggest, a "cloven fiction," one which separates the mental and physical worlds that his art attempts to marry. In this light, then, we have to say that Blake's text unites poem and picture in a more radical sense than simply placing them in proximity to one another. Blake treats his pictorial art as if it were a kind of writing and summarizes the entire history of writing from pictogram to hieroglyphic to alphabetic script in the pages of his illuminated books. Blake's images are riddled with ideas, making them a visible language—that is, a kind of writing.[59]

But Blake's art does not just involve pushing painting toward the ideogrammatic realm of writing; he also pushes alphabetic writing toward the realm of pictorial values, asking us to see his alphabetic forms with our senses, not just read through or past them to the signified speech or "concept" behind them, but to pause at the sensu-ous surface of calligraphic and typographic forms. What do we see during this pause? Often the symbolic values of Blake's calligraphy seem utterly transparent and straightforward. On the title-page of *The Marriage of Heaven and Hell,* for instance, the two contraries of "Heaven" and "Hell" are printed in austere Roman capitals. The word "Marriage," on the other hand, is inscribed in flowing en-graver's calligraphy, and the tails of the letters merge with the vegeta-tive forms in the pictured scene. Blake literally embodies in the calli-graphic form of "marriage" the symbolic marriage that his "types" prefigure in the text of *The Marriage of Heaven and Hell.*

There is a similarly transparent symbolism in the title-pages to *Songs of Innocence and of Experience,* where Blake presents "Experi-ence" in the stiff mathematical precision of Roman type and "Inno-cence" in flowing calligraphy. But there is another pattern in the ty-pography of the *Songs* that does not fit this schema so well. Most of the *Songs of Innocence* are printed in Roman, while the *Songs of Experience* are printed in italic, a form meant to recall the flowing, slanted lines of the calligrapher's running hand. Perhaps Blake is sim-ply resolved to be a "contrary fellow" and wants to keep us off bal-ance (as he does with the emblems of book and scroll), to both invite and prevent codification of his lettering style. Whatever his motives,

59. Lessing's strictures against allegorical, ideogrammatic painting are couched in terms of precisely this fear that the practice will lead painting into "abandoning its proper sphere and degenerating into an arbitrary method of writing." *Laocoon* (1766). I quote from Ellen Frothingham's translation (New York: Noonday Press, 1969), p. x.

it is the italic style of *Songs of Experience* that tends to dominate the typography of the later illuminated books. Roman print appears only in the early philosophical tracts (*All Religions Are One* and *There Is No Natural Religion*), *Songs of Innocence,* and the "Proverbs of Hell" section of *The Marriage.* All of the other illuminated books are printed (with variations in size, spacing, and degree of ornamentation) in italic letters. The general point of this stylistic choice is not terribly difficult to grasp. Blake wanted a letter form that would be uniform and readable, but which would declare its handcrafted origins. He also wanted, I suspect, to stress his association with the great writing-masters of the Renaissance, the Italian humanists who gave "italic" its name, and who, along with Italian engraving masters like Marcantonio Raimondi, provide a model for his graphic style.[60] This link with the calligraphy of humanism, the "littera humanistica" as it was known, is probably Blake's "litteral sense" when he claims that "every Word & every Character / Was Human" in the visionary discourses that close *Jerusalem.*

The notion of a "human Character" or "littera humanistica" goes well beyond the association with humanistic script, however. Readers of Blake's notebook will recall that he explored the idea of human letters in drawings which accommodate the human form to the shape of alphabetic script. These figures illustrate a principle that transcends the particular conformity of some human posture to the shape of a "Y," an "I," an "O," or a "P," and that is the tendency of Blake's graphic art to display repeated or "iterated" forms—figures which occur often enough to be recognized as constitutive elements in a code, like the letters of an alphabet.[61] The point is not that a human

60. See Donald Anderson, *The Art of Written Forms,* pp. 112–24, for a discussion of the Italian calligraphers. Blake's books provided one of the models, of course, for the nineteenth-century revival of calligraphy led by William Morris.

61. Morris Eaves provides a useful caution here: "while I think you can see the *tendency* to link alphabetic with human forms and *ultimately* then with the Human Form Divine, it also seems important to keep your eye on the evident fact that the letters tend to remain letters and pictures pictures . . . and that the human-letter-form business was just a one-time experiment demonstrating a possibility" (marginal notes on the first draft of this essay). I agree with most of this warning. I don't think Blake was so much a "literalist of the imagination" (Yeats's phrase) that he saw human figures as letters or eliminated all differences between texts and images. My claim is, however, that the "human letters" of the *Notebook* illustrate a *principle* as well as a

figure or other graphic form must look like a character in the English or Hebrew alphabet, but that it be repeated often enough to be differentiated and recognized as a "character" in an ensemble of symbolic forms. And the symbolism of such characters need not be understood as a univocal system of representation: the paired emblems of book and scroll are a perfect example of the use of iterated forms that generate, through patterns of similitude and difference, an infinite range of meanings.

These kinds of repeated iconographic and formal patterns occur in the work of every pictorial artist; they are what Gombrich calls the "schemata" or "grammar" of visual art, and their meaning arises from their resemblance, not to natural objects or appearances, but to one another. They are also the constituents of what we call "style" in the graphic arts, a term that suggests, in its connection with the writing tool or *stylus,* the point of convergence between writing and painting. The style is the *signature* of the artist or school, the "characteristic" iterated and re-iterated pattern. Blake as a highly self-conscious writer-painter-printer simply foregrounds this general principle of artistic style, making the links between verbal expression, graphic representation, and mechanical reproduction explicit and "litteral."

I've argued elsewhere that Blake's pictorial style is constructed at its deepest level out of four abstract forms or characters (the spiral, circle, S-curve, and inverted U) that correspond to structures Blake associates with sensory openings (ear, eye, tongue, nose).[62] This "alphabet of the senses" would make sense of Blake's claim that the "human Character" of his art of writing "was Human according to the Expansion or Contraction, the Translucence or / Opakeness of Nervous Fibres such was the variation of Time & Space / Which vary according as the Organs of Perception vary." This is also the point, however, at which Blake's art of writing ceases to be just a *visible* language and becomes a synaesthetic spectacle that "the eye of man hath not heard, the ear of man hath not seen, man's hand is not able to taste, his tongue to conceive, nor his heart to report." And as

possibility, and that is the notion of formal, graphic *iterability.* This principle links text and image, especially in the medium of engraving, and tends to subvert any perception of *essential* and *necessary* difference based in the supposed nature of the media, the kinds of objects they represent, or the kinds of perception they demand. See *The Notebooks of William Blake,* edited by David Erdman (London: Oxford University Press, 1973), p. 74.

62. See *Blake's Composite Art,* pp. 58–69.

Bottom warns us, "Man is but an ass if he go about to expound this dream," this language, or this dream of language.

The good critic, however, like Blake's devil, must always be an ass and rush in to expound where angels fear to read. The dream of a language that would play upon all the stops of the human senses is more than a proposal for the "improvement of sensual enjoyment" with multimedia devices. It is the use of such devices to create what Marx called "the poetry of the future," a poetry which demands the rethinking of all human discourse and of the social relations inscribed in that discourse. Blake's sensuous alphabet of "human letters" is both a fulfillment of and a tacit critique of the Enlightenment schemes for a "universal character" to unite mankind.[63] Blake wants a writing that will make us see with our ears and hear with our eyes because he wants to transform us into revolutionary readers, to deliver us from the notion that history is a closed book to be taken in one "sense." Northrop Frye made something like this point when he closed *Fearful Symmetry* with the following remark:

> the alphabetic system of writing can be traced back to the Semitic people of "Canaan," and perhaps if we knew more about it we should discover that it was not a moral code but an alphabet that the Hebrews learned at Mount Sinai, from a God with enough imagination to understand how much more important a collection of letters was than a collection of prohibitions.[64]

Blake as a post-Enlightenment poet recognizes that this "collection of letters" wasn't given by a sky-god with imagination, but that this god *is* the human imagination, the letters a human invention, and that the adequate alphabet for imagination is till being delivered to us—most recently in his own "wond'rous art of writing."

63. These systems often invoked hieroglyphics and picture-writing as possible models for the "universal character." See James Knowlson, *Universal Language Schemes in England and France, 1600–1800* (Toronto: University of Toronto Press, 1975).

64. Northrop Frye, *Fearful Symmetry: A Study of William Blake* (Princeton, NJ: Princeton University Press, 1947), p. 416.

EKPHRASIS AND THE OTHER

undying accents
repeated till
the ear and the eye lie
down together in the same bed
 —William Carlos Williams

 This otherness, this
"Not-being-us" is all there is to look at
In the mirror, though no one can say
How it came to be this way.
 —John Ashbery, "Self-Portrait in a Convex Mirror"

Radio Photographs: Ekphrastic Poetics

Anyone who grew up in the age of radio will recall a popular comedy duo called "Bob and Ray." One of their favorite bits was a scene in which Bob would show Ray all the photographs of his summer vacation, accompanying them with a deadpan commentary on the interesting places and lovely scenery. Ray would usually respond with some comments on the quality of the pictures and their subject matter, and Bob would invariably say at some point, as an aside to the audience, "I sure wish you folks out there in radioland could see these pictures." Perhaps this line sticks in my memory because it was such a rare break in the intimacy of Bob and Ray's humor: they generally ignored their radio listeners, or (more precisely) pretended as if the listener was sitting with them in the studio, so fully present to their conversation that no special acknowledgment was required. If one can imagine what it would be to wink knowingly at someone over the radio, one can understand the humor of Bob and Ray. One can also, I think, begin to see something of the fascination

in the problem of ekphrasis, the verbal representation of visual representation.[1]

This fascination comes to us, I think, in three phases or moments of realization. The first might be called "ekphrastic indifference," and it grows out of a commonsense perception that ekphrasis is impossible. This impossibility is articulated in all sorts of familiar assumptions about the inherent, essential properties of the various media and their proper or appropriate modes of perception. Bob and Ray's photographs can never be made visible over the radio. No amount of description, as Nelson Goodman might put it, adds up to a depiction.[2] A verbal representation cannot represent—that is, make present—its object in the same way a visual representation can. It may refer to an object, describe it, invoke it, but it can never bring its visual presence before us in the way pictures do. Words can "cite," but never "sight" their objects. Ekphrasis, then, is a curiosity: it is the name of a minor and rather obscure literary genre (poems which describe works of visual art) and of a more general topic (the verbal representation of visual representation) that seems about as important as Bob and Ray's radio photographs.

The minority and obscurity of ekphrasis has not, of course, prevented the formation of an enormous literature on the subject that traces it back to the legendary "Shield of Achilles" in the *Iliad*, locates its theoretical recognition in ancient poetics and rhetoric, and finds instances of it in everything from oral narrative to postmodern poetry.[3] This literature reflects a second phase of fascination with the topic I will call "ekphrastic hope." This is the phase when the impossibility of ekphrasis is overcome in imagination or metaphor, when we discover a "sense" in which language can do what so many writers have wanted it to do: "to make us see."[4] This is the phase in which

1. This definition of ekphrasis as "the verbal representation of visual representation" is also the basis for James Heffernan's article, "Ekphrasis and Representation," *New Literary History* 22, no. 2 (Spring 1991): 297–316. See also Heffernan's *The Museum of Words: The Poetics of Ekphrasis from Homer to Ashbery* (Chicago: University of Chicago Press, 1994).

2. Nelson Goodman, *Languages of Art* (Indianapolis: Hackett, 1976), p. 231.

3. For a good survey of this scholarship, see Grant F. Scott, "The Rhetoric of Dilation: Ekphrasis and Ideology," *Word & Image* 7, no. 4 (October–December 1991): 301–10.

4. The pun in "cite"/"sight" above might be cited (or sighted) as an exam-

Bob and Ray's "radio magic" takes effect, and we imagine in full detail the photographs we hear slapping down on the studio table. (Sometimes Bob would acknowledge this moment in a variation of his punchline: instead of a wish, an expression of gratified desire— "I'm sure glad you folks could look at these pictures with us today.") This is like that other moment in radio listening when the "thundering hoofbeats of the great horse Silver" make the giant white stallion with his masked rider gallop into the mind's eye.[5]

It is also the moment when ekphrasis ceases to be a special or exceptional moment in verbal or oral representation and begins to seem paradigmatic of a fundamental tendency in all linguistic expression. This is the point in rhetorical and poetic theory when the doctrines of *ut pictura poesis* and the Sister Arts are mobilized to put language at the service of vision. The narrowest meanings of the word ekphrasis as a poetic mode, "giving voice to a mute art object," or offering "a rhetorical description of a work of art,"[6] give way to a more general application that includes any "set description intended to bring person, place, picture, etc. before the mind's eye."[7] Ekphrasis may be even further generalized, as it is by Murray Krieger, into a general "principle" exemplifying the aestheticizing of language in what he calls the "still moment."[8] For Krieger, the visual arts are a

ple of a "literal" (that is, conveyed by "letters") intrusion of visual representation into verbal representation.

5. The iconic character of radio "sound images" is a nonverbal form of ekphrasis. These images (onomatopoeic thundering, studio sound effects) might be said to provoke visual images by metonymy, or customary contiguity.

6. Jean Hagstrum, *The Sister Arts: The Tradition of Literary Pictorialism and English Poetry from Dryden to Gray* (Chicago: University of Chicago Press, 1958), p. 18. See also Wendy Steiner, *The Colors of Rhetoric* (Chicago: University of Chicago Press, 1982), pp. 42–43, for an account of ekphrasis as literature's nostalgia for the visual arts. Further page references will be cited in the text.

7. George Saintsbury, quoted in Hagstrum, *The Sister Arts*, p. 18.

8. Murray Krieger, "The Ekphrastic Principle and the Still Moment of Poetry; or *Laokoon* Revisited," in *The Play and Place of Criticism* (Baltimore: Johns Hopkins University Press, 1967). This essay, which has without question been the single most influential statement on ekphrasis in American criticism, has now been incorporated by Krieger into a booklength study, *Ekphrasis: The Illusion of the Natural Sign* (Baltimore, MD: Johns Hopkins University Press, 1992).

metaphor, not just for verbal representation of visual experience, but for the shaping of language into formal patterns that "still" the movement of linguistic temporality into a spatial, formal array. Not just vision, but stasis, shape, closure, and silent presence ("still" in the other sense) are the aims of this more general form of ekphrasis.[9] Once the desire to overcome the "impossibility" of ekphrasis is put into play, the possibilities and the hopes for verbal representation of visual representation become practically endless. "The ear and the eye lie / down together in the same bed," lulled by "undying accents." The estrangement of the image/text division is overcome, and a sutured, synthetic form, a verbal icon or imagetext, arises in its place.[10]

But the "still moment" of ekphrastic hope quickly encounters a third phase, which we might call "ekphrastic fear." This is the moment of resistance or counterdesire that occurs when we sense that the difference between the verbal and visual representation might collapse and the figurative, imaginary desire of ekphrasis might be realized literally and actually. This is the moment when we realize that Bob and Ray's "wish" that we could see the photographs would, if granted, spoil their whole game, the moment when we wish for the photographs to stay invisible.[11] It is the moment in aesthetics when the difference between verbal and visual mediation becomes a moral, aesthetic imperative rather than (as in the first, "indifferent" phase of ekphrasis) a natural fact that can be relied on. The classic expression of ekphrastic fear occurs in Lessing's *Laocoon*, where it is "prescribed

9. The doctrine can, of course, expand even further to become a general principle of effective rhetoric or even of scientific language, where it appears under the rubric of clear, "perspicuous" representation, modeled on perspectival, rationally constructed imagery. More typical, however, is the use of ekphrasis as a model for the power of literary art to achieve formal, structural patterns and to represent vividly a wide range of perceptual experiences, most notably the experience of vision. The graphic, pictorial, or sculptural models for literary art range from the quasi-scientific claims of perspectival realism, to the grand patterning of architecture, to the focusing of a literary work in a single image, whether an emblem, a hieroglyph, a landscape, or a human figure.

10. On the distinction between "image/text," "image-text," and "image-text," see chapter 3, footnote 9.

11. Those who saw Bob and Ray's television debut on "Saturday Night Live" know that their humor loses much of its force when they cease to be invisible voices and are revealed as what we always knew them to be: two very ordinary-looking middle-aged men.

as a law to all poets" that "they should not regard the limitations of painting as beauties in their own art." For poets to "employ the same artistic machinery" as the painter would be to "convert a superior being into a doll." It would make as much sense, argues Lessing, "as if a man, with the power and privilege of speech, were to employ the signs which the mutes in a Turkish seraglio had invented to supply the want of a voice."[12]

The tongue, of course, was not the only organ that the mutes in the Turkish seraglio were missing. Lessing's fear of literary emulation of the visual arts is not only of muteness or loss of eloquence, but of castration, a threat which is re-echoed in the transformation from "superior being" to "doll," a mere feminine plaything. The obverse of ekphrasis, "giving voice to the mute art object," is similarly denounced by Lessing as an invitation to idolatry: "superstition loaded the [statues of] gods with symbols" (that is, with arbitrary, quasi-verbal signs expressing ideas) and made them "objects of worship" rather than what they properly should be—beautiful, mute, spatial objects of visual pleasure.[13] If ekphrastic hope involves what Françoise Meltzer has called a "reciprocity" or free exchange and transference between visual and verbal art,[14] ekphrastic fear perceives this reciprocity as a dangerous promiscuity and tries to regulate the borders with firm distinctions between the senses, modes of representation, and the objects proper to each.[15]

Ekphrastic fear is not some minor curiosity of German idealist aesthetics. It would be easy to show its place in a wide range of literary theorizing, from the Marxist hostility to modernist experiments with

12. Gotthold Lessing, *Laocoon,* translated by Edith Frothingham (1766; New York: Noonday Press, 1969), pp. 68–69.

13. For Lessing, arbitrary visual signs (emblems, hieroglyphs, pictographs) such as, for instance, serpents that signify divinity, are well on their way to being a form of writing. See my essay, "Space and Time: Lessing's *Laocoon* and the Politics of Genre," chapter 4 in *Iconology* (Chicago: University of Chicago Press, 1986).

14. Françoise Meltzer, *Salome and the Dance of Writing: Portraits of Mimesis in Literature* (Chicago: University of Chicago Press, 1987), p. 21.

15. Lessing traces "adulterous fancy" among the ancients—especially women—to the use of serpents as "emblems of divinity" on ancient statues. Not just the phallic shape of the serpent, but its impropriety as an arbitrary sign attached, like language or voice, to a properly "beautiful" and mute statue, is the provocation to adultery. See Lessing, *Laocoon,* pp. 10–11. Further page references will be cited in the text.

literary space, to deconstructionist efforts to overcome "formalism" and "closure," to the anxieties of Protestant poetics with the temptations of "imagery," to the romantic tradition's obsession with a poetics of voice, invisibility, and blindness.[16] All the goals of "ekphrastic hope," of achieving vision, iconicity, or a "still moment" of plastic presence through language become, from this point of view, sinister and dangerous. All the utopian aspirations of ekphrasis—that the mute image be endowed with a voice, or made dynamic and active, or actually come into view, or (conversely) that poetic language might be "stilled," made iconic, or "frozen" into a static, spatial array—all these aspirations begin to look idolatrous and fetishistic. And the utopian figures of the image and its textual rendering as transparent windows onto reality are supplanted by the notion of the image as a deceitful illusion, a magical technique that threatens to fixate the poet and the listener.

The interplay of these three "moments" of ekphrastic fascination—fear, hope, and indifference—produce a pervasive sense of ambivalence, an ambivalence focused in Bob and Ray's photographs: they know you can't see them; they wish you could see them, and are glad that you can; they don't want you to see them, and wouldn't show them if they could. But to describe this ambivalence as I have done is not to explain it. What is it in ekphrasis that makes it an object of utopian speculation, anxious aversion, and studied indifference? How can ekphrasis be the name of a minor poetic genre and a universal principle of poetics? The answer lies in the network of ideological associations embedded in the semiotic, sensory, and metaphysical oppositions that ekphrasis is supposed to overcome. In order to see the force of these oppositions and associations, we need to re-examine the utopian claims of ekphrastic hope and the anxieties of ekphrastic fear in the light of the relatively neutral viewpoint of ekphrastic indifference, the assumption that ekphrasis is, strictly speaking, impossible.

The central goal of ekphrastic hope might be called "the overcoming of otherness." Ekphrastic poetry is the genre in which texts encounter their own semiotic "others," those rival, alien modes of representation called the visual, graphic, plastic, or "spatial" arts. The "scientific" terms of this otherness are the familiar oppositions of semiotics: symbolic and iconic representation; conventional and natural signs; temporal and spatial modes; visual and aural media. These

16. For further discussion of romantic iconophobia, see chapter 4, pp. 114–20.

oppositions, as I have argued at length in *Iconology*, are neither stable nor scientific. They do not line up in fixed columns, with temporality, convention, and aurality in one row, and space, nature, and visuality in the other. They are best understood as what Fredric Jameson has termed "ideologemes," allegories of power and value disguised as a neutral metalanguage.[17] Their engagement with relations of otherness or alterity is, of course, not determined systematically or a priori, but in specific contexts of pragmatic application. The "otherness" of visual representation from the standpoint of textuality may be anything from a professional competition (the *paragone* of poet and painter) to a relation of political, disciplinary, or cultural domination in which the "self" is understood to be an active, speaking, seeing subject, while the "other" is projected as a passive, seen, and (usually) silent object. Insofar as art history is a verbal representation of visual representation, it is an elevation of ekphrasis to a disciplinary principle.[18] Like the masses, the colonized, the powerless and voiceless everywhere, visual representation cannot represent itself; it must be represented by discourse.

Unlike the encounters of verbal and visual representation in "mixed arts" such as illustrated books, slide lectures,[19] theatrical pre-

17. For a more extended account of Jameson on the ideologeme and his use of the categories of space and time, see Jameson's *The Political Unconscious* (Ithaca, NY: Cornell University Press, 1981), p. 87, and my essay, "Space, Ideology, and Literary Representation," in *Poetics Today* 10, no. 1 (Spring 1989): 91–102.

18. As Marcelin Pleynet puts it, "The objective of the text of art criticism . . . is for me to place myself . . . before something that implies another discourse, a discourse that will not be in the text. . . . " (*Painting and System*, translated by Sima Godfrey [1977; Chicago: University of Chicago Press, 1984], p. v).

19. John Hollander proposes a distinction between "notional" ekphrases of "imaginary" or lost works of art and descriptions of visual representation that refer to familiar, widely reproduced, or even present objects of visual representation. See "The Poetics of *Ekphrasis*," *Word and Image* 4 (1988): 209–19. I want to suggest, however, that in a certain sense all ekphrasis is notional, and seeks to create a specific image that is to be found only in the text as its "resident alien," and is to be found nowhere else. Even those forms of ekphrasis that occur in the presence of the described image disclose a tendency to alienate or displace the object, to make it disappear in favor of the textual image being produced by the ekphrasis. The art history slide lecture is a perfect illustration of this point. A fixed convention of the slide lecture is the declaration that the image projected on the screen is a totally

sentations, film, and shaped poetry, the ekphrastic encounter in language is purely figurative. The image, the space of reference, projection, or formal patterning, cannot literally come into view. If it did, we would have left the genre of ekphrasis for concrete or shaped poetry, and the written signifiers would themselves take on iconic characteristics.[20] This figurative requirement puts a special sort of pressure on the genre of ekphrasis, for it means that the textual other must remain completely alien; it can never be present, but must be conjured up as a potent absence or a fictive, figural present. These acts of verbal "conjuring" are what would seem to be specific to the genre of ekphrastic poetry, and specific to literary art in general, insofar as it obeys what Murray Krieger calls "the ekphrastic principle." Something special and magical is required of language. "The poem," as Krieger puts it, "must convert the transparency of its verbal medium into the physical solidity of the medium of the spatial arts."[21] This "solidity" is exemplified in such features as descriptive vividness and particularity, attention to the "corporeality" of words, and the patterning of verbal artifacts. The ekphrastic image acts, in other words, like a sort of unapproachable and unpresentable "black hole" in the verbal structure, entirely absent from it, but shaping and affecting it in fundamental ways.

Now the skeptic, indifferent to the magic of ekphrastic hope, is likely to point out that this whole argument is a kind of sham, creating difficulties at the level of representation and signs that do not exist. The "genre" of ekphrasis is distinguished, the skeptic might point out, not by any disturbance or dissonance at the level of signifiers and representational media, but by a possible reference to or thematizing of this sort of dissonance. Ekphrastic poetry may speak to, for, or about works of visual art, but there is nothing especially problematic

inadequate representation (the colors have faded, the lighting was poor, the texture has all been lost). Even when the lecture is performed in the presence of the object itself, the commentator is never at a loss for strategies of displacement and upstaging, the most obvious being a discourse that removes the object from the museum or gallery and situates it in some other, more authentic or appropriate place (the site of its original display or production, the artist's studio, the artist's mind, or—best of all—the mind of the commentator).

20. The claim that they *do* take on iconic characteristics, achieving verbal artifacts that "resemble" at some level the visual form they address, is one of the central claims of ekphrastic hope.

21. Krieger, *Play and Place of Criticism*, p. 107.

or unique in this speech: no special conjuring acts of language are required, and the visual object of reference does not impinge (except in analogical ways) upon its verbal representation to determine its grammar, control its style, or deform its syntax. Sometimes we talk as if ekphrasis were a peculiar textual feature, something that produced ripples of interference on the surface of the verbal representation. But no special textual features can be assigned to ekphrasis, any more than we can, in grammatical or stylistic terms, distinguish descriptions of paintings, statues, or other visual representations from descriptions of any other kind of object.[22] Even "description" itself, the most general form of ekphrasis, has, as Gerard Genette has demonstrated, only a kind of phantom existence at the level of the signifier: "the differences which separate description and narration are differences of content, which, strictly speaking, have no semiological existence."[23] The distinctions between description and narration, representation of objects and actions, or visual objects and visual representations, are all semantic, all located in differences of intention, reference, and affective response. Ekphrastic poems speak to, for, or about works of visual art in the way that texts in general speak about anything else. There is nothing to distinguish grammatically a description of a painting from a description of a kumquat or a baseball game. An address or apostrophe to a statue could, from the semiotic standpoint, just as well be an address to a tomato or a tomcat. And the projection of a fictive voice into a vase produces no special ripples or disturbances in the grammar that voice employs. When vases talk, they speak our language.

Our confusion with ekphrasis stems, then, from a confusion between differences of medium and differences in meaning. We are continually falling into some version of Marshall McLuhan's dazzling and misleading metaphor, "the medium is the message." In ekphrasis, the "message" or (more precisely) the object of reference is a visual

22. Another way to put this is to note that the ekphrasis of a work of visual art need not produce either an "iconic" effect (though this is certainly a possibility) or any other "literary" feature. Ekphrastic prose is an equally available possibility, and the presence or absence of iconism or "literarity" in this prose is not preordained by its reference to a visual representation. Ekphrasis and verbal iconicity are, in short, independent features.

23. See Gerard Genette, *Figures of Literary Discourse*, translated by Alan Sheridan (New York: Columbia University Press, 1984), p. 136. George Saintsbury's account of ekphrasis as a *set* description" reflects this desire to "frame" or "set off" description as a separable feature. See footnote 7 above.

representation; and, therefore, (we suppose) the medium of language *must* approximate this condition.[24] We think, for instance, that the visual arts are inherently spatial, static, corporeal, and shapely; that they bring these things as a gift to language. We suppose, on the other side, that arguments, addresses, ideas, and narratives are in some sense *proper* to verbal communication, that language must bring these things as a gift to visual representation. But neither of these "gifts" is really the exclusive property of their donors: paintings can tell stories, make arguments, and signify abstract ideas; words can describe or embody static, spatial states of affairs, and achieve all of the effects of ekphrasis without any deformation of their "natural" vocation (whatever that may be).[25]

The moral here is that, from the *semantic* point of view, from the standpoint of referring, expressing intentions and producing effects in a viewer/listener, there is no essential difference between texts and images and thus no gap between the media to be overcome by any special ekphrastic strategies. Language can stand in for depiction and depiction can stand in for language because communicative, expressive acts, narration, argument, description, exposition and other so-called "speech acts" are not medium-specific, are not "proper" to some medium or other. I can make a promise or threaten with a visual sign as eloquently as with an utterance. While it's true that Western painting isn't generally used to perform these sorts of speech acts, there is no warrant for concluding that they could never do so, or that

24. Texts *may*, of course, achieve spatiality or iconicity, but the visual object invoked does not require or cause these features.

25. The strange irreality of these "gifts" does not, of course, prevent us from giving them and from thinking of the whole ekphrastic gesture as a kind of ritual of exchange. One of the most frequent sites of ekphrasis in classical poetry is the singing contest between two shepherds who describe and exchange artifacts as tokens of mutual esteem (see, for instance, Theocritus' Idyll, Virgil's Eclogue V). "The art objects used as gifts or prizes may be read as the rewards poets should receive for their productions . . . and the ekphrastic description asserts poetry's worth by showing that poetry can indeed 'capture' in and receive such valuable things" (Joshua Scodel, correspondence with the author, 1989). The Shield of Achilles is a gift from the hero's goddess mother, and the ekphrasis of this shield by Homer is a gift from his muses that is, in turn, given to the reader/listener. I am very grateful to Joshua Scodel for his extended response to early drafts of this essay, and I will be quoting from his letters to me throughout this essay.

pictures more generally cannot be used to say just about anything.[26] It would be very difficult to account for the existence of pictographic writing systems if pictures could not be employed as the medium for complex verbal expressions.

The independence of so-called "speech acts" from phonetic language is illustrated by the subtlety and range of communication available to the Deaf in visual/gestural sign languages. These signs are not, of course, purely pictorial or linguistic (it's hard to imagine what "purity" of this sort would mean in any medium) but they are necessarily *visual,* and with same sort of necessity that makes Bob and Ray's photographs "auditory." The mistaken assumption that language is medium-specific, that it must be phonetic, is responsible for what Oliver Sacks has called a "militant oralism" in the education of the Deaf, an insistence that they learn spoken language first. Sacks argues that "the congenitally deaf need to acquire, as early as possible, a complete and coherent language—one not demanding understanding or transliteration of a spoken tongue: this *has* to be a sign language. . . . "[27]

One lesson of a general semiotics, then, is that there is, *semantically* speaking (that is, in the pragmatics of communication, symbolic behavior, expression, signification) no *essential* difference between texts and images; the other lesson is that there are important differences between visual and verbal media at the level of sign-types, forms, materials of representation, and institutional traditions. The mystery is why we have this urge to treat the medium as if it were the message, why we make the obvious, practical differences between *these* two media into metaphysical oppositions which seem to control our communicative acts, and which then have to be overcome with utopian fantasies like ekphrasis. A phenomenological answer would start, I suppose, from the basic relationship of the self (as a speaking

26. In fact, a moment's reflection suggests innumerable instances where pictures stand in for words and whole speech acts. Linda Seidel has shown, for instance, that Van Eyck's famous Arnolfini portrait is best understood as something like a marriage contract, and the "cave canem" inscription on the fierce dog mosaics at Pompeii (often cited by Gombrich as examples of "apotropaic" imagery) seems redundant in view of the image. See Seidel, "The Arnolfini Portrait," *Critical Inquiry* 16, no. 1 (Fall 1989): 54–86; and Ernst Gombrich, "The Limits of Convention," in *Image and Code,* edited by Wendy Steiner (Ann Arbor, Michigan, 1981), pp. 11–42.

27. Oliver Sacks, *New York Review of Books,* 23 October 1986, p. 69.

and seeing subject) and the other (a seen and silent object).[28] It isn't just that the text/image difference "resembles" the relation of self and other, but that the most basic pictures of epistemological and ethical encounters (knowledge of objects, acknowledgment of subjects) involve optical/discursive figures of knowledge and power that are embedded in essentialized categories like "the visual" and "the verbal." (Panofsky's opening move into the discipline of "iconology" as a discourse on images is, as we've seen, a visual, gestural encounter with another person.)[29] It is as if we have a metapicture of the image/text encounter, in which the word and the image are not abstractions or general classes, but concrete figures, characters in a drama, stereotypes in a Manichean allegory or interlocutors in a complex dialogue.

The "otherness" we attribute to the image-text relationship is, therefore, certainly not exhausted by a phenomenological model (subject/object, spectator/image). It takes on the full range of possible social relations inscribed within the field of verbal and visual representation. "Children should be seen and not heard" is a bit of proverbial wisdom that reinforces a stereotypical relation, not just between adults and children, but between the freedom to speak and see and the injunction to remain silent and available for observation. That is why this kind of wisdom is transferable from children to women to colonized subjects to works of art to characterizations of visual representation itself. Racial otherness (especially in the binarized "black/white" divisions of U.S. culture) is open to precisely this sort of visual/verbal coding. The assumption is that "blackness" is a transparently readable sign of racial identity, a perfectly sutured imagetext. Race is what can be *seen* (and therefore named) in skin color, facial features, hair, etc. Whiteness, by contrast, is invisible, unmarked; it has no racial identity, but is equated with a normative subjectivity and humanity from which "race" is a visible deviation. It's not merely a question of analogy, then, between social and semiotic stereotypes of the other, but of mutual interarticulation.[30] That is why forms of

28. See Daniel Tiffany's essay, "Cryptesthesia: Visions of the Other," *The American Journal of Semiotics* 6, nos. 2/3 (1989): 209–19.

29. See chapter 1, "The Pictorial Turn."

30. I take this to be Jacqueline Rose's point when she says "the link between sexuality and the image produces a particular dialogue which cannot be covered adequately by the familiar opposition between the formal operations of the image and a politics exerted from outside" (*Sexuality in the Field of Vision* [London: Verso, 1986], p. 231). Needless to say, the positioning of racial otherness within the field of vision would display complex intersections

resistance to these stereotypes so often take the form of disruptions at the level of representation, perception, and semiosis: Ralph Ellison's *Invisible Man* is not "empirically" unseen; he refuses visibility as an act of insubordination.[31] The emergence of the racialized other into a visibility that accords with their own vision, conversely, is frequently understood as dependent on their attainment of language and literacy. As Henry Louis Gates and Charles Davis put it, "the very *face* of the race . . . was contingent upon the recording of the black *voice*."[32] If a woman is "pretty as a picture" (namely, silent and available to the gaze), it is not surprising that pictures will be treated as feminine objects in their own right and that violations of the stereotype (ugliness, loquaciousness) will be perceived as troublesome. "Western thought," says Wlad Godzich, "has always thematized the other as a threat to be reduced, as a potential same-to-be, a yet-not-same."[33] This sentence (with its totality of "Western thought" and its "always") performs the very operation it criticizes. Perhaps ekphrasis as "literary principle" does the same thing, thematizing "the visual" as other to language, "a threat to be reduced" (ekphrastic fear), "a potential same-to-be" (ekphrastic hope), "a yet-not-same" (ekphrastic indifference).

The ambivalence about ekphrasis, then, is grounded in our ambivalence about other people, regarded as subjects and objects in the field of verbal and visual representation. Ekphrastic hope and fear express our anxieties about merging with others. Ekphrastic indifference maintains itself in the face of disquieting signs that ekphrasis may be far from trivial and that, if it is only a sham or illusion, it is one which, like ideology itself, must be worked through. This "working

with and differences from the image/text as a gendered or sexual relation. See Toni Morrison on "The Alliance between Visually Rendered Ideas and Linguistic Utterances in the Construction of the Color Line," in *Playing in the Dark* (Cambridge, MA: Harvard University Press, 1992), p. 49.

31. Cp. also Toni Morrison's short story, "Recitatif" (1982), with its deliberate confusing of the verbal/visual signs of racial identity; reprinted in *Confirmation: An Anthology of African American Women,* edited by Amiri Baraka (Leroi Jones) and Amina Baraka (New York: William Morrow, 1983), pp. 243–61.

32. *The Slave's Narrative,* edited by Charles T. Davis and Henry Louis Gates, Jr. (Oxford: Oxford University Press, 1985), p. xxvi. For more on this subject, see chapter 6, "Narrative, Memory, and Slavery."

33. From the foreword to Michel de Certeau's *Heterologies: Discourse on the Other* (Minneapolis: University of Minnesota Press, 1989), p. xiii.

through" of ekphrastic ambivalence is, I want to suggest, one of the principal themes of ekphrastic poetry, one of the things it *does* with the problems staged for it by the theoretical and metaphysical assumptions about media, the senses and representation that make up ekphrastic hope, fear, and indifference.

So far I have been treating the social structure of ekphrasis mainly as an affair between a speaking/seeing subject and a seen object. But there is another dimension to the ekphrastic encounter that must be taken into account, the relation of the speaker and the audience or addressee of the ekphrasis.[34] The ekphrastic poet typically stands in a middle position between the object described or addressed and a listening subject who (if ekphrastic hope is fulfilled) will be made to "see" the object through the medium of the poet's voice. Ekphrasis is stationed between two "othernesses," and two forms of (apparently) impossible translation and exchange: (1) the conversion of the visual representation into a verbal representation, either by description or ventriloquism; (2) the reconversion of the verbal representation back into the visual object in the reception of the reader. The "working through" of ekphrasis and the other, then, is more like a triangular relationship than a binary one; its social structure cannot be grasped fully as a phenomenological encounter of subject and object, but must be pictured as a *ménage à trois* in which the relations of self and other, text and image, are triply inscribed. If ekphrasis typically expresses a desire for a visual object (whether to possess or praise), it is also typically an offering of this expression as a gift to the reader.[35]

The fullest poetic representation of the ekphrastic triangle is probably to be found in the Greek pastoral or, to use Theocritus's term, "idylls" ("little pictures"). These poems often present singing contests between male shepherds who regale each other with lyric descriptions of beautiful artifacts and women and who exchange material gifts as well. As Joshua Scodel notes:

> The art objects used as gifts or prizes may be read as the rewards poets should receive for their productions-honor, fame, money,etc.—and the ekphrastic description asserts poetry's worth by showing that poetry

34. I am grateful, once again, to Joshua Scodel for pointing out that this matter was not sufficiently thematized in early drafts of this essay.

35. One might think of the psychoanalytic process of dream interpretation as a staging of the ekphrastic scene in which the manifest visual content of the dream is the ekphrastic object, the analysand is the ekphrastic speaker, and the analyst is the reader/interpreter.

can indeed "capture" in and receive such valuable things. But the ekphrastic objects are normally treated as compensatory substitutes for the unfulfilled desire for a female Other. . . . the ekphrastic object registers both the woman that the poet cannot capture in poetry and the possibility of another, beneficent relationship between a poet and his male audience.[36]

I'm not suggesting that the triangle of ekphrasis invariably places a feminized object "between men" (to echo Eve Sedgwick's memorable study of the "exchange of women"). Bob and Ray's photographs are enjoyed by them in common, in an intimate male friendship that excludes (while pretending to include) their entire audience. Whatever specific shape the ekphrastic triangle may take, it provides a schematic metapicture of ekphrasis as a social practice, an image that can now be tested on a number of texts.

Cups and Shields: Ekphrastic Poetry

The earliest examples of ekphrastic poetry are not, it seems, principally focused on painting, but on utilitarian objects that happen to have ornamental or symbolic visual representations attached to them. Goblets, urns, vases, chests, cloaks, girdles, various sorts of weapons and armor, and architectural ornaments like friezes, reliefs, frescos, and statues *in situ* provide the first objects of ekphrastic description, probably because the detachment of painting as an isolated, autonomous, and moveable object of aesthetic contemplation is a relatively late development in the visual arts. The functional context of ekphrastic objects is mirrored in the functionality of ekphrastic rhetoric and poetry as a subordinate feature of longer textual structures. Ekphrastic poetry originates, not as an independent verbal set-piece, but as an ornamental and subordinate part of larger textual units like the epic or pastoral. Homer, as Kenneth Atchity points out, develops the significance of his hero "by associating Achilles, in one place or another, with nearly every . . . kind of artifact in the Iliadic world. Like Priam and Hekabe, Achilles stores his treasures in a splendid ["elaborately wrought"] chest; like Nestor, he possesses a remarkably ["wrought"] goblet."[37] Occasionally one of these objects is singled

36. Joshua Scodel, correspondence with the author.

37. Kenneth Atchity, *Homer's Iliad: The Shield of Memory* (Carbondale, IL: Southern Illinois University Press, 1978), p. 158. See also Marc Eli

out for special attention and extended description, and these occasions are the putative "origin" of ekphrasis.

I'd like to begin, however, not at the origin, but with a very late and pure example of ekphrastic poetry, Wallace Stevens's "Anecdote of a Jar."

> I placed a jar in Tennessee,
> And round it was, upon a hill.
> It made the slovenly wilderness
> Surround that hill.
>
> The wilderness rose up to it,
> And sprawled around, no longer wild.
> The jar was round upon the ground
> And tall and of a port in air.
>
> It took dominion everywhere.
> The jar was gray and bare.
> It did not give of bird or bush,
> Like nothing else in Tennessee.

Stevens's poem provides an allegory and a critique of its own generic identity and might almost be seen as a parody of the classical ekphrastic object. The jar appears, not as a crucial feature of an epic narrative, an ornament to a pastoral drama, or even a focus for elevated lyric meditation. Instead, the jar is the principal actor in a mere "anecdote," literally, an "unpublished," private story that is "not given out" and the tone of which would have to be described as impassive, neutral, and unforthcoming. The jar is stripped, moreover, of all the features that constitute the generic expectations of ekphrasis. There are no "elaborately wrought" ornaments, no pictured scenes or "leaf-fringed legends" of God or man, only the purely functional made object, a simple "commodity" in all its prosaic lack of splendor. Indeed, the apparent lack of visual representation on the urn might lead us to rule this out of the genre of ekphrasis altogether, at least from that central tradition of ekphrasis devoted to the description of aesthetic objects. It is as if Stevens were testing the limits of the genre, offering us a blank space where we expect a picture, a cipher in the place of a striking figure, a piece of refuse or litter where we look for art.

Blanchard, "In the World of the Seven Cubit Spear: The Semiotic Status of the Object in Ancient Greek Art and Literature," *Semiotica* 43, nos. 3/4 (1983): 205–44.

And yet the emphasis on the shape, appearance, and what can only be described as the "activity" of the jar make it clear that this is no "mere" object, but a highly charged *form* and a representational form at that. If the jar negates the classical expectation of ornamental design or representational illusion, it alludes quite positively to the whole topos of the personified artifact and, specifically, the biblical trope of man as a clay vessel and God as the potter: "we are the clay, and thou our potter; and we are all the work of thy hand" (Isaiah 64:8). The creation of Adam (whose name means clay) out of the dust of the ground is the making of a human "vessel" into which life may be breathed. Stevens simply literalizes the biblical metaphor, or reverses the valence of tenor and vehicle: instead of man-as-jar, jar-as-man—a jar that (like Adam) stands solitary and erect on a hilltop, organizes the wilderness, and "takes dominion everywhere." Stevens also replaces the role of the creating deity, god-as-potter, with something more like a detached observer and "distributor." The narrator does not make the jar; he "places" it; he doesn't show the production of the ekphrastic object (as in Homer's description of Achilles' shield) but its distribution and influence; and he doesn't place it in a new world or a wilderness, but "in Tennessee," a world already named, mapped, and organized. If "Adam" as vessel is reduced to a personified commodity, a barren jar, "God" the speaker/viewer is reduced to a traveling salesman with a sense of irony and order.

The jar's role as a kind of empty relay point or site of commerce and exchange is signaled by its characterization as "a port in air," and Stevens employs it to exemplify three forms of alterity and difference in its relation to its "world" and to the poet: (1) the difference between the human and the natural (the jar is "like nothing else in Tennessee"); (2) between the divine and the human (suggested by the allusion to the biblical creation myth); and (3) between the human and its own artificial productions. And yet each of these forms of otherness is simultaneously overcome: the "slovenly wilderness" (which is already "Tennessee") is made to "surround" the jar in imitation of its roundness; the creaturely subject becomes a sovereign; and the static, spatial image of ekphrastic description is temporalized as the principal actor in a narrative. The poem stages for us the basic project of ekphrastic hope, the transformation of the dead, passive image into a living creature. It does not witness this transformation as a fulfillment of hope, however, but as something more like a spectacle that induces a stunned, laconic ambivalence in the speaker, a kind of suspension between ekphrastic indifference and fear. The jar is, despite all the connotations of orderliness and aesthetic formality that

commentators usually celebrate, a kind of idol or fetish, a made object that has appropriated human consciousness. There is something menacing and slightly monstrous about its imperious sterility ("It did not give of bird or bush / Like nothing else in Tennessee.") The double negatives ("did not give" / "Like nothing") perfectly enact the power of the ekphrastic image as intransigent Other to the poetic voice, its role as a "black hole" in the text. Is the jar simply barren and infertile, as empty within as it is "gray and bare" on its surface? Or is it the womb of a more active negation, a "port" that "gives of" an empire of nothingness, fruitfully multiplying its own sterility throughout its dominions? And what, we must ask, does the poet give the reader? Perhaps an "anecdote" that not only refuses to "give itself out," but actively negates every expectation of ekphrastic pleasure.

As the metaphors of barrenness and fertility suggest, there is just a hint of the feminine in Stevens's jar, and the treatment of the ekphrastic image as a female other is a commonplace in the genre. I've already suggested that female otherness is an overdetermined feature in a genre that tends to describe an object of visual pleasure and fascination from a masculine perspective, often to an audience understood to be masculine as well. Ekphrastic poetry as a verbal conjuring up of the female image has overtones, then, of pornographic writing and masturbatory fantasy (the image of the jar as both "round upon the ground" and "tall and of a port in air" lends it an equivocal status as a kind of "phallic womb," as if the jar were both the erection and the visual image that provokes it). Rousseau's *Confessions* provides the classic account of masturbation and visuality: "This vice . . . has a particular attraction for lively imaginations. It allows them to dispose, so to speak, of the whole female sex at their will, and to make any beauty who tempts them serve their pleasure without the need of first obtaining her consent."[38] Rousseau "fondling her image in [his] secret heart" is like the male poet or reader fondling the mental image of ekphrasis, indulging the pleasures of voyeurism, actual or remembered.

This, at any rate, is one of the mechanisms of ekphrastic hope, but it rarely occurs without some admixture of ekphrastic fear, as we

38. Jean-Jacques Rousseau, *Confessions* (1781), translated by J. M. Cohen (New York: Penguin Books, 1953), p. 109. See Marcelin Pleynet, *Painting and System,* p. 153, for a suggestion that Freud's analysis of the relation between narcissism, scopophilia, and auto-eroticism "merits formalization within the field of an approach to painting." Cp. Freud, "Instincts and Their Vicissitudes," in *Collected Papers* (London: Hogarth, 1949), vol. 4, p. 66.

have seen in Stevens's image of the jar. The voyeuristic, masturbatory fondling of the ekphrastic image is a kind of mental rape that may induce a sense of guilt, paralysis, or ambivalence in the observer. A good example of voyeuristic ambivalence is the divided voice in William Carlos Williams's "Portrait of a Lady," an ekphrastic poem that may be an address to a woman who is compared to a picture, or a woman in a picture:

> Your thighs are appletrees
> whose blossoms touch the sky.
> Which sky? The sky
> where Watteau hung a lady's
> slipper. Your knees
> are a southern breeze—or
> a gust of snow. Agh! what
> sort of a man was Fragonard?
> —as if that answered
> anything. Ah, yes—below
> the knees, since the tune
> drops that way, it is
> one of those white summer days,
> the tall grass of your ankles
> flickers upon the shore—
> Which shore?—
> the sand clings to my lips—
> Which shore?
> Agh, petals maybe. How
> should I know?
> Which shore? Which shore?
> I said petals from an appletree.

The intrusive questioning voice may be that of the addressed woman, or of the poet's unconscious, or of the poem's implied reader, impatiently interrupting the ekphrasis to demand more clarity and specificity. In either case, the voice resists the smooth, pleasurable fondling of the ekphrastic image, the sensuous contemplation of the woman's body, mediated through the familiar metaphors of fruit, blossoms, petals, wind, and sea. It helps, of course, to know that the poem probably alludes to Fragonard's *The Swing*, a sensuous rococo pastoral depicting a young swain delightedly looking up the dress of a young woman on a swing. Williams may be projecting his voices into this picture, imagining a kind of dialogue between the swinging maiden and the youthful voyeur. Whether this painting is to be under-

stood as the scene of the poem or only as a passing comparison to a real scene, the ambivalence of voyeurism—the desire to see accompanied by a sense of its prohibition—seems to underlie the dissonance of the two voices. The discreet, metaphorical evasions of "thighs" as "appletrees / whose blossoms touch the sky" is immediately countered by an insistence on explicit literalness: "Which sky?" The answer, of course, can only be the heaven to which the young man wants to ascend, deferred figuratively as a sky in yet another painting, "where Watteau hung a lady's slipper." The speaker can even find a figure for his own ambivalence between hot desire and cold diffidence in his response to her "knees" as a "southern breeze—or / a gust of snow." The movement of the speaker's gaze and of his "tune" follows the line of discretion and diffidence: from thighs whose "blossoms" touch the sky, the "tune drops" to knees, ankles, and the "shore" on which those ankles "flicker." As in Freud's primal scene of fetishism, the boy's gaze finds something threatening in the female image (for Freud, the woman's lack of a penis threatens the boy with the possibility of castration), so he must find metonymic or metaphoric substitutes—a lady's slipper "hung" in the sky; a seashore where the poet seems to fall on his face, the sand clinging to his lips.[39] The more intricate the metaphorical evasions, the more insistent the voice of literal desire, demanding to know "which sky?" "which shore?" and the more fixated and repetitious the poetic voice. The fetishist finally returns to the first substitute image he seized upon, rejecting the traditional fetish-objects of slippers and feet in favor of the initial metaphor of the poem: "I said petals from an appletree."[40]

The most famous instance of ekphrastic ambivalence toward the female image is Keats's "Ode on a Grecian Urn," which presents the ekphrastic object as a potential object of violence and erotic fantasy: the "still unravish'd bride" displays scenes of "mad pursuit" and "struggle to escape." Yet all this "happy, happy love" adds up to a sterile, desolate perfection that threatens the adequacy of the male voice (the urn can "express a flowery tale more sweetly than our rhyme") and "teases us out of thought." Keats may call the urn a "friend to man," but he treats her more like an enemy who only

39. "Fetishism" (1927) in *The Complete Psychological Works of Sigmund Freud*, translated by James Strachey (London: Hogarth, 1961), 21:152–57.

40. "The foot or the shoe owes its preference as a fetish—or a part of it—to the circumstance that the inquisitive boy peered at the woman's genitals from below, from her legs up" (Freud, Complete *Works*, 21:155).

shows up at funerals ("in midst of other woe"), where she pipes the repetitious and comfortless ditty of no tone, "Truth is beauty, beauty truth / That is all ye know on earth and all ye need to know." Perhaps the scholarly controversy over the boundary between what the urn says and what Keats says reflects a kind of ekphrastic disappointment. If the poet is going to make the mute, feminized art object speak, he could at least give her something interesting to say.[41]

A more compelling strategy with the ekphrasis of the female image is suggested by Shelley's manuscript poem, "On the Medusa of Leonardo Da Vinci in the Florentine Gallery." I'm not saying this is a better poem than "Ode on a Grecian Urn," but I do think it lays bare the ekphrastic anxieties that underlie the urn:

> It lieth, gazing on the midnight sky,
> Upon the cloudy mountain-peak supine;
> Below, far lands are seen tremblingly,
> Its horror and its beauty are divine.
> Upon its lips and eyelids seems to lie
> Loveliness like a shadow, from which shine,
> Fiery and lurid, struggling underneath,
> The agonies of anguish and of death.
>
> Yet it is less the horror than the grace
> Which turns the gazer's spirit into stone,
> Whereon the lineaments of that dead face
> Are graven, till the characters be grown
> Into itself, and thought no more can trace;
> 'Tis the melodious hue of beauty thrown
> Athwart the darkness and the glare of pain,
> Which humanize and harmonize the strain.
>
> And from its head as from one body grow,
> As [river] grass out of a watery rock,
> Hairs which are vipers, and they curl and flow
> And their long tangles in each other lock,
> And with unending involutions show
> Their mailed radiance, as it were to mock
> The torture and the death within, and saw
> The solid air with many a ragged jaw.

41. I've always found Kenneth Burke's rewriting of this line as "Body is turd, turd body" the best antidote to Keats's ending.

And from a stone beside, a poisonous eft
Peeps idly into those Gorgonian eyes;
Whilst in the air a ghastly bat, bereft
Of sense, has flitted with a mad surprise
Out of the cave this hideous light had cleft,
And he comes hastening like moth that hies
After a taper, and the midnight sky
Flares, a light more dread than obscurity.

'Tis the tempestuous loveliness of terror,
For from the serpents gleams a brazen glare
Kindled by that inextricable error,
Which makes a thrilling vapour of the air
Become a [dim] and ever-shifting mirror
Of all the beauty and the terror there—
A woman's countenance, with serpent-locks,
Gazing in death on Heaven from those wet rocks.

If ekphrastic poetry has a "primal scene," this is it. Shelley's Medusa is not given any ventriloquist's lines. She exerts and reverses the power of the ekphrastic gaze, portrayed as herself gazing, her look raking over the world, perhaps even capable of looking back at the poet. Medusa is the image that turns the tables on the spectator and turns the spectator into an image: she must be seen through the mediation of mirrors (Perseus' shield) or paintings or descriptions. If she were actually beheld by the poet, he could not speak or write; if the poet's ekphrastic hopes were fulfilled, the reader would be similarly transfixed, unable to read or hear, but perhaps to be imprinted with alien lineaments, the features of Medusa herself, the monstrous other projected onto the self.

Medusa is the perfect prototype for the image as a dangerous female other who threatens to silence the poet's voice and fixate his observing eye. Both the utopian desire of ekphrasis (that the beautiful image be present to the observer) and its counterdesire or resistance (the fear of paralysis and muteness in the face of the powerful image) are expressed here. All of the distinctions between the sublime and the beautiful, the aesthetics of pain and pleasure, or of the masculine and the feminine, that might allow ekphrasis to confine itself to the contemplation of beauty are subverted by the image of Medusa. Beauty, the very thing which aestheticians like Edmund Burke thought could be viewed from a safe position of superior strength, turns out to be itself the dangerous force: "it is less the horror than the grace" that paralyzes the observer. Medusa fully epitomizes the ambivalence

that Keats hints at: instead of "teasing us out of thought" with a paralyzing eternity of perfect desolation, she paralyzes thought itself, first, by turning "the gazer's spirit into stone," and then by engraving the lineaments of the Gorgon onto the beholder's petrified spirit, "till the characters be grown / Into itself, and thought no more can trace."[42] If ekphrasis, as a verbal representation of a visual representation, is an attempt to repress or "take dominion" over language's graphic Other, then Shelley's Medusa is the return of that repressed image, teasing us out of thought with a vengeance.

Shelley's own voice and text, however, seem designed to deconstruct, not just the repression of Medusa, but the genre of ekphrasis as a verbal strategy for repressing/representing visual representation. The text seems to struggle to efface itself and any other "framing" elements that might intervene between the reader and the image: that this is a painting is mentioned only in the title; after that, Medusa is described as if she were directly present to the poetic observer, and Leonardo's painterly authority vanishes (in fact, as Shelley may have known, the painting was not by Leonardo).[43] Roles of verbal authority like Stevens's anecdotal narrator, or Keats's apostrophizing poet are eschewed in favor of the purest, most passive sort of description. The speaking and seeing subject of this poem does not speak of or (in a sense) even *see* Medusa or the painting in which she is represented (figure 29): the opening three words appropriate both these roles: "It lieth, gazing." Medusa, the supposed "seen object" of the poem, is presented as herself the active gazer; other possible "gazers" on this spectacle are presented as passive recipients. The voice of the poem is simply a passive recorder, an "ever-shifting mirror" that traces the "unending involutions" of its subject. The pun on "lieth" suggests that the mute ekphrastic object awaiting the ventriloquism of the poetic voice already has a voice of its own.

Medusa is not personified or "given a voice," therefore, to dictate her own story: that would simply amount to a reinscription of poetic authority in the speaker. Instead, the subject of the poem remains irrevocably Other, an "it" that can only "be described" by an anonymous, invisible, and passive poet who has himself been imprinted by Medusa. "It" is the principal agent in the frozen action of the poem;

42. See Carol Jacobs, "On Looking at Shelley's Medusa," *Yale French Studies* 69 (1985): 163–79, for a good reading of this passage.

43. See Neville Rogers, "Shelley and the Visual Arts," *Keats-Shelley Memorial Bulletin* 12 (1961): 16–17.

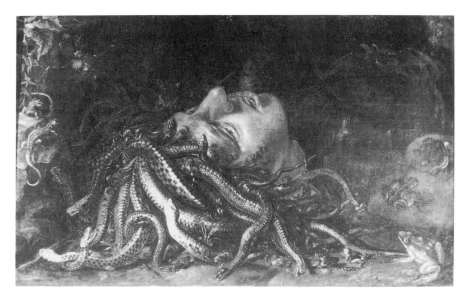

29. Leonardo's *Medusa*. Alinari/Art Resource, NY.

" 'Tis" and "Yet 'tis" are its favorite predications. It is as if Being itself were describing itself in and inscribing itself on Shelley's text.

But it is not just the ahistorical and mythic presence of Medusa that Shelley contemplates in this poem. Medusa was a potent image in British cultural politics in the early nineteenth century, deployed as an emblem of the political Other, specifically the "glorious Phantom" of revolution, which Shelley (like many other radical intellectuals) was prophesying in 1819.[44] The use of the female image of revolution was, of course, a commonplace in nineteenth-century iconography, Delacroix's bare-breasted *Liberty Leading the People* being the most familiar example. This was an image that could be conjured with by both radicals and conservatives: Burke caricatured the revolutionaries of the 1790s as a mob of transvestites and abandoned women, comparing them to "harpies" and "furies" reveling in "Thracian orgies"; Shelley, twenty-five years later, could visualize his revolutionary avenging angel as "some fierce Maenad" whose "bright hair uplifted from the head" is "the locks of the approaching storm," an image

44. See Jerome McGann, "The Beauty of Medusa: A Study in Romantic Literary Iconology," *Studies in Romanticism* 11 (1972): 3–25.

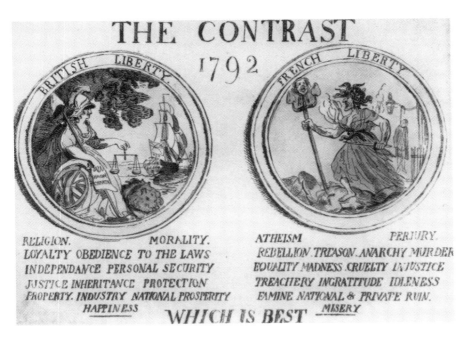

30. *The Contrast*, 1792. Emblems of Athena and Medusa, or British Happiness versus French Misery.

that suggests a link between the menacing locks of Medusa and the orgiastic women of Burke's reactionary fantasies.

But Shelley would not have needed to go to Burke to compose his image; Medusa was, as Neil Hertz has shown, a popular emblem of Jacobinism and was often displayed (figure 30) as a figure of "French Liberty" in opposition to "English Liberty," personified by Athena, the mythological adversary of Medusa.[45] The choice of Medusa as a revolutionary emblem seems, in retrospect, quite overdetermined. To conservatives, Medusa was a perfect image of alien, subhuman monstrosity—dangerous, perverse, hideous, and sexually ambiguous: Medusa's serpentine locks made her the perfect type of the castrating, phallic woman, a potent and manageable emblem of the political Other. To radicals like Shelley, Medusa was an "abject hero," a victim of tyranny whose weakness, disfiguration, and mon-

45. Neil Hertz, "Medusa's Head: Male Hysteria Under Political Pressure," *Representations* 4 (Fall 1983): 27–54.

strous mutilation become in themselves a kind of revolutionary power. The female image of ekphrasis is not an object to be caressed and fondled with contemplative ambivalence like Keats's Urn, Stevens's Jar, or Williams's Lady, but a weapon to be wielded. (Athena's shield or "aegis" is decorated with the head of Medusa, the perfect image to paralyze the enemy.) But this weapon is already latent in the masturbatory fantasies of ekphrastic beauty and shapelessness: it is simply the aggressive, exhibitionist answer to the voyeuristic pleasure staged in ekphrastic urns and jars. Freud's comments on Medusa are worth quoting here:

> If Medusa's head takes the place of the representation of the female genitals, or rather if it isolates their horrifying effects from the pleasure-giving ones, it may be recalled that displaying the genitals is familiar in other connections as an apotropaic act. What arouses horror in oneself will produce the same effect upon the enemy against whom one is seeking to defend oneself. We read in Rabelais of how the Devil took to flight when the woman showed him her vulva.[46]

Understood as what Gombrich calls an "apotropaic image," a deadly, monstrous, paralyzing spectacle, the visual image of ekphrasis is properly located, not on an urn or jar, but on a shield which may be displayed to the enemy while protecting its bearer. It seems entirely fitting, then, that the canonical "origin" of classical ekphrasis is the description of Achilles' shield in the 18th book of the *Iliad*. What is odd about Achilles' shield in this context, however, is that it does not contain an apotropaic image, but an encyclopedic vision of the Homeric world, filled with narrative scenes rather like those we find on Keats's urn. Achilles' shield does not paralyze its beholders with a frightful monstrosity, but overawes them with its impression of divine artifice, an emblem of the irresistible destiny of its bearer. The shield is a perfectly balanced image of fear and hope, serving both as a "beacon" to rally the Achaeans and as a spectacle to dazzle the enemy ("Trembling took hold of all the Myrmidons. None had the courage to look straight at it.") Indeed, it's not clear that anyone in the poem actually examines the shield. Achilles is just happy to have such formidable equipment, and the blind Homer of course can't claim to have seen it. He is just repeating what he has heard from the muses. The image on Achilles' shield is really for us, the readers and listeners who

46. "Medusa's Head," in *Sexuality and the Psychology of Love*, p. 212. quoted in Hertz, p. 30. Hertz notes the re-enactment of female exhibitionism as a revolutionary weapon in the Paris uprisings in June 1848.

are given time, by virtue of ekphrasis, to look at its production and appearance in detail.[47]

As a generic prototype, Achilles' shield has a capacity to focus ekphrastic fear and hope in the reader as well. For the tradition of literary pictorialism, Homer's set-piece certifies the ancient pedigree of ekphrasis and provides a model for poetic language in the service of pictorial representation. For antipictorialists, the passage is a problem to be explained away. Lessing, for instance, treats the shield not as a prototype of ekphrasis, but as an alternative to it. The distinctive feature of Homer's description is that it is not really a descriptive "arresting of movement" at all, but a continuation of the narrative:

> Homer does not paint the shield finished, but in the process of creation. Here again he has made use of the happy device of substituting progression for co-existence, and thus converted the tiresome description of an object into a graphic picture of an action. We see not the shield, but the divine master-workman employed upon it. (p. 114)

An apostle of ekphrastic hope like Jean Hagstrum must, of course, dispute Lessing's argument:

> This is not, as Lessing believed, the presentation of an action or a process. The reader's attention is made to concentrate on the object, which is described panel by panel, scene by scene, episode by episode. It is remarkable how the eye is held fast to the shield. (p. 19)

Let's look for ourselves at a representative sample of this passage:

> He made the earth upon it, and the sky, and the sea's water,
> and the tireless sun, and the moon waxing into her fullness,
> and upon it all the constellations that festoon the heavens,
> the Pleiades and the Hyades and the strength of Orion
> and the Bear, whom men give also the name of the Wagon,
> who turns about in a fixed place and looks at Orion
> and she alone is never plunged in the wash of the Ocean.

This passage can, in fact, be mobilized to support either Lessing or Hagstrum, or perhaps neither. If we insist on thinking of this passage as an occasion for visualization, it seems clear that the reader is stationed in a position to move freely from visualizations of Hephaestos at work to the images on which he works, and equally free to see the images in motion or at rest. The passage equivocates between the categories of time and space, like the image of "the Bear . . . who

47. My thanks to Joshua Scodel for pointing this out.

turns about in a fixed place." The question is one of foreground and background, or scene and frame, or the emphasis imposed by the reader's desire: certainly the god's activity frames each scene, bracketing its descriptive noun phrases with the predicates of making. Just as certainly, the made object seems always already to be completed, even as it comes into being. The same ambiguity arises when we fix our eye on the images themselves. Cedric Whitman notes that "one is not sure whether the pictures on the shield are static or alive. Homer, in fact, is not quite sure just what kind of pictures are made by Hephaestos, whose golden automata have mind and move by themselves."[48] The supposedly "static" images that Lessing wants to temporalize with the verbs of making, and which Hagstrum wants to "hold fast" in the mind's eye, are already in motion, already narrativized, as Hagstrum's own phrase, "episode by episode," should suggest. A similar undecidability characterizes the description of the materials of the shield, and the objects those materials signify:

> . . . The oxen turned in the furrows,
> straining to come to the end of the new-ploughed land;
> all lay black behind them, and looked like ploughed soil,
> yet it was gold; indeed, a very wonder was wrought.

Homer's whole point seems to be to undermine the oppositions of movement and stasis, narrative action and descriptive scene, and the false identifications of medium with message, which underwrite the fantasies of ekphrastic hope and fear. The shield is an imagetext that displays rather than concealing its own suturing of space and time, description and narration, materiality and illusionistic representation.[49] The point of the shield from the reader's perspective is thus quite distinct from its function for those who behold it within the fiction. We are stationed at the origin of the work of art, at the side of the working Hephaestos, in a position of perceptual and interpretive freedom. This is a utopian site that is both a space within the narrative, and an ornamented frame around it, a threshold across which the reader may enter and withdraw from the text at will.

The double face of Achilles' shield becomes even more evident when we ask what its imagery represents as a whole, how it functions in the *Iliad,* and what its status is as the "parent" or prototype of a genre called ekphrasis. Lessing, of course, wants to deny the existence

48. Cedric Whitman, *Homer and the Heroic Tradition* (Cambridge, MA: Harvard University Press, 1958), p. 205.

49. See chapter 3, footnote 14, for a discussion of image-text suturing.

of ekphrasis as a proper genre, a separable, identifiable poetic kind. Achilles' shield cannot be separated from its place in the epic; to emulate this sort of set-piece as an independent literary kind is to produce exactly the sort of visual fixation he fears. Even within an epic context, ekphrasis threatens to separate itself, as it does, according to Lessing, in Virgil's description of the shield of Aeneas. The *Aeneid* wrongly separates the making of the shield from Aeneas's viewing of it, thus producing an image framed by predicates of vision ("admires"; "are seen") and plain indicatives ("here is"; "there is"; "near by stands").[50] Lessing's rhetoric of blame for this practice is worth quoting:

> The shield of Aeneas is therefore, in fact, an interpolation, intended solely to flatter the pride of the Romans; a foreign brook with which the poet seeks to give fresh movement to his stream. The shield of Achilles, on the contrary, is the outgrowth of its own fruitful soil.

The link between ekphrasis and otherness could not be clearer. Ekphrasis is, properly, an ornament to epic, just as Hephaestos's designs are an ornament to Achilles' shield. But ekphrastic ornament is a kind of foreign body within epic that threatens to reverse the natural literary priorities of time over space, narrative over description, and turn the sublimities of epic over to the flattering blandishments of epideictic rhetoric.

If Lessing could have seen the subsequent development of Homeric criticism, he would have found his worst fears justified. Not only did ekphrasis establish itself firmly as a distinct poetic genre, but the great prototype of Achilles' shield seems, in the work of modern classical scholarship imbued with assumptions of formalism, to have established a kind of dominance over the epic of which it is supposed to be a mere ornament. This is not just a question of the popularity of the passage as an object of teaching, research, and analysis. It also has to do with a sense of the function of the shield as an emblem of the entire structure of the *Iliad;* the shield is now understood as an image of the entire Homeric world-order, the technique of "ring composition" and geometrical patterning that controls the large order of the narrative, and the microscopic ordering of verse and syntax.[51] Indeed, the shield (and ekphrastic hope along with it) may have even

50. The indicatives cited here are the ones singled out by Lessing as "cold and tedious" (*Laocoon,* p. 116).

51. See Whitman, *Homer and the Heroic Tradition,* and Atchity, *Homer's Iliad: The Shield of Memory.*

more grandiose aspirations than this sort of synecdochical representation of the whole in the part, for the shield represents much more of Homer's world than the *Iliad* does.[52] The entire universe is depicted on the shield: nature and man; earth, sky, and ocean; cities at peace and at war; plowing, harvest, and vintage; herding and hunting; marriage, death, and even a scene of litigation, a prosaic alternative to the settlement of disputes by war or blood revenge. Achilles' shield shows us the whole world that is "other" to the epic action of the *Iliad,* the world of everyday life outside history that Achilles will never know. The relation of epic to ekphrasis is thus turned inside out: the entire action of the *Iliad* becomes a fragment in the totalizing vision provided by Achilles' shield.

Like Stevens's jar, Achilles' shield illustrates the imperial ambitions of ekphrasis to take "dominion everywhere." These ambitions make it difficult to draw a circle around ekphrasis, to draw any finite conclusions about its nature, scope, or place in the literary universe. Ekphrasis resists "placement" as an ornamental feature of larger textual structures, or as a minor genre. It aims to be all of literature in miniature, as Murray Krieger's reflections on the ekphrastic principle demonstrate. My own claim about ekphrasis would be both more and less sweeping. I don't think ekphrasis is the key to the difference between ordinary and literary language, but merely one of many figures for distinguishing the literary institution (in this case, by associating verbal with visual art). I do think ekphrasis is one of the keys to difference *within* language (both ordinary and literary) and that it focuses the interarticulation of perceptual, semiotic, and social contradictions within verbal representation. My emphasis on canonical examples of ekphrasis in ancient, modern and romantic poetry has not been aimed at reinforcing the status of this canon or of ekphrasis, but at showing how the "workings" of ekphrasis, even in its classic forms, tends to unravel the conventional suturing of the imagetext and to expose the social structure of representation as an activity and a relationship of power/knowledge/desire—representation as something done to something, with something, by someone, for someone. Stevens's jar, in my view, doesn't fulfill the poetic genre of ekphrasis so much as it implodes it, parodying the whole gesture of the utopian imagetext.

My examples are also canonical in their staging of ekphrasis as a

52. Cp. Marc Eli Blanchard, "World of the Seven Cubit Spear," p. 224: "The plot of the *Iliad,* underscored by the manufacture of the shield, has now become a decorative episode on the surface of the metal."

suturing of dominant gender stereotypes into the semiotic structure of the imagetext, the image identified as feminine, the speaking/seeing subject of the text identified as masculine. All this would look quite different, of course, if my emphasis had been on ekphrastic poetry by women. But the difference, I would want to insist, would not be simply readable as a function of the author's gender. The voice and "gaze" of the male, as Williams's "Portrait of a Lady" should make clear, is riddled with its own counter-voices and resistances, and no one is going to blame the Grecian urn for the banalities Keats forces her to utter.

The more important point is to see that gender is not the unique key to the workings of ekphrasis, but only one among many figures of difference that energize the dialectic of the imagetext. The alien visual object of verbal representation can reveal its difference from the speaker (and the reader) in all sorts of ways: the historical distance between archaic and modern (Keats's Urn); the alienation between the human and its own commodities (Stevens's Jar); the conflict between a moribund social order and the monstrous revolutionary "others" that threaten it (Shelley's Medusa); the gap between a historical epic obsessed with war and a vision of the everyday, nonhistorical order of human life that provides a framework for a critique of that historical struggle (Homer's Shield). It is also clear that the otherness of the ekphrastic image is not just defined by the subject matter of the visual representation, but also by the kind of visual representation it is (metal engravings and inlays on a shield; paintings on an urn; a rococo pastoral by Fragonard; an anonymous Renaissance oil painting; a plain, unadorned jar). I have not mentioned the verbal representation of other kinds of visual representation such as photography, maps, diagrams, movies, theatrical spectacles, nor reflected on the possible connotations of different pictorial styles such as realism, allegory, history painting, still-life, portraiture, and landscape, each of which carries its own peculiar sort of textuality into the heart of the visual image. This treatment of ekphrasis, then, like the typical ekphrastic poem, will have to be understood as a fragment or miniature.

NARRATIVE, MEMORY, AND SLAVERY

(for Hortense Spillers)

"I was cautioned not so long ago that 'we already know about slavery,' which amounts to saying that we can only look forward to repeating what everybody 'knows.' "
>—Hortense Spillers

"I have a survivalist intention to forget certain things."
>—Toni Morrison

"I do not remember to have ever met a slave who could tell of his birthday."
>—Frederick Douglass

"Description is *ancilla narrationis*, the ever-necessary, never-emancipated slave of narrative."
>—Gerard Genette

The natural place to start an investigation of narrative, memory, and slavery, I suppose, would be with that genre of literature known as "the slave narrative." Hundreds of American slave narratives survive from the nineteenth century.[1] Some of them, most notably Frederick Douglass's *Narrative of the Life of Frederick Douglass*, are acknowledged literary masterpieces. Taken together with the enormous outpouring of historical documents on the eco-

1. John Blassingame notes that a "staggering" number of first-person accounts of American slavery survive, not only in the form of full-length autobiographies, but in interviews and transcripts published in the abolitionist press. See his *Slave Testimony* (Baton Rouge: Louisiana State University Press, 1977), and *Slave Community* (2d ed., New York: Oxford University Press, 1979), p. 378.

nomics and sociology of slavery, the archive of American slave narratives provides unprecedented access into one of the great atrocities of modern history, an access to horror paralleled, perhaps, only by the body of holocaust survivor narratives. Slavery occupies a position in the American national memory similar to that of the Holocaust in German memory: it is that which we think we know about, what we can never forget, and which seems continually to elude our understanding.

I want to attempt a different starting place, one that comes at the problem from the standpoint of some formal problems in the construction of narratives, memories, and their interrelations and that circles back only very indirectly to the "main story" of slavery itself. I take this indirect route partly as a matter of professional competence: that is, I feel much better prepared to say something of substance about the construction of narrative and memory than I do about "slavery itself." But I also want to contribute, in a very minor way, to Hortense Spillers's gestures of resistance to the historical "knowledge industry" that has turned slavery into an object of "massive demographic and economic display," a phenomenon so well known that nothing more is to be known about it.[2] My subject, then, is not "slavery itself," but the representation of slavery in narrative and memory. More specifically, I want to examine the ways in which the descriptive aspects of narrative and the visual-spatial features of memory figure in accounts of servitude. The problem of this essay may be focused by contrasting it with the previous chapter's reflections on ekphrasis. The typical ekphrastic text might be said to speak to or for a semiotic "other"—an image, visual object, or spectacle—usually *in the presence* of that object. The point of view of the text is the position of a seeing and speaking subject in relation to a seen and usually mute object. But suppose the "visual other" was not merely represented by or "made to speak" by the speaking subject? Suppose that the "other" spoke for herself, told her own story, attempting an "ekphrasis of the self"? Suppose further that this "self" is a *former* self, not present to the speaker, but mediated and distanced by memory and autobio-

2. See Spillers's important essay, "Changing the Letter: The Yokes, the Jokes of Discourse, or, Mrs. Stowe, Mr. Reed," in *Slavery and the Literary Imagination*, edited by Deborah E. McDowell and Arnold Rampersad (Baltimore: Johns Hopkins Press, 1989), pp. 25–61. Spillers has been principally responsible for the critical redescription of slavery as a heterogeneous "spatio-temporal object" and a *"primarily* discursive" phenomenon that must be "reinvented" by "every generation of . . . readers" (pp. 28–29).

graphical transformation? What would it mean for the ekphrastic "object" to speak of and for itself in a former time, from the standpoint of a present in which it is no longer an object, but has become a subject? The answer, I will argue, is to be found in the nexus of narrative, memory, and slavery.

It is a commonplace in the criticism of slave narratives that description is the dominant rhetorical feature. Early reviewers of slave narratives regularly compare them to "windows" and "mirrors" which provide "transparent access" to slavery and are to be praised in proportion to the sense of "ocular conviction" they provide.[3] Although the title of George Bourne's *Picture of Slavery* is somewhat unusual, it typifies the dominance of visual, graphic metalanguages to describe slave narrative as assemblages of "scenes" and "sketches" linked in an episodic structure that confines temporality to particular "incidents."[4] This feature seems answerable both to the desire for

3. The visual emphasis is marked both at the level of inscription ("visible language" in the sense of chapter 4) and the level of description. The "act of writing," as Charles Davis and Henry Louis Gates note, was "considered the visible sign of reason," and one of the first questions to be asked about a slave narrative was whether it was *written* (as Frederick Douglass advertised his) by the narrator or transcribed by someone else. The ability to decipher "visible language," to *read*, is of course taken as an even more fundamental sign of freedom and rationality and is often presented in vivid scenes that Davis and Gates identify as "the figure of the talking book," the spectacle of the white master reading aloud. See *The Slave's Narrative*, edited by Charles T. Davis and Henry Louis Gates, Jr. (Oxford: Oxford University Press, 1985), pp. xxiii, xxvii. Davis and Gates document as well the need for skeptical Northern readers to be "ocularly convinced" by eyewitness accounts (p. 9), and the heavy emphasis on visual/visionary rhetoric: "The narrated, descriptive 'eye' was put into service as a literary form to posit both the individual 'I' of the black author, as well as the collective 'I' of the race. . . . The very *face* of the race . . . was contingent upon the recording of the black *voice*" (p. xxvi).

4. Early reviews of slave narratives testify to this rhetoric of transparency: "Through the well written life of such an individual, we can look in upon the character, condition, and habits of his class with as much clearness and confidence as through a window. . . . we think the reader will not retain, through many pages, a doubt of the perfect accuracy of its picture of slavery. If it is a mirror, it is of the very best plate glass, in which objects appear so clear and 'natural' that the beholder is perpetually mistaking it for an open window without any glass at all." Anonymous review of Charles Ball's *The Life and Adventures of a Fugitive Slave*, from the *Quarterly Anti-Slavery*

"eye witness authenticity," the "unvarnished truth," and to what James Olney has characterized as a severe limitation on slave narrative—the poverty of the whole genre with respect to complex plot devices or what Paul Ricoeur calls "configurational time," the large, complicated reflections on temporality and memory he finds in canonical Western narratives, particularly autobiography.[5]

The opening of Frederick Douglass's *Narrative* illustrates the dominance of visual and spatial codes and their relation to a sense of lack. Douglass begins by insisting that while he has exact knowledge of the place of his birth, he was systematically deprived of the knowledge of time ("I have no accurate knowledge of my age"). Temporal consciousness is a privilege of white children, of the master. Spatial consciousness, focused on place, on scene, on the sketching of "incidents" linked in an episodic structure is what is left to the slave to work with. The descriptive textual strategies associated with vision and space play a double role then, as symptoms of both lack and plenitude, erasure of time, memory, and history, and direct access to its sensory actuality.

The role of memory in slave narrative admits, similarly, of absolutely contradictory descriptions. On the one hand, it is a transparent window into past experience. James Olney suggests that there is "nothing doubtful or mysterious about memory" in slave narrative: "On the contrary, it is assumed to be a clear, unfailing record of events sharp and distinct that need only be transformed into descriptive language." Olney argues that memory is simply an instrumental feature of slave narrative, not a topic of reflection: "of course ex-slaves do exercise memory in their narratives, but they never talk about it as Augustine does, as Henry James does. . . . "[6] On the other hand, the transparent window seems to reveal strange gaps and blind

Magazine 1:4 (1836), reprinted in Davis and Gates, *The Slave's Narrative*, p. 6. See also William Andrews, *To Tell a Free Story* (Urbana: University of Illinois Press, 1986), p. 15, on the "spectacle" of the slave auction as a regular motif in slave narrative. Hortense Spillers also discusses the role of "iconism" and the "image crisis" in "Changing the Letter," p. 50.

5. James Olney, " 'I Was Born': Slave Narratives, Their Status as Autobiography and as Literature," in Davis and Gates, *The Slave's Narrative*, pp. 148–75. Olney remarks on "the nearly total lack of any 'configurational dimension' " in slave narrative and the lack of self-consciousness about memory, which is "a clear-glass, neutral" faculty that gives "a true picture of slavery as it really is" (p. 150).

6. Davis and Gates, *The Slave's Narrative*, p. 151.

spots.[7] There are indications of a blankness in memory so radical that it can't be described as forgetting, amnesia, or repression, but as the absolute *prevention* of experience, the excision not just of "memories" as a content, but the destruction of memory itself, either as an artificial technique or a natural faculty.[8] When Frederick Douglass opens his autobiography by saying "I do not remember to have ever met a slave who could tell of his birthday," we cannot read his words literally without noticing what Olney claims is unheard of in slave narrative, a complex reflection on memory and the very possibility of remembered experience.

Douglass seems at first to cast the radical blankness of slave consciousness in the moderated form of "forgetting," as if he might have met a slave who remembered his birthday, but has simply forgotten about it. The fact is that if Douglass had ever met a slave with such memories, he would certainly have remembered it. What he is really saying (we suppose) is that slavery is a *prevention* of memory: no slave was allowed to "remember" his birthday, either in the sense of knowing when it was or commemorating its annual return. But there is an even more literal sense in which, of course, no one, free or slave, can remember their birthday. Some experiences—birth, the origins of existence—certainly "happened" but are simply prior to the formation of memory. This literal reading erases the slave's difference from other human beings; none of us can "tell of" our birthdays in the sense of narrating a remembered experience. How could we remember a time before memory? What sense could "forgetting" have for a creature that lacks the faculty of memory?

7. William Andrews notes these gaps, but traces them to incapacity and lack: "When we find a gap in a slave narrator's objective reportage of the facts of slavery, or a lapse in his prepossessing self-image, we must pay special attention. These deviations may indicate either a loss of narrative control or a deliberate effort by the narrator to grapple with aspects of his or her personality that may have been repressed out of deference to or fear of the dominant culture" (*To Tell a Free Story*, p. 8). Again Douglass's *Narrative* indicates a counter possibility, that silence or "gaps" in the story may be a sign of resistance. Douglass explains his refusal to tell how he escaped from Maryland as a pragmatic issue (he wants to protect the routes available to other fugitive slaves) and as an act of literary discretion, a refusal of the pleasures of romance and adventure.

8. Cp. Houston Baker on the "extraordinary blankness" (Henry James's phrase) that links white and black American autobiography in the nineteenth century ("Autobiographical Acts and the Voice of the Southern Slave," in Davis and Gates, *The Slave's Narrative*, p. 243).

Yet Douglass's words pretend as if we could remember the immemorial. They conjure with the possibility of a memory of the blankness prior to the formation of memory. He doesn't say that no slave could tell of his birthday; only that he can't remember having met one. It could be that he has simply forgotten. Douglass plays here with two meanings of memory, the recollection of past experience by an individual, and the "passing on" ("telling") of memory from one person to another, as when we ask to be remembered to someone. There is a simple reason Douglass and other slaves had no (collective) memory of their birthdays. They were separated from the one person who might pass on this memory, who might connect the personal and social, the directly experiential and the mediated forms of memory, namely, the mother who would likely be the only one with exact knowledge of the birthday based on personal experience. By eliding in a single sentence the personal and intersubjective senses of memory, Douglass opens up the possibility of remembering a time before memory, in both senses. This impossible feat is exactly what it means, of course, to remember slavery—that is, to remember the time, not just of "forgetfulness" or amnesia, but to remember the time when there was nothing to remember with.

I hope this laborious reading of Douglass's sentence will have planted two suspicions: first, the notion that "there is nothing doubtful or mysterious about memory" in slave narrative is, like the related notion of descriptive transparency, an aspect of the ideological packaging of these writings and not an adequate account of the way they actually work. Perhaps this is only to remind ourselves of what is simply a truism in the contemporary analysis of cultural forms, that representation (in memory, in verbal descriptions, in images) not only "mediates" our knowledge (of slavery and of many other things), but obstructs, fragments, and negates that knowledge.[9] This isn't to say that we learn nothing from memory and narrative, but that their construction does not provide us with straightforward access to slavery or anything else. They provide something more like a site of cul-

9. Davis and Gates make exactly this point in their introduction to *The Slave's Narrative*, p. xi. Hortense Spillers testifies with considerable eloquence, however, to her ambivalence to "the spread-eagle tyranny of discursivity across the terrain of what we used to call, with impunity, 'experience' " ("Changing the Letter," p. 33). This ambivalence is, in my view, traceable to what Spillers shows to be the heterogeneity of discourse itself, its intersections with representation and iconicity.

tural labor, a body of textual formations that has to be worked through interminably.

The blankness of personal memory that Douglass evokes is matched by the collective, national amnesia about his subject after the Civil War. Slave narrative virtually disappeared from American cultural memory for over a century, surfacing only as grist for the mill of "history," or as an object-lesson in the poverty of subliterary genres (with Douglass always granted a grudging exceptional status).[10] In the last generation it has reappeared as the object of serious reading, and the present effort is an attempt to contribute to that reappearance, not so much by rereading the slave narratives themselves, but by using it to redescribe our picture of narrative and memory and the access or knowledge they mediate.

The second suspicion has to do with the relation of slave narrative to something called "Western autobiography," the canonical tradition that runs from Augustine to Rousseau to Henry Adams. Perhaps there are, after all, self-conscious reflections on memory in slave narrative if we only knew where to look. Or, more precisely, perhaps slave narrative teaches something fundamental about the nature of memory, something that might actually reflect on the strange turns of memory in the "master" narratives of Western autobiography, especially those forms of bourgeois and spiritual autobiography that were so important to the formation of slave narrative. "The truth of the master is in the slave."[11]

These suspicions about the transparency of description and memory are not doubts about the veracity of narrators, but about the perspicuity of readers and their illusion of access. The dilemma of our access to slave narrative is not new; it isn't a consequence of our historical distance from slavery, but is fundamental to the genre from its beginnings. Slave narrative is not just difficult to read, but in a literal sense, impossible to write. Impossible because the slave narrative is never literally that of a slave, but only of an ex-slave, already

10. See William Andrews, *To Tell a Free Story*, chapter 6, on the canonization of Douglass's *Narrative* at the expense of his second autobiography, *My Bondage and My Freedom*. Andrews's own master-narrative of the increasing literary sophistication of slave narrative as a movement toward "free storytelling" (p. xi) tends to reinforce the notion that the earlier narratives (including Douglass's) are less "readerly."

11. Jacques Derrida, "From Restricted to General Economy: A Hegelianism without Reserve," *Writing and Difference*, translated by Alan Bass (Chicago: University of Chicago Press, 1978), p. 255.

removed from the experience by time, forgetfulness, and often by editings, rewritings, interpolations by sentimental abolitionist transcribers. The slave narrative is always written by a former slave; there are no slave narratives, only narratives about slavery written from the standpoint of freedom. It is not even quite accurate to say that the slave narratives are "about" slavery; they are really about the *movement* from slavery to freedom. A narrative which was simply about slavery (like a narrative which was simply about freedom) is conceivable, but unlikely, and neither could find an author to "own" it as autobiography, as a record of an actual life. Actual narratives, like actual lives, always play off slavery against freedom, which is perhaps why *pure* slave narrative is both impossible and fundamental to the understanding of narrative as such.

Rather than talk of what we "know" about slavery, then, we must talk of what we are prevented from knowing, what we can never know, and how it is figured for us in the partial access we do have. This raises a question which goes beyond the genre of slave narrative to narrative modes of representation as such. Narrative seems to be a mode of knowing and showing which constructs a region of the unknown, a shadow text or image that accompanies our reading, moves in time with it, like Douglass's blankness, both prior to and adjacent to memory. It is a terrain crisscrossed by numerous internal borders, fringes, seams, and frontiers. This is not only a question of the "content" of the slave narrative, which invariably recites a moment (or several moments) of "crossing" or "passing" the frontiers that divide slavery from freedom or from one kind of slavery to another. Slave narrative is notable for its formal frontiers as well, its textual heterogeneity, its multiple boundaries and frames—prefaces, frontispieces, and authenticating documents.[12] But narrative in general is, as structuralism taught us long ago, a hybrid form, patching together different kinds of writing, different levels of discourse. It is the form of this heterogeneity, this difference, that solicits our attention when we look at the resistances and blockages, the boundaries we as readers must pass to get at something we call slavery.

The specific formal boundary we are concerned with here is canonical to narrative in general and crucial to slave narrative in par-

12. "The most obvious distinguishing mark is that it is an extremely mixed production. . . . " (Olney, "I Was Born," p. 151). See also Robert Burns Stepto on slave narrative as "an eclectic narrative form," in "I Rose and Found My Voice: Narration, Authentication and Authorial Control in Four Slave Narratives," in Davis and Gates, *The Slave's Narrative,* pp. 225–41.

ticular: Gerard Genette calls it the "frontier" between narration "proper," the unfolding of actions in time, and its improper twin, the mode of description, the rendering of a spatialized scene or state of affairs, often marked by a densely visual or multisensory rhetoric.[13] This is of course not the only frontier in narrative, nor necessarily the most important. The distinctions between diegesis and mimesis (telling the story and "miming" or performing it, as in dialogue) or discourse and narration are at least as important and more ancient than the description/narration distinction. It is, as Genette notes, a relatively recent and fragile distinction; from a strict structuralist standpoint, focusing on the semiotic fabric of the text, it is really a phantom distinction, with no really clear boundary between narrative and description.[14] Nevertheless, it seems to be part of the pragmatic metalanguage of stories (and especially of slave narrative), one of the ways the seamless web of textuality is crossed by the difference between temporal and spatial modes, visual and aural codes.

It will be obvious by now that the narration/description distinction has a strong connection with the medium of memory. It may seem odd to speak of memory as a medium, but the term seems appropriate in a number of senses. Since antiquity, memory has been figured not just as a disembodied, invisible power, but as a specific

13. Gerard Genette, "The Frontiers of Narrative," in *Figures of Literary Discourse*, translated by Alan Sheridan (New York: Columbia University Press, 1984). See also *Yale French Studies* special issue, "Toward a Theory of Description," 61:13 (Summer 1980), particularly the essays by Philippe Hamon and Michel Beaujour, which develop in great detail the metalanguage of description, the "figures of literary discourse" that describe the function of the descriptive.

14. The precise moment of the historical emergence of the narration-description distinction as an internal frontier of narrative form would be devilishly difficult to locate. Genette's sense that it is modern, or relatively recent, seems generally sound, and I'm tempted to identify it with the rise of the novel and the emergence of secular subjectivity as a central feature of narrative. Certainly the "visual/aural" difference that might be linked with the descriptive interpolation can take other forms. Thucydides division of his *Peloponnesian War* into eyewitness descriptions of actions and orally remembered set-speeches (what he calls "erga" and "logoi"; cp. chapter 3) produces this cut in a radically different way, one that is congruent with the diegesis/mimesis distinction. But one would also want to take into account certain powerful precedents such as the tradition of ekphrasis, set-piece descriptions of special objects, works of art, and visual scenes in epic. See chapter 4 on ekphrasis.

technology, a mechanism, a material and semiotic process subject to artifice and alteration.[15] More specifically, memory takes the form in classical rhetoric of a dialectic between the same modalities (space and time), the same sensory channels (the visual and aural), and the same codes (image and word) that underlie the narrative/descriptive boundary.[16] That is, the classical memory technique is a way of reconstructing temporal orders by mapping them onto spatial configurations (most notably architectural structures, with various "loci" and "topoi" or "memory places" inhabited by striking images and sometimes even words); it is also a way of mapping an oral performance, an oration from memory, onto a visual structure. Memory, in short, is an imagetext, a double-coded system of mental storage and retrieval that may be used to remember any sequence of items, from stories to set speeches to lists of quadrupeds.

Now it might be objected here that it is inappropriate to connect the ancient memory systems of classical rhetoric with the problematics

15. The classic study here is, of course, Frances Yates, *The Art of Memory* (Chicago: University of Chicago Press, 1966). See also Mary Carruthers's excellent study, *The Book of Memory: A Study of Memory in Medieval Culture* (Cambridge: Cambridge University Press, 1990). Carruthers notes the persistence of the key figures of memory (the wax tablet or writing surface, the storage box, and the visual/pictorial impression) well beyond antiquity. She also argues convincingly against the "current opinion that there are radical differences between 'oral culture' (based upon memory) and 'literate culture' (based upon writing)" (p. 16). Carruthers also corrects the impression left by Frances Yates that "artificial memory" was an "occult" rather than "commonplace" tradition after antiquity (p. 258). For a broad survey of mnemic phenomena, see Edward Casey, *Remembering: A Phenomenological Study* (Bloomington: Indiana University Press, 1987), and for an important study of treatments of memory in ancient and modern philosophy (roughly, Plato through Derrida), see David Farrell Krell, *Of Memory, Reminiscence, and Writing* (Bloomington: Indiana University Press, 1990).

16. See Frances Yates, *The Art of Memory*, for a magisterial account of the ancient memory systems as "imagetexts." The key move in Yates's account is her noticing that the legendary inventor of the art of memory, Simonides of Ceos, is also credited with originating the *ut pictura poesis* tradition (see p. 28). David Krell discusses the comparison of the soul to an illustrated book in Plato's *Philebus*, noting that the soul contains two "artists," an "internal scribe" and a "painter . . . who comes after the writer and paints in the soul icons of these discourses. . . . Thus the graphics of the soul . . . include the incising of both words and pictures. . . . " (see *Memory, Reminiscence, and Writing*, p. 46).

of memory in slave narrative. The problem isn't only one of anachronism (shouldn't one have a "history of memory" that would reconstruct the appropriate models for memory in the nineteenth century), but also of "fit." The ancient memory systems are artificial, cultivated techniques designed as aids to public verbal performance; the modern sense of memory treats it as something more like a natural faculty, an aspect of private consciousness. The appropriate terms for this kind of memory would seem to be located in psychology rather than rhetoric. Insofar as this essay has an argument to make about memory, it would dispute every one of these objections. The difference between "artificial" and "natural" memory was regarded as quite permeable by the ancient rhetoricians. And the difference between public and private recollection (say, between the memorial oration and the psychoanalytic session) is exactly what is under most pressure in autobiographical narratives whose function is to bear witness to a collective, historical experience.[17] Even more fundamentally, while the specific cultural articulations of memory may vary from one place and time to another, the composite imagetext structure of memory seems to be a deep feature that endures all the way from Cicero to Lacan to the organization of computer memory.[18]

17. One of the main problems with the philosophical literature on memory traced by David Krell's important study is that it treats memory mainly as a subjective, private, individual phenomenon—a relation between a "soul" and its past—rather than a public, intersubjective practice, a collective recollection of a social past. That may be why Krell's study eschews the problem of memory and learning, the "passing on" of memory in oral tradition and historical record, and why his approach tends to replay the aporias between accounts of memory as an immaterial, spiritual activity (on the one hand) and an embodied media technology of types, icons, and graphic traces (on the other). The reason, in my view, why accounts of memory inevitably appeal to models of writing, painting, photography, sculpture, printing, etc. is that memory is an intersubjective phenomenon, a practice not only of recollection *of* a past *by* a subject, but of recollection *for* another subject. Perhaps slave narrative, and tales of victimage and abjection more generally, simply make this question—"remembered *for whom?*"—unavoidable. For an account of memory that stresses its social function, see Jacques LeGoff, *History and Memory*, translated by Steven Rendall and Elizabeth Claman (New York: Columbia University Press, 1992).

18. David Krell's survey of philosophical accounts of memory from the ancients through empiricism, German idealism, and contemporary studies of artificial intelligence argues for "the staying-power of the ancient model for memory. In contemporary empirical and cognitive psychologies, neurophysi-

"Stories," in the sense of a temporal sequence of events, are not the only elements of memory that can be withdrawn from the storehouse of memory. Descriptions come out too, and they have an odd status in relation to the visual and spatial order from which they emerge. Description might be thought of as the moment in narration when the technology of memory threatens to collapse into the materiality of its means. Description typically "stops" or arrests the temporal movement through the narrative; it "spreads out the narrative in space," according to Genette.[19] But the point of the spatial memory system is orderly, reliable movement through *time*. Description threatens the function of the system by stopping to look too closely and too long at its parts—those "places" with their "images" in the storehouse of memory. Memory, like description, is a technique which should be subordinate to free temporality: if memory becomes dominant, we find ourselves locked in the past; if description takes over, narrative temporality, progress toward an end, is endangered, and we become paralyzed in the endless proliferation of descriptive detail.

That is why both description and memory are generally characterized as instrumental or "servant" functions in the realms of textuality and mental life. Memory is a technology for gaining freedom of movement in and mastery over the subjective temporality of consciousness and the objective temporality of discursive performance. To lack memory is to be a slave of time, confined to space; to have memory is to use space as an instrument in the control of time and language. Description is, in Gerard Genette's words, "the ever-necessary, ever submissive, never emancipated slave" of narrative temporality.[20] Genette is not talking about "slave narrative" here, of course, but about narrative in general, and the internal hierarchies of typical narrative structures. The questions we need to answer then are deceptively straightforward: how do these formal or structural hierarchies in narrative and memory engage with various forms of social hierarchy and domination? How do the descriptive components of narrative and the visual/spatial technology of memory "serve" the articulation of the "servant voice"? What happens when the "servitude of descrip-

ology, and biochemistry, as well as data-processing and information technology, the selfsame model perdures—even if the wax has given way to magnetic tape or the floppy disc" (*Memory, Reminiscence, and Writing*, p. 5).

19. Gerard Genette, "The Frontiers of Narrative," chapter 7 of *Figures of Literary Discourse*, translated by Alan Sheridan (New York: Columbia University Press, 1982), pp. 127–43.

20. Ibid., p. 134.

tion" is explicitly addressed to the *description of servitude,* when the memory of slavery is narrated?[21]

A full account of these questions would engage not just the power relations of master-slave in the structure of representation, but would address as well the whole issue of economics and exchange—the value of narrative, the conversion of the slave-as-commodity into the slave *narrative* as commodity. In place of such a full account, let me simply offer an inventory of the narrative/memory/slavery intersection in terms of what Derrida has called "economimesis."[22]

Narration as enumeration. We need to be mindful of the whole panoply of figures that link narration to counting, recounting, "giving an account," (in French, a *conte*), "telling" and "tallying" a numerical total, and the relation between "stories" and "storage." Description in particular is often figured as the textual site of greatest wealth, an unbounded cornucopia of rich detail, rendered in the rhetoric of "copiousness."

Memory as a counting-house. We need to recall the figures of memory as a storehouse in which experience is "deposited" (sometimes to accrue "interest") and the memory technology characterized as a device for "withdrawing" these deposits on demand.[23] Cicero's

21. The narrative/descriptive hierarchy is, of course, only one of many sites of power difference in the structure of textuality. The distinctions between speech and writing, between telling a story and commenting on it, are perhaps even more obvious thresholds of contention. Frederick Douglass's struggle with the Garrisonian abolitionists was often waged over these textual frontiers. Douglass's decisions to *write* (rather than merely serve the movement as a platform orator) and to be an *editor* (rather than merely serve as a writer for Garrison's publications) are deliberate crossings of thresholds within the literary institution. That this sort of threshold had already been violated from the first time Douglass opened his mouth is indicated in the first reactions to Douglass's oratory: "In those days, whenever Douglass strayed from narrating wrongs to denouncing them, Garrison would gently correct him by whispering, 'Tell your story, Frederick', and John Collins would remark more directly, 'Give us the facts, . . . we will take care of the philosophy.'" Quoted from Robert Stepto, "Storytelling in Early Afro-American Fiction: Frederick Douglass' 'The Heroic Slave,'" in *Black Literature and Literary Theory,* edited by Henry Louis Gates, Jr. (New York: Methuen, 1984), p. 175.

22. Jacques Derrida, "Economimesis," *Diacritics* 11 (Summer 1981): 3–25.

23. See Carruthers, *The Book of Memory,* on memory as a "treasure-hoard" and "money-pouch" (p. 39).

account of the invention of artificial memory in *De Oratore*[24] tells the story of the invention of memory as a story of misguided thrift, the failure to give the poet/rhetorician (and by implication) the gods their due. Simonides dedicates half his poem to the twin gods Castor and Pollux, half to his noble patron, Scopas, who meanly refuses full payment and tells Simonides to collect the other half from the gods. Simonides is then called from the banquet hall by a servant who tells him that two young men want to see him outside. While he is outside, the banquet hall collapses, crushing Scopas and all his guests, leaving their bodies disfigured and unrecognizable to all but Simonides, who is able to identify the bodies because he has been using the architectural places in the hall as a memory system for his own recitation. The memory palace of praise, lyric celebration, and free generosity is transformed into a charnel house; the memory of words gives way to the re-membering of dismembered bodies.

The slave as commodity. The central issue is clearly the reduction of human personhood and individuality to the status, not just of mere instrumentality and servitude, but to commodity, object of economic exchange. In his analysis of the fetish-character of commodities, Marx imagines what it would be like if the commodity could speak. The deepest answer, I suggest, is contained in the nexus of narrative, memory, and slavery. It is not just that the slave speaks of a time when he was a commodity, but that his speaking itself becomes a new form of commodity.[25] The slave's memory of suffering is traded in for cash and credit, and the "authenticating documents," the "letters of credit" that verify the truth of the narrative, are as important as the "story proper." The slave's narrative becomes his principal stock in trade, the cultural capital which he invests by putting it into circulation. His memories are money, his account earns "interest" in a market that is beyond his control. The collapse of slavery after the Civil War was a disaster for the literary market in slave narrative. "Essentially," say Davis and Gates, "the slave narrative proper could

24. Recounted in Yates, *The Art of Memory*, chapter 1.

25. James Olney points out that "the narrative lives of the ex-slaves were as much possessed and used by the abolitionists as their actual lives had been by slaveholders" (in Davis and Gates, *The Slave's Narrative*, p. 154). Frederick Douglass notes that when he was urged to speak at an antislavery convention in 1841, he felt that "it was a severe cross and I took it up reluctantly. The truth was, I felt myself a slave, and the idea of speaking to white people weighed me down. I spoke but a few moments, when I felt a degree of freedom" (*Narrative*, p. 119).

no longer exist after slavery was abolished."[26] The value of slave narrative seemed to depend on the real existence of chattel slavery, as if a gold reserve of "real wealth" in human suffering had to back up the paper currency of the writings on slavery.

Marcel Mauss's studies of exchange in archaic societies suggest that slavery is inseparable from the general problem of the human being as object of exchange, as an item to be "given freely" in rituals of gift-giving, or bought and sold in the marketplace.[27] (Sethe, the central character in Toni Morrison's *Beloved* is a "timely present for Mrs. Garner";[28] Frederick Douglass is given by his master to a relative in Baltimore.) The slave regularly appears as a commodity along with moveable furniture, symbolic and ornamental artifacts, animals, and (most notably) women and children.[29]

This conjunction suggests that the special problem of slave discourse might be illuminated by the contexts of "object discourse" or ekphrasis (when mute objects seem to speak), prosopopoeia or personification (when the nonhuman acquires a voice), and—most obviously—the narratives of women and children. "Ekphrasis and the Other" explored the problem of object discourse, especially the object-as-person. In the remainder of this essay I want to work back toward the problem of slave narrative with a series of snapshots of specific conjunctions of description and memory in the imagetexts of women, children, and "survivors"—representatives of groups that have, in various ways, suffered forms of subjection and abject powerlessness that compel public acts of autobiography. At the outset, of course, we have to register some distinctions. Women's narrative often describes memories of subjection and victimization comparable to slave narrative, but it rarely does so from the standpoint of an "ex-woman," while the slave narrative, as we've noted, always seems to be that of an "ex-slave." Narratives of childhood memories are often,

26. Davis and Gates, *The Slave's Narrative,* p. xxii.

27. Marcel Mauss, *The Gift: The Form and Reason for Exchange in Archaic Societies,* translated by W. D. Halls (Norton, 1990). Further page references will be cited in the text. I'm indebted to Jacques Derrida's lectures, *Le donner la temp* (now published in English as *Given Time* [Chicago: University of Chicago Press, 1993]), and to a number of conversations with Professor Derrida for the application of Mauss's work to the question of slavery.

28. Toni Morrison, *Beloved* (New York: Plume Books, 1987), p. 10; further page references will be cited in the text.

29. See Mauss, *The Gift,* p. 49.

like slave and women's narratives, recollections of abjection and pow-
erlessness, but they recall a domain of experience that, unlike slavery
and womanhood, seems as close to being universal as we can imagine.
The survivor's narrative comes close to the border of "blankness" in
memory that Frederick Douglass describes, but that blankness is fig-
ured, not as a durable, extended condition of servitude and commodi-
fication, but as the threat of the total extinction of all witnessing
memory, on the one hand, and the unendurable pain of experiential
memory on the other.

• • • • • • •

Wordsworth's *Prelude* will serve as my paradigm for the autobio-
graphical narrative focused on memories of early childhood. Words-
worth's characterization of his childhood as a "fair seed time" of
blessed freedom and sensual delight may seem an odd example to
juxtapose with the horrors of slave narrative, but it is precisely the
remoteness and freedom of *The Prelude* from these issues that makes
it an interesting comparison. *The Prelude* is about narrative and mem-
ory as technologies of freedom and power. It is riddled with exactly
those sorts of complex reflections on memory that are supposed to be
absent from slave narrative and emerges from a social position of
"bourgeois consciousness" very similar to the sentimental liberalism
that enframes the early white abolitionist reception of slave narrative.

Like the slave narratives, Wordsworth's autobiography is punctu-
ated by intensely visualized descriptive passages he calls "spots of
time," a transference of the classical memory architecture onto scenes
(usually) of natural landscape. The experiences stored in these mem-
ory places play a double role as (1) repositories of poetic "wealth,"
storehouses of impressions that nourish the mature poet's imagina-
tion, and (2) reminders of power, reassurances that "the mind is lord
and master," outward sense the "obedient servant" of the mind's
"will." What Wordsworth calls the "eye" of his song roams freely
over these memory scenes, "recollecting" the "interest" invested in
them, and employing their visionary power to undo the "despotism
of the eye."

This, at any rate, is the Wordsworthian ideology of a stabilized
master-slave dialectic between temporal narration and spatial descrip-
tion, adult maturity and childish sensuality. In fact, however, the posi-
tions of dominance and servitude are not as secure as Wordsworth
might wish. The "spots of time" do not typically show us the "mas-

tery" of the mind or will, but the unruliness of imagination and sensation. They don't show a freely moving temporal subjectivity, but a compulsive tendency to return to scenes of traumatic experience, often characterized by a "visionary dreariness" and impoverishment and invested with a nameless, exorbitant guilt. The mature poet may claim to have "mastered" the sensuous child he once was, but the Child still asserts itself as Father to the man, an image of lost power and freedom that recedes in the face of a future of declining power and imaginative poverty. Wordsworth's "mastery," in short, is the ambivalence of the bourgeois "sovereign subject," a rather more modest role than his unqualified egotism might like to claim. Wordsworth's narrative progress through the time-space structure of his memory system is as much an account of a man flying from something he dreads as seeking something he loves.

If *The Prelude* exemplifies the ambivalent conjunction of narrative, memory, and subjection characteristic of male "poetic sensibility" in the early nineteenth century, Charlotte Brontë's *Jane Eyre* provides a corresponding type of the poetical female. For Jane, however, the sublime egotism of *The Prelude* (and its accompanying ambivalence about the self as "master" or "slave") is not so readily available. *Jane Eyre* seems designed to affirm both the thematized social position of servitude (the governess's progress from orphaned social outcast to security as wife and mother) and the formal servitude of description of visual space, the renunciation of narrated actions in time. This feature is announced in the first sentence of the novel, a negative declaration that "There was no possibility of taking a walk that day," followed almost immediately by an affirmation of this negativity: "I was glad of it."[30] I don't mean, of course, that *Jane Eyre* has no action or temporality, only that the narration of action is subordinated to and organized by the description of—indeed the fixation on—spatial settings. The narrator of *Jane Eyre* doesn't even have the illusion of Wordsworthian freedom to roam "at will" over space and time, picking places and actions in accordance with the requirements of a liberation narrative. Her telling is strictly confined to a sequence of places that are also to be understood as times. In each of these place-times (Gateshead Hall, Lowood School, Thornfield, Marsh End, Ferndean) the circumscribing of point of view mirrors the immuring of the heroine. These "spots of time" are more like prisons. When Jane surveys an infinite Wordsworthian prospect from

30. Charlotte Brontë, *Jane Eyre* (1847; Hammondsworth: Penguin Books, 1966), p. 39; further page references will be cited in the text.

her window ("there was the garden; there were the skirts of Lowood; there was the hilly horizon") and longs for the "liberty" it suggests, her immediate reaction is to abandon her petition in favor of a prayer for "a new servitude" (p. 117). Within each of these memory places, the narrative emphasizes Jane's role as a seeing subject, a sharp-eyed observer and visionary painter, and the passages between these places are regularly occluded by episodes of relatively unstable vision and uncertain narrative representation. The transition from Gateshead to Lowood occurs in a dreamy night-journey; the move from Lowood to Thornfield is presented as the unrepresented gap between the acts of a play; the flight from Thornfield to Marsh End is told by a narrator lost in a storm.

In both *The Prelude* and *Jane Eyre,* then, the role of memory and the technology of memory as a composite image-text system is ostensibly constructive and positive. Memory, like description, is the servant of the narrative and of the narrator's identity. The spots of time and place-times allow the narrator's life to be re-traced, re-membered, and re-experienced in a mutual interchange with the reader. Wordsworth's addressed "friend" becomes a "we" who goes back with him to the origins of his own consciousness, a collaborator in the process of turning Wordsworth's private memory places into public commonplaces that will be a shareable patrimony, the renewed national identity of an "English soul." Jane Eyre's reader is, like Rochester, in the paradoxical position of mastery and subservience, "led by the hand" (in Virginia Woolf's phrase) and forced to see what Jane sees. Jane "serves" as our eyes; like Hegel's master, the reader becomes a dependent overseer. Like Wordsworth, she publicizes her memory, not so much to establish a utopian public sphere of English "nature," but to stabilize a sphere of feminine privacy in which a certain limited and therapeutic freedom may be exercised.

But memory, as Borges loves to remind us, may be a mixed blessing, and not merely "mixed" in the manner of the stabilized ambivalence narrated by Wordsworth and Brontë. What if memory took us back to that blankness before memory conjured with by Frederick Douglass? What if the materials of memory are overwhelming, so traumatic that the remembering of them threatens identity rather than reconstituting it? What if identity had to be constituted out of a strategic amnesia, a selective remembering, and thus a selective *dis*(re)membering of experience? What if the technology of memory, the composite visual-verbal architecture of the memory palace becomes a haunted house? What if recollection led us back, not to a stabilized public or private sphere, but into what Hortense Spillers calls "the dizzying

motions of a symbolic enterprise" that must be continually rein-vented?[31]

The negativity of memory, the need to forget while remembering, is perhaps most vividly illustrated in Holocaust survivor narratives. Claude Lantzmann's *Shoah*, for instance, rigorously excludes a certain kind of visual memory and narration, refusing to show any documen-tary footage of the concentration camps or of the war.[32] All visual representation of the camps is situated in the present of the film's narration, from the standpoint of its *récit*, in the *now* of the 1980s. Auschwitz is presented as a springlike pastoral landscape in which all the signs of horror and suffering are muted and nearly forgotten. Memory is carried by the soundtrack, the voice of the interviewer and his interlocutors, painstakingly reconstructing not only "what happened" (the *histoire* of the narrative), but how it felt, how it looked, what the experience was. While Lantzmann's camera eye seems to wander blindly, almost aimlessly, over the unreadable sur-face of a landscape that effaces all but the most general contours of memory, the voice-over dialogue penetrates and probes like a surgeon searching out a hidden cancer. At times the patient cries out in protest, as when one survivor explodes in resentment against Lantzmann's insistent, seemingly impertinent questions about the color of the trucks that carried them to the camps.

"What color were the trucks?"

"What color? I don't remember! Perhaps green, I think. No. I can't say. I will tell you what happened, but don't ask me to go back in memory. I don't go back in memory.

The refusal to "go back" in memory, triggered by the request to recall a color, is a refusal to revive a visual memory, to remember the experience in a form that brings it too close, too near to a re-experiencing of the unspeakable. "Telling" or "passing on" a story, the public, verbal recounting of a temporal sequence of events, is possible, allows perhaps a mastery of the materials. But *describing* the experience, recounting the experiential density of visual details, especially those trivial details that do nothing to advance the narra-tive, but "spread the narrative in space" as Genette puts it—this way of telling is too dangerous. It threatens to master the narrator, to produce all too vividly an *effet de reel* and take the narrator "back in

31. Spillers, "Changing the Letter," p. 29.

32. Cp. the effacement of visual memory in Art Spiegelman's *Maus*, dis-cussed in chapter 3 of this volume.

memory" to a place he cannot endure. The visual imagery in narrative description activates the mnemotechnique as an uncontrollable technology; the phantom figures in the landscape or memory palace threaten to come alive, to be re-membered and resurrected from the dead as ghosts who act upon the material world and the body of the narrator. We should recall here that the legendary origin of the rhetorical memory system involves Simonides' being asked to identify the disfigured bodies of those killed when the banqueting hall/memory palace collapses on them. Simonides has to convert the function of memory from its proper function as an artificial aid to public performance into a mode of private, experiential recollection that will make possible, in its turn, the public commemoration of the dead. Although cheated by Scopas, Simonides as the lone survivor owes his listeners that much. The Holocaust survivor narrative is also the payment of a debt owed to the dead; failure to bear witness may be even more unendurable than the act of recollection. As Mauss notes, "the punishment for failure to reciprocate" the gift in archaic systems of exchange "is slavery for debt" (p. 49).

Toni Morrison's *Beloved* insists upon a similar obligation to remember, to carry memory back into materials both forgotten and immemorial, to explore both repressed experience and experience located in the blankness prior to memory.[33] Morrison describes her own method of "literary archeology" in her essay, "Sites of Memory," as a "recollection that moves from the image . . . to the text." Starting with "a journey to a site to see what remains were left behind and to reconstruct the world that these remains imply," she goes on to a text, a narrative, an account of the temporal processes that produced the image. "By 'image,' " Morrison insists, "I don't mean 'symbol,' " a prefabricated literary sign. "I simply mean 'picture' and the feelings that accompany the picture."[34] Much of the novel is built accordingly

33. As I was finishing the final revisions of this essay, Mae Henderson's excellent account of the intersection between "public" and "private" memory, specifically psychoanalysis and historiography, in *Beloved* came to my attention. See Henderson, "Toni Morrison's *Beloved*: Re-Membering the Body as Historical Text," in *Comparative American Identities*, edited by Hortense Spillers (New York: Routledge, 1991), pp. 62–86.

34. Quoted in Henderson, "Re-Membering the Body," pp. 65–66; see also Toni Morrison, "Sites of Memory," in *Inventing the Truth: The Art and Craft of Memoir*, edited by William Zinsser (Boston: Houghton-Mifflin, 1987).

upon intensely vivid visual descriptions of memorable scenes, what Sethe calls her "rememories":

> Some things you forget. Other things you never do. . . . Places, places are still there. If a house burns down, it's gone, but the place—the picture of it—stays, and not just in my rememory, but out there, in the world. What I remember is a picture floating out there outside my head.

These pictures, Sethe insists, are not private or subjective. They are not mere "memories," but "rememories," a term that suggests a memory that contains its own independent mechanism of retrieval, as if memory could remember itself. Even if Sethe dies "the picture of what I did, or knew, or saw is still out there" (p. 36). One thing that gives rememories endurance and objectivity is, of course, the very act of telling about them, which has the potential to produce a re-experiencing of the original event, a "passing on" of the rememory. When Beloved tells her memories to Denver, her sister "began to see what she was saying and not just to hear it" (p. 77).

But the narrative voice of Morrison's novel repeatedly suggests that her purpose is not just the traditional fictional aim of "making us see" these events in vivid detail; nor is it the traditional historical aim (as articulated by Collingwood) of constructing "a picture, a coherent whole," and filling in the gaps, penetrating the "veil" that pain, propriety, and national amnesia have placed over the unspeakable experience of American slavery. Morrison's story aims to make the very process of "passing on" the story and its rememories a problem—the very subject of the story—in itself. The narrator concludes the final chapter by repeating three times, "It was not a story to pass on," an ambiguous refrain that suggests both the imperative to remember and to forget. Does "passing on" emphasize the "passing," implying that it is not a story that one can avoid, a story one cannot "take a pass on"? Is the story actually a blockage or impossible border that prevents the teller or hearer from "passing" from negritude and slavery to freedom?[35] Or is "passing on" a story to "telling" or "re-

35. Mae Henderson also notes this ambiguity and is worried about the implications of the most obvious, literal reading of "not a story to pass on": "Must Morrison's story, along with Sethe's past, be put behind? . . . Clearly such an injunction would threaten to contradict the motive and sense of the entire novel," which is, in Henderson's view, the reconstruction of "public history" ("Re-Membering the Body," p. 83). As will become evident below, I think Morrison intends the negative meaning and is affirming the need, not

counting" it, something like the difference between handing over a story as something like a material object, a gift, legacy, commodity, and simply "reporting" a series of events as a way of getting rid of them. This difference is much like the division between descriptive *fixation* on visual remembering and re-experiencing and the forms of narrative that aim at a temporal "passing" through a sequence of events, passing beyond them with an account that puts the story, as we say, "behind us," or even "before us," as a story to be read and reread. Genette admits that the narration/description "frontier" may be nothing but a late development in the history of narrative structures; perhaps it is a modern formation connected with secular autobiography, the narrative form in which subjective memory and privacy establish their "classic" relation to the public sphere.[36] The narrative/descriptive boundary may be nothing more than a phantom difference, an ideologeme imposed on the seamless web of language and narration. That does not keep it from impinging on actual practices of storytelling and reception. The difference between vision and voice, the narrator as seeing and speaking subject, between "passing on" and "telling" a story, haunts the practice of storytelling the way ghosts haunt the living memory.

The descriptive passages of *The Prelude* are haunted by "mighty forms" that veil a guilt about an abandoned child and childhood

for a "national amnesia," but for a related kind of forgetting we might call "national mourning." Clearly the vivid re-membering of such pictures as Sethe's flayed back is not produced in order to be forgotten (see Frances Yates, *The Art of Memory,* chapter 1, on the technique of *disfiguring* the *imagines agentes,* the figures located in memory places, by splashing red paint on them to make them more vivid and memorable). The disfigured bodies are re-membered, as Simonides' task reminds us, in order to be identified and given a proper reburial, a public ceremony of commemoration. The alternative to this twofold project of disinternment and reburial is the haunting of national memory by the unquiet dead, the ghosts of slaves whose experiences and memories are not to be passed on. *Beloved* is utopian and comic in its faith that this nation might be able to make the transition from haunting to mourning, from amnesia to public commemoration.

36. I'm using the concept of the "classic public sphere" here in Jurgen Habermas sense, as a formation associated with the rise of bourgeois social structures in the eighteenth century. See *The Structural Transformation of the Public Sphere: An Inquiry into a Category of Bourgeois Society* (Cambridge: MIT Press, 1989) and the remarks on "Pictures and the Public Sphere" that introduce Part V of this volume.

Wordsworth can never quite specify.[37] *Jane Eyre* is haunted by the marginally representable figure of Bertha Mason, the Creole madwoman in the attic. The construction of Jane's secure identity depends, as Gayatri Spivak has shown, on the erasure of her memory—literally, the burning of her along with the place she inhabits.[38] But Toni Morrison's task is to remember slavery, to reconstruct the experiential place-times of racial degradation, loss of identity, and abject servitude. The "haunting" of memory can, therefore, not be marginalized in representation; it must be allowed full sway. The ghost has to be re-membered so vividly and physically that it can lift chairs, eat, be seen by the neighbors, get sick, get pregnant, and finally disappear in full view of an entire community. *Beloved* is arguably the most physically literal and material ghost story ever written, and the reason is that its "rememories" are too powerful and dangerous to pass on without elaborate defenses and mediations, including the defense of laughter and the presentation of a ghost who walks in the noonday sun. Beloved, the slaughtered baby, must be simultaneously remembered and forgotten, resurrected and dismembered:

> Everybody knew what she was called, but nobody anywhere knew her name. Disremembered and unaccounted for, she cannot be lost because no one is looking for her, and even if they were, how can they call her if they don't know her name? Although she has claim, she is not claimed. In the place where the long grass opens the girl who waited to be loved and cry shame erupts into her separate parts, to make it easy for the chewing laughter to swallow her all away.
>
> It was not a story to pass on.
>
> They forgot her like a bad dream. After they made up their tales, shaped and decorated them, those that saw her that day on the porch quickly and deliberately forgot her. (p. 274)

But Toni Morrison's narrator, the speaking/seeing voice of *Beloved,* has not forgotten. She tells the story of remembering, dismembering, and disremembering. Who is she? We cannot say, even as to her gender. She is a classic, omniscient narrative voice—not an autobiographical "I"/"Eye" as in the slave narrative, but a disembod-

37. See my essay, "Influence, Autobiography, and Literary History: Rousseau's *Confessions* and Wordsworth's *The Prelude,*" *ELH* 57:3 (Fall 1990): 643–64.

38. Gayatri Spivak, "Three Women's Texts and a Critique of Imperialism," in *"Race," Writing, and Difference,* edited by Henry Louis Gates, Jr. (Chicago: University of Chicago Press, 1986), pp. 262–80.

ied, anonymous voice/inscription that cannot be located except by a kind of proximity to Sethe, Denver, Paul D., Beloved, and most generally to the places in which most of the story transpires and is recollected. *Beloved*'s narrator is the ghost of the "sites," the textual placetimes or pictorial rememories that she haunts relentlessly. The central place-time of *Beloved*, the memory palace that structures its narrative, is a haunted house, 124 Bluestone Road in Cincinnati, Ohio, the place in which all the other place-times of the story (the landscape setting of "The Clearing"; the slave pastoral of "Sweet Home," the hells of the Georgia prison camp and the Middle Passage) may be reassembled.

The centrality of this house is stressed from the opening sentence of the novel: "124 was spiteful. Full of a baby's venom. The women in the house knew it and so did the children." The first "character" to be introduced in the narrative is the house, but it is not even named as a house (though it is given an emotion of its own). Only a number designates the house, a number which (as we learn by the end of the first paragraph) "it didn't have . . . then, because Cincinnati didn't stretch that far." The narrative begins, in other words, with a simultaneous immersion in and distancing from the *histoire* it recounts: "spiteful" designates the condition of the house from 1855 to 1873, the period when it was haunted by an invisible baby ghost who shatters mirrors and leaves handprints on the cake. But "124" designates the house at a much later period, when Cincinnati has extended its suburbs, when the story has passed on into legend and finally into forgetfulness and laughter.[39] The opening sentence is thus anachronistic, temporally impossible. "124" never was spiteful; "the gray and white house on Bluestone Road" was spiteful. The contradiction is between an "account" or "recounting" from a historical distance (when "124" has a meaning) and describing, remembering, placing, and seeing the colors and location on a specific road itself named for local colors like "bluestone."

The insistence on producing this chronologically impossible sentence is the opening move in a narrative of "disrememberment." It shows us how to tell a story that is not a story to pass on. Morrison also shows us what it would mean *not* to be able to disremember, to be overwhelmed by the remembering and re-experiencing of slavery,

39. Hortense Spillers's conjunction of history and farce, "yokes" (of slavery) and "jokes," in her comparison of Harriet Beecher Stowe and Ishmael Reed is apposite here. See "Changing the Letter."

in her account of Grandma Baby Suggs withdrawal from her active life as a leader of the black community after their betrayal of Sethe and the death of Beloved. Grandma Baby puts herself to bed: "her past had been like her present—intolerable—and since she knew death was anything but forgetfulness, she used the little energy left her for pondering color." It is as if Baby Suggs' were performing an exercise in amnesia, veiling the disfigured images of memory in shrouds of pink and blue. Perhaps she is also "pondering color" in a more abstract sense, as the "veil" or color line that doesn't merely cover the memory figures, but disfigures them in the first place.

124 Bluestone Road, like all memory palaces, is both a private site and a public location, a "commonplace" in a social, even a national imaginary. "Not a house in the country ain't packed to its rafters with some dead Negro's grief," is Baby Suggs' practical response to being haunted. The house is thus "a person rather than a structure" (p. 29), and yet it is also a structure (like a person) of intersubjective memory spaces. Sethe's daughter Denver has "lived all her life in a house peopled by the living activity of the dead" and thus sees it simultaneously as a person, a building, and a narrative riddled with puns on "story" and the "storage" of memory. She provides the most explicit visualization of the narrative architecture and the pictured site in memory that is haunted by the text of *Beloved*, a remarkable passage that offers a metapicture of the novel, and the final epigraph to this essay:

> Easily she stepped into the told story that lay before her eyes on the path she followed away from the window. There was only one door to the house and to get to it from the back you had to walk all the way around to the front of 124, past the storeroom, past the cold house. And to get to the part of the story she liked best, she had to start way back. (p. 29)

III····Pictorial·Texts

The problem of the text in the picture might look, at first glance, like a mirror-image of the picture in the text. Like texts, pictures disclose a certain wariness toward their semiotic "others." The text is an intrusion on the image, even (as Magritte and Foucault suggest) a negation or interdiction. The wall labels in museums take more of the spectators' time than the images. They are a substitute for seeing, replacing the material, visual presence of the picture with labels, anecdotes, and the reassurance of the famous-artist brand name: "Ah! A Courbet!"

Texts present, in general, a greater threat to concepts of the "integrity" or "purity" of images than vice versa. For one thing, they unavoidably and literally impose themselves within and around the pictorial object, on the walls, outside, inside, and on the frame, even "in the air" through which the object is seen and discourse about it is conducted. The images in texts, by contrast, are generally regarded as immaterial, figurative, and dispensable: ekphrasis is a minor genre, and description is merely "ancillary" to narrative. When the text is conjoined with literal and material visual forms (in writing or interpolated illustrations) it is remarkable how many ready-made strategies are available to dismiss or bracket these as merely supplementary, inessential features. Is it too obvious and trivial to point out that the interpretation of images is, for the most part, conducted in various forms of verbal discourse, while the interpretation of texts is not generally conducted by means of pictures? Of course, one can say that a paint-

ing or photograph "interprets" a text, but one would be using the word interpretation in a very loose sense (such as, a "creative" interpretation) quite distinct from its institutional, professional, and disciplinary meaning.

This point becomes even clearer if one contrasts the position of the imagetext in the disciplines of art history and literary study. Art history, for all its insistence on the irreducible visuality of its objects, is mainly devoted to inserting those objects into various explanatory and interpretive discourses; that is why the arrival of semiotics and literary theory in art history, though it occasioned some grumbling, has been mainly greeted as a liberating event. Literary studies, by contrast, have not exactly been transformed by the new discoveries in the study of visual culture. The notion of an "iconology of the text," of a thorough rereading or reviewing of texts in the light of visual culture is still only a hypothetical possibility, though the emergence of studies in film, mass culture, and of larger ambitions within art history make it seem more and more unavoidable.

The suturing of the imagetext, then, is not a symmetrical or invariant relationship, but depends upon the institutional context of the medium in which it appears. In the following group of essays, I explore the imagetext dialectic in three institutions of visual representation: (1) painting (particularly modernist abstract painting) and its reaction against "literary pictorialism" as summarized in the *ut pictura poesis* tradition; (2) sculpture (particularly postmodern minimalist sculpture) whose physical materiality and worldly presentness forces the problem of "word

and image" to veer into the relation of word and *object,* the relation between names and things, labeling and looking; and (3) photography (specifically in the composite form known as "the photographic essay" in both modernism and postmodernism) and the special relationship between image and language that emerges from the pictorial medium that seems most antithetical to language, yet is so routinely sutured to verbal representations.

UT PICTURA THEORIA:
ABSTRACT PAINTING AND LANGUAGE

When the purist insists upon excluding "literature" and subject matter
from plastic art, now and in the future, the most we can charge him
with is an unhistorical attitude.
 —Clement Greenberg, "Towards a Newer Laocoon" (1940)

Ten years ago one heard on all sides that abstract art was dead.
 —Alfred Barr, *Cubism and Abstract Art* (1936)

This may be an especially favorable moment in intellectual his-
tory to come to some understanding of notions like "abstrac-
tion" and "the abstract," if only because these terms seem so
clearly obsolete, even antiquated, at the present time.[1] The obso-
lescence of abstraction is exemplified most vividly by its centrality in
a period of cultural history that is widely perceived as being just
behind us, the period of modernism, ranging roughly from the begin-
ning of the twentieth century to the aftermath of the Second World
War.[2] Abstract art is now a familiar feature of our cultural landscape;

1. A version of this essay was written as the keynote address for the
University of Michigan Colloquium on "The Abstract" in 1987. I'm grateful
for the stimulating responses of Rudolph Arnheim and Julie Ellison on that
occasion.

2. I define modernism and "the age of abstraction" here in familiar art-
historical terms, as a period extending from Kandinsky and Malevich to (say)
Jasper Johns and Morris Louis. There are other views of this matter which
would trace modernism back to the emergence of an avant-garde in the 1840s
(T. J. Clark), or to romanticism (Stanley Cavell), or even to the eighteenth
century (Robert Rosenblum, Michael Fried). My claim would be that "the
Abstract" as such only becomes a definitive slogan for modernism with the
emergence of abstract painting around 1900.

it has become a monument to an era that is passing from living memory into history. The experiments of cubism and abstract expressionism are no longer "experimental" or shocking: abstraction has not been associated with the artistic avant-garde for at least a quarter of a century, and its central masterpieces are now firmly entrenched in the tradition of Western painting and safely canonized in our greatest museums. That does not mean that there will be no more abstract paintings, or that the tradition is dead; on the contrary, the obsolescence we are contemplating is in a very precise sense the precondition for abstraction's survival as a tradition that resists any possible assault from an avant-garde. Indeed, the abstract probably has more institutional and cultural power as a rearguard tradition than it ever did as an avant-garde overturning of tradition.[3] For that very reason, its self-representations need to be questioned more closely than ever, especially its account of its own nature and history. This seems important, not just to "set the record straight" about what abstract art was, but to enable critical and artistic experimentation in the present and a more nuanced account of both pre- and postmodern art, both of which are in danger of being swallowed up by the formulas (and reactions against the formulas) of abstract formalism. If art and criticism are to continue to play an oppositional and interventionist role in our time, passive acceptance and reproduction of a powerful cultural tradition like abstract art will simply not do.

Many stories of the emergence of abstract art have been told, and I don't propose to tell a new version here. My aim is rather to examine a few important variations on these narratives which represent abstract art as a repression of literature, verbal discourse, or language itself in favor of "pure" visuality or painterly form and to ask whether

3. For an attempt to demonstrate this power from a self-consciously anachronistic and belated standpoint, see Charles Altieri, *Painterly Abstraction in Modernist American Poetry* (Cambridge: Cambridge University Press, 1989). Altieri argues that "before we allow ourselves . . . distanced analytic stances for reading *against* texts" in skeptical, deconstructive, and historicizing ways, "we must learn to read *through* them by coming to appreciate the specific imaginative experiences they offer when taken as deliberate authorial constructs." This implies a two-stage reading process in which constructive, appreciative interpretation lays the groundwork for deconstructive connections of artistic works to social practices and ideology. But Altieri goes on immediately to deny the second stage: "once one has put in the necessary labor . . . there seems little point in such suspicious enterprises" (p. 7). The mutual necessity of these two stages is, in my view, the fundamental dialectic of historical criticism.

this repression was successful and what it meant. A capsule version of one such narrative appears in the opening paragraph of an essay by Rosalind Krauss entitled "Grids":

> In the early part of this century there began to appear, first in France and then in Russia and in Holland, a structure that has remained emblematic of the modernist ambition within the visual arts ever since. Surfacing in pre-War cubist painting and subsequently becoming ever more stringent and manifest, the grid announces, among other things, modern art's will to silence, its hostility to literature, to narrative, to discourse. As such, the grid has done its job with striking efficiency. The barrier it has lowered between the arts of vision and those of language has been almost totally successful in walling the visual arts into a realm of exclusive visuality and defending them against the intrusion of speech.[4]

The basic point of this passage seems clear enough, but there is something curiously at odds with this point in the rhetorical figures that Krauss employs. It seems a bit strange, for instance, to describe this image of hostility to language as an "emblematic" structure, since emblems, along with hieroglyphs, pictograms, and symbols, are the kinds of pictures that are traditionally regarded as being most contaminated by language; an emblem, in fact, is technically a composite visual-verbal form, an allegorical image accompanied by a textual gloss. And it seems almost wilfully paradoxical to personify this anti-linguistic grid with its "will to silence" as someone who "announces" things. If this grid has been so successful at placing a barrier between the arts of vision and language, one wonders how it could have the eloquence Krauss ascribes to it.

 Whatever criticism we might make of Krauss's rhetoric, we certainly could not charge her with presenting an eccentric or unprecedented account of the history of abstract art. One might even call this an entirely orthodox version of the story, one that has been retold in many ways over the last ninety years, usually under the rubric of abstractions like "opticality" and "purity."[5] The abstract artist, as

4. Rosalind Krauss, "Grids," in *The Originality of the Avant Garde and Other Modernist Myths* (Cambridge, MA: MIT Press, 1985), p. 9; further page references will be cited in the text.

5. Krauss herself has been, it should be noted, a resolute critic of the orthodoxy of "optical purity" in more recent writings. See her essay, "Anti-Vision," *October*, no. 36 (Spring 1986), and *The Optical Unconscious* (Cambridge, MA: MIT Press, 1993).

Clement Greenberg put it, is a "purist" who "insists upon excluding 'literature' and subject matter from plastic art."[6] Although the elimination of subject matter—the represented objects of traditional painting—is the more famous and obvious gesture of abstract art, the truly fundamental problem, in Greenberg's view, was the inevitable literary associations these objects carried: "It was not realistic imitation in itself that did the damage so much as realistic illusion in the service of . . . literature."[7]

The project of abstract painting (as understood by some of its principal advocates) is only secondarily an overcoming of representation or illusion; the primary aim is the erection of a wall between the arts of vision and those of language. Sometimes this project expresses itself more generally as an attack on the "confusion of the arts," the blurring of the boundaries between painting and other media. In Michael Fried's highly influential accounts of abstract painting, this confusion is called "theatricality," a term which evokes the necessary mixture of visual/verbal codes in theatrical presentation and designates a notion of art as a performative or persuasive act directed toward and conscious of a beholder.[8] Fried opens his classic essay, "Art and Objecthood" (1967), by suggesting that anti- or postmodernist art (what Fried calls "Literalist" art) achieves this theatrical orientation by recourse to language: "It seeks to declare and occupy a position—one which can be formulated in words, and in fact has been formulated by some of its leading practitioners . . . this distinguishes it from modernist painting and sculpture" (p. 438). We should note here the subtle equivocation in Fried's claim. The formulation of the Literalist position "in words" and that this position has been formulated "by some of its leading practitioners" (not by critics) are

6. *Clement Greenberg: The Collected Essays and Criticism,* 2 vols., edited by John O'Brian (Chicago: University of Chicago Press, 1986), I:23. All subsequent quotations will be from this edition, cited in the text by volume and page number.

7. Greenberg qualifies this by specifying "sentimental and declamatory" literature as the offender but then qualifies his qualification by saying that *all* of "Western and Graeco-Roman art" shows that these offensive literary values go "hand in hand" with "realistic illusion" (Greenberg, "Towards a Newer Laocoon" [1940], I:27).

8. See especially Michael Fried's "Art and Objecthood," *ArtForum* (June 1967), reprinted in *Aesthetics: A Critical Anthology,* edited by George Dickie and Richard Sclafani (New York: St. Martin's, 1977), pp. 438–60; further page references will be cited in the text.

equally crucial in distinguishing it from modernism. Modernist art, presumably, occupies a position that either *cannot* or *need not,* in some basic sense, be formulated in words, especially by its practitioners. Obviously this cannot mean that modernist art is beyond all verbal commentary (Fried's own writing is testimony enough on this point), but it does suggest that modernism in the visual arts involves a certain resistance to language, a discipline of the eye and the critical/artistic voice that seeks to acknowledge the pure, silent presence of the work. Words allow us to place the painting *"in a situation"* which *"includes the beholder"* (p. 445), compromising the purity of the medium by reducing it to rhetoric and turning the paintings into merely "literal"[9] objects in a stage setting. The stakes in this choice between purity and confusion are, at a minimum, the values of the modernist tradition as opposed to rival arts and movements: "there is a war going on between theater and modernist painting, between the theatrical and the pictorial" (p. 451). At a maximum, the very values of art as such are at stake: "theater and theatricality are at war today, not simply with modernist painting . . . but with art as such" (p. 455); "the concepts of quality and value—and to the extent that these are central to art, the concept of art itself—are meaningful or wholly meaningful, only within the individual arts. What lies between the arts is theater" (p. 457).

Given these assumptions, it is not surprising that Fried has little use for many of the movements associated with postmodernism. Performance art, installations, hyper-realism, the New Imagism, intermedia experiments, and other recent movements are often deliberately theatrical, deliberately situated "between the arts," and they have been aptly summarized by Craig Owens as "an eruption of language into the field of the visual arts."[10] This metaphor captures rather melodramatically the sense that postmodernism is an explosive breaking down of that barrier between vision and language that had been rigorously maintained by modernism. Among the most theatrically transgressive of these visual-verbal compositions are Jonathan Borofsky's installations of silhouettes of human figures standing in front of his abstract paintings (figure 31).[11] These monumental automatons

9. The "literal" plays a role in Fried's criticism analogous to the "literary" in Greenberg.

10. Craig Owens, "Earthwords," *October,* no. 10 (Fall 1979): 126–27.

11. See *Jonathan Borofsky,* catalog of the show at the Philadelphia Museum of Art, compiled by Mark Rosenthal and Richard Marshall (1984), pl. 62: *Green Space Painting with Chattering Man.*

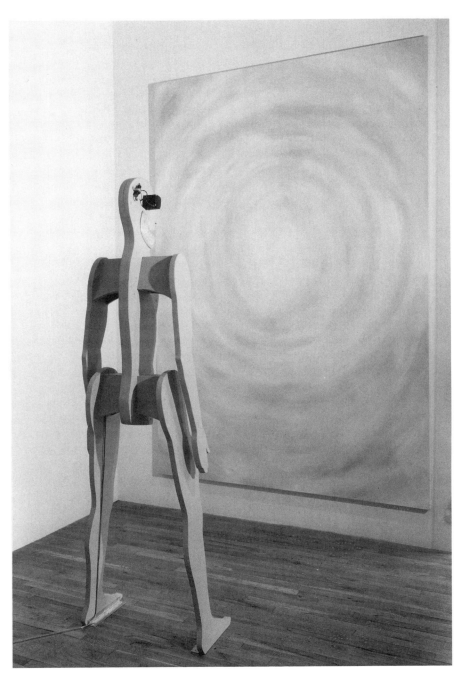

31. Jonathan Borofsky, photograph (by Geoffrey Clements) of installation entitled *Green Space Painting with Chattering Man at 2,841,789.* 1983. Collection of the artist. Photograph courtesy of the Paula Cooper Gallery, New York.

have small loudspeakers planted in their mouths and motorized pulleys moving their metal jaws. As the jaw swings up and down, we hear the recorded voice monotonously droning the words "chatter, chatter; chatter, chatter," as if the figure were one of those gallery-goers who feels compelled to talk endlessly about every painting in the exhibition. It's hard to imagine a funnier travesty of what Krauss calls "modern art's will to silence," its "defence against the intrusion of speech." All the taboos against "confusion of the arts" in the name of the aesthetic purity of the medium are violated by this grafting of sculpture, painting, and voice in a theatrical, almost fun-house setting.

What makes this particular installation especially provocative, however, is not just its violation of modernist taboos, but its suggestion that those taboos were never successfully enforced, that the silent temple of pure abstraction was always a place where a lot of prefabricated people with talking heads gathered to repeat a litany of prerecorded utterances. Borofsky gives us a kind of three-dimensional animated cartoon of the space of artistic exhibition as a place where people come to talk about and even "to" the paintings. This image is strikingly at odds with Rosalind Krauss's account of the "grid" of abstraction as an almost "totally successful" suppression of language. Borofsky may be suggesting that, in point of fact, the reverse was true, that the fewer verbal promptings provided by the painter in the form of titles, narrative clues, or subject matter, the more demand for the spectator to fill the void with language. Not that this suggestion is original with Borofsky (or with me).[12] Early in the seventies the journalist Tom Wolfe, in a hilariously vulgar and philistine put-down of modern art, made his own "break-through" in comprehending the pure visuality of abstraction:

> All these years I, like so many others, had stood in front of a thousand, two thousand, God-knows how many thousand Pollocks, de Koonings, Newmans, Nolands, Rothkos, Rauschenbergs, Judds, Johnses, Olitskis, Louises . . . now squinting, now popping the eye sockets open, now drawing back, now moving closer . . . waiting for something to radiate directly from the paintings on these invariably pure white walls . . . into my own optic chiasma. All these years . . . I had assumed that in art, if nowhere else, seeing is believing. Now at last . . . I could see. I

12. Harold Rosenberg notes also that "the place of literature has been taken by the rhetoric of abstract concepts," but he regards this as a mainly negative development. See *The De-definition of Art* (New York: Macmillan, 1972), p. 56.

219

had gotten it backward all along. Not "seeing is believing," you ninny, but "believing is seeing," for *Modern Art has become completely literary: the paintings and other works exist only to illustrate the text.*[13]

Wolfe was aware, of course, of what "every art-history student is told," that "the Modern movement began about 1900 with a complete rejection of the *literary* nature of academic art" (p. 7), but he came to a realization which seems to have eluded, not just the apologists for modernism, but postmodern theorists as well: the wall erected against language and literature by the grid of abstraction only kept out a certain kind of verbal contamination, but it absolutely depended, at the same time, on the collaboration of painting with another kind of discourse, what we may call, for lack of a better term, the discourse of theory. If we summarize the traditional collaboration of painting and literature under the classic Horatian maxim, *ut pictura poesis,* as in painting, so in poetry, then the maxim for abstract art is not hard to predict: *ut pictura theoria.* Or, as Wolfe expresses it: "these days, without a theory to go with it, I can't see a painting" (p. 4).

Even with a theory, of course, Wolfe can't see abstract painting, and he only bothered to learn enough about it to make a few cheap shots about the contradiction between abstract art's professed elimination of language and its actual involvement with language. Like his "scandalous" discovery that abstract artists actually cared about acquiring money and fame from their painting, Wolfe's revelation of this paradox in the ideology of modernism goes about as deep as the average political cartoon. Which doesn't prevent us from learning something from this cartoon that seems to have eluded most commentators on abstract art: namely, that the entire antiverbal ideology of abstraction, its depiction as a rigorous "barrier" between vision and language, is a myth that needs to be understood and not just debunked. If abstract art actually was and is an art of "the painted word," as Wolfe claims, what is that word, how is it made manifest in the paintings, and why did its presence have to be denied?

I've already suggested a short answer to the first question: "theory" is the "word" that stands in the same relation to abstract art that traditional literary forms had to representational painting. By "theory" I mean that curious hybrid of mainly prose discourse compounded from aesthetics and other branches of philosophy, as well

13. Tom Wolfe, *The Painted Word* (New York: Bantam Books, 1976), p. 6; further page references will be cited in the text.

as from literary criticism, linguistics, the natural and social sciences, psychology, history, political thought, and religion. Sometimes this sort of writing is called "intellectual prose" or simply "criticism," and it is characterized, generally, by a refusal of disciplinary identity—it is rarely *just* history or science or moral philosophy, but a synthetic discourse that ranges over several specialized idioms.

A good way to see how this sort of prose comes to be focused on the problems of abstract painting is to ask oneself what sorts of things Clement Greenberg, the most important American apologist for abstraction, had to know in order to write the sort of criticism he wrote. The answer is: a fair amount of art history, the fundamentals of Kantian aesthetics, a sense of Marxist historical and critical categories, mediated mainly through Trotsky, experience as a painter and friend of painters, four languages, some practical experience in business and government bureaucracy, an acquaintance with European politics, and membership in the group of intellectuals writing for *Partisan Review* around World War II. Other writers on abstract art bring other areas of expertise: Rudolf Arnheim brings a great deal of Kant and a wealth of experimental evidence from studies of visual perception in gestalt psychology; Michael Fried brings a phenomenological perspective leavened by the tradition of Anglo-American philosophy mediated through Stanley Cavell; Rosalind Krauss unites a firsthand acquaintance with the art world with a combination of structuralism, deconstruction, and a Foucauldian approach to history. The other thing all these writers share is that they write well, or persuasively, or in a style which enables discussion of abstract paintings, often by providing a set of formulas, a language game that can be carried on. Their effect is to make the apparent "wall" or "grid" between abstract art and language seem more like a screen door through which the winds of theoretical discourse blow freely. These "winds" may include a fair amount of hot air, as Jonathan Borofsky suggests. There is no necessary connection between good theory and good painting (Leo Steinberg complains, for instance, that Jasper Johns is a very good painter but a very bad theorist).[14] There is, however, a necessary connection between the meaning of abstract painting and the theoretical discourse around it.

A predictable objection to my claim here is that this discourse arises only *after* the fact of artistic creation; it may provide an expla-

14. Leo Steinberg, *Other Criteria* (London: Oxford University Press, 1972), p. 52: "I think he [Johns] fails, not as a painter, but as a theorist." Michael Fried would perhaps express just the opposite judgment.

nation of a painting or a movement, but it is not constitutive of and prior to painting the way traditional literary and historical narratives were. *Ut pictura poesis* meant an art of mutual imitation and collaboration between two "sister arts," both dwelling in the realm of the aesthetic; *ut pictura theoria* is an unequal relationship of mere convenience, between the master-work of abstract painting and the humble servant of critical prose. There are two sorts of answers to this objection. The first is simply the empirical fact that, for many modern artists, theory has been a constitutive *pre*-text for their work.[15] Cézanne believed that "all things, particularly in art, are theory developed and applied in contact with nature."[16] An even more comprehensive and ambitious claim for a tradition of *ut pictura theoria* has recently been articulated by Robert Morris, a sculptor and painter whose career spans the major American art movements from late modernism to the present.[17] Morris argues that the evolution of modern art may be mapped as a progression of textualizing theories: early abstraction (Kandinsky, Malevich, Mondrian) builds principally on the theoretical manifestos written by the artists' themselves, and based on their readings of nineteenth-century idealist philosophy; American abstract expressionism tends to rely more on critics like Clement Greenberg, a division of labor between the silent artist and his critical spokesman;[18] with minimalism and postmodernism, Morris argues, the textual accompaniments to visual art are once again being produced by the artists' themselves, and the theoretical resources of these texts are to be found in structuralism and deconstruction.

But this answer is still open to the objection that this language is somehow all "outside" the paintings themselves, no matter who produces it or when. It still does not seem *visible* or "coded" in the works

15. Indeed, the notion of "painting theory" precedes modernist abstraction, as the examples of Turner, Blake, and Hogarth show. See my essay, "Metamorphoses of the Vortex," in *Articulate Images*, edited by Richard Wendorf (Minneapolis: University of Minnesota Press, 1983), pp. 125–68.

16. Paul Cézanne, "Letter to Charles Camoin," 22 February 1903, reprinted in *Theories of Modern Art*, edited by Herschel B. Chipp (Berkeley: University of California Press, 1968), p. 18.

17. Robert Morris, "Words and Images in Recent Art," *Critical Inquiry* 15:2 (Winter 1989): 337–47.

18. See Ann Gibson, "Abstract Expressionism's Evasion of Language," *Art Journal* 47:3 (Fall 1988): 208–14, for ample documentation of the resistance to verbalization by American painters and sculptors in the forties and fifties.

of Jackson Pollock or Mondrian the way biblical narratives were made visible and immanent in the paintings of Raphael and Michelangelo. One answer to this objection is simply that biblical narratives are *not* visible to spectators who don't already know the stories from other sources; traditional painting is not so different from modern in that respect.[19] But, more fundamentally, we have to understand the way abstract art sees itself as having changed the rules of the game. It is one of the principal doctrines of abstract art that although iconography and represented objects may disappear, content and subject matter do not. These paintings, no matter how abstract, are never merely formal or decorative; the "greatest fear" of the abstract artist, as Krauss says, "is that he may be making *mere* abstraction, abstraction uninformed by subject, contentless abstraction" (p. 237).[20] The question is, how can a painting without represented objects have a subject? How can pure forms of paint on canvas say *anything,* much less articulate complex theoretical concepts?

The remarkable thing is that once this question is raised about an abstract painting, there are so many answers. Take, for instance, Kasimir Malevich's composition commonly known as "Red Square and Black Square" (figure 32), arguably the most famous and familiar abstract painting ever made. The problem with this picture is not that we have nothing to say about it, or that it says nothing to us, but rather that we feel overwhelmed and embarrassed by the number of things it can be made to say. I once stood in front of this painting with my thirteen-year-old son at the Museum of Modern Art. His innocent eyes took in the situation at once. "I suppose you're going to tell me how great and full of significance *this* one is, too," he said. Several replies crossed my mind. I thought about explaining to him Malevich's wish "to free art from the ballast of the objective world."[21] I thought of Rosalind Krauss's claim that Malevich is painting the "operations of the Hegelian dialectic." I sorted through my stock of

19. One of the principal objectives of early modernist formalism was the attempt to suspend or erase awareness of literary, narrative elements in traditional painting to allow concentration on things like "significant form."

20. Cp. Clement Greenberg's contention that "every work of art" (including pure abstraction) "must have content." Greenberg distinguishes, however, "content" from "subject matter," the latter referring to "something the artist does or does not have in mind when he is actually at work" ("Towards a Newer Laocoon," *Collected Essays,* I:28).

21. Quoted in Alfred Barr, *Cubism and Abstract Art* (1936; Cambridge, MA: Harvard University Press, 1986), p. 122.

32. Kasimir Malevich, *Painterly Realism. Boy with Knapsack—Color Masses in the Fourth Dimension* (1915). Formerly titled *Suprematist Composition: Red Square and Black Square*. Oil on canvas, 28 × 17½″. The Museum of Modern Art, New York.

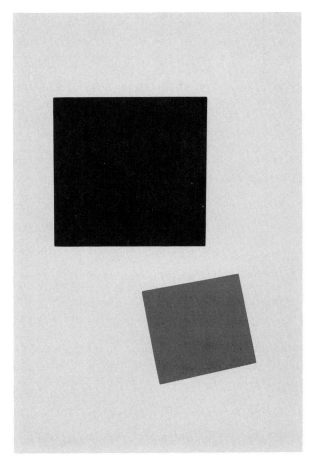

iconographic conventions for the meaning of the colors red and black, the numerological significance of the square as an emblem of earthly foundations, the square as an "expression" (in Malevich's terms) "of binary thought."[22] I recalled a few basic principles from Arnheim on the psychology of visual perception that might explain the effects of the whole composition, effects of size, placement, relation to frame, etc. Ultimately, of course, I resorted to the usual evasion fathers inflict on their sons on these occasions and appealed to authority. I said, "Well, believe it or not, I know someone who has written seventy-five

22. Quoted in Krauss, "Reading Jackson Pollock Abstractly," in *Originality of the Avant-Garde*, p. 238.

pages just trying to explain this one painting."[23] My son looked at me in disbelief: "Well I could say everything there is to say about it in one sentence." "Oh?" I said. "And what is that one sentence?" He scarcely hesitated: "There is a small tilted red square below a larger black square."

It didn't take too much prodding on my part to get my son to admit that he hadn't quite said *everything* there is to say about the painting in this one sentence (he said nothing about the white background, for instance, or the fact that "below" is not quite exact enough). But this answer stuck with me for several reasons. First, it does seem to me that there is a real truth in thinking of this as a "one-sentence" painting, in the way a geometrical figure may illustrate a single algebraic proposition, or a haiku may attempt to capture a scenic image. Second, I was glad to see that my son seemed intuitively to grasp a crucial feature of the language game of abstract art: he didn't say it was a "picture of a red and black square," or a representation of these figures. He saw it as a direct *pre*sentation of the figures: "there *is* a small tilted red square below a larger black square." Third, I felt gratified that he shared my sense that the "hero" of this painting, the protagonist of its one-sentence narrative, is the tilted red square. I'm not sure I'd want to claim that this is an objective "fact" about the painting's meaning, a message that is unequivocally coded in its composition; there must be viewers who identify with the black square. But I can at least testify that it is a social fact about the perception of the painting, verified in numerous other conversations. Even more interesting, I would suggest, are the little scenes like this one that are played out repeatedly in front of abstract paintings, in which a believer or connoisseur (or somebody who has taken Art 101) tries to explain one of these objects to a nonbeliever.

This sort of social fact is, I would suggest, a primary piece of data that tends to be repressed by abstract art's ideology of silent meditation, its tendency to project a solitary, sensitive spectator vibrating to the ineffable tunes of the Hegelian dialectic or the Kantian categories. Perhaps the most important thing this little conversation with my son reminded me of was the fact that Hegel's dialectic is at bottom a social relationship, an image of the mutual dependence of master and

23. I was thinking of Charles Altieri's painstaking efforts to rescue the notion of "representation" (or, more precisely, "representativeness") in abstract painting. See Altieri, "Representation, Representativeness, and Non-Representational Art," *Journal of Comparative Literature and Aesthetics* 5 (1982): 1–23.

slave. Malevich's image is surely dialectical and abstract, but language, narrative, and discourse can never—should never—be excluded from it. The relation of beholder and image is not exhausted by an epistemological model of subject and object, but includes an ethical-political relation, an intersubjective, dialogical encounter with an object that is itself dialectically constructed. The relation of black square to red square is not just the relation between abstract opposites like stability and tilt, large and small, but of more potent, ideologically charged associations like deadly black and vivid, revolutionary red, domination and resistance, or of even more personal and emotional relationships like father and son. I take it that there's no need for me to specify which square is the father, which the son.[24]

These sorts of "square," sentimental, bourgeois associations are exactly what abstract art tried to deny as "kitsch" in the name of high artistic "purity." But this denial was never entirely successful; it was continually contradicted, in social fact, by the elaboration of a quasi-philosophical discourse called "art theory," which filled the exhibition space with subtle, learned chatter. This discourse was difficult and esoteric, of course, so that it could easily become the property of a priesthood uniquely qualified to speak it. The true face of the "will to silence" in abstract art is not the "grid" of its compositional forms, but the imposition of a social mandate: you, who are not qualified to speak about this painting, keep your mouths shut. The uninstructed public, like my thirteen-year-old son, suspecting that there is nothing interesting to be said about these objects in any case, has been content to leave it to the acolytes of abstraction or to give these objects what the ideology of abstraction demanded—silent, mystified reverence, repressed suspicion. The difficult question remains: why was it so crucial to pretend that language was being kept out of the picture? Why did the "purity" of the visual arts need to be so rigorously protected from the contamination of language? Why could "ut pictura theoria" not speak its own name?

One problem with this question is that it has too many answers: the repression of language in abstract painting was, to borrow a term from psychoanalysis, "overdetermined" or excessively motivated. The shortest answer is, of course, a denial of the whole premise of the question in the orthodox claim that abstract art does not repress language; it simply creates "purely visual" images that have no linguistic or literary features to be repressed. Abstraction, on this ac-

24. The new title of Malevich's composition, *Boy with Knapsack*, makes his work look even less abstract.

count, is merely allowing the natural teleology of the visual and pictorial field to realize itself. This answer usually comes up in "scientific" accounts of abstraction as experiments in the physiology of vision and may be seen in Clement Greenberg's quite orthodox account of Courbet as "the first real avant-garde painter," who "tried to reduce his art to immediate sense data by painting only what the eye could see as a machine unaided by the mind" (1:29). A similar orthodoxy informs Greenberg's discussion of the impressionists' "discovery" that "the data of sight, taken most literally, are nothing but colors" (1:201). This mechanistic, materialist explanation could then be adduced in support of more refined, spiritual accounts, notions of "intuition," and the quasi-religious aesthetic of "revelation at first glance" (1:xxiv). In contrast to traditional art with its anecdotes and allegories, there is no temporal sequence to be "read" or deciphered in abstract painting: its forms are grasped in an instantaneous, intuitive perception—a single moment crystalized in space. Paintings are to be seen, not heard, or heard only as a silent, frozen music. The notion of Kantian "intuition" or Hegelian "Being/Nothingness" might be adduced as a philosophical clincher for this strange synthesis of science, religion, and psychology, but the link with linguistic structures remains almost invisible.

These external rationalizations for the purging of literary/linguistic values in painting found strong support in many painters' sense of the history of their own craft. Despite the official ideology of the "sister arts" and *ut pictura poesis,* the actual relations of verbal and visual art since the Renaissance might be more aptly described as a battle or contest, what Leonardo da Vinci called a *paragone.* From the standpoint of professional competition, the incorporation of literary elements in painting could be viewed as a mere expedient in the long struggle of painters to attain the respectability enjoyed by poets. This objective attained, painting was ready to "come into its own," to shed its reliance on literature, and turn its attention to the unique problems of its own medium. The notions of self-reflexive art and art for art's sake collaborated with a heightened sense of professional self-regard that was fueled by the philosophical and scientific theories of "pure vision" and "intuition." When all these elements united with a sense of moral fervor and revolutionary enthusiasm, the combination was irresistible. The "purity" of abstract art could be understood simultaneously as a scientific, religious, and ethical-political reformation. The "innocent eye" of the ideal spectator was at once the unbiased eye of science and the spiritually purified eye of the individuals in a new social order to be produced by religious reformation and/or material

revolution. The totems of this new religious/social order were to be the paintings themselves, now finally emergent as the dominant art form of advanced culture. As a not-so-incidental professional side effect, the traditional dominance of literature over the visual arts would be reversed; painting would not only "come into its own," it would become the model for literature.

Now I hope it is clear, not only how powerful and convincing this array of motivations for the repression of literature could be, but how unstable and self-contradictory its elements were.[25] Ruthless scientific materialism had to cooperate with refined idealism, spiritualism, and aestheticism. (At the time I was first drafting this essay, an exhibition on "The Spiritual in Modern Art" in Los Angeles was heralding itself as a corrective to the falsely materialistic, secular, and hedonistic image that it saw dominating abstract painting.) Other contradictions came to abstraction as external forces. The cult of the "innocent eye" had to confront the empirical fact that innocent, uncultivated spectators found the new art utterly mystifying. The hope for an art that would prepare revolutionary consciousness had to face the reality that the only two actual revolutionary movements in the modern period, fascism and communism, both quickly rejected the avant-garde and abstraction.[26] The purist ideology of abstraction was continually disrupted, then, by impurities and contradictions within its own rhetoric, within the practice of its own artists, and from without—from the concrete world of historical circumstance.

Clement Greenberg's unquestionable supremacy as the apologist of abstract art in the United States is a direct consequence of his marvelous rhetorical juggling act, his ability to elide the contradictions in the program of abstract art. Greenberg's way of accomplishing this was to station himself as an insider/outsider to an avant-garde equated with pictorial abstraction, sympathetic to its basic program, but in a position to be historically critical of it at the same time. A

25. Clement Greenberg noted the contradictory elements of the abstractionist avant-garde ("tendencies go in opposite directions, and cross-purposes meet") but emphasizes their consolidation "into a school, dogma, and credo" (*Collected Essays*, I:30, 36).

26. It's important to note, however, that abstraction was only one among many avant-garde styles in the modern era. Among Greenberg's accomplishments was his fostering of the myth that abstraction was the uniquely privileged bearer of advanced artistic consciousness and that rival movements like dadaism and surrealism could be dismissed. For more on the privileging of abstraction, see the discussion of Alfred Barr and the note to Buchloh below.

typical expression of this equivocal position is the now-familiar sentence from "Towards a Newer Laocoon" (1940): "When the purist insists upon excluding 'literature' and subject matter from plastic art, now and in the future, the most we can charge him with off-hand is an unhistorical attitude" (I:23).

Greenberg puts himself in the position of the friendly advocate who helps out his client by minimizing the charge (the avant-garde is merely unhistorical) and offering to pay the fine by supplying that missing history. This history is, as it turns out, precisely that narrative of failed revolution and political marginalization of the avant-garde that, as we have seen, contradicts its idealized self-image. Even more disquieting, Greenberg makes it clear that the avant-garde, far from occupying a revolutionary posture, is actually a bourgeois movement that depends upon the patronage of the capitalist ruling classes for its sustenance; its "purity," from either a political or religious point of view, is continually in danger of being compromised by the vulgarity and materialism around it. In another sense, however, this very vulgarity, the popular productions of mass culture that Greenberg labels "kitsch," is what he offers to avant-garde culture as something to oppose, a common enemy that may distract it from its own impurities and contradictions. Kitsch is art which has not renounced its reliance on literature, which is filled with representations of familiar, formulaic, and sentimental stories: magazine covers (most notably the *Saturday Evening Post,* calendar art, Socialist Realism, and Hollywood movies (recently—in the forties—corrupted even further by learning to talk) are the principal visual examples. Kitsch is mass-produced, notes Greenberg, for the "industrial masses" who have recently been transformed by "universal literacy" into proper consumers for pseudo-art. Abstract art, then, is (like all high "formal" culture) actually an aristocratic form, made by and for a tiny elite in the cosmopolitan centers of advanced capitalist countries; in preindustrial societies, Greenberg even suggests that formal culture is "generally much superior" in "slave-owning tribes" (I:19n.6). All the pretensions to purity, immediacy, and "innocent eyes" are belied by the reliance of high formalist art on a very impure socioeconomic base and its appeal to a sophisticated, cultivated spectator whose eyes are far from innocent. The only thing that prevents this art from being, in Greenberg's words, a decadent "Alexandrianism" is that it is not "motionless," but dynamic and changing (I:6).

Greenberg's account of the materialist underside of abstract art is too vulgar for some consumers, not vulgar enough for others (he doesn't contemplate the possibility, for instance, that the "dynamic

movement" in avant-garde art may be something like the dynamic movement in automobile styles and dress fashions).[27] But it did have the salutary effect of exposing the contradictions of the avant-garde while at the same time holding it together in a precarious unity, at least for a few years. T. J. Clark has summarized Greenberg's position as an "Eliotic Trotskyism," a phrase that nicely captures the synthesis of conservative elitism and left-wing radicalism in Greenberg's rhetoric.[28] Greenberg codified both the ahistorical self-image of abstract purity and its claims to a historically inevitable role, a synthesis that can be seen falling to pieces in the debate between Michael Fried and T. J. Clark, Fried following what Clark calls the "old-time religion" of Greenberg's aestheticism, Clark following what Fried calls the "vulgar and demeaning" tendencies of Greenberg's Marxism.[29]

Greenberg's repression of the verbal element in abstract art, while thorough, was too explicit about the social meaning of these repressions, too clearly embattled in contradictions, to be successful in inaugurating a stable orthodoxy that could be elaborated as a discipline. (One might say that what Greenberg bequeathed us was a debate, of which the Clark-Fried encounter was a recent example.) The institutionalization of abstract art was already well prepared, however, by a slightly earlier text, Alfred H. Barr's *Cubism and Abstract Art*, the catalog for the 1936 show of European abstract painting at the Museum of Modern Art. Barr's way of repressing the verbal dimension of abstract art is, in contrast to Greenberg, simply not to mention it as a matter that was *ever* of concern to painters of any period. The motive force in Barr's history is nothing more complex than boredom:

> The pictorial conquest of the external visual world had been completed and refined many times and in different ways during the previous half millennium. The more adventurous and original artists had grown bored with painting facts. By a common and powerful impulse they were driven to abandon the imitation of natural appearance. (first published, 1936; Cambridge, MA: Harvard University Press, 1986, p. 11)

27. See Leo Steinberg, *Other Criteria*, for a consideration of this possibility.

28. See "Clement Greenberg's Theory of Art," in *The Politics of Interpretation*, edited by W. J. T. Mitchell (Chicago: University of Chicago Press, 1983), pp. 203–20.

29. This debate, which first developed in *Critical Inquiry* (September 1982), grew out of Fried's response to Clark's essay on Clement Greenberg, cited above, and is reprinted in *The Politics of Interpretation*, pp. 203–38.

The "history" that follows is a sequence of artifacts, names of move-ments, styles, and influences with only the most cursory reference to the historical conditions that gave them urgency. What Barr does provide in the place of history, however, is a highly compelling myth that synthesizes perfectly the scientific and religious self-representations of abstract art. This myth, in contrast to the entangled controversies of art theory, is a kind of exoteric, publicly accessible crystallization of theory, one that can be codified easily for classroom presentations. Although Barr's text has actually been reissued only three times—1966, 1974, and 1986—its determination of the basic sequence of objects in the Permanent Collection of the Museum of Modern Art has exerted its influence upon thousands of beholders who have never read the book.[30]

If it seems that I am exaggerating in calling *Cubism and Abstract Art* a "mythic" text, I would ask you to read Robert Rosenblum's foreword to the 1986 edition. Rosenblum, a distinguished art histo-rian who has written important books on the tradition of "pre-abstract" art in the eighteenth and nineteenth centuries,[31] defines Barr's influence in the most precise terms when he calls it the "Bible of modern art," a kind of "talisman" for the "budding art historian," with "an authority verging on the Old Testament's," a "rockbottom foundation for all my subsequent studies of twentieth century art" (p. 1), as it has been, I'm sure, for many generations of graduate students in art history. Even more significant than this tribute to Barr's

30. For an excellent account of Barr's de-historicizing influence on the American reception of modernism, see Benjamin H. D. Buchloh, "From Faktura to Factography," in *October: The First Decade, 1976–1986,* edited by Annette Michelson, Rosalind Krauss, Douglas Crimp, and Joan Copjec (Cambridge, MA: MIT Press, 1987), pp. 77–113. Buchloh makes it clear that Barr laid the groundwork for the equation of the avant-garde with abstract painting. During Barr's visit to the Soviet Union in 1927 he tried in vain to find abstract paintings, the new productivist aesthetic having pushed painting aside. Undeterred, Barr "continued in his plan to lay the foundations of an avant-garde art in the United States according to the model that had been developed in the first two decades of this century . . . " (p. 78). For more on Barr's "reduced, decontextualized, and exclusionary view of modern art's history," see Terry Smith, *Making the Modern* (Chicago: University of Chi-cago Press, 1993), chapter 11, "'Pure' Modernism, Inc.," pp. 385–95.

31. Robert Rosenblum, *Transformations in Late Eighteenth Century Art* (Princeton: Princeton University Press, 1967), and *Modern Painting and the Northern Romantic Tradition* (New York: Harper and Row, 1975); further page references will be cited in the text.

authority is Rosenblum's singling out of a particular image in Barr's text that mediated this authority. This image is not, as we might expect, the Malevich composition which adorns the cover of the 1986 edition, nor any of the Kandinskys or Braques or Picassos which punctuate its historical narrative. It is, rather, a scholar's image, a diagram of the evolution of modern art from impressionism to 1936 (figure 33). Rosenblum's commentary on this diagram (the diagram itself has unaccountably been left out of the 1986 reprint) is worth quoting at length:

> As for this diagram, I still recall vividly its heraldic power; for it proclaimed, with a schema more familiar to the sciences, an evolutionary pedigree for abstract art that seemed as immutable as a chart tracing the House of Windsor or the Bourbon Dynasty. Darwinian assumptions merged with the pursuit of genealogical blue blood in pronouncing, for instance, that a coupling of van Gogh and Gauguin created Fauvism, just as sodium and chlorine would make salt; and that Cubism, that most fertile of monarchs, had an amazing variety of princely offspring, from Orphism to Purism. At the bottom of the chart, which was marked off, in graph-paper fashion, by five-year periods, starting in 1890 at the top and ending with what was then the present, 1935, this multiplicity had been distilled into two parallel but polarized currents, nongeometrical and geometrical abstract art. The skeletal clarity and purity of this diagram were fleshed out in the text itself, which . . . outlined in the most pithy and impersonal way the visual mutations and the historical facts that accounted for the thrilling invention of a totally unfamiliar art belonging to our century and no other. (pp. 1–2)

Rosenblum's amazing pastiche of metaphors captures perfectly the contradictory elements in Barr's abstract image of abstract art: it is a religious icon and yet a scientific graph; a figure of ancient, traditional privilege and yet an image of chemical processes and Darwinian selection; an emblem of complex variety reducible to binary polarities converging in a single origin; a mere heuristic device, which could be casually left out of the latest edition, and a "heraldic" device invested with power and aura. All the paradoxes we have seen in the self-representation of abstract art are captured in Barr's diagram and naturalized as an organic image, an inverted tree which is at the same time a rational, artificial construction, a pyramid of deductions from first premises. This diagram can serve, moreover, for the elaboration of an indefinite number of narratives about the evolution of abstract art—as a quest-romance in which heroic artists search for the holy grail of pure abstraction, smashing the false, illusionistic images of

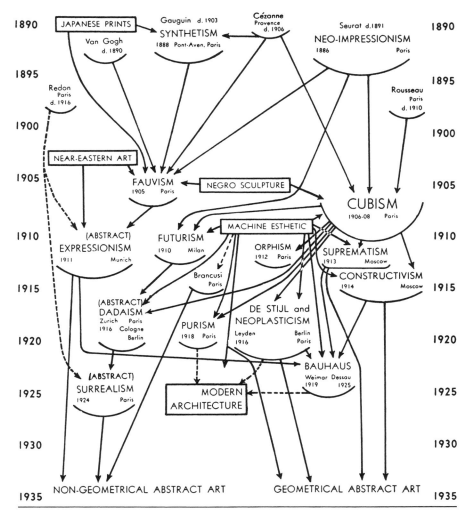

33. Chart prepared by Alfred H. Barr, Jr., for the jacket cover of the exhibition cata-
log *Cubism and Abstract Art*, by Alfred H. Barr, Jr., published by The Museum of
Modern Art, New York, 1936. Exhibition held 2 March–19 April 1936. Photograph
courtesy of The Museum of Modern Art, New York.

mere "nature" to find a spiritual essence; as a modern epic of scientific discovery that unveils the laws of light and visual perception; as a revolutionary saga that records the victories of an avant-garde in quest of moral and political regeneration. The discursive cement that holds all of these narratives together is a "rhetoric of iconoclasm" that stages the quest for purity as the destruction of outmoded, superstitious, or illusory images, a rhetoric in which aesthetic elitism, Marxist radicalism, and scientific rationalism can find a common language.[32]

Perhaps the most fundamental message of Barr's diagram is its graphic refutation of the idea that the modernist "grid" is a barrier between vision and language. What Barr provides, most conspicuously, is a *narrative* dimension to the perception of modern art which synthesizes the rhetoric of religious reformation with scientific "breakthroughs" and political progress. The myth of the absolute presence of the individual painting is articulated side-by-side with an even more insistent emphasis on its position in a temporal sequence: this is partly a result of Barr's treatment of paintings themselves as "events," as historically important moments in a master-narrative: "earlier and more creative years of a movement or individual have been emphasized at the expense of later work which may be fine in quality but comparatively unimportant historically" (p. 9). But even more significant is Barr's discussion of paths of influence as "entertaining sequences," a suggestion that one of the constitutive aesthetic *pleasures* in abstract painting is our sense of its place in a more or less familiar story. The story, in short, *should not be in principle* (though it may be in practice) the province of art historical professionals; it should be publicly readable and visible in the object. Clement Greenberg's claim that the pleasure of traditional painting is produced by the stories it represents resurfaces in a new form in Barr's version of abstract art. The difference is that the stories are represented in a different way and are known only to an elite audience of connoisseurs, critics, and historians; for them, the expressive improvisations of Kandinsky and the pure geometry of Malevich are eloquent hieroglyphics, memorials of great moments in the epic of abstract painting, stations of the cross in the theatrical passion play of modernism.

Barr's diagram, then, is like all abstract paintings a visual machine for the generation of language. Much of this language may be trivial chatter, as Jonathan Borofsky suggests, or misguided, as Clement Greenberg complained when he predicted that the average gallery-

32. See my essay, "The Rhetoric of Iconoclasm," in *Iconology* (Chicago: University of Chicago Press, 1986).

goer would mutter "nothing but wallpaper" when confronted with a Jackson Pollock. Much of it may be the refinement and detailed elaboration of myths, as is a large portion of the art historical writing that grows out of Alfred Barr. But there is no use thinking we can ignore this chatter in favor of "the paintings themselves," for the meaning of the paintings is precisely a function of their use in the elaborate language game that is abstract art. There is also no use thinking that we could make an end run around the paintings and the discourse they embody into some objective "history" that will explain them. Our problem, I would suggest, is to work through the visual-verbal matrix that is abstract art, focusing on those places where this matrix seems to fracture its gridlike network of binary oppositions and admit the presence of something beyond the screen.

The best way I can illustrate this point is by focusing more closely on a disruptive element in the symmetry of Barr's diagram. Rosenblum describes this image as reducing the "multiplicity" of abstract art to "two parallel but polarized currents, nongeometrical and geometrical abstract art." But Rosenblum also notes in passing that there is a third current, represented in red in the first edition, but reduced to monochromatic black in the later printings. This "third current" is the "external" influence of "foreign" arts (the influence of what was called "Negro sculpture" on cubism being the most famous) and what might be called "internally foreign" arts drawn from industrial design—the box labeled "machine esthetic." Unlike the "heresies" of surrealism, dadaism, or synthetic cubism (all of which Barr manages to contain dialectically in the master-narrative of abstract art), these elements seem to originate elsewhere, to occupy the role of silent Other to abstract art's binary dialogue with itself. I say "silent Other" because Negro sculpture (for instance) does not "inform" or "influence" or "speak to" cubism the way cubism speaks to and dominates its "princely offspring." The black arrows in Barr's diagram mean something quite different from the red arrows—the difference, say, between influencing and being appropriated, or dominating and being dominated. The black arrows are father-son relationships; the red describe the relation of imperial master to colonial subject. Both the industrial basis of imperial domination (figured in the "machine esthetic") and the colonized subjects play the Other to the idealist dialectics of abstraction.[33]

33. It might be worth pondering the uncanny echoing of the color scheme in Malevich's *Red Square and Black Square,* which replaced Barr's diagram as the cover image in the 1986 edition of *Cubism and Abstract Art.*

Barr's abstract grid, then, has a thread in it which, if read properly, opens onto a history and a social reality that complicates its self-representation as a quest for purity. Cool rationality and problem-solving "breakthroughs" may have as much to do with the automobile industry as with Platonic idealism.[34] As for the religious side of abstraction: Meyer Schapiro noted long ago the curious fact that "the highest praise" of a modern work of art "is to describe it in the language of magic and fetishism."[35] But which fetishism? The sense of irrational, timeless power discovered in the exotic arts of the primitive or the oriental? Or the more familiar, domestic phenomenon known as "commodity fetishism"—the projection of a magical halo onto expensive or well-publicized objects? Both these paths of abstraction lead back to the ordinary world—to the vulgar realities of imperialism at its outer and inner borders, to "kitsch," undeniably the world's first universal, imperial culture, to mass literacy and communication, to the universal narratives of "literary" painting, and to the social, historical realities abstraction tries to renounce under the name of literature. The only thing we can charge the purist with when he denies "literature," says Greenberg, "is an unhistorical attitude."

If we ask when abstraction stopped being an avant-garde movement, dying to be reborn as a tradition that must treat these forbidden subjects as heresies to be repressed, an obvious answer is: at least as early as Barr, who noted in 1935 that "ten years ago one heard on all sides that abstract art was dead" (p. 9) and who sees his own work as "in no sense a pioneering effort."[36] In America, the death knell is usually placed thirty years later, right after the Korean War, when a discharged soldier named Jasper Johns returned from America's first sobering experience as an imperial power and began to produce a series of paintings that outraged the high abstractionists and are

34. See Leo Steinberg, *Other Criteria,* for a development of this idea.

35. Meyer Schapiro, *Modern Art, 19th and 20th Centuries: Selected Papers* (New York: Braziller, 1978), p. 200. Schapiro is, so far as I know, the only early commentator on abstract art to see that its "primitivism" was directly linked to the "colonial imperialism that made these primitive objects physically accessible" (p. 200).

36. This may be Barr's tacit acknowledgment of his impressions during his 1927 visit to the Soviet Union where he indeed did hear "on all sides" that abstraction was no longer the interest of the avant-garde. The death knell in this case might be put back to 1915. See note to Buchloh above.

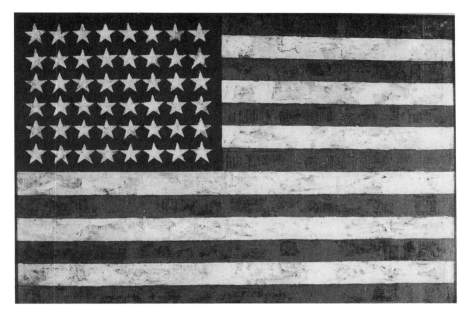

34. Jasper Johns, *Flag* (1954–55; dated 1954 on reverse). Encaustic, oil, and collage on fabric mounted on plywood, 42¼ × 60⅝″. The Museum of Modern Art, New York. Gift of Philip Johnson in honor of Alfred H. Barr, Jr. © Jasper Johns/VAGA, New York 1993.

widely regarded as bringing the end of modernist abstraction and the beginning of postmodernism. Johns's two most famous motifs of this period, the "Flag" and "Target" series (see figures 34 and 35), bring us back to where we started, to the silent grid, now uniting the two traditions of Barr's diagram by rendering pure geometry with expressionistic, antigeometrical brush-strokes. The Hegelian binarism is preserved at the level of form and technique, an apt focus for the by now traditional discourse of *ut pictura theoria,* with its metaphysics of purity, flatness, and anti-illusionism. But a new "other" from the concrete, ordinary world breaks into and dominates this refined discourse—nothing less than the sort of kitsch icons Greenberg had banished from serious art. The first is a sentimental emblem, a totem of mass culture surrounded by the connotations of nationalistic demagoguery that Clement Greenberg had always associated with kitsch and Walter Benjamin associated with fascism (associations that seem unavoidable for a painting from the early fifties, the era of HUAC,

35. Jasper Johns, *Target with Four Faces* (1955). Assemblage: encaustic and collage on canvas with objects, 26 × 26″ surmounted by four tinted plaster faces in wood box with hinged front. Box, closed, 3³/₄ × 26 × 3¹/₂″. Overall dimensions with box open, 33⁵/₈ × 26 × 3″. The Museum of Modern Art, New York. Gift of Mr. and Mrs. Robert C. Scull. © Jasper Johns/ VAGA, New York 1993.

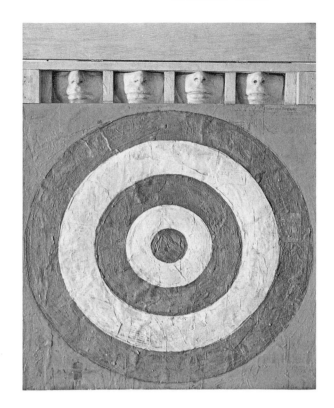

McCarthy, and Cold War flag-waving).[37] The other motif, like the flag, is a version of the grid, but in this case it is not the grid of national unity and imperial power, but a figure of the field of power and surveillance on which it stands, an optical array whose function is the cultivation of predatory, aggressive vision. The purity of this optical, painterly statement is disrupted by a kind of sculptural editorial comment in the plaster figures displayed across the top. In one version we find four identical faces with the eyes cut off, as if the aggressive vision invited by the target implied a blindness somewhere else. In another version, we find fragments of the human form, once again, displayed as a kind of consequence of or comment on the proposition articulated by the target. It's hard to imagine a more

37. These associations were clear to Alfred Barr, who refused to buy *Flag* for the Museum of Modern Art, "fearing political repercussions." See Michael Crichton, *Jasper Johns* (New York: Harry Abrams, 1977), p. 73.

vulgar and direct set of statements combined with a more subtle commentary on the tradition that Johns grows out of and deconstructs. In retrospect, it may seem hard to understand how difficult it was for critics committed to the purist, abstractionist agenda to see what was happening in these works, to comprehend their inevitability in relation to the master-narratives to which the purists were themselves committed. The "Flags" and "Targets" compositions have by now become as transparently emblematic of an artistic revolution as the abstractions of Malevich were to Alfred Barr. The revolution they signal, commonly called "postmodernism," in retrospect, has been no less problematic, equivocal, unfinished, and prematurely obsolete than the modernism it claimed to supersede. The replacement of global imaginaries like the Cold War and nuclear holocaust by new global realities such as the triumph of corporate capitalism and neofascist nationalisms no doubt requires a reassessment and a renaming of the cultural dominants of our period and a reconsideration of exactly what postmodernism has come to.

Among the accomplishments of the revolution signaled by Johns's "Flags" and "Targets" was the reopening of art (for better or worse) to what Edward Said would call "wordly" concerns—to kitsch, mass culture, the mixture of media, political propaganda, and theater—the resurgence of artistic impurity, hybridity, and heterogeneity summarized as the "eruption of language into the aesthetic field." This "eruption" has occasioned new, revisionist histories of the modernism it supplanted, histories in which Greenbergian abstraction tends to be de-centered and jostled about by alternative traditions in modernism. The survival of these alternative modernist traditions—not only the obvious ones like surrealism, dadaism, and constructivism, but what one might call the "redlined" zones of Barr's diagram, the "primitive" and the "industrial"—made possible the opening of new regions of the seeable and sayable in both modernism and postmodernism. The exploration of one of these regions, the reconfigured relation of word, image, and object in minimalism, specifically in the sculpture, painting, and writing of Robert Morris, will be the subject of the next essay.

36. Robert Morris, *Card File*, 1963. Mixed media on board. Ca. 10 × 20″. Pompidou Center, Paris.

WORD, IMAGE, AND OBJECT: WALL LABELS FOR ROBERT MORRIS

The relation of word and image seems exactly analogous to the relation of words and objects. The imagetext reinscribes, within the worlds of visual and verbal representation, the shifting relations of names and things, the sayable and seeable, discourse *about* and experience *of*. And yet the obvious analogy draws all its interest from the equally obvious and radical discrepancy between images and objects, representations and *pre*sentations. What is this discrepancy? Is it nothing more than a flash of repetition, a double take like the one that transforms an object into an image, a picture into a metapicture? What is an object? What is its relation to a subject and to the words and images that subjects construct to make objects intelligible? The contemporary artist who has thought most deeply about these questions is Robert Morris, whose work and writing have also been central to the articulation of what might now be called "High Postmodernism," the mounting of a direct challenge to and continuation of the modernist tradition of *ut pictura theoria*. In the sixties, Morris was the principal antagonist of Michael Fried's "great refusal" of new antimodernist work in "Art and Objecthood": he served as the major exemplar of theatricality, mixtures of media, and a new kind of obdurate, objectlike sculpture that seemed to deny any possibility of optical, pictorial, or figural incident, while drawing quite explicitly on a theoretical discourse for which the works seemed to function as demonstrations. I'm less interested in positioning Morris within the familiar narratives of postmodernism, however, than in tracing his inquiry into the relations of images, objects, and words, especially those words that allow us to label artistic objects and thus to tell stories about them, including stories about "modernism" and "postmodernism."[1] My aim, in short, is to examine the way Morris's

1. Among the numerous studies of postmodernism, I have found most stimulating and reliable Fredric Jameson's *Postmodernism, or the Cultural Logic of Late Capitalism* (Durham, NC: Duke University Press, 1991), and

work complicates and contests the labels that make his objects intelligible.

The appearance of Morris's work in a major Guggenheim retrospective in 1994 ought to have settled the question of his status. The label of "Major Artist" could now be safely inscribed over the entrance to the exhibition, and the works could be safely labeled as masterpieces, no matter how unprepossessing their visual appearance. All that remained was the packaging of Morris's work in a canonical history that would position him in the contexts of modernism and postmodernism and unpack the meanings of his objects in the terms provided by poststructuralist theories of art.

> *The wall label disturbed my sleep. It grew to threatening proportions, entwined itself around me, babbled in my ear, wrapped itself over my eyes. It was a tangled, suffocating shroud of seething words in my dream. But in dreams begin responsibility, as the insomniac poet said. Have I had a dream of warning? I get up edgy.*[2]

It is a tribute to both the intransigence of the art-viewing public and the resilience of Morris's art that the labeling, packaging, and securing of both the Work and the works is not likely to proceed without some trouble. More than any American artist of his generation, "Morris" (considered as the name of a total oeuvre) has managed to remain unpredictable, hard to classify, and difficult to label in the terminology of styles, artistic movements, and periods. And yet, if one had to produce a "representative" American artist for the period from 1960 to 1990, one could hardly do better than Morris. One of the complaints about his work, in fact, is that it is *too* representative, that it merely holds up a mirror to the art of its time, working across all the genres of postmodern artistic practice (minimalist and conceptual sculpture, performance art, land art, scatter pieces, felt works, painting, drawing, photography, ready-mades, image-text composites, procedural works) without committing itself to any single mode or style.

David Harvey, *The Condition of Postmodernity* (Cambridge, MA: Blackwell, 1990). Harvey and Jameson share a refusal to accept postmodernism on its own terms (that is, as a collapse of metanarratives, the search for a new ensemble of artistic styles, or a mere negation of modernism) and an insistence on strategic gestures of totalizing (as distinct from presumed "totalities"). While Pop Art (and typically the work of Andy Warhol) has become canonical for the historical periodization of nascent postmodernism in the sixties, the role of American minimalism seems to me equally crucial.

2. Dream journal entry by Robert Morris, 10/28/90.

Morris's work both invites and resists labeling, lending itself to instant (mis)recognition in terms of the generic labels endemic to post-modernism, while refusing the overall label of the individual artistic style or "look." There is no way to identify "a Morris" by its visual appearance from across a room, no way to predict with any certainty what his new work will look like, and yet his work never seems to appear without inviting ready-made labels.[3] His turn in the late eighties to works that look like monumental paintings (the Holocaust and firestorm series; the blind time drawings; the Wittgenstein drawings and the associated series of large encaustic paintings on aluminum panels) could hardly have been predicted from his previous work. Those who had defined Morris's career as a practitioner within specific media had grown used to labeling him as a sculptor and (more important) as a sculptor who saw his medium as expressing concerns "not only distinct but hostile to those of painting."[4] The reaction of critics to his "shift" to painting was predictable. There was, on the positive side, a rush to certify his credentials as a painter by bringing out his early exercises in abstract expressionism.[5] On the negative side, he was accused (as so often before) of being a merely eclectic experimentalist and imitator of prevailing fashion. The large encaustic paintings with their enigmatic stenciled texts were seen as belated attempts to capitalize on the fashion for image-text composites pioneered by younger American artists in the late eighties.[6]

My own insomnia begins. What have I previously ignored, not wished to think about? A mere wall label? An institutional excrescence, a blurt

3. One notable exception to this generalization might be his use of flat gray paint on the minimalist objects of the sixties. As David Antin noted, this gray became "a signature and to that extent, perhaps, somewhat independent of any individual work, like Newman's stripes" (*ArtNews* 65:2 [April 1966]: 56). At the same time, the paradoxical implications of using a neutral colorless color like gray as a signature of a personal style can hardly be ignored. The noncommittal character of grayness is more like a mask for any personal identity, a kind of coloristic "John Doe" signature that signals Morris's refusal to underwrite his works with claims to authentic or personal self-revelation.

4. Robert Morris, "Notes on Sculpture I," *ArtForum* 4:6 (February 1966): 42.

5. See the essays by Barbara Rose and Terrie Sultan in *Inability to Endure or Deny the World*, the catalog of the Corcoran Gallery's 1990–91 Morris retrospective.

6. See Roberta Smith, "A Hypersensitive Nose for the Next New Thing," *New York Times*, 20 January 1991, p. 33.

of public relations jargon, a mere supplement? Ah, there's the rub. Beware of supplements.

The problem of labeling Morris is, I want to suggest, not merely a pragmatic or curatorial issue concerned with the management of an unusually large and diverse oeuvre. It reflects a whole set of issues internal to Morris's work and characteristic of the shifting relation of art and language in the era for which he is such an apt representative. Thus, on the one hand, Morris's work has consistently engaged itself not just with the elaboration of a verbal program that lies "behind" the art, as a theoretical scaffolding or prop for the objects, but with the exploration of art itself as language, of the object or image as a complex intersection of the seeable, the sayable, and the palpable. Morris's writing and his art have staged this intersection, not as a settled boundary between words and images, words and objects, but as a site of anxiety, play, and disruption. That we do not know what a Morris will "look like," that he offers no consistent visual style, is at once cause and consequence of the difficulty with labeling, of mustering an adequate, much less authoritative, descriptive language for his work.

The wall label disturbed my sleep. It raises the insomniac's cold sweat. This wall label begins to throb with ambiguous threat, refusing its repressed status as linguistic blurb. This institutional, tautological annoyance slithers and coils in the shadows. It begins to grow larger than the works proper in my dream galleries; a snarling, looming, hypnagogic presence.

This difficulty with labeling is, moreover, not simply a problem with Morris, but reflects a central obsession of postmodernism, which has itself consistently been labeled as the exploration of a new relation between art and language. Modernism—at least in Clement Greenberg's classic formulation—sought to evacuate language, literature, narrative, and textuality from the field of visual art.[7] Postmodern art, not surprisingly, has been defined as the negation of this negation, "an eruption of language into the aesthetic field."[8] From a

7. See Clement Greenberg's "Towards a Newer Laocoon," (1940), reprinted in *The Collected Essays and Criticism,* edited by John O'Brian (Chicago: University of Chicago Press, 1986), pp. 23–37, and the discussion of abstraction and language in chapter 7.

8. Craig Owens, "Earthwords," *October* 10 (Fall 1979): 125–26.

gridlike art of "purity" and opticality expressing what Rosalind Krauss calls a "will to silence,"[9] we have (so the story goes) moved to an art of noise, discourse, and speechifying, characterized by impure, hybrid forms that couple the visual and the verbal, or erase the difference between image and text. The de-purifying of artistic opticality has been accompanied by a de-throning of the notion of the artist as the creator of an original *image*, a novel visual gestalt that bursts fully formed from the mind of the artistic "seer" to dazzle and fixate the spectator. In the place of this art of the purified and original image, postmodernism has offered pastiche, appropriation, ironic allusion, an art addressed to spectators who are more likely to be puzzled than dazzled and whose thirst for visual pleasure often seems deliberately thwarted.

Like all art-historical master narratives, this one is a myth, a compound of half-truths and oversimplifications that nevertheless has a certain power to frame the production and reception of art. It is a story to which Morris himself has contributed, both as narrator and actor, writer and artist.[10] It is, in short, a story whose historical effects must be reckoned with, even by those who want to resist them or who want to situate this story in relation to larger, longer, or more nuanced histories. A larger historical frame, for instance, would ask us to consider the relation of this (mainly American) story of art to the fortunes of American culture in the era of the Cold War and the nuclear nightmare, a period that, in the very moment of Morris's retrospective, seems now to be clearly "behind" us, replaced by the quite different concerns of a post-nuclear, post–Cold War "New World Order," and the final victory of capitalism as a world system.[11] A longer view would ask whether the changing relation of art and language central to postmodernism was not already occurring in its basic forms in early European modernism (notably in dadaism, surre-

9. Rosalind Krauss, "Grids," in *The Originality of the Avant-Garde and Other Modernist Myths* (Cambridge, MA: MIT Press, 1985), p. 8.

10. See Morris's essay, "Words and Images in Modernism and Post-modernism," *Critical Inquiry* 15:2 (Winter 1989): 337–47, and my article, "*Ut Pictura Theoria*: Abstract Painting and the Repression of Language," pp. 348–71, for a discussion of this history.

11. For a discussion of Morris's work in the context of the late Cold War culture of the 1980s, see O. K. Werckmeister, *Citadel Culture* (Chicago: University of Chicago Press, 1991), especially the chapter entitled "Lucas, Morris."

alism, and in the work of the various historical avant-gardes).[12] From this standpoint, the cult of visual purity and the will to silence might look more like a temporary aberration, an interlude associated with the removal of modern art, especially abstract painting, from its European context into the purified spaces of the Museum of Modern Art. The "eruption of language into the aesthetic field" might seem less transgressive and look more like the restoration of a basic condition of art, which has, after all, been impure for most of its history. A more nuanced view, finally, would have to address the ways in which the cults of both visual purity and visual-verbal hybridity intersect with transformations in visual and textual culture more broadly considered. If Clement Greenberg's "kitsch" became the impure negative foil for his purist "avant-garde" at a certain cultural moment around World War II, we would have to notice that this dialectic between mass and elite culture takes on a variety of other forms in other places and times, both before and after the moment of high modernist abstraction in the United States. However much minimalism may have departed from some of the pictorialist and expressivist tendencies of formal abstraction, there is no doubt that it continued this tradition in its search for purity and its aesthetic elitism. In this respect, minimalist visual art, especially sculpture, seems quite antithetical to the sort of decorative, patterned musical minimalism of Steve Reich or Phil Glass. John Cage's 4'33" of "silence" provides the appropriate musical setting for Morris. Duchamp, not the mass media, provides the model for the hybrid visual/verbal character of his objects: "One foot in images, the other in language, this is the least immediate and most discursive form of art-making."[13]

> Now I am awake, yet the label refuses to shrink. Here beneath the dim lamp its rectangularity seems to pulsate, its language groans and threatens. This blot of words screeches and sobs and finally recedes to a menacing tell-tale tick of mumbling under the floor boards.

The relation of art and language, object and label, is one of the principal paradoxes of minimalist sculpture. On the one hand, the beholder is confronted by simple, spare, elemental, usually "untitled"

12. See Morris's discussion of writer-artists like Kandinsky, Malevich, Gabo, and Mondrian who "contributed to a growing body of theoretical texts, some in the form of manifestos, which grew up alongside the material production of the images. . . . " in "Words and Images," p. 341.

13. Robert Morris, "American Quartet," *Art in America* (December 1981): 104.

objects that seem deliberately "inexpressive," "deadpan," and "inarticulate."[14] What can objects labeled "Slab," "Beam," and "Box" say to us? What can we possibly say about them? The labels seem to say it all, to exhaust the object and the visual experience of the object. The whole situation of minimalism seems designed to defeat the notion of the "readable" work of art, understood as an intelligible allegory, an expressive symbol, or a coherent narrative. On the other hand, minimalism is often characterized as an unprecedented intrusion by language—especially critical and theoretical language—into the traditionally silent space of the aesthetic object. As Harold Rosenberg put it: "No mode in art has ever had more labels affixed to it by eager literary collaborators. . . . No art has ever been more dependent on words than these works pledged to silent materiality. . . . The less there is to see, the more there is to say."[15] Even worse than the "literary collaborators" and the chatter of the ever-helpful critics, according to Rosenberg, is the fact that the minimalist artists themselves became writers. All the traditional divisions of labor in the art/language game were confused. The mute, inarticulate sculptor who was supposed to make infinitely expressive images for the delectation of the infinitely receptive (and articulate) aesthete, has been replaced by the articulate sculptor who makes mute objects for a puzzled beholder.

Then with a certain trembling it strikes me, there is no such thing as a 'mere wall label.' The phrase ratchets through my feverish brain. This label, this mutter of slurred information has a secret ambition. No doubt about it, its aim is nothing less than dominating my images there on the wall. Its linguistic hysteria begins to erode the encaustic from my panels.

In one sense this paradox has now been prematurely resolved by institutional art history. The canonizing of minimalism, the stabilizing of its label as a fixture in the succession of twentieth-century styles, has now made these mute objects, once so strange and silent, seem

14. Rosalind Krauss, *Passages in Modern Sculpture* (Cambridge, MA: MIT Press, 1977), pp. 236, 199.

15. Harold Rosenberg, "Defining Art," in *Minimal Art: A Critical Anthology*, edited by Gregory Battcock (New York: Dutton, 1968), p. 306. See also Michael Fried's characterization of the minimalist object as "literalist" (understood as a hypostatizing of objecthood) and dependent upon an "ideological" position, "one that can be formulated in words, and in fact has been formulated by some of its leading practitioners" ("Art and Objecthood," *ArtForum* (June 1967), reprinted in Battcock, pp. 116–17).

full of memorable association and anecdote for those in the know. The writings and conversation of the artists, most notably of Morris—"the most subtle of the Minimalist dialecticians," according to Rosenberg (p. 305), have now become inseparable from the experience of the knowledgeable beholder. But what about the ignorant beholder, the one who walks into the gallery or museum cold and experiences minimalism as a shock of deprivation and disappointment? We can't even console ourselves that this shock is something like that of the original puzzled beholder (for example, Rosenberg) in the sixties, because the context now is quite different. The jury is no longer out. The works have the authority of canonical labeling. If you don't get the point, it is a judgment on you, not on the works. What do we say to the innocent viewer now? What is the present availability of these works? Do they have any fate beyond canonization in a system of labels and myths?

> *The wall label has disturbed my sleep. I must get a grip on myself, or at least on the label. I must squeeze it back to its true ignoble proportions. But it is elusive as it gleams there in the dark with its Poe-like atmospherics of linguistic threat and verbal iconoclasm.*

Morris himself seems unsure on this point, noting already in 1981 that minimalism had run out of steam: "As the dialectical edge of minimalism grew dull, as it had to in time, and as the radicality of its imagery, contexts or processes became routine, its options dwindled to a formula; use more space."[16] But Morris was only a drop-in minimalist in the first place, albeit its most articulate spokesman. His interest from the first was much more complex and general than any work within a style or movement "look." He had been concerned with nothing less than the philosophical task of art, the employment of sculpture, understood as a hybrid grafting of word, image, and object, as the vehicle for a reflection on art.[17] This makes Morris unpopular and impolitic. He is an "artist's artist," not in the usual sense of technical, stylistic virtuosity (despite his reputation as a perfectionist craftsman), but in the depth of his intervention into the basic issues of aesthetics, and particularly the history of sculpture in

16. Robert Morris, "American Quartet," p. 96.

17. See Annette Michelson's important essay, "Robert Morris—An Aesthetics of Transgression," for the catalog of the 1969 show at the Corcoran Gallery of Art for the first serious treatment of Morris as a philosophical sculptor.

what Krauss aptly calls its "expanded" field.[18] Morris makes philosophical objects that need not have any *visual* family resemblance, no "look" that can be labeled. What they have in common is strictly not visible, not representable, and difficult to label except perhaps as something like "philosophy." It is a body of questions and decisions, some rational, others arbitrary; a series of concerns, experiments, concepts, procedures, attitudes—in short, a discursive field or grid, like a card file, a catalog of the considerations and topics that might come up in the making of an art object labeled "Card File" (figure 36). This means his work is hard to consume, much less digest, at the level of visual pleasure. The objects don't even do us the courtesy of "illustrating" Morris's discourse in any straightforward way. One might think of his objects less as examples or illustrations than as *cases* to be opened, pondered, and (sometimes) closed,[19] specific word/image/object assemblages that, when successful, exceed and explode (or incorporate) the labels that accompany them.[20]

Show yourself in the light, wall label. Come out of the shadows of the gallery. But this protean linguistic monster hides behind the institutional leadenness of its prose.

In short, one actually has to do some hard thinking, some serious talking to oneself or a friend in the presence of this work. One has to understand the dialogue provoked by the objects *in situ* as part of

18. Rosalind Krauss, "Sculpture in the Expanded Field," in *The Originality of the Avant-Garde*, pp. 276–90.

19. Sometimes, of course, Morris's "cases" cannot be opened. We may know that the minimalist pieces of the sixties are hollow, but the impossibility of looking inside them is part of the point. Morris's cabinet with lock and key and inscription, "Leave key on hook inside" suggests another situation—a case that could be "looked into" one and only one time, and then would be closed forever.

20. I'm thinking here of the "case" as the concept is used in sociology and psychology (case "studies" and case "histories") and the concomitant ambiguity about the theoretical/empirical status of the elementary units of research. For an outline of the basic concept of the sociological "case," see Charles C. Ragin and Howard S. Becker, *What Is A Case?* (New York: Cambridge University Press, 1992), p. 9. The literal and material figure of the "case" as a hollow container and its figurative extension to hermeneutics (the secret or solution to a mystery hidden inside a case) is also relevant here. I'm grateful to James Chandler for bringing the sociological analysis of the case to my attention.

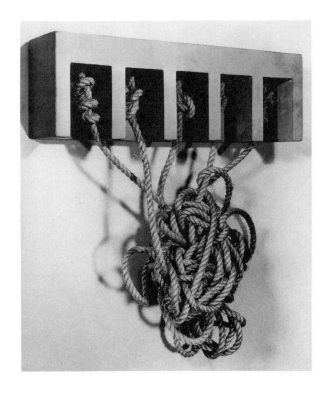

37. Robert Morris, *Untitled ("Knots")*, 1963. Wood box, 5⅛ × 15¼ × 3½" (overall height with rope approximately 20 inches.

what the works are. The objects take time, much more time than a label allows, certainly more time than we have (though John Cage, reportedly, sat and listened for three and one-half hours to the entire tape loop of *Box with the Sound of Its Own Making*). And this time is not a hermeneutic duration, a process of interpretation and description that leads to the hidden truth or meaning, but a movement from apparent order to a labyrinth of knots, unsolved problems, conundrums, and disagreeable absences.[21] (As an emblem of this movement, one might consider Morris's notched wooden bar with knots [figure 37], which displays a rational, machine-tooled object as the "support" for a chaotic tangle, or his various "ruler" pieces that display the

21. Michael Fried accurately gauged, I think, the peculiar temporality involved in minimalist sculpture, contrasting it with the sense of "instantaneousness" he associates with modernist painting and sculpture. See "Art and Objecthood," in Battcock, pp. 144–46.

constructed, conventional, and arbitrary character of rational measurement.)

Morris couples the purism of the abstract formalist tradition with the relentless, corrosive irony of Duchamp to produce a "rational" or at least "systematic" art that aims at perfect lucidity about the possibility that art and history (not to mention art history) might be nightmares from which we can never awake. Like Walter Benjamin, he asks us to contemplate his objects as "dialectical images," documents of civilization that insist on being seen simultaneously as documents of barbarism.[22] The cool, gray formalism of the polyhedrons and the chaotic anti-form of the scatter pieces are incompatible within the short circuit of "look" and "label," but rigorously connected within a dialectics of the object. Morris's "baroque" phase of firestorm and holocaust paintings in the 1980s is, at the level of "look" and "label" a regression to expressionist painting (figure 38). And their look and scale is surely appropriate to a meditation on the monumentalization of death and annihilation in the eighties, the Decade of Greed, Star Wars, and Reaganomics—the final glorious days of triumph over the "Evil Empire," the transition from the prospect of sudden nuclear catastrophe to slow environmental destruction. No wonder they look like ornaments suitable for Darth Vader's boudoir.[23] They are not "expressions" of this period, however, but quotations of neoexpressionism enframed within sculptural counterquotations. In these works, the sculptor confronts the painter, insisting on the *frame* as an equal partner in the work "proper," not a mere supplement or neutral setting for the picture. The hydrocal frames with their imprinted body parts and post-holocaust detritus stand as the framing "present" of the works, trophies or relics encrusted around the past event, the catastrophe that left the fossils as the imprints in which it is enframed.[24] Frame is to image as body is to the destructive element, as present is to past. Or (to be literal about it)

22. Walter Benjamin, "Theses on the Philosophy of History" (1940), in *Illuminations,* edited by Hannah Arendt (New York: Schocken, 1969), p. 256.

23. I owe this analogy to Janice Misurell Mitchell. See also O. K. Werckmeister's provocative discussion of Morris's firestorm and Holocaust paintings in *Citadel Culture,* especially the juxtaposition of Morris's "pre-war" paintings with the *Star Wars* trilogy by George Lucas, pp. 142–63.

24. Morris's inscriptions to these works move across the temporal dimensions suggested by the relation of frame to image. Thus "none *will be* ready when it touches down. Yet we *have seen* it gathering all these years. You *said* that there was nothing that could be done."

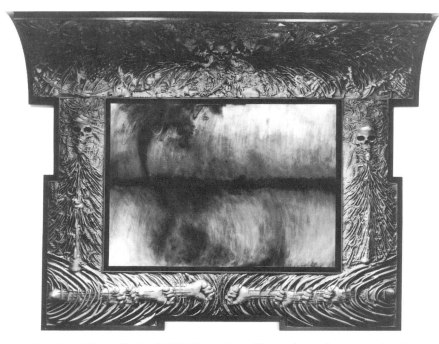

38. Robert Morris, *Untitled*, 1984. Painted cast Hydrocal, pastel on paper. Inscription: "None will be ready when it touches down. Yet we have seen it gathering all these years. You said there was nothing that could be done."

frame is to image as a remote possible future is to a less remote future. Someday, the works suggest, the past will be enframed in a present that makes these works look natural.

The "knot" arises when one realizes that this future would be one in which these paintings could never exist. Morris makes them look as if they were meant to survive a nuclear holocaust, but he (and we) are well aware that survivors of such a scene would have little interest in his or anybody else's art. This is art for a possible future in which art would not exist, monuments to a time beyond monuments. They critique a world in which, as Benjamin put it, "mankind . . . can experience its own destruction as an aesthetic pleasure of the first order."[25]

An anonymous editorial comment appended to Morris's 1981 *Art*

25. Walter Benjamin, "The Work of Art in the Age of Mechanical Reproduction" (1936), in *Illuminations*, p. 242.

in America essay, "American Quartet," accused the artist-writer of a kind of ghoulishness and gloom in his meditations on the aesthetic monumentalizing of death and destruction. The editor's polemic drew a picture of the relation between words and images, visual monuments and critical commentary in Morris's own essay, that locates the artist's "cultural charnel house" in the present of 1981, not in a projected future:

> For it suggests the image of works we deem significant, those which elicit extensive critical interpretation and even incite perpetual reinterpretation, as some sort of cultural carcasses, swarming and half-buried with seething words which, like the movement of a mass of maggots, impart both a certain disgusting motion and transformation to dead things. ("American Quartet," p. 105)

The very structure of this art critical hoax (the "editor" was Morris himself) epitomizes a typical Morris procedure. The essay is structured around the flagrantly minimalist image of a *table,* whose four corners represent Morris's canonical "grid," his picture of the four major figures and tendencies of American art (Pollock's abstract expressionism, Duchamp's metasystems, Hopper's mimetic realism, and Joseph Cornell's decorative surrealism): "considered as a totality, the model suggested here has three distinct levels: the upper grid, like a table-top, which locates positions and orientations; the four key paradigmatic lines (or legs) which form foci and boundaries as well as indicate a vertical dimension of enduring traditions; and at the roots of these traditions we pass into a theoretical realm" (p. 95). Morris evokes the tradition of the *tavola* and the historical/conceptual *tableau,* the classic rationalist device for spatializing a discursive totality, treating his "polygon" as a stage for art critical gestures that mimic the characteristic gestures of its four "key points" or "lodestones." Thus, his own prose (as the outraged editorial commentary complains) "wander[s] around a great deal," like the tracks of Pollock; it portrays the artist in the "sealed space of alienation" in the style of Hopper; it stuffs the virtual "box" of its conceptual grid with fragments of the entire history of modern art in the manner of Cornell. Then it turns, in the manner of Duchamp, and deconstructs the entire structure as "the ghoulish image of critics mumbling and chewing their dead artifacts on the table of commentary" (p. 105).

Are you innocence, sincerity? Are you but a few simple guiding words, a soothing "orientation"? Ah, but I catch your sneer, your twitching suspect words, your double meanings, your dominating strategies dis-

guised beneath your platitudes. You wish to triumph once again (endlessly and forever) over the imagistic. Your agendas are always hidden.

Morris's ambivalence about the adequacy of the visible form, then, does not imply any complacency or certainty about the place of philosophical language or critical discourse. You can't run from the objects to the labels or narratives provided by Morris's own writings. "American Quartet" is a self-devouring imagetext; it eats itself alive. Neither the image nor the word nor the object can be relied on to stabilize experience or meaning. Or perhaps it would be better to say: the stabilizing of relations among words, images, and objects is exactly what Morris's work tries to resist: "the only authenticity is one which has refused every identity conferred by an institution, a discourse, an image or a style, as well as every delight and oppression offered by that gulag called the autobiographical."[26] The rude blocks and beams of minimalism are, in Morris's usage, neither allegories of cultural totalities or figures of Platonic perceptual foundations:[27] they are better seen as something like the bricks that Ignatz the Mouse hurls at Krazy Kat whenever he has uttered some profound moral truism.[28] That is why the minimalist objects don't really reward an analysis that looks for phenomenological foundations as opposed to phenomenological *process* and contradiction. The choice of extraordinarily clear elementary polyhedrons, executed in specific materials at a precise scale in relation to the human body is aimed at revealing the disjunctions in the perceptual process, not at establishing elemental foundations (see installation view, figure 39). As the viewer moves in relation to the object, or the object moves into new situations, its "open and neutral" shape undergoes infinite variation:

> Even its most patently unalterable property—shape—does not remain constant. For it is the viewer who changes the shape constantly by his change in position relative to the work. Oddly, it is the strength of the constant, known shape, the gestalt, that allows this awareness to become so much more emphatic in these works than previous sculpture.

26. Robert Morris, interview with Robert Denson, forthcoming in *Critical Inquiry*.

27. See *Iconology*, pp. 93 and 158, however, for a discussion of the Platonic concept of the "provocative" and its relation to the concept of the dialectical image.

28. See Morris's unpublished interview with Robert Denson (forthcoming in *Critical Inquiry*), in which the artist recapitulates his entire career as a series of Krazy Kat dialogues, with minimalist objects as Ignatzian bricks.

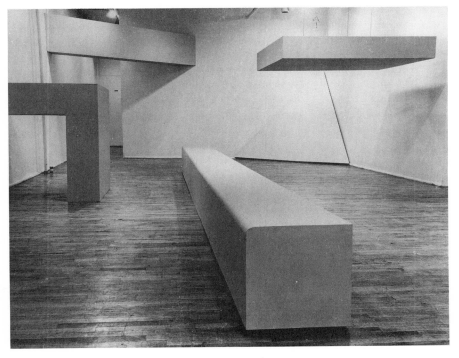

39. Robert Morris, Installation view with assorted polyhedrons.

A Baroque figurative bronze is different from every side. So is a six-foot cube. The constant shape of the cube held in the mind but which the viewer never literally experiences, is an actuality against which the literal changing, perspective views are related. There are two distinct terms: the known constant and the experienced variable. Such a division does not occur in the experience of the bronze.[29]

The terms here go back at least as far as Plato's division between the "intelligible" and the "visible," rephrasing them in the nominalist distinction between the "literal" and the "actual," a shift from an epistemological frame to a poetics or metaphysics of experience.[30] The question raised by Plato is how one distinguishes a "provocative" or

29. "Notes on Sculpture," in Battcock, p. 234.
30. See Nelson Goodman on the "literal" and the "actual" in *Languages of Art* (Indianapolis, IN: Hackett, 1976), p. 68.

"dialectical" object—"things that are provocative of thought"—from things that are not. His answer is that "provocative things . . . impinge upon the senses together with their opposites."[31] That is what makes them dialectical—namely, occasions for the experience of difference and contradiction and thus provocatives to dialogue. The staging of the object, its insertion into a space and an institutional context that invites aesthetic reflection is, obviously, a necessary but not sufficient condition for the provocation to dialogue. The object itself—its specific materials, facture, lighting, color, orientation—offers factors that must be taken into account. Above all, its *scale* (especially in relation to the norm of the human body) invites "the intelligence . . . to contemplate," in Plato's words, "the great and small, not thus confounded but as distinct entities" (p. 159). In Morris's terms, the goal is to explore the delicate intermediate realm "between the monument and the ornament," between the private sphere of intimacy and the gigantic proportions of mass perception, an in-between space that Morris consistently associates with a "public mode" of perception.[32]

Another way to define the delicate intermediate zone opened up by this sort of object is to ask exactly how valuable or important the object is, what sort of claims it puts on the beholder. It's clear, for instance, that Morris's polyhedrons are not unique objects, but material realizations of three-dimensional concepts, open to indefinite reproduction. Many of his "original" minimal objects have been lost or destroyed and have been refabricated in other (often more expensive and durable) materials than the original plywood constructions. The decision to refabricate many of these objects in plywood for his retrospective, rather than to borrow them from the collections where they now reside, illustrates the peculiar chameleon quality of the pieces. On one hand, this choice would seem to reflect a certain historicist nostalgia for the "original" materials and feel of the objects in the sixties; on another, it cheerfully flouts the cult of the original by substituting mere copies that will certainly not be fabricated by the hand of the artist, negating the world with his Skilsaw. The materiality, visual presence, and autographic identity of the objects is not unimportant, but it is not everything. Of equal importance is their mobility, reproducibility, and textual/pictorial/legal identity in draw-

31. Plato, *Republic,* Book VII:8, translated by Paul Shorey (Cambridge: Harvard University Press, 1935), p. 159.

32. "Notes on Sculpture," in Battcock, p. 233. See also Fried on the question of scale in relation to the human body, "Art and Objecthood," in Battcock, pp. 128–29.

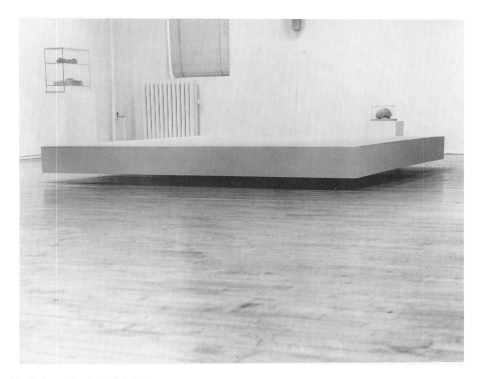

40. Robert Morris, *"Slab,"* 1963.

ings, specifications, and considerations of "intellectual property."[33] The objects themselves, as Morris put it in "Notes on Sculpture," are "important, but perhaps not quite so self-important" as traditional *objets d'art.*

An early and (apparently) simple example may help to clarify these issues. The work called *SLAB* (figures 40 and 41) presents at least three disjunctive identities: (1) it is a literal object, a hollow

33. The "existence" of numerous minimalist works as nothing more than folders full of documents, "blueprints or certificates that confer title to conceptual items," makes them especially problematic for critics who remain fixed on the notion that a work of art is nothing if it is not a material object. See John Richardson's attack on the Guggenheim for overinvesting in this sort of paper currency, "Go Go Guggenheim," in *The New York Review of Books,* 16 July 1992, p. 19.

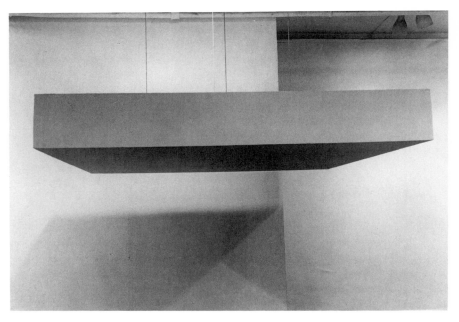

41. Robert Morris, *"Slab (Cloud),"* 1963.

square plywood box painted gray, 8 by 8 feet wide by 8 inches high; (2) it is an *image* of a slab, a hollow, painted simulacrum whose look and label suggests gray stony solidity, not hollowness; (3) it is a work of art with a title, a provenance, a set of labels and descriptive terms for its materials, dimensions, construction and placement, open to any number of refabrications and language games (traditional responses to form, beauty, and emotional association; the game of artspeak and historical labeling; the game of philosophical meditation on the relation of objects, images, and words). *SLAB* is public in the sense that it is open to all these language games (and others as well). Or, more precisely, it is like a door into a public sphere, one that can be left closed and labeled with a look (like a restroom), or opened into a philosophical gaze and inquiry that may have no determinate outcome, no systematic payoff.[34]

34. I am using the term "public sphere" in the sense made familiar by the critical tradition associated with Jurgen Habermas, particularly his historical study of publicity, *The Structural Transformation of the Public Sphere* (1962), translated by Thomas Burger (Cambridge, MA: MIT Press, 1989). The term

Read as a text rather than a label the word "SLAB" is the key that opens the object as a case of philosophical provocation. In particular, it opens the object to reflection on one of the most ancient and durable theories of the relation between language and objects, the theory that language itself is a system of labels, that

> individual words in language name objects—sentences are combinations of such names.—In this picture of language we find the roots of the following idea: Every word has a meaning. This meaning is correlated with the word. It is the object for which the word stands.[35]

This "picture of language" is so ancient and pervasive that it hardly needs the authority of Wittgenstein (or St. Augustine, to whom Wittgenstein attributes it) to be a public commonplace. What "SLAB" does, however, is to materialize this picture, to stage it for public reflection. Morris is following Wittgenstein's instructions to "imagine a language for which the description given by Augustine is right," a scene that turns out to be something like an exhibition of minimalist sculpture being put to use or employed as props to a performance.[36] In Wittgenstein's language game, the minimal objects are imagined as functional elements in a practical activity:

> The language is meant to serve for communication between a builder A and an assistant B. A is building with build-stones; there are blocks, pillars, slabs and beams. B has to pass the stones, and that in the order in which A needs them. For this purpose they use a language consisting of the words "block," "pillar," "slab," "beam." A calls them out;—B brings the stone which he has learnt to bring at such-and-such a call.—Conceive this as a complete primitive language.[37]

Wittgenstein then proceeds to demonstrate that the Augustinian model of the word as name or label for an object is radically incom-

is not to be confused with the notion of "public art" in its legal or bureaucratic sense. For more on this subject, see *Art and the Public Sphere,* edited by W. J. T. Mitchell (Chicago: University of Chicago Press, 1992).

35. Ludwig Wittgenstein, *Philosophical Investigations* (1953), translated by G. E. M. Anscombe (New York: Blackwell, 1958), p. 2.

36. The importance of Wittgenstein's philosophy to Morris's art would require a separate study in its own right and would probably take its key from the remarkable series of drawings connected with texts from the *Philosophical Investigations* that Morris executed in 1990.

37. Wittgenstein, *Philosophical Investigations,* p. 3.

plete and that even in a primitive scene like the one he has imagined, the words do a great deal more than name or label the objects. They function in a "language game," one in which the meanings of words are not given by the objects they designate, but by their practical use in a form of life. "SLAB" signifies, not just the object, but something like "bring me a slab." It is a token in a system of exchange, a command, an index of a social relationship: "is the call 'Slab!' . . . a sentence or a word?—If a word, surely it has not the same meaning as the likesounding word of our ordinary language. But if a sentence, it is surely not the elliptical sentence: 'Slab!' of our language."[38]

Wittgenstein's language game turns "SLAB" from a label into an imperative declaration in a form of life we might call "work" (specifically, the social division of labor between a master-builder and his workers). Morris's *SLAB* is an invitation to transform a curatorial label into a perceptual and intellectual form of public work. The "work," therefore, does not encrypt its skill, time, and effort in the traditional model of the "case" whose inside/outside structure unites the "work of art" with the commodity fetish as a container of hidden value and meaning—what Marx called "congealed labor power" and Freud diagnosed as the fetishism of objects concealing the labor of the unconscious.[39] The objects are better described in the terms of Freud's "uncanny," that is, as "cases" that are simultaneously strange and familiar.[40] We do not stand in fixated admiration of Morris's "work" (either his object, or its significance as a trace of his skill, time, and labor), but find ourselves placed in relation to the object as a co-worker, a potential collaborator. The work (both the object and its making) are disseminated, made exoteric, public, even "broadcast"

38. Ibid., p. 8.

39. See my discussion of the parallel between the romantic conception of the work of art and Marx's concept of the commodity fetish in *Iconology*, chapter six. Fried's remarks on the "hollowness of most literalist work . . . as though the work in question has an inner, even secret life," are useful here, though I think insufficiently *literal*. The hollowness of Morris's objects is, in my view, an index of their insistence that they have "nothing to hide," and (as Cage might have said) "they are hiding it." This antihermeneutic openness about the hidden interior, the mockery of the sealed, hermetic "case," is the precise phenomenological basis for Morris's effort to produce objects that have the ability to activate a public sphere.

40. See Freud's essay, "The 'Uncanny,'" (1919), in *The Complete Psychological Works of Sigmund Freud*, edited by James Strachey (London: Hogarth Press, 1955), vol. 17, pp. 219–52.

(in the case of the *Box with the Sound of Its Own Making*). This is not "self-reference" to the artist's ego, his autobiography, or even his objectified work, but a de-crypting of the hidden "creative process" that parodies the cult of secrecy associated with romantic expressivist creation and the associated production of cult objects.

Morris's *SLAB* (as word, image, or object) does not tell us what to do: its grammatical mood is interrogative, not imperative. It invites the contemplation of a simple, primitive object in relation to a straightforwardly unambiguous label, the Augustinian model of the relation between words and things, language and the world. This work can be invisible, effortless, and reassuring: there is the object, there is the label, perfectly coordinated, end of story. But the slightest hesitation opens the beholder to a labyrinth of knots. If "SLAB" is an expression in a language game, should we translate it as "This is a slab"? or as "This is 'SLAB'"? Is "SLAB" a proper name or a generic label? Is it to be written as *SLAB* or "SLAB"? Is the object it refers to a type or a token, a unique individual work or a concept to be replicated in an indefinite series of objects? Is this object (whether type or token) really "simple," and are "simples" what names really designate?[41]

> But what are the simple constituent parts of which reality is composed?—What are the simple constituent parts of a chair?—The bits of wood of which it is made? Or the molecules, or the atoms?—"Simple" means: not composite. And here the point is: in what sense 'composite'? It makes no sense at all to speak absolutely of the simple parts of a chair'. (*Philosophical Investigations*, p. 21)

The rejection of "composite" objects, the construction of a sculpture without "syntax," internal relations of parts, in favor of simple elementary forms is generally taken to be the central program of minimalism. But the real point of this program is not to reify a notion of the absolutely simple, but to explore the complexity and compositeness of the simple, to crack the atomic structure of both common sense and rational positivism.[42] Perhaps we should translate the simple

41. Richard Wollheim's classic essay, "Minimal Art," was the first, I believe, to see the fruitfulness of the type-token distinction for the description of minimalist objects. See his essay in Battcock, pp. 387–99.

42. Wittgenstein's remarks on the "simple" and the "composite" must also be understood as attempts to shatter the atomic concept of the "simple" associated with his own earlier work in the *Tractatus* and with the work of Bertrand Russell and the logical positivists.

word "SLAB," then, as a Wittgensteinian imperative like "look at this slab and say the word aloud or to yourself"; or a Wittgensteinian question: "How do you see this object? What do you see it *as*? What does the name have to do with what you see?" In either case, the "translation" of the label is clearly not the end of the process, the solution to a puzzle or allegory. It is only the opening move in a language game that has no determinate outcome. (John Cage went to the first show where *SLAB* was exhibited and reported that he didn't see any works of art in the gallery, just a slab on the floor.) Wittgenstein urges us not to be troubled by the simple, primitive, and incomplete character of these kinds of games:

> If you want to say that this shows them to be incomplete, ask yourself whether our language is complete;—whether it was so before the symbolism of chemistry and the notation of the infinitesimal calculus were incorporated in it; for these are, so to speak, suburbs of our language. (And how many houses or streets does it take before a town begins to be a town?) Our language can be seen as an ancient city; a maze of little streets and squares, of old and new houses, and of houses with additions from various periods; and this surrounded by a multitude of new boroughs with straight regular streets and uniform houses. (*Philosophical Investigations*, p. 8)

Are Morris's minimal objects better seen as the postmodern suburbs of the language game of art or as primitive building blocks deployed in its oldest districts, provocatives to the ancient questions about words, images, and objects posed by Plato and Augustine? This question might also be thought of as a translation of what it means to say "SLAB?" in the presence of this object.

In retrospect, then, the attempts to divide the work of Morris and the minimalists from traditional forms of art with categories like "literalness" and "figurality" and "objecthood" versus "artifice" begin to look more like temporary rhetorical strategies than durable categories. As so often in the history of art, the new is defined as a negation of the old, and both the acceptance and the refusal of the new are expressed in exactly the same terms, with the valences of value reversed. Both the indictment of minimalism (chiefly by Michael Fried in "Art and Objecthood") and its canonization by defenders of the American avant-garde in the sixties are conducted in the language of absolute breaks with the past, undialectical negations of a reified "tradition." This is not to say that there was nothing new, original, or transgressive about minimalism, but that the terms in which its newness might best be articulated are still open to inquiry and are

262

not to be settled by a merely historicist recapitulation of the debates of the sixties and the "verdict of history." The objects themselves are now in a new situation, awakening to find themselves somewhere near the "end of postmodernism," if that word has any meaning as the designation of a period. Their provocation today cannot be what it was in the sixties, though it cannot be separated from it either. The provocation of "SLAB" carries all the way out to the historical situation of its first production and reception, and its current exhibition in a blockbuster show, where (one hopes) it will continue to burst various kinds of mental blocks. (Another kind of language game that might be played with "SLAB" and its brethren would reflect on its position within the history of sculpture, the relation between machine and handmade objects, and the importance of the base. In a very real sense, Morris is simply asking us to look at the foundations of sculpture *as* sculpture: the plinth or pedestal—which is sculpture's equivalent of a frame or support—is itself put on display.)[43] Perhaps, like the monolith of *2001: A Space Odyssey*, Morris's slab is an extraterrestrial teaching machine whose shuttling aspects can now be switched on. Its simplicity, blankness, muteness is inseparable from, yet antithetical to, its eloquence, wit, and complexity. Its rational purity and flaunting of radical renunciation is inseparable from its flirtation with scandal, fraud, and boredom (at least in relation to traditional notions of artistic propriety, authenticity, and interest). Insofar as the label "minimalism" provides a way to stabilize the object, to enframe it ideologically, to deny boredom and demand interest, to defeat skepticism and compel conviction, it dulls the edge of the dialectical image presented by the object, and the brick misses its mark.

In the light you seem so small there on the wall and straightforward
in your brief rectangularity and nearly prim in your crisp paragraphs.
You wish to appear luminous with the innocence of your cogent facts.

Perhaps the best indication of Morris's desire to keep these objects free of minimalist doctrine, to keep the shuttle in motion, is his insistence on a certain intermediate scale between the private and the public work, the intimate and the monumental. The exhaustion of minimalism came, in his view, when it seemed to have nowhere to go but up and out: "as the radicality of its imagery, contexts or processes

43. See Jack Burnham, *Beyond Modern Sculpture* (New York: Braziller, 1967), chapter one, for a discussion of the foregrounding of the base.

became routine, its options dwindled to a formula: use more space."[44] This is why Morris finds the employment of a minimalist vernacular in the Vietnam Veteran's Memorial so offensive, for the VVM is, in his view, a one-sided, nondialectical appropriation of the vanguard style of the sixties to bandage over a wound that would better be kept open: "Could there ever be a more ingenious act of substituting private grief for public guilt? Has political criminality ever been more effectively repressed than by this weeping wound to the will of the critical? Has there ever been a more svelte Minimal mask placed over governmental culpability?"[45]

Morris's own work has, in general, been devoted to procedures of unmasking, which means of course that it has to both construct and remove various kinds of masks—the labels affixed to objects, the fetishistic character of images and visual pleasure, and (most fundamentally) the mask of the "object itself," the notion of the irreducibly elemental thing. Morris's proposed sculptural tribute to veterans of World War II was a piece of ready-made minimalism, the casings of the atomic bombs dropped on Japan to be installed in the plaza of a Florida VA hospital (figure 42). The proposal was doubly decorous in its evocation of tradition and populist American ideology: what more appropriate war memorial than the weapons of the last war? (cp. the cannon on the courthouse lawn). What more appropriate image for a veterans' *hospital* than the objects which (we are told) "saved American lives" in World War II? There is even a certain "svelteness" in the perfect fit of these hollow casings with the traditional hollowness of minimalist sculpture and Morris's own habit of treating the object as what I have called a "case" rather than an example or illustration. But these cases/casings offered the sort of mask that slipped off all too easily to reveal the merry wink and the death's head grin beneath to representatives of a "public" that wants its memorials to erase guilt and historical memory. *Bomb Sculpture* remains in the archive of "rejected proposals," perhaps as a time bomb waiting to go off.

Morris's early minimalist pieces may now be, in the space of a retrospective, bombs that have already gone off or that have been

44. Robert Morris, "American Quartet," p. 96. On the question of scale, see also "Notes on Sculpture," and Fried, footnote 32 above.

45. Denson interview, forthcoming *Critical Inquiry*. My own view is that the Vietnam Veterans' Memorial succeeds precisely because it keeps the wound open and enables national mourning as well as private grief and public amnesia. See chapter 12 for more discussion.

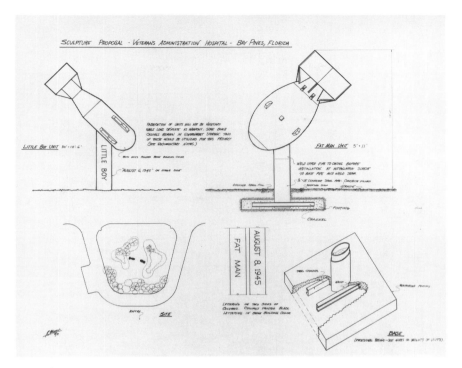

42. Robert Morris, *Bomb Sculpture Proposal* (artist's archives, Guggenheim Museum).

defused by the labels of canonization and art historical explanation. Once one "gets the concept" of *SLAB* or *BEAM,* we must ask, what need is there to actually *look* at the pieces? Hasn't their material and visual presence been made superfluous by the welter of discourse that surrounds them? Don't we already know, as a staple of everyday common sense, that simple polyhedrons take on different appearances from different angles? Why do we have to look at *these* constructions to test or confirm that knowledge? What might we learn by actually beholding *Box with the Sound of Its Own Making* that isn't already contained in its label and what might be inferred from it? We can certainly understand this object's parodying of the expressionist "action-painting" aesthetic without ever actually seeing it.

The occasion of a retrospective is, in Morris's case, a thoroughly experimental event, for it cannot know the answers to these questions beforehand. Insofar as the blockbuster show has become a mass cul-

tural spectacle in recent years, an occasion for rapid consumption of vast quantities of visual pleasure, these objects will not feel comfortable, either with themselves or their beholders. What sort of "Morris souvenirs" will make it to the museum store? What's to see? What's to like? The audience has to do all the work. And what sort of perceptual or intellectual work can it be expected to do, trooping through in busloads, listening to taped commentaries, swimming toward the wall labels as if they were so many life preservers? Morris's work may simply serve as a reminder of the austere elitism that divides certain kinds of art from mass culture. As a "historical" figure defined by the label of minimalism, he represents an aspect of the sixties that many of us missed, bedazzled by Pop and Op and neoexpressionism. The audience may feel reproached, the critics defensive.

You are the paragon of gentleness as you tell them what to think. You proto and pre-critical patch of writing. You totalitarian text of totalizing. You linguistic grenade. You footnoteless, illustrationless, iconoclastic epitome of generic advertizing. You babbling triumph of the information byte. You, labelless label, starched and washed and swinging that swift and fatal club of "education" to the head.

The blockbuster show is supposed to provide artistic fetishes and totems that can be inserted into mass circulation—that is, objects that acquire "aura" through their incarceration in the gulag of the artist's or beholder's autobiography (the source of fetishistic "intimacy") or through their monumentalization as the sacred totems of mass culture. Morris's work consistently steers between these alternatives, seeking the "delicate situation" of the philosophical object, a dialectical imagetext that is materialized in a specific constructed thing, with a relation to specific human bodies in a particular situation. This delicate situation is also something like a "public sphere," in the sense of an open, relatively uncoerced speech situation. The only way I know of conveying this sense of Morris's openness is to dwell on a few specific, perhaps typical objects in a relatively common language (I've suggested that Wittgenstein's vocabulary and his willingness to pause over the obvious as an appropriate, though by no means exclusive, model).

I-Box (figures 43 and 44), for instance, activates a kind of infinite labyrinthine circuit among the elementary questions: what is an image? what is a word? what is an object? What sort of creature weaves its world, and its model for itself, out of this specific assemblage: a box with a door shaped like the letter "I"; a photographic image of the maker of the box naked behind the door? The first gesture of the

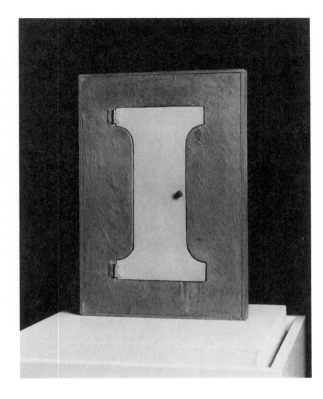

43. Robert Morris, *I-Box*, (closed), 1962. Plywood cabinet, sculpt-metal, photograph, 19 × 13¼ × 1⅜". Collection of Leo Castelli.

opened box is to flaunt the impasse of the short-circuit, the joke that is too easy and obvious, the puzzle that is solved without effort, as easy as opening a single door. Like Magritte's "This Is Not a Pipe," it invites us to say, "of course" or "so what?" and move on. Magritte's pipe is only an image, not an object. The I-Box is even simpler. It doesn't even offer a paradoxical gesture like Magritte's "contradiction" between the words and the image. Morris's image of himself naked is unequivocally labeled by the word "I." Word and image are apparently redundant, capturing the self in a double cipher.[46] As David Antin says, "You don't know anything you didn't know before. . . . Everything that is revealed is concealed."[47] But the I-Box is also

46. See Michel Foucault, *This Is Not a Pipe* (Berkeley: University of California Press, 1982), chapter 2 on the "calligram" as "double cipher."

47. David Antin, in *ArtNews* 65:2 (April 1966).

44. Robert Morris,
I-Box, (open).

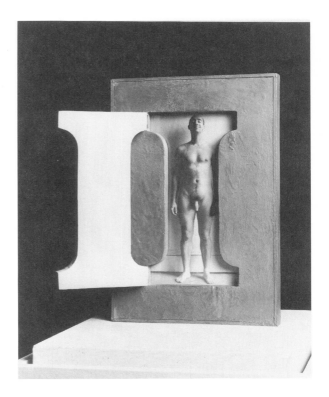

like Magritte's pipe in insinuating a hesitation: is there not something more?

The answer, of course, is that there is as much more as an observer is willing to invest. If one takes *I-Box* as a *case* for meditation on the fundamental elements it isolates for attention (not merely as an example to be labeled "artistic self-reference"), one risks being lost in a labyrinth of questions. What is the word "I" that it makes sense used in this way? What sense does it make in this case? Does it actually *refer* to something? To the photographic image of Morris, or to the body to which the image refers, or to the box in which it serves as a door and a proper name? If it is a label, to what does it apply? What model of the relation between words, images, and objects does this little assemblage construct?

We might begin by interrogating the "I" of the I-Box, noting that the equivocal character of its reference (to the artist, the artist's image, the box) straightforwardly illustrates the impossibility of fixing the

reference of "I." The "I" has no firmer relation to the invisible "self" or visible body of the artist than it does to the box or to the material shape of an I-Beam. It is revealed as what linguists call a "shifter," an indexical sign whose referent can only be determined with respect to the relation of interlocutors in a specific speech situation (thus the first person designates the speaker, the second person the listener or addressee).[48] Like the words "here" and "now" its meaning shifts with time and the flow of discourse, the give and take of conversation. The word "I," in short, is like a door, swinging on the hinge of dialogue, now open to use by anyone, now closed by someone's appropriation of it to themselves. When the door of the I-Box is closed, its reference is open, unfixed; when the door is open, its reference closes in on and enframes the image of the artist.

Is the I-Box merely an example or illustration of a linguistic commonplace then? Or does its materiality and visual presence make it a *case* of self-reference, a kind of metapicture of a whole language game?[49] A better question might be: What kinds of mind-language-perception games can be played with this object? Four immediately suggest themselves: (1) a fort-da game of concealment and revelation of a "self," a peek-a-boo game as simple as the opening and shutting of an "I/Eye," a shuttling between privacy and publicity, the secret and the disclosure—one which seems to show everything (the naked photographic truth) and nothing (the empty verbal sign) in very rapid succession; (2) a game of allusions to genres and prototypes within the media of painting, sculpture, and photography—the linkages of this object with self-portraiture, pornography and scandal; with surveillance (this looks like a police photo); with the encrypting of sacred icons, and fetishes in protective niches, arks, tabernacles, or casements—in this case wood encased in gray metal; with the calligraphic tradition of the letter as work of art, the historiated initial, fusing the body with the verbal sign of what hides inside the body—a self that can say "I," inside a body enframed as the written character "I";[50] (3) a game of metaphors, analogies for the way we think of the self and the body as an inside-outside structure with the senses (especially

48. "Shifter" is Roman Jakobson's term. See the entry on "Deictics" in Oswald Ducrot and Tzvetan Todorov, *Encyclopedic Dictionary of the Sciences of Language,* translated by Catherine Porter (Baltimore, MD: Johns Hopkins University Press, 1979), p. 252.

49. For more on this concept, see my essay, "Metapictures," chapter 2 of this volume.

50. See the section of chapter 4 on "Human Letters."

the eye) conceived as apertures or thresholds like windows and doors; the relation of visual and verbal signs, showing and speaking, seeing and reading, to a self that speaks and writes versus the self that displays itself and looks back; (4) a game of "signifying," in which a whole set of pieties about art and the self (and the selves of artists) are mocked and parodied: the fetishism of the art object as an effluence of its divine creator is laid bare, the tabernacle is opened and desecrated. *I-Box* mocks a form of life in which we talk of the self as an invisible presence concealed behind an opaque surface, inside a hollow case or body. Wittgenstein argued that "the human body is the best picture of the human soul." Morris literalizes this claim, opening the case to show us that inside there is nothing but another outside. The label on the surface conceals nothing but another surface to trap the look.

What does it mean that this inner surface is that of a naked male body, displaying its manhood with a facial expression that can only be described as "cocky"? How would it change the meaning of the I-Box if it revealed a naked female body? A full consideration of these questions would take us into a whole new essay on the language games of gender as an intersection of body, image, and label in Morris's art. One might begin the inquiry by noting that most of Morris's works seem designed to neutralize all traces of autobiography and personal identity, to treat the sexually labeled body of both the artist and the beholder as a theatrical role or a site of experimentation. And yet Morris's work could hardly be described as "gender-neutral," insofar as the contingent fact of his own gender and the historical gendering of the artistic role are irreducible material and cultural givens, like the materials of wood, photographic paper, and sculpt-metal.[51] Certainly Morris's "cockiness" in the I-Box can be read as a parodic mockery of the phallic male genius that had become institutionalized by abstract expressionism, just as his *SLAB* mocks the subordination of the sculptural support to the phallic verticality of the statue. (Compare, in this regard, the scandalous portrait of Morris in a fascist sado-masochistic get-up in the poster for the Castelli-Sonnabend Gallery exhibition of 1974 [figure 45] and his performance piece, *Site,* which stages Carolee Schneemann as Manet's Olympia,

51. In this context I must disagree with Hal Foster's suggestion that "the minimalist delineation of perception . . . is somehow before or outside history, language, sexuality power—that the perceiver is not a sexed body, that the gallery or museum is not an ideological apparatus" ("The Crux of Minimalism," in *Individuals* [Los Angeles Museum of Contemporary Art, 1986], p. 172).

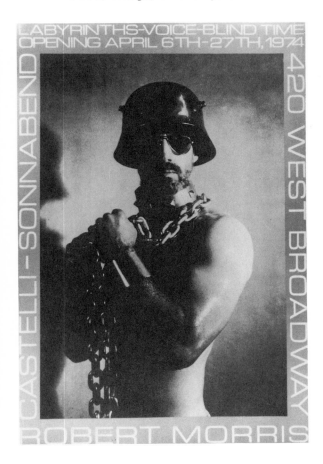

45. Robert Morris,
Poster for Castelli-
Sonnabend Gallery Exhi-
bition, 6–27 April 1974.

with Morris playing the role of minimalist stagehand [figure 46]).
Along with Cage, Rauschenberg, Johns, and the emergent American
avant-garde of the sixties, Morris seems consistently to undermine the
notion of a foundational identity in gender and to treat sexual catego-
ries as labels that circulate in the exchanges of bodies, images, and
discourses.[52]

52. See Caroline Jones's discussion of the reaction by the Cage generation
against the macho cult of abstract expressionism in her essay, "Finishing
School: John Cage and the Abstract Expressionist Ego," *Critical Inquiry* 19:4
(Summer 1993): 628–65.

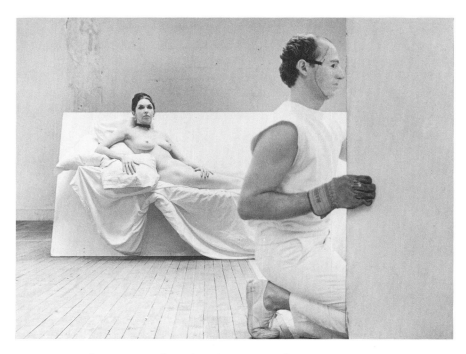

46. Robert Morris and Carolee Schneemann performing in Morris's *Site,* May 1965. Photograph by Hans Namuth, 1965; © Hans Namuth 1991.

In the fall of 1990, Robert Morris had a nightmare about a wall label. His account of this nightmare has been a counterpoint to my own attempt to write about his work without relying on labels. I don't offer the text of this dream as the unique key to Morris's meanings, nor the occasion for any psychoanalytic decoding of his work. In fact, I'm very skeptical about the authority of this dream. It strikes me as flagrantly literary, with its echoes of Poe's "Tell-Tale Heart" and the scene of Eve's temptation in *Paradise Lost* ("it babbled in my ear"). It is the sort of dream one makes up (perhaps unconsciously) for one's analyst. The simultaneously phallic and "labial" images associated with the label (it "entwines" itself, "slithers and coils in the shadows," and "seems to pulsate" like an uncontrollable erection that Morris must "get a grip on"; yet it is devouring, loquacious, "prim" and "chaste") suggest a highly conscious fantasy about the image of a Medusalike phallic female whose "aim is nothing less than dominating my images there on the wall." The particular images that Morris refers to in this dream are the encaustic paintings on aluminum

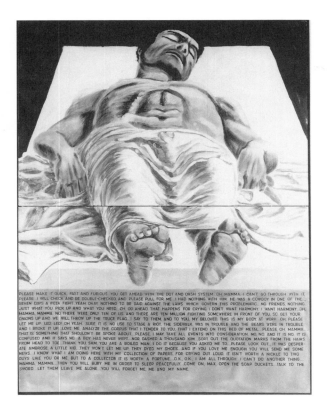

47. Robert Morris, *Pro-hibition's End or the Death of Dutch Schulz,* 1989. Encaustic on alumi-num panel. Collection of Leo Castelli.

panels he executed in the spring and summer of 1990 and first exhib-ited at the Corcoran Gallery in December of that year (figures 47 and 48) Morris suspects that the label's "linguistic hysteria" will "erode the encaustic from my panels."

This series of paintings does not appear in the Guggenheim retro-spective. That is regrettable, if only because these paintings, produced under the foreshadowing prospect of a major retrospective, are them-selves a retrospective not only of Morris's own artistic career, but of the fortunes of art and language, the look and the label, in what Arthur Danto has called this "Post-Historical Period of Art."[53] The paintings are very much of a piece with the Gothic phantasmagoria

53. Arthur Danto, *Beyond the Brillo Box* (New York: Farrar, Straus, Giroux, 1992), p. 10. I hope it is clear, however, that I regard any notion of the present as having gone "beyond history" as quite premature.

48. Robert Morris, *Improvident/Decisive/Determined/Lazy . . .*, 1990. Encaustic on aluminum panel 143¼ × 94¾″. Collection of Leo Castelli.

of Morris's nightmare, employing gloomy, lurid colors and iconography that evoke a range of art historical reference from Mantegna's *Dead Christ* to Holbein's anamorphic skull to Goya's black paintings. Most notable, however, are the texts in stenciled lettering on the surface of the images. Like the wall labels of Morris's dream, they are "elusive as [they] gleam there in the dark with its Poe-like atmospherics of linguistic threat and verbal iconoclasm." Morris's command to "show yourself in the light, wall label" has not been heeded, even in his own paintings. The letters swim in and out of legible focus, refusing either to disappear or to come into the light to explain the images.

We can, of course, label the labels on these paintings as references

(along with the encaustic medium) to Jasper Johns's employment of stenciled lettering in his early paintings, just as we can label virtually every image in the paintings as an allusion to some art historical or popular source. My impression is that hunting down these allusions is not the point, or at least not the *immediate* point of these works. The point is rather more simple and superficial and can be grasped just by recognizing that these paintings are networks of allusion to previous art and popular imagery without necessarily being able to identify every iconographic and stylistic reference. In conversations about these pieces at the time of their production, it became clear to me that Morris was indifferent to the identification of sources as keys to meaning and that he had forgotten many of them himself. The immediate subject of the paintings is the process of artistic retrospection itself, more specifically the relation between image, object, and label in memory. The first thing one has to note about Morris's labels is that many are almost unreadable; the second is that they are almost uninterpretable. The labels do not label the images; they only look like labels, functioning more like stray bits of associative language that (like the elusive pictorial allusions) flicker in and out of verbal recognition. It's impossible even to label the labels as some single generic type of verbal expression: they include proverbial sayings reminiscent of Goya's enigmatic *Caprichos* ("Rotten With Criticism"; "Memory is Hunger"), Nietzschean echoes ("Slave Morality"), fragmentary descriptions of states of being ("Inability to Endure or Deny the World"), associative puns ("Horde/Hoard/Whored"), and fantastic verbal collages like the conflation of the transcript of Dutch Schultz's death ravings with phrases from Derrida in "Prohibition's End," appended as the "text" for a recognizable rendering of Mantegna's *Dead Christ*.

These image-text composites are *nearly* unreadable, but of course we do finally read them; their obscurity invites interpretation, and I have no doubt that future scholars will drag both the images and their labels into the light of art historical analysis. When that is done, however, my hunch is that everything revealed will remain concealed (not that this devalues the process of revelation). Take as an instance one of the more transparent compositions in this series, the magnificent tribute to Jackson Pollock labeled *Monument Dead Monument/ Rush Life Rush* (figure 49). This painting is based on the famous Hans Namuth photograph of Jackson Pollock at work (figure 50). Morris has doubled the Namuth image and assembled it as a vertical diptych, the upper and lower panels appearing as inverted, mirror images of one another. The lower (upside down) panel is more clearly

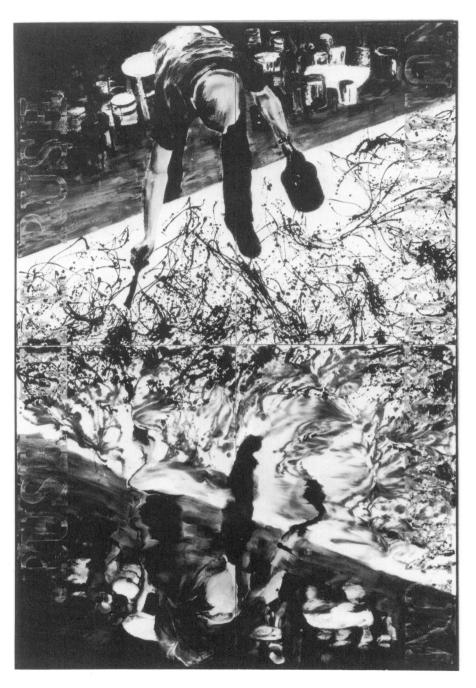

49. Robert Morris, *Monument Dead Monument/Rush Life Rush*. Encaustic on aluminum panel. Collection of Leo Castelli.

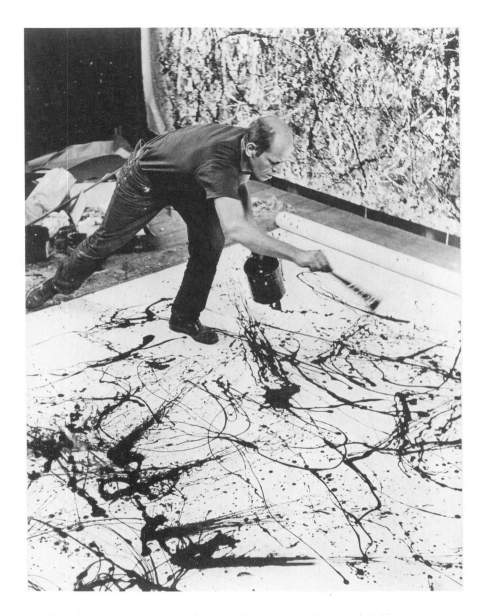

50. Hans Namuth, photograph of Jackson Pollock at work. Photograph © Hans
Namuth 1991.

delineated, the upper having been subjected to heat which caused the encaustic to melt on the aluminum support, blurring the contours of the image. The mirrorlike, vertical (a)symmetry of the images is matched laterally by the labels that run up and down its margins: on the left, "Monument Dead Monument" ascends; on the right "Rush Life Rush" descends.

What tribute does this painting pay to Jackson Pollock, the man who has been called "the greatest American painter of the twentieth century," the painter whose work was a decisive influence on Morris's earliest work and the epitome of the expressionist aesthetic against which early minimalism set its face? A highly equivocal tribute, I would say, one which refers us back to—even re-enacts—the original pouring process of "action painting," the figure of the artist merging with his art, his life rushing out in paint, at the same time it refers us back to the monumentalizing of this process into an artistic dead end—the myth of the macho, expressionist creator whose private fetishes become public totems. Morris's picture is like a hall of verbal-visual mirrors in which the reflected object is the genesis, production, reproduction, and consumption of art itself. The asymmetry of this artistic life-cycle, its tendency to "advance" by processes of devolution and negation, remembering, forgetting, and disremembering, is articulated verbally by the labels, visually by the dissolving reflection that surmounts the more focused "original," and materially by the processes enacted in the object. If Pollock showed us that the primary material fact about paint is that it pours, Morris shows us that the primary material fact about wax (encaustic) is that it melts. What we are left with is not merely a tribute to Pollock's rushing life, nor a sardonic commentary on his subsequent monumentalization, but a vision of the birth and death of a monument, its vital origin, its fixing as a memorable icon, and its melting down in forgetfulness and chaotic oblivion.

These retrospective paintings look radically different from most of the sculptural productions that will enjoy pride of place in the Guggenheim retrospective. But their deepest concerns are all of a piece with the earlier work. They share the same concern for investigating the identity of the work of art as a nexus of vision, language, and objecthood. They seek to occupy the same precarious threshold between form and anti-form, between the private fetish and the public totem. Above all, they play the same game of philosophical provocation and psycho-poetic experimentation that has characterized Morris's work from the first. We would not be far wrong in calling them "conversation pieces," occasions for debate on a whole series

51. Robert Morris, *Cuban Missile Crisis*. Gray paint on newsprint. 1963. Artist's collection.

of artistic and nonartistic issues, from the nature of looking at and labeling objects, to the historical character of artistic production, to the institutional history and discourse that makes these conversations possible. On the "issues of the day," whatever they will be in autumn of 1993, these works will be almost inaudible and unreadable, like those gray paintings Morris executed on newspapers covered with headlines about the Cuban Missile Crisis in 1963 (figure 51). On the fundamental questions of what art is for, what it might attempt, and what our relation to it might be, these may be bombs re-fused by popular disrespect, bricks flying in the night toward an unknown destination.

THE PHOTOGRAPHIC ESSAY: FOUR CASE STUDIES

Three questions:

1. *What is the relation of photography and language?*
2. *Why does it matter what this relation is?*
3. *How are these questions focused in the medium known as the "photographic essay"?*

Three answers:

1. *Photography is and is not a language; language also is and is not a "photography."*
2. *The relation of photography and language is a principal site of struggle for value and power in contemporary representations of reality; it is the place where images and words find and lose their conscience, their aesthetic and ethical identity.*
3. *The photographic essay is the dramatization of these questions in an emergent form of mixed, composite art.*

What follows is an attempt to connect these questions and answers.

Photography and Language

The totality of this relationship is perhaps best indicated by saying
that appearances constitute a half-language.
 —John Berger, *Another Way of Telling*

The relationship of photography and language admits of two basic descriptions, fundamentally antithetical. The first stresses photography's difference from language, characterizing it as a "message without a code," a purely objective transcript of visual reality.[1] The second

1. The phrase "message without a code" is from Roland Barthes's essay, "The Photographic Message," in *Image/Music/Text*, translated by Stephen Heath (New York: Hill and Wang, 1977), p. 19. I am grateful to David Antin

turns photography into a language, or stresses its absorption by language in actual usage. This latter view is currently in favor with sophisticated commentators on photography. It is getting increasingly hard to find anyone who will defend the view (variously labeled "positivist," "naturalistic," or "superstitious and naive") that photographs have a special causal and structural relationship with the reality that they represent. Perhaps this is due to the dominance of linguistic and semiotic models in the human sciences or to the skepticism, relativism, and conventionalism which dominates the world of advanced literary criticism. Whatever the reason, the dominant view of photography is now the kind articulated by Victor Burgin when he notes that "we rarely see a photograph *in use* which is not accompanied by language" and goes on to claim that the rare exceptions only confirm the domination of photography by language: "even the uncaptioned 'art' photograph," argues Burgin, "is invaded by language in the very moment it is looked at: in memory, in association, snatches of words and images continually intermingle and exchange one for the other."[2] Indeed, Burgin carries his argument well beyond looking at photography to "looking" as such, deriding the "naive idea of purely retinal vision," unaccompanied by language, a view which he associates with "an error of even greater consequence: that ubiquitous belief in 'the visual' as a realm of experience totally separated from, indeed antithetical to, 'the verbal'" (p. 53). Burgin traces "the idea that there are two quite distinct forms of communication, words and images" from the neoplatonic faith in a "divine language of things, richer than the language of words" to Ernst Gombrich's modern defense of the "natural" and "nonconventional" status of the photograph. "Today," concludes Burgin, "such relics are obstructing our view of photography" (p. 70).

What is it that troubles me about this conclusion? It isn't that I disagree with the claim that "language" (in some form) usually enters the experience of viewing photography or of viewing anything else. And it isn't the questioning of a reified distinction between words and images, verbal and visual representation; there seems no doubt that these different media interact with one another at numerous levels in

and Alan Trachtenberg for their many intelligent suggestions and questions about an earlier version of this essay.

2. Victor Burgin, "Seeing Sense," in *The End of Art Theory: Criticism and Post-Modernity* (Atlantic Highlands, NJ: Humanities Press, 1986), p. 51; further page references will be cited in the text.

cognition, consciousness, and communication. What troubles me, I suppose, is the confidence of tone, the assurance that we are able "today" to cast off certain "relics" that have mystified us for over two thousand years in favor of, presumably, a clear, unobstructed view of the matter. I'm especially struck by the figure of the "relic" as an obstructive image in contrast to the unobstructed view, since this is precisely the opposition which has (superstitiously) differentiated photography from more traditional forms of imagery and which formerly differentiated perspectival representation from "pre-scientific" modes of pictorial representation. Burgin's conclusions, in other words, are built upon a figurative opposition ("today/yesterday"; "clear view/obstructive relic") he has already dismissed as erroneous in its application to photography and vision. This return of an inconvenient figure suggests, at a minimum, that the relics are not quite so easily disposed of.

I'm also troubled by Burgin's confidence that "our view" can so easily be cleared up. Who is the "we" that has this "view"? It is implicitly divided between those who have overcome their superstitions about photography and those naifs who have not. "Our view" of photography is, in other words, far from homogeneous, but is the site of a struggle between the enlightened and the superstitious, moderns and ancients, perhaps even "moderns" and "postmoderns." Symptoms of this struggle emerge in Burgin's rhetoric when he speaks of the photograph as "invaded by language" (p. 51); what he seems not to consider is that this invasion might well provoke a resistance or that there might be some value at stake in such a resistance, some real motive for a defence of the nonlinguistic character of the photograph. Burgin seems content to affirm the "fluidity" (p. 52) of the relation between photography and language and to treat photography as "a complex of exchanges between the verbal and the visual" (p. 58).

But why should we suppose this model of free and fluid "exchanges" between photography and language to be true or desirable? How do we account for the stubbornness of the naive, superstitious view of photography? What could possibly motivate the persistence in erroneous beliefs about the radical difference between images and words and the special status of photography? Are these mistaken beliefs simply conceptual errors, like mistakes in arithmetic? Or are they more on the order of ideological beliefs, convictions that resist change by ordinary means of persuasion and demonstration? What if it were the case that the "relics" which "obstruct" our view of photography also *constitute* that view? What if the only adequate formula-

tion of the relation of photography and language was a paradox: photography both is and is not a language?

This, I take it, is what lies at the heart of what Roland Barthes calls "the photographic paradox," "the co-existence of two messages, the one without a code (the photographic analogue), the other with a code (the 'art', or the treatment, or the 'writing', or the rhetoric of the photograph)."[3] Barthes works through a number of strategies to clarify and rationalize this paradox. The most familiar is the division of the photographic "message" into "denotation" and "connotation," the former associated with the "mythical," nonverbal status of the photograph "in the perfection and plenitude of its analogy," the latter with the readability and textuality of the photograph. Barthes sometimes writes as if he believes that this division of the photographic message into "planes" or "levels" may solve the paradox:

> how, then, can the photograph be at once 'objective' and 'invested,' natural and cultural? It is through an understanding of the mode of imbrication of denoted and connoted messages that it may one day be possible to reply to that question. (p. 20)

But his more characteristic gesture is to reject easy answers predicated on a model of "free exchange" of verbal and visual messages, connoted or denoted "levels": "structurally," he notes, "the paradox is clearly not the collusion of a denoted message and a connoted message . . . it is that the connoted (or coded) message develops on the basis of a message *without a code*" (p. 19). To put the matter more fully: one connotation always present in the photograph is that it is a pure denotation; that is simply what it means to recognize it as a photograph rather than some other sort of image. Conversely, the denotation of a photograph, what we take it to represent, is never free from what we take it to mean. The simplest snapshot of a bride and groom at a wedding is an inextricably woven network of denotation and connotation: we cannot divide it into "levels" which distinguish it as a "pure" reference to John and Mary, or a man and a woman, as opposed to its "connotations" of festivity. Connotation goes all the way down to roots of the photograph, to the motives for its production, to the selection of its subject matter, to the choice of angles and lighting. Similarly, "pure denotation" reaches all the way up to the most textually "readable" features of the photograph: the photograph is "read" *as if it were* the trace of an event, a "relic" of an occasion

3. Roland Barthes, "The Photographic Message," in *Image/Music/Text*, p. 19; further page references will be cited in the text.

as laden with aura and mystery as the bride's garter or her fading bouquet. The distinction between connotation and denotation does not resolve the paradox of photography; it only allows us to restate it more fully.

Barthes emphasizes this point when he suggests that the "structural paradox" of photography "coincides with an ethical paradox: when one wants to be 'neutral', 'objective', one strives to copy reality meticulously, as though the analogical were a factor of resistance against the investment of values" (pp. 19–20). The "value" of photography resides precisely in its freedom from "values," just as, in cognitive terms, its principal connotation or "coded" implication is that it is pure denotation, without a code. The persistence of these paradoxes suggests that the "mode of imbrication" or overlapping between photography and language is best understood, not as a structural matter of "levels" or as a fluid exchange, but (to use Barthes's term) as a site of "resistance." This is not to suggest that resistance is always successful or that "collusion" and "exchange" between photography and language is impossible or automatically undesirable. It is to say that the exchanges which seem to make photography just another language, an adjunct or supplement to language, make no sense without an understanding of the resistance they overcome. What we need to explore now is the nature of this resistance and the values which have motivated it.

The Photographic Essay

The immediate instruments are two: the motionless camera and the printed word.

— James Agee, *Let Us Now Praise Famous Men*[4]

The ideal place to study the interaction of photography and language is in that subgenre (or is it a medium within the medium?) of photography known as the "photographic essay." The classic examples of this form (Jacob Riis's *How the Other Half Lives*, Margaret Bourke-White and Erskine Caldwell's *You Have Seen Their Faces*) give us a literal conjunction of photographs and text—usually united by a documentary purpose, often political, journalistic, sometimes scien-

4. James Agee and Walker Evans, *Let Us Now Praise Famous Men* (Originally published, 1939; New York: Houghton Mifflin, 1980), p. xiv; further page references will be cited in the text.

tific (sociology). There is an argument by Eugene Smith that the photographic series or sequence, even without text, can be regarded as a photo-essay,[5] and there are distinguished examples of such works (Robert Frank's *The Americans*).[6] I want to concentrate, however, on the kinds of photographic essays which contain strong textual elements, where the text is most definitely an "invasive" and even domineering element. I also want to focus on the sort of photo-essay whose text is concerned, not just with the subject matter in common between the two media, but with the way in which the media address that subject matter. Early in Jacob Riis's *How the Other Half Lives* he describes an incident in which his flash powder almost set a tenement on fire. This event is not represented in the photographs: what we see, instead, are scenes of tenement squalor in which dazed subjects (who have often been roused from their sleep) are displayed in passive bedazzlement under the harsh illumination of Riis's flash powder (figure 52). Riis's textual anecdote reflects on the scene of production of his images, characterizing and criticizing the photographer's own competence, perhaps even his ethics. We might say that Riis allows his text to subvert his images, call them into question. A better argument would be that the text "enables" the images (and their subjects) to take on a kind of independence and humanity that would be unavailable under an economy of straightforward "exchange" between photographer and writer. The photographs may be "evidence" for propositions quite at odds with the official uses that Riis wants to put them. The beholder, in turn, is presented with an uncomfortable question: is the political, epistemological power of these images (their "shock" value) a justification for the violence that accompanies their production? (Riis worked as a journalist in close collaboration with the police; many of these photos were taken during nighttime raids;

5. See Tom Moran, *The Photo Essay: Paul Fusco and Will McBride*, in the Masters of Contemporary Photography series (Los Angeles, CA: Alskog, Inc., 1974). Eugene Smith's remarks on the genre of the photo-essay were made in conversation with the editors of this book and appear on pages 14–15.

6. Robert Frank, *The Americans* (1st edition, 1959; rev. and enlarged ed., New York: Grossman Publishers, 1969). Frank's book is not entirely free of text, however. All the photographs are accompanied by brief captions, usually a designation of subject, time, or location, and there is an introduction by Jack Kerouac that emphasizes the implicit verbal coding of Frank's photographs: "What a poem this is, what poems can be written about this book of pictures some day by some young new writer . . . " (p. iii).

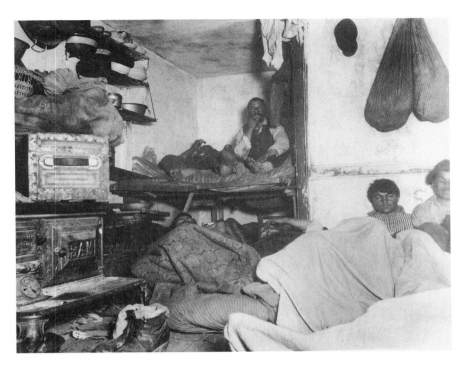

52. Jacob Riis, *Lodgers in Bayard St. Tenement* . . . Page spread from *How the Other Half Lives* (1890). Photo reproduced courtesy of the Museum of the City of New York.

these are, in a real sense, surveillance photographs; they also had a profound effect on reform efforts in the New York slums.) Riis's joining of an inconvenient, disruptive text foregrounds this dilemma, draws us into it. A resistance arises in the text-photo relation; we move less easily, less quickly from reading to seeing. Admittedly, this resistance is exceptional in Riis, whose general practice is to assume a straightforward exchange of information between text and image. But its emergence even in this relatively homogeneous photo-essay alerts us to its possibility, its effect and motivations.

Another way to state this dilemma is as a tension between the claims of the ethical and the political, the aesthetic and the rhetorical. Photo-essays have been, by and large, the product of progressive, liberal consciences, associated with political reform and leftist causes. But the best of them, I want to suggest, do not treat photography or

287

language simply as instruments in the service of a cause or an institution. Nor are they content to advertise the fine moral or artistic sensitivities of their producers. The problem is to mediate these disparate claims, to make the instrumentality of both writing and photography and their interactions serve the highest interests of "the cause" by subjecting it to criticism while advancing its banner. Agee distinguishes between the "immediate instruments" of the photo-essay, "the still camera and the printed word," and the "governing instrument—which is also one of the centers of the subject—[which] is individual, anti-authoritative human consciousness" (p. xiv). The production of the photo-essay, the actual labor that goes into it, should not be, in Agee's view, simply an instrumental application of media to politics, ideology, or any other subject matter. The "taking" of human subjects by a photographer (or a writer) is a concrete social encounter, often between a damaged, victimized, and powerless individual and a relatively privileged observer, often acting as the "eye of power," the agent of some social, political, or journalistic institution. The "use" of this person as instrumental subject matter in a code of photographic messages is exactly what links the political aim with the ethical, creating exchanges and resistances at the level of value that do not concern the photographer alone, but which reflect back on the writer's (relatively invisible) relation to the subject as well and on the exchanges between writer and photographer.[7]

One last question about the genre: why should it be called the "photographic *essay*"? Why not the photo novel or lyric or narrative or just the "photo text"? There are, of course, examples of all these forms: Wright Morris has used his photographs to illustrate his fiction; Paul Strand and Nancy Newhall link photographs with lyric poems in *Time in New England;* Jan Baetens has analyzed the emergent French genre of the "photographic novel." What warrant is there for thinking of the "photo-essay" as an especially privileged model for the conjunction of photography and language? One reason is simply the dominance of the essay as the textual form that conventionally accompanies photography in magazines and newspapers. But there are, I think, some more fundamental reasons for a decorum that seems to link the photograph with the essay in the way that history painting was linked to the epic or landscape painting to the lyric poem. The

7. For an excellent account of the way writers address the ethical issues of "approach to the subject" made visible by the photographic apparatus in action, see Carol Schloss, *In Visible Light: Photography and the American Writer: 1840–1940* (New York: Oxford University Press, 1987), p. 11.

first is the presumption of a common referential reality: not "realism" but "reality," nonfictionality, even "scientificity" are the generic connotations that link the essay with the photograph.[8] The second is the intimate fellowship between the informal or personal essay, with its emphasis on a private "point of view," memory, and autobiography, and photography's mythic status as a kind of materialized memory trace imbedded in the context of personal associations and private "perspectives." Third, there is the root sense of the essay as a partial, incomplete "attempt," an effort to get as much of the truth about something into its brief compass as the limits of space and writerly ingenuity will allow. Photographs, similarly, seem necessarily incomplete in their imposition of a frame that can never include everything that was there to be, as we say, "taken." The generic incompleteness of the informal literary essay becomes an especially crucial feature of the photographic essay's relations of image and text. The text of the photo-essay typically discloses a certain reserve or modesty in its claims to "speak for" or interpret the images; like the photograph, it admits its inability to appropriate everything that was there to be taken and tries to let the photographs speak for themselves or "look back" at the viewer.

In the remainder of this essay I want to examine four photo-essays that, in various ways, foreground the dialectic of exchange and resistance between photography and language, the things that make it possible (and sometimes impossible) to "read" the pictures, or to "see" the text illustrated in them. I will limit myself to four main examples: the first, Agee and Evans's *Let Us Now Praise Famous Men*, generally acknowledged as a "classic" (and a modernist) prototype for the genre, will be used mainly to lay out the principles of the form. The other three, exemplifying more recent and perhaps "postmodern" strategies (Roland Barthes's *Camera Lucida*, Malek Alloula's *The Colonial Harem*, and Edward Said and Jean Mohr's *After the Last Sky*), will be analyzed in increasing detail to show the encounter of principles with practice. The basic questions to be addressed with each of these works are the same: what relationship

8. Recall the classic photo-essays based in scientific discourse such as geological surveys (Timothy O'Sullivan, for instance) and sociological studies (the work of Dorothea Lange and Paul Taylor). The modern discipline of art history is inconceivable without the illustrated slide lecture and the photographic reproduction of images. Any discourse that relies on the accurate mechanical reproduction of visual evidence engages with photography at some point.

between photography and writing do they articulate? What tropes of differentiation govern the division of labor between photographer and writer, image and text, the viewer and the reader?

Spy and Counter-spy: Let Us Now Praise Famous Men

Who are you who will read these words and study these photographs, and through what cause, by what chance and for what purpose, and by what right do you qualify to, and what will you do about it.

　　　—James Agee

The central formal requirements of the photographic essay are memorably expressed in James Agee's introduction to *Let Us Now Praise Famous Men*: "The photographs are not illustrative. They and the text, are coequal, mutually independent, and fully collaborative" (p. xv). These three requirements—equality, independence, and collaboration—are not simply given by putting any text together with any set of photographs, and they are not so easily reconcilable. Independence and collaboration, for instance, are values that may work at cross-purposes, and a "co-equality" of photography and writing is easier to stipulate than it is to achieve or even to imagine. Agee notes, for instance, that "the impotence of the reader's eye" (p. xv) will probably lead to an underestimation of Evans's photographs; it is not hard to imagine a deafness or illiteracy underestimating the text as well—a fate that actually befell *Let Us Now Praise Famous Men* when it reached the editors of *Fortune* magazine, who had commissioned it.[9] Agee's generic requirements are not only imperatives for the producers of an art form that seems highly problematic, they are also prescriptions for a highly alert reader/viewer that may not yet exist, that may in fact have to be created.

It is easy enough to see how *Famous Men* satisfies the requirements of independence and co-equality. The photographs are completely separate, not only from Agee's text, but from any of the most minimal textual features that conventionally accompany a photoessay: no captions, legends, dates, names, locations, or even numbers are provided to assist a "reading" of the photographs. Even a rela-

9. For a good account of the reception of Agee and Evans's work, see William Stott, *Documentary Expression and Thirties America* (New York: Oxford University Press, 1973), pp. 261–66.

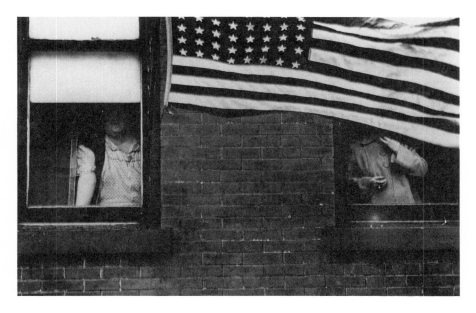

53. Robert Frank, *Parade—Hoboken, New Jersey* (1955–1956), from *The Americans* (1958). Copyright © Robert Frank. Courtesy, Pace/MacGill Gallery, New York.

tively "pure" photographic essay like Robert Frank's *The Americans* provides captions telling the subject and the location. Frank's opening image, for instance, of shadowy figures at the window of a flag-draped building (figure 53), is accompanied by the caption "Parade— Hoboken, New Jersey" which immediately gives us informational location not provided by the photograph and names a subject which it does not represent. Evans allows us no such clues or access to his photographs. If we have studied Agee's text at some length, we may surmise that the opening photograph is of Chester Bowles, and we may think we can identify three different tenant families in Evans's pictures based on their descriptions in Agee's text, but all of these connections must be excavated; none of them are unequivocally given by any "key" that links text to images. The location of Evans's photos at the front of the volume is an even more aggressive declaration of photographic independence. In contrast to the standard practices of interweaving photos with text or placing them in a middle or concluding section where they can appear in the context provided by the text, Evans and Agee force us to confront the photographs without context,

before we have had a chance to see a preface, table of contents, or even a title page. When we do finally reach the contents, we learn that we are already in "Book Two" and that the photographs are the "Book One," which we have already "read."

The "co-equality" of photos and text is, in one sense, a direct consequence of their independence, each medium being given a "book" of its own, each equally free of admixture with the other—Evans providing photos without text, Agee a text without photos. But equality is further suggested by the feeling that Evans's photos really do constitute, in W. Eugene Smith's phrase, an "essay" in their own right.[10] The sequence of Evans's photos does not tell a story but suggests rather a procession of general "topics" epitomized by specific figures—after the anomalous opening figure (figure 54) whose rumpled sport coat suggests a wealth and class somewhat above those of the tenant farmers, a survey of representative figures: Father (figure 55), Mother (figure 56), Bedroom (figure 57), House (figure 58), and Children (Girl-Boy-Girl) of descending ages (figures 59, 60, 61).[11] It is possible to construct a master-narrative if we insist on one. Agee provides one some eighty pages later if we are alert to it: "a man and a woman are drawn together upon a bed and there is a child and there are children" (p. 55). We can even give these figures proper names: George and Annie Mae Gudger, their house, their children. But these text-image "exchanges" are not *given* to us by either the text or the images; if anything, the organization of the volume makes this difficult; it resists the straightforward collaboration of photo and text. And this resistance is not overcome by repeated readings and viewings, as if a secret code linking the photos to the text were there to be deciphered. When all the "proper" names and places are identified, we are reminded that these are fictional names: the Gudgers, Rickettses, and Woodses do not exist by those names. We may feel we "know" them through Evans's images, through Agee's intimate meditations on their lives, but we never do, and we never will.

What is the meaning of this blockage between photo and text? One answer would be to link it with the aesthetics of a Greenbergian

10. Eugene Smith argues that photojournalists tend to work within narrative conventions, producing "picture stories": "that's a form of its own, not an essay" (*The Photo Essay*, p. 15).

11. This "topical" and nonnarrative format persists throughout the sequence of Evans's photos. The photos are divided into three sections, the first concentrating on the Gudgers and Woodses, the second on the Rickettses, and the third on the towns in their neighborhood.

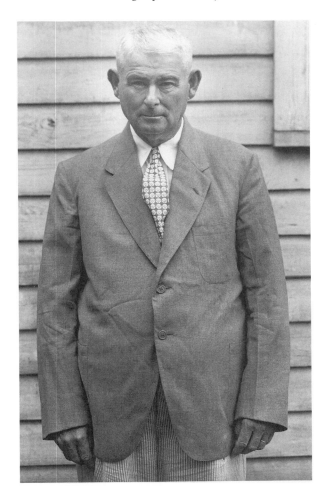

54. Walker Evans, photograph from *Let Us Now Praise Famous Men* (1939) by James Agee and Walker Evans. Photograph courtesy of the Library of Congress.

modernism, a search for the "purity" of each medium, uncontaminated by the mixing of pictorial and verbal codes. Evans's photos are like aggressively untitled abstract paintings, bereft of names, reference, and "literary" elements. They force us back onto the formal and material features of the images in themselves. The portrait of Annie May Gudger (see figure 56), for instance, becomes a purely formal study of flatness and worn, "graven" surfaces: the lines of her face, the weathered grain of the boards, the faded dress, the taut strands of her hair, the gravity of her expression all merge into a visual complex that is hauntingly beautiful and enigmatic. She becomes an

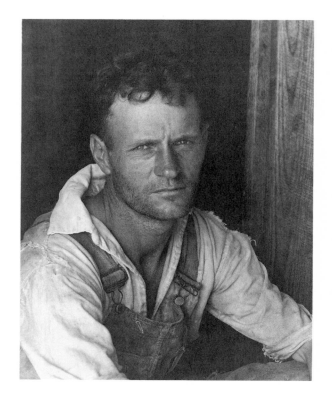

55. Walker Evans, photograph from *Let Us Now Praise Famous Men* (1939) by James Agee and Walker Evans. Photograph courtesy of the Library of Congress.

"icon," arguably the most famous of all the anonymous men and women captured by Evans's camera, a pure aesthetic object, liberated from contingency and circumstance into a space of pure contemplation, the Mona Lisa of the Depression.

There is something deeply disturbing, even disagreeable, about this (unavoidable) aestheticizing response to what after all is a real person in desperately impoverished circumstances. Why should we have a right to look on this woman and find her fatigue, pain, and anxiety beautiful? What gives us the right to look upon her, as if we were God's spies? These questions are, of course, exactly the sorts of hectoring challenges Agee's text constantly confronts us with; they are also the questions that Evans's photos force on us when he shows us the tenant farmers as beautiful, formal studies filled with mystery, dignity, and presence. We cannot feel easy with our aesthetic appreciation of Annie Mae Gudger any more than we can pronounce her true name. Her beauty, like her identity, is held in reserve from us, at a

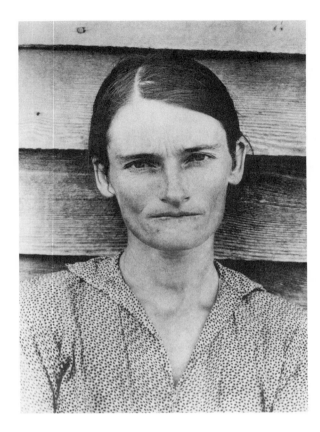

56. Walker Evans, *Annie Mae Gudger*, photograph from *Let Us Now Praise Famous Men* (1939) by James Agee and Walker Evans. © Copyright, Estate of Walker Evans.

distance: she looks back at us, withholding unreadable secrets. She asks as many questions of us as we of her: "who are you who will read these words and study these photographs?"

The aestheticizing separation of Evans's images from Agee's text is not, then, simply a formal characteristic but an ethical strategy, a way of preventing easy access to the world they represent. I call this an "ethical" strategy because it may well have been counterproductive for any political aims. The collaboration of Erskine Caldwell and Margaret Bourke-White in the representation of tenant farmers provides an instructive comparison. *You Have Seen Their Faces* offers unimpeded exchange between photos and text: Bourke-White's images interweave with Caldwell's essay; each photo is accompanied by a "legend" locating the shot and a "quotation" by the central figure.

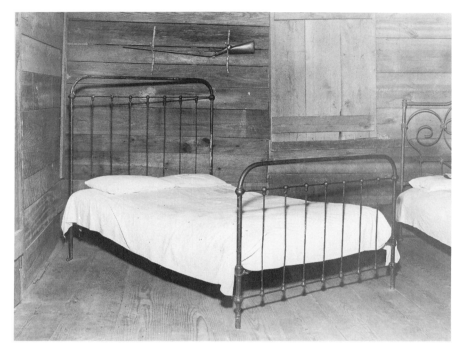

57. Walker Evans, photograph from *Let Us Now Praise Famous Men* (1939) by James Agee and Walker Evans. Photograph courtesy of the Library of Congress.

Consider *Hamilton, Alabama*/"We manage to get along" (figure 62).[12] The photograph restates the legend in its pictorial code, creating with its low-angle viewpoint and wide-angle lens an impression of monumentality and strength (note especially how large the figures' hands are made to seem). This sort of rhetorical reinforcement and repetition is by far the more conventional arrangement of the photo-essay, and it may explain the enormous popular success of *You Have Seen Their Faces*.

12. The reader who supposes that these quotations have some documentary authenticity, or even an expressive relation to the photographic subject, should heed Bourke-White's opening note: "the legends under the pictures are intended to express the authors' own conceptions of the sentiments of the individuals portrayed; they do not pretend to reproduce the actual sentiments of these persons." The candor of this admission is somewhat offset by the

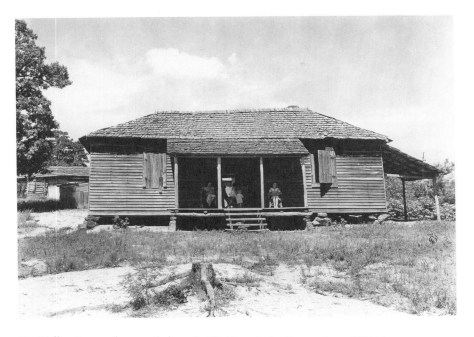

58. Walker Evans, photograph from *Let Us Now Praise Famous Men* (1939) by James Agee and Walker Evans. Photograph courtesy of the Library of Congress.

It also illustrates vividly the kind of rhetorical relation of photo and text that Evans and Agee were resisting. This is not to say that Evans and Agee are "unrhetorical," but that their "collaboration" is governed by a rhetoric of resistance rather than one of exchange and cooperation. Their images and words are "fully collaborative" in the project of subverting what they saw as a false and facile collaboration with governmental and journalistic institutions (the Farm Security Administration, *Fortune* magazine).[13] The blockage between photo and

persistent fiction of the "quotation" throughout the text. This manipulation of verbal material is quite in keeping with Bourke-White's penchant for rearranging the objects in the sharecroppers' households to conform with her own aesthetic tastes.

13. Jefferson Hunter's book, *Image and Word: The Interaction of Twentieth Century Photographs and Texts* (Cambridge, MA: Harvard University Press, 1987) notes this resistance but sees it merely as an "affront" to convention that made *Famous Men* "unsuccessful in 1941" and "uninfluential now"

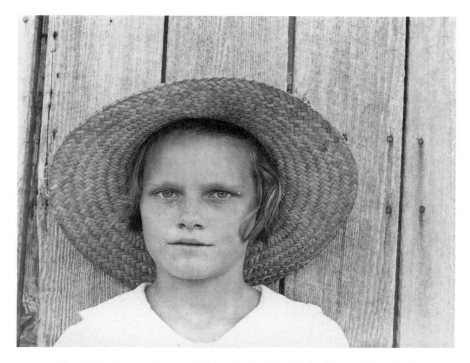

59. Walker Evans, photograph from *Let Us Now Praise Famous Men* (1939) by James Agee and Walker Evans. Photograph courtesy of the Library of Congress.

text is, in effect, a sabotaging of an effective surveillance and propaganda apparatus, one which creates easily manipulable images and narratives to support political agendas. Agee and Evans may well have agreed with many of the reformist political aims of Caldwell and Bourke-White and the institutions they represented: where they parted company is on what might be called the "ethics of espionage." Agee repeatedly characterizes himself and Evans as "spies": Agee is "a spy, traveling as a journalist"; Evans "a counter-spy, traveling as a photographer" (p. xxii). The "independence" of their collaboration is the strict condition for this spy/counter-spy relation; it is their way of

on the practice of photo-text collaboration. Hunter takes the "stylistic consistency" of Bourke-White and Caldwell as a model for the way "collaborative efforts succeed" (p. 79).

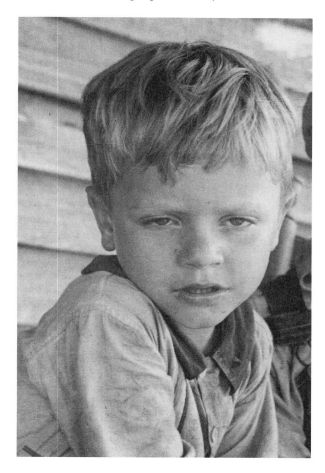

60. Walker Evans, photograph from *Let Us Now Praise Famous Men* (1939) by James Agee and Walker Evans. Photograph courtesy of the Library of Congress.

keeping each other honest, playing the role of "conscience" to one another. Evans exemplifies for Agee the ruthless violence of their work and the possibility of doing it with some sort of honor. The visibility of the photographic apparatus brings their espionage out into the open, and Agee admires the openness of Evans at work, his willingness to let his human subjects pose themselves, stage their own images in all their dignity and vulnerability, rather than treating them as material for pictorial self-expression. Agee, for his part, is all self-expression, as if the objectivity and restraint of Evans's work had to be countered by the fullest subjectivity and copiousness of confession. This division of labor is not just an ethics of production affecting the

61. Walker Evans, photograph from *Let Us Now Praise Famous Men* (1939) by James Agee and Walker Evans. Photograph courtesy of the Library of Congress.

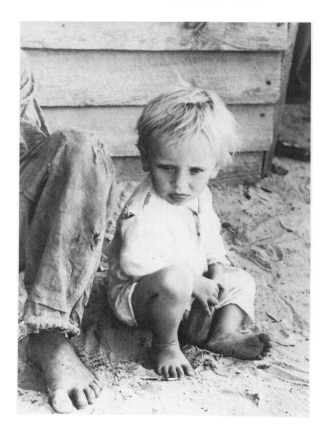

work of the writer and photographer;[14] it is, in a very real sense, an ethics of form imposed on the reader/viewer in the structural division of the photos and text. Our labor as beholders is as divided as that of Agee and Evans, and we find ourselves drawn, as they were, into a vortex of collaboration and resistance.[15]

14. For an excellent account of what I'm calling an "ethics of production," see Carol Schloss's chapter on Agee and Evans in her *In Visible Light*.

15. I use the word "vortex" here to echo Agee's allusions to the Blakean vortex and to the presence of Blake as a presiding genius in *Famous Men*. I do not know how familiar Agee was with Blake's work as a composite artist, but if he knew the illuminated books, he must have been struck by the oft-remarked independence of Blake's engravings from his texts, an independence

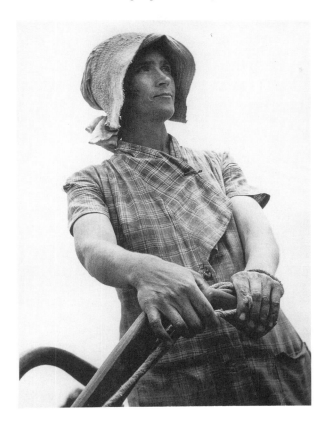

62. Margaret Bourke-White, *HAMILTON, ALABAMA.* *"We manage to get along."* From *You Have Seen Their Faces*, by Erskine Caldwell and Margaret Bourke-White. Courtesy of the Estate of Margaret Bourke-White.

Labyrinth and Thread: Camera Lucida

A labyrinthine man never seeks the truth, but only his Ariadne.
 —Nietzsche (quoted by Barthes)[16]

The strong, "agonistic" form of the photographic essay tends, as we have seen, to be as concerned with the nature of photography, writing,

which is coupled, of course, with the most intimate collaboration. For more on Blakean text-image relations, see my *Blake's Composite Art* (Princeton, NJ: Princeton University Press, 1977), and chapter 4 above.

 16. Roland Barthes, *Camera Lucida* (French original, 1981; New York: Hill and Wang, 1981), p. 73; further page references will be cited in the text.

and the relation of the two, as with its represented subject matter (tenant farming, New York tenements, migrant workers, etc.). But most essays on photography (including this one) are not "photographic essays" in the sense I am giving the term here. Walter Benjamin's "A Short History of Photography" is not a photographic essay for the obvious reason that it is not illustrated. But even if it were, the photos would only be there to illustrate the text; they would not have the independence or co-equality that permits collaboration in a truly composite form.

One of the few "essays on photography" that approaches the status of a photographic essay is Barthes's *Camera Lucida*. The "independence" and "co-equality" of the photographs in Barthes's text is achieved, not by grouping them in a separate "book" where their own syntactical relations may emerge, but by a consistent subversion of the textual strategies that tend to incorporate photographs as "illustrative" or evidentiary examples. We open *Camera Lucida* to a frontispiece (figure 63), a color polaroid by Daniel Boudinet that never receives any commentary in the text. The only words of Barthes that might be applied to it are equivocal or negative ("Polaroid? Fun, but disappointing, except when a great photographer is involved" [p. 9]; "I am not very fond of Color . . . color is a coating applied *later on* to the original truth of the black-and-white photograph . . . an artifice, a cosmetic (like the kind used to paint corpses)" [p. 81]. Are we to suppose, then, that Barthes simply "likes" this photograph and admires Boudinet's art? These criteria are continually subverted in Barthes's text by his seemingly capricious preferences, his refusal to assent to canonized masterpieces and masters: "there are moments when I detest Photographs: what have I to do with Atget's old tree trunks, with Pierre Boucher's nudes, with Germain Krull's double exposures (to cite only the old names)?" (p. 16). The Boudinet polaroid stands independent of Barthes's text: the best "reading" we can give it is perhaps simply as an emblem of the unreadability of photography, its occupation of a site forever prior to and outside Barthes's text. The photo presents an image of a veiled, intimate *boudoir*, simultaneously erotic and funereal, its tantalizingly partial revelation of light gleaming through the cleavage in the curtains like the secret at the center of a labyrinth. Barthes tells us that "it is a mistake to associate Photography . . . with the notion of a dark passage (*camera obscura*). It is *camera lucida* that we should say" (p. 106). But the darkened chamber of Barthes's frontispiece refuses to illustrate his text. If there is a *camera lucida* in this image it resides beyond the curtains of this scene,

or perhaps in the luminous opening at its center, an evocation of the camera's aperture.[17]

Most of the other photographs in Barthes's text seem, at first glance, purely illustrative, but a closer reading subverts this impression. Barthes's commentaries are doggedly resistant to the rhetoric of the "*studium*," the "rational intermediary of an ethical or political culture" (p. 26) that allows photographs to be "read" or that would allow a scientific theory of the photograph to emerge. Instead, Barthes emphasizes what he calls the "*punctum*," the stray, pointed detail that "pricks" or "wounds" him. These details (a necklace, bad teeth, folded arms, dirt streets) are accidental, uncoded, nameless features that open the photograph metonymically onto a contingent realm of memory and subjectivity: "it is what I add to the photograph and *what is nonetheless already there*" (p. 55), what is more often remembered about a photograph than what is seen in its actual presence.[18] The effect of this rhetoric is to render Barthes's text almost useless as a semiological theory of photography, while making it indispensable *to* such a theory. By insisting on his own personal experiences of photographs, by accepting the naive, primitive "astonishment," "magic," and "madness" of photography, Barthes makes his own experience the raw material or experimental data for a theory—a

17. The *camera lucida*, as Barthes knew, is not properly translated as a "light room" in opposition to a "dark room." It is "the name of that apparatus, anterior to Photography, which permitted drawing an object through a prism, one eye on the model, the other on the paper" (p. 106). The opening in the curtains, as optical aperture, plays precisely this role.

18. "I may know better a photograph I remember than a photograph I am looking at, as if direct vision oriented its language wrongly, engaging it in an effort of description which will always miss its point of effect, the *punctum*" (p. 53). The opposition between *studium* and *punctum* is coordinated, in Barthes's discussion, with related distinctions between the public and the private, the professional and the amateur. The captions further reinforce what Barthes calls "the two ways of the Photograph," dividing themselves into a scholarly, bibliographic identification of photographer, subject, date, etc. and an italicized quotation registering Barthes's personal response, the *punctum*. This practice of double captioning is, I think, a pervasive convention in photographic essays, often signaled by hyphenation (as in Robert Frank's *The Americans*), or contrasting type-styles (as in *You Have Seen Their Faces*): *Hamilton, Alabama*/ "We manage to get along."

63. Daniel Boudinet, *Polaroid, 1979*, in Roland Barthes, *Camera Lucida* (1981). © 1993 ARS, New York/SPADEM, Paris.

data, however, that is filled with consciousness of a skepticism about the theories that will be brought to it.[19]

The photograph that is of most importance to Barthes's text, a "private" picture of his mother taken in a glassed-in conservatory or "Winter Garden" when she was five years old, is not reproduced. "Something like the essence of the Photograph," says Barthes, "floated in this particular picture." If "all the world's photographs

19. Victor Burgin regards the antiscientific rhetoric of *Camera Lucida* with dismay: "The passage in *Camera Lucida* where Barthes lambasts the scientist of the sign (his own other self) has become widely quoted amongst precisely the sorts of critics Barthes opposed" ("Re-reading *Camera Lucida*," in *The End of Art Theory,* p. 91). Burgin's reduction of this to a straightforward political clash ignores the fact that the "sorts of critics" Barthes "opposed" included *himself,* and this opposition is precisely what gives his criticism ethical and political force.

304

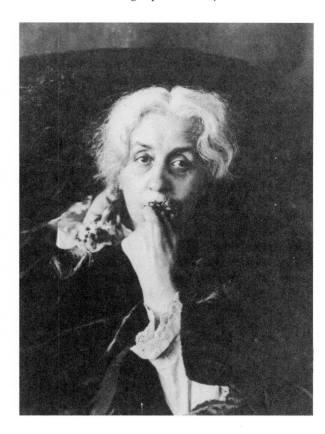

64. Nadar, *The Artist's Mother (or Wife)* (n.d.), in Roland Barthes, *Camera Lucida* (1981). © 1993 ARS, New York/ SPADEM, Paris.

formed a Labyrinth, I knew at the center of this Labyrinth I should find nothing but this sole picture" (p. 73). But Barthes cannot take us into the center of the labyrinth except blindfolded, by ekphrasis, leading us with the thread of language. Barthes "cannot reproduce" the photograph of his mother because it "would be nothing but an indifferent picture" for anyone else. In its place he inserts a photograph by Nadar of *The Artist's Mother (or Wife)* (figure 64), which one "no one knows for certain" (p. 70).[20] This photograph receives

20. Joel Snyder informs me that these identifications are confused. The photograph was taken by Paul Nadar, the artist's son, and is of his mother, Nadar's wife. Given the use Barthes makes of the photograph, the confusion of father and son, wife and mother, is hardly surprising. The manifest uncertainty of the caption and its misquotation of Barthes's own text suggest that Barthes was deliberately attaching a confused "legend" to this photo.

only the most minimal, even banal commentary ("one of the loveliest photographs in the world" [p. 70]) and an equally banal caption which pretends to be quoted from the text, but (characteristically) is misquoted or constructed especially for this image: "'Who do you think is the world's greatest photographer?' 'Nadar'" (p. 68). Barthes's substitution of this maternal image for his own mother launches him into a series of increasingly general associative substitutions: this photograph becomes "*the* Photograph" becomes "*the* Image"; Barthes's mother becomes "The Artist's Mother" becomes "*the* Mother." The link between "Image" and "Mother" is then summarized as a universal cultural complex which has been reproduced in the particularity of Barthes's own experience of photography:

> Judaism rejected the image in order to protect itself from the risk of worshipping the Mother. . . . Although growing up in a religion-without-images where the Mother is not worshipped (Protestantism) but doubtless formed culturally by Catholic art, when I confronted the Winter Garden photograph I gave myself up to the Image, to the Image-Repertoire. (pp. 74–75).

Barthes is not a photographer; he made none of the photographs in his book, his only responsibility being to collect and arrange them within his text. He therefore has no collaborator in the usual sense. His collaborator is "Photography" itself, exemplified by an apparently miscellaneous collection of images, some private and personal, most the work of recognized masters from Niepce to Stieglitz to Mapplethorpe and Avedon.[21] "All the world's photographs" are treated by Barthes as a labyrinth whose unrepresentable center conceals the Mother, *his* mother. A mother who, like the subjects of all photographs, "is dead and . . . is going to die" (p. 95) unites all the photographs in Barthes's text, endowing them with the independent unity that enables them to look back at us while withholding their secrets. The Nadar portrait, its maternal figure gazing abstractedly out of the photo, mouth discreetly covered by the rose she kisses, is the closest we come to an emblem of this self-possession and reserve.

21. The twenty-five European and American photos in *Camera Lucida* range from journalism to art photos to personal family photographs and include examples of "old masters" (the "first photograph"—by Niepce; Charles Clifford, "The Alhambra"; G. W. Wilson, "Queen Victoria") from the nineteenth century as well twentieth-century works. The effort is clearly to suggest "Photography" in its full range without making any effort to be comprehensive or systematic.

The relation of the photographs to Barthes's text is, then, that of labyrinth and thread, the "maternal image-repertoire" and the umbilical cord of language. His role as a writer is not to master the photos, but to surrender himself as captivated observer, as naive subject of the idolatrous magic of images. The whole project is an attempt to suspend the appropriate "scientific" and "professional" discourse of photography in order to cultivate photography's resistance to language, allowing the photographs to "speak" their own language—not "its usual blah-blah: 'Technique,' 'Reality,' 'Reportage,' 'Art,' etc." but making "the image speak in silence" (p. 55). Barthes dismisses, therefore, much "sophisticated" commentary on photography, his own included:

> It is the fashion, nowadays, among Photography's commentators (sociologists and semiologists), to seize upon a semantic relativity: no "reality" (great scorn for the "realists" who do not see that the photograph is always coded) . . . the photograph, they say, is not an *analogon* of the world; what it represents is fabricated, because the photographic optic is subject to Albertian perspective (entirely historical) and because the inscription on the picture makes a three-dimensional object into a two-dimensional effigy. (p. 88)

Barthes declares this argument "futile," not just because photographs, like all images, are "analogical" in their coded structure, but because realism must be located in a different place: "the realists do not take the photograph for a 'copy' of reality, but for an emanation of *past reality*: a *magic*, not an art." This lost "magic" of photography, based in its naive realist stage (also its place in modernism), is what Barthes's text attempts to recover and why it must seem to efface itself, "give itself up to" its photographs, even as it weaves them into a labyrinth of theory and desire, science and autobiography.[22]

Voyeurism and Exorcism: The Colonial Harem

It is as if the postcard photographer had been entrusted with a social mission: *put the collective phantasm into images.* He is the first to benefit from what he accomplishes through the delegation

22. This respect for the "naive realism" of photography is also a crucial feature of Agee's text. Agee notes "how much slower white people are to catch on than negroes, who understand the meaning of a camera, a weapon, a stealer of images and souls, a gun, an evil eye" (p. 362).

of power. The true voyeurism is that of the colonial society as a whole.

—Malek Alloula

The "magic" of photography can be the occasion of mystification as well as ecstasy, a point that is made by Malek Alloula's photographic essay on French colonial postcards of Algerian women.[23] Alloula dedicates his book to Barthes and adopts his basic vocabulary for the description of photographic magic, but he inverts Barthes's textual strategies in order to confront a body of images that exercised a detestable, pernicious magic over the representation of Algeria:

> What I read on these cards does not leave me indifferent. It demonstrates to me, were that still necessary, the desolate poverty of a gaze that I myself, as an Algerian, must have been the object of at some moment in my personal history. Among us, we believe in the nefarious effects of the evil eye (the evil gaze). We conjure them with our hand spread out like a fan. I close my hand back upon a pen to write *my* exorcism: *this text.* (p. 5)

There is no nostalgia here for a lost "primitive" or "realist" stage; there is no room for the "*punctum*" or ecstatic "wound" Barthes locates in the accidental detail. There is only the massive trauma of the "degrading fantasm" legitimating itself under the sign of photographic "reality." These photographs exclude all the "accidents" Barthes associates with the subversive "white magic" of the image. They stage for the voyeuristic French consumer the fantasy of "Oriental" luxury, lust, and indolence, as the unveiled "booty" before the colonial gaze. The critical text is counter-magic, a contrary incantation, repetitiously intoning its execrations on the filthy European pornographers with their ethnographic alibis.

Alloula's text fulfills the three conditions of the photographic essay in a quite unsuspected manner: his text is obviously independent of the images, that independence a direct result of Algeria's revolutionary independence of the French empire (Barbara Harlow's introduction places the book quite explicitly in the framework of Pontecorvo's film, *The Battle of Algiers*). There is "equality" of text and image in at least two senses. First, the text offers a point-by-point

23. Malek Alloula, *The Colonial Harem,* translated by Myrna and Wlad Godzich (French edition, 1981; English edition, Minneapolis: University of Minnesota Press, 1986); further page references will be cited in the text.

critical refutation of the implicit "argument" of the images. Second, it attempts to realize a contrary visual image or "staring back" into the face of the predatory colonial gaze. Alloula's text presents itself as a kind of substitute for a body of photographs that should have been taken, but never were:

> A reading of the sort that I propose to undertake would be entirely superfluous if there existed photographic traces of the gaze of the colonized upon the colonizer. In their absence, that is, in the absence of a confrontation of opposed gazes, I attempt here . . . to return this immense postcard to its sender. (p. 5)

Finally, there is "collaboration" in the sense that the postcards must be reproduced along with the text and thus forced to collaborate in their own deconstruction, their own "unveiling," much as the *algérienne* were forced to collaborate in the misrepresentation of Algerian women and their images forced to collaborate in a false textualizing—their insertion into a staged fantasy of exotic sexuality and unveiling, the colonial "chit-chat" (full of crude jokes) written on their backs, the colonial seal stamped across their faces, canceling the postage and their independent existence in one stroke.

Alloula's project is clearly beset on every side by contradictory impulses, the most evident being the necessity of reproducing the offending postcards in a book which may look to the casual observer like a coffee-table "collector's item" of exactly the sort he denounces. Occasional "classics" and "masterpieces" emerge, even in a pornographic genre:

> It is on "accomplishments" of this sort that a lucrative business of card collecting has been built and continues to thrive. It is also by means of this type of "accomplishment" that the occultation of meaning is effected, the meaning of the postcard that is of interest to us here. (p. 118)

"Aestheticization," far from being an antidote to the pornographic, is seen as an extension of it, a continuing cover-up of evil under the sign of beauty and rarity. This problem was also confronted by Agee, who dreaded the notion that his collaboration with Evans would be mystified by notions of special expertise or authority, chief among these the authority of the "artist": "the authors," he said, "are trying to deal with it not as journalists, sociologists, politicians, entertainers, humanitarians, priests. or artists, but seriously" (p. xv). "Seriousness" here means something quite antithetical to the notion of a canonical "classic" stamped with "aesthetic merit" and implies

a sense of temporary, tactical intervention in an immediate human problem, not a claim on the indefinite future. That is why Agee wanted to print *Let Us Now Praise Famous Men* on newspaper stock. When told that "the pages would crumble to dust in a few years," he said, "that might not a bad idea" (Stott, p. 264).

Let us add, then, to the generic criteria of the photographic essay a notion of seriousness which is frequently construed in anti-aesthetic terms, as a confrontation with the immediate, the local and limited, with the un-beautiful, the impoverished, the ephemeral, in a form that regards itself as simultaneously *indispensable* and *disposable*. The text of Alloula's *The Colonial Harem* sometimes reads as if it wanted to shred or incinerate the offending postcards it reproduces so well, to disfigure the pornographic beauty of the colonized women. But that would be, like most shreddings of historical documents, only a cover-up that would guarantee historical amnesia and a return of the repressed. Although Alloula can never quite say this, one feels that his essay is not simply a polemic against the French evil, but a tacit confession and purgation. Alloula reproduces the offending images, not just to aggressively "return an immense postcard to its sender," but to repossess and redeem those images, to "exorcise" an ideological spell that captivated mothers, wives, and sisters, as well as the "male society" that "no longer exists" (p. 122) in the colonial gaze. The rescue of women is an overcoming of impotence; the text asserts its manhood by freeing the images from the evil eye.

Barthes found the secret of photography in an image of his pre-pubescent mother at the center of a labyrinth. His text is the thread that takes us toward that center, a ritual surrender to the maternal image-repertoire. Alloula drives us out of the mystified labyrinth constructed by European representations of Arab women. He avenges the prostitution not only of the Mother, but of Photography itself, seeking to reverse the pornographic process.

What are we left with? Are the images redeemed, and if so, in what terms and for what sort of observer? How do we see, for instance, the final photograph of the book (figure 65), which Alloula only mentions in passing, and whose symmetry approaches abstraction, reminiscent of an art nouveau fantasy. Can an American observer, in particular, see these photographs as anything more than quaint, archaic pornography, hauntingly beautiful relics of a lost colonial era, "collector's items" for a coffee-table book? I don't have a simple answer to this question, but my first impulse is to register a feeling of *impotence* in the face of these women, whose beauty is now mixed with danger, whose nakedness now becomes a veil that has

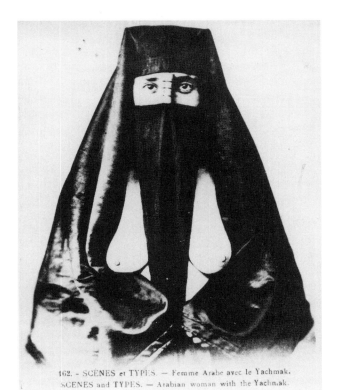

65. *Scenes and Types: Arabian woman with the Yachmak* (n.d.), from *The Colonial Harem* (1986) by Malek Alloula, translated by Myrna and Wlad Godzich (French edition, 1981; English edition, Minneapolis: University of Minnesota Press, 1986).

always excluded me from the labyrinth of their world.[24] I feel exiled from what I want to know, to understand, or (more precisely) what I want to acknowledge and to be acknowledged by. In particular,

24. This impotence is perhaps nothing more than the familiar liberal guilt of the white male American becoming conscious of complicity in the ethos of imperialism. But it is also a more personal reaction which stems from a not altogether pleasant failure to react "properly" to the pornographic image, a failure which I can't take credit for as a matter of moral uprightness (morality, I suspect, only enters in when the proper reaction is there to be resisted). I had registered this feeling at the first perusal of the photographs in *The Colonial Harem*. Needless to say, a sensation of the uncanny attended my reading of the final paragraph of Alloula's text: "Voyeurism turns into an obsessive neurosis. The great erotic dream, ebbing from the sad faces of the wage earners in the poses, lets appear, in the flotsam perpetuated by the postcard, another figure: that of *impotence*" (p. 122).

Alloula's text forces these acknowledgments from me: that I cannot read these photographs; that any narrative I might have brought to them is now shattered; that the labyrinth of photography, of the maternal image-repertoire, defies penetration and colonization by any textual system, including Malek Alloula's. The photographs, so long exchanged, circulated, inscribed, and traded, now assert their independence and equality, looking at us as they collaborate in the undoing of the colonial gaze.

Exile and Return: After the Last Sky

But I am the exile.
Seal me with your eyes.
 —Mahmoud Darwish

Feelings of exile and impotence in the face of the imperial image are the explicit subject of Edward Said and Jean Mohr's photographic essay on the Palestinians. But instead of the aggressive "return of the repressed" in the form of degraded, pornographic images, *After the Last Sky*[25] projects a new set of images, self-representations of the colonized and dispossessed subjects, representations of their views of the colonizers: "our intention was to show Palestinians through Palestinian eyes without minimizing the extent to which even to themselves they feel different" (p. 6). The text is (as in *Camera Lucida*) a thread leading the writer and his readers back into the labyrinth of otherness and the self-estrangement of exile. Its task is to see that the "photographs are not" seen as "the exhibition of a foreign specimen" (p. 162), without, on the other hand, simply domesticating them. Said's text is not, then, like Alloula's, a scourge to drive Western eyes out the labyrinth. If Alloula treats the collaboration of text and image as a violent, coercive confrontation, Said and Mohr create a dialogical relation of text and image that is collaborative in the classic (that is, modernist) sense articulated by Agee and Evans, a cooperative endeavor by two like-minded and highly talented professionals, writer and photographer.

The results of this "positive" collaboration are anything but straightforward. The independence of text and image is not asserted directly, as in Agee and Evans, by a strict physical separation. Said

25. Edward Said and Jean Mohr, *After the Last Sky* (London: Pantheon, 1986); further page references will be cited in the text.

and Mohr follow something closer to the mode of *Camera Lucida*'s dialectical, intertwined relation of photos and essay, a complex of exchange and resistance.[26] Writer and photographer both refuse the stereotyped division of labor that would produce a "text with illustrations" or an "album with captions." Said's text oscillates between supplementary relations to the images (commentary, meditations, reflections on photography) and "independent" material (the history of the Palestinians, autobiographical anecdotes, political criticism). Mohr's photographs oscillate between "illustrative" relations (pictures of boys lifting weights, for instance, document the "cult of physical strength" Said describes among Palestinian males) and "independent" statements that receive no direct commentary in the text, or play some kind of ironic counterpoint to it. An example: Said's discussion of his father's lifelong attempt to escape memories and material mementos of Jerusalem is juxtaposed (on the facing page) with an image that conveys just the opposite message and which receives no commentary, only a minimal caption: "the former mayor of Jerusalem and his wife, in exile in Jordan" (figure 66). Behind them a photographic mural of the Mosque of Omar in Jerusalem occupies the entire wall of their living room. The collaboration of image and text here is not simply one of mutual support. It conveys the anxiety and ambivalence of the exile whose memories and mementos, the tokens of personal and national identity, may "seem . . . like encumbrances" (p. 14). The mural seems to tell us that the former mayor and his wife *cherish* these encumbrances, but their faces do not suggest that this in any way reduces their weight.

The relation of photographs and writing in *After the Last Sky* is consistently governed by the dialectic of *exile* and its overcoming, a double relation of estrangement and re-unification. If, as Said claims, "exile is a series of portraits without names, without context" (p. 12), return is figured in the attachment of names to photographs, contexts to images. But "return" is never quite so simple: sometimes the names are lost, unrecoverable; too often the attachment of text to an image can seem arbitrary, unsatisfactory. Neither pole in the dialectic of exile is univocally coded: estrangement is both imposed from without by historical circumstance and from within by the painfulness of memory, the will to forget and shed the "encumbrance" of Palestinian

26. Mohr's earlier collaborations with John Berger are clearly an important precedent also. See especially *The Seventh Man* (Originally published, Penguin, 1975; London: Writers and Readers, 1982), a photographic essay on migrant workers in Europe.

66. Jean Mohr, *Mayor of Jerusalem*, page spread from *After the Last Sky*, by Edward W. Said. Copyright © 1986 by Edward W. Said. Reprinted by permission of Pantheon Books, a division of Random House, Inc.

identity. "Re-unification," similarly, is the utopian object of desire and yet an object of potential aversion in its utopian impracticality. "Homecoming," says Said, "is out of the question. You learn to transform the mechanics of loss into a constantly postponed metaphysics of return" (p. 150). Where does the exile go "after the last sky" has clouded over, after Beirut, Cairo, Amman, the West Bank have failed to provide a home? What attitude do the physically exiled Palestinians take to the "exiles at home," the "present absentees" who live in "The Interior," inside Israel? The ambivalence expressed in these questions is also inscribed in the delicate, intricate, and precarious relations of text and image—the inside and outside, as it were, of this book.

314

The casual "Outsider," the beholder who takes this simply as an album of photographs, will have no difficulty grasping the major polemical point of the book, which is to counter the usual visual representation of Palestinians as menacing figures with *kaffiyas* and ski-masks. Anonymous "terrorists" are displaced by a set of visual facts that everyone knows in theory, but rarely acknowledges in practice—that Palestinians are also women, children, businessmen, teachers, farmers, poets, shepherds, and auto mechanics. That the representation of Palestinians as ordinary human beings, "capturable" by ordinary, domestic sorts of snapshots, should be in itself remarkable is a measure of how extraordinarily limited the normal image of the Palestinian is. There is an acceptable "icon" of the Palestinian, as Said puts it, and the images in *After the Last Sky*—domestic, peaceful, ordinary—do not fit this decorum, as anyone will find who attempts to insert this book among the other photographic texts that adorn the typical coffee-table.

The history of this particular set of photographs suggests that this decorum is not simply natural or empirical but has to be reinforced by the most stringent prohibitions. Jean Mohr was commissioned to take the pictures for an exhibition at the International Conference on the Question of Palestine held by the United Nations in Geneva in 1983. "The official response," as Said notes

> was puzzling. . . . You can hang them up, we were told, but no writing can be displayed with them. No legends, no explanations. A compromise was finally negotiated whereby the name of the country or place (Jordan, Syria, West Bank, Gaza) could be affixed to the much-enlarged photographs, but not one word more. (p. 3)

The precise motives for this bureaucratic "prohibition on writing" never become clear. Said speculates that the various Arab states who participated in the conference (Israel and the United States did not) found the Palestinian cause "useful up to a point—for attacking Israel, for railing against Zionism, imperialism, and the United States," but the notion of considering the Palestinians *as a people* (that is, with a story, a text, an argument) was unacceptable. The prohibition on writing was perhaps a way of keeping these disturbing images from taking on an even more disturbing voice. Context, narrative, historical circumstances, identities, and places were repressed in favor of what might be seen as a parody of the abstract and "modernist" space of visual exhibition: minimal captions, no "legends," pure vi-

sual display without reference or representation. Exile is a series of photographs without texts.

After the Last Sky, then, is a violation of a double prohibition against a certain kind of image (nonbellicose, nonsublime) and against a writing joined to these images. This might seem an excessively formalistic point. But Said notes that "most literary critics . . . focus on what is said in Palestinian writing . . . [its] sociological and political meaning. But it is the *form* that should be looked at" (p. 38). This "form" is not something distinct from content; it *is* the content in its most material, particular sense, the specific places it carves out as the site of Palestinian existence. As such, it resists the reduction of the Palestinian question to a political issue, insisting on the ethical as well as aesthetic relation of text and image. The collaboration of photographer and writer in *After the Last Sky* cannot be seen, then, simply as corrective to the prohibition which segregates the Palestinian image from the Palestinian text. This collaboration is also embedded in a complex field of heterogeneities that can never quite be accommodated to traditional dialectical forms of aesthetic unity. We don't find a Coleridgean "multeity in unity" in this book, but something more like a multeity of glimpses of unity, seen as if through a pair of spectacles, one lens of which is shattered. (This image, drawn from one of the most striking photographs in the book, is one I will return to later.)

The two lenses of this book are writing and photography, neither understood abstractly or generically but as constructions of specific histories, places, and displacements. The photographer, a German born in Geneva, naturalized as a Swiss citizen in 1939, has had concrete experience of intra-European exile. The writer is a Palestinian Christian born in Jerusalem, exiled to Lebanon, Egypt, the United States. From one point of view the writer is the insider, the clear, intact lens who can represent through his own experience a focused image of "the Palestinian"; the photographer is the alien, unable to speak the languages of Palestine or Israel, "seeing" only the mute, inarticulate fragments of lives that the camera allows (thus, many of the people in Mohr's photographs are anonymous, unidentified, and photography re-doubles the exile of image from referent). From another point of view, the photographer is the clear, intact lens. His Swiss neutrality allows him what was denied to the writer in the 1980s, the freedom to travel throughout Israel and the West Bank, to go "inside" Palestine and represent it with the transparent accuracy of photography. The writer is the alien, the outsider, estranged from

316

a land he dimly remembers as a child, a land in which he would have been, as an urbane, Christian intellectual, estranged from the rural, local culture of the Palestinian masses. The writer acknowledges that he himself is the "cracked lens," unable to see, quite literally, the native country he longs for except in fragmentary glimpses provided by others.

The divisions of labor we have traced between writer and photographer—spy and counter-spy, thread and labyrinth, voyeur and exorcist—are consistently undermined by the tightly woven collaboration of *After the Last Sky*. But there is one vestige of traditional divisions of labor in the way Said's meditations on gender difference suggest the collaboration of a male text with a body of female images. Like Barthes, Said installs Woman at the center of the photographic matrix. The section of the book called "Interiors" (concerned with Palestinians who live inside Israel, with domestic spaces and the theme of privacy) is mainly devoted to images of women. Said also follows Barthes in finding that the primal scene of the photograph involves his mother. A British customs official rips up her passport, destroying her legal identity and (presumably) her photographic image in the same gesture. Like Alloula, Said is vindicating the disfigured image of his mother; like Barthes, he is trying to re-assemble the fragments of her identity. But he also portrays the women as the real preservers of this identity, associated with "the land" and the idea of home, portrayed as clinging irrationally, stubbornly, to "memories, title deeds, and legal claims" (p. 81). The women are also the keepers of images in the Palestinian interior, the ones who hang up too many pictures too high on the walls, who save the photograph albums and mementos that may encumber the male Palestinian who wants to travel light. (Recall that Said's father "spent his life trying to escape these objects" [p. 14].) Yet Said acknowledges a "crucial absence of women" (p. 77) in the representation of Palestinians. The official icon is one of "automatic manhood," the macho terrorist who may feel himself both goaded and reproached by the "protracted discipline" (p. 79) of women's work.

Like Barthes, Said wants to preserve the feminine mystique of the image, its difference from the male writer's "articulate discourse" (p. 79). Thus, it sometimes seems as if he would prefer to leave the female images unidentified and therefore mysterious. Like Barthes, he does not reproduce an image of his mother, but substitutes an image of an elderly woman, generalized as an emblem—"a face, I thought when I first saw it, of our life at home" (p. 84). But six months later

317

67. Jean Mohr, *Amman, 1984. Mrs. Farraj.* In *After the Last Sky,* by Edward W. Said. Copyright © 1986 by Edward W. Said. Reprinted by permission of Pantheon Books, a division of Random House, Inc.

Said is reminded by his sister that this woman (figure 67) is actually a distant relative whom he met in the forties and fifties, a reminder that produces mixed emotions:

> As soon as I recognized Mrs. Farraj, the suggested intimacy of the photograph's surface gave way to an explicitness with few secrets. She is a real person—Palestinian—with a real history at the interior of ours. But I do not know whether the photograph can, or does, say things as they really are. Something has been lost. But the representation is all we have. (p. 84)

The uncharacteristic awkwardness of Said's writing here is, I think, a tacit acknowledgment of his ambivalence toward the associative complex, Woman/Image/Home, a confession of his complicity in the sentimentalizing of women and of the lost pastoral homeland that fixates the imagination of the Palestinian male.[27] His candor about

27. "I can see the women everywhere in Palestinian life, and I see how they exist between the syrupy sentimentalism of roles we ascribe to them

68. Jean Mohr, *Elderly Palestinian Villager. Ramallah, 1984.* In *After the Last Sky,* by Edward W. Said. Copyright © 1986 by Edward W. Said. Reprinted by permission of Pantheon Books, a division of Random House, Inc.

this ambivalence, his recognition that the photographic image has a life beyond the discursive, political uses he would make of it, allows the photograph to "look back" at him and us and assert the independence we associate with the strong form of the photo-essay. The poetic secrecy and intimacy he had hoped to find in this image is replaced by a prosaic familiarity and openness.

Jean Mohr provides Said with a striking emblem of his own ambivalence in a photograph which comes closer than any other in this book to supplying a portrait of the writer. Once again, the photo is an unidentified portrait, exiled from its referent, an image of an "elderly Palestinian villager" with a broken lens in his glasses (figure 68). The photograph reminds Said of Rafik Halabi, "a Palestinian-Druze-Israeli" whose book, *The West Bank Story,* is highly critical of Israeli occupation, but "who writes from the viewpoint of a loyal Israeli"

(mothers, virgins, martyrs) and the annoyance, even dislike that their unassimilated strength provokes in our warily politicized, automatic manhood" (p. 77).

who served in the army and "subscribes to Zionism." Said finds Halabi's position impossibly contradictory. Either he is "deluded" or "up to some elaborate rhetorical game" which Said does not understand. Either way, "the result is a book that runs on two completely different tracks" (p. 127). It occurs to Said, of course, that there is something of himself, and perhaps of his own book, in this image: "Perhaps I am only describing *my* inability to order things coherently, sequentially, logically, and perhaps the difficulties of resolution I have discerned in Halabi's book and in the old man with broken glasses are mine, not theirs" (p. 130). First, the image is a double portrait of the Other as Insider, "a symbol, I said to myself, of some duality in our life that won't go away—refugees and terrorists, victims and victimizers, and so on" (p. 128). Not a bad reading, but Said is unhappy with it, as he is generally with emblematic readings that reduce the photograph to convenient verbal formulas. The man's face is "strong and gentle," the "blotch is on the lens, not in him" (p. 128). He has agreed to be photographed this way, so he can watch the camera and exert some control over his own image.

The resulting visual field (both for the wearer of the glasses and the beholder), Said notes, will always disclose a "small disturbance," a "curiously balanced imbalance" which is "very similar to the textual imbalance in Halabi's book" and, clearly, in Said and Mohr's. The Palestinians, a people without a geographic center and with only the most fragile cultural and historical identity have "no one central image," no "dominant theory," no "coherent discourse"; they are "without a center. Atonal" (p. 129). At moments like this, one glimpses Said's allegiance to the musical aesthetics of modernism, to that combination of pessimism and formalism we associate with Adorno. Said's composite, decentered, shifting, imbalanced collaboration with Mohr is nonetheless a shapely, congruent, and formal creation, a material embodiment of the reality he wants to represent, built out of a refusal to simplify, to sentimentalize or settle for polemic. Both writer and photographer could see themselves in this anonymous portrait, itself in exile from its subject: exile is indeed "a series of portraits without names, without contexts" (p. 12). But if photographs sundered from texts portray exile, photographs *with* text are images of return, sites of reconciliation, accommodation, acknowledgment. The delicate balancing act of a book "on two different tracks" may be a rhetorical game Said does not understand even as he is compelled to play it, but then he remarks that Palestinians sometimes "puzzle even ourselves" (p. 53).

The "central image" of the Palestinians is, for the moment, a double vision of just this sort—secular, rational, yet deeply involved in the emotions of victimage—figures in a rhetoric of paranoia which constructs them as the enemy of the victims of the Holocaust or as mere pawns in geopolitical schemes. Said and Mohr cannot be content, therefore, with a propaganda piece to "pretty up the image" of the Palestinians; they must work as well for an *internally directed* representation and critique, chiding not only the Arab and Israeli and Big Power interests, but the Palestinians themselves, Said included. The Palestinians' failings—their pursuit of inappropriate revolutionary models such as Cuba and Algeria, their impatient, macho romanticism, their failure to organize properly with the "protracted discipline" of women, their lack of a coherent history—are all part of the picture. The idea of the book, then, is ultimately to help bring the Palestinians into existence for themselves as much as for others; it is that most ambitious of books, a nation-making text.

Texts that make nations are, of course, what we call "classics," the worst fate (according to Agee) that can befall a book. It was a fate that befell *Let Us Now Praise Famous Men* after a period of neglect and misunderstanding. Our understanding of the thirties, particular the Depression, is often seen as a product of Evans's and Agee's collaboration, and it helped to form an image of a nation in poverty, presented with dignity, sympathy, and truth. But Evans and Agee could never hope, as Said and Mohr do, to address the people they represent, to help bring them into being as a people. Whether this book fulfills such a hope is a question that will be settled beyond its pages: "there is no completely coherent discourse adequate to us, and I doubt whether at this point, if someone could fashion such a discourse, we could be adequate for it" (p. 129). It is at such moments of inadequacy, perhaps, that a mixed, hybrid discourse like that of the photographic essay emerges as a historical necessity.

Insofar as my own remarks here have been essays toward the definition of a genre or a medium, an attempt to articulate the formal principles of the photographic essay, they might be seen as a betrayal of the anti-aesthetic, anticanonical experimentalism of this form. Why attempt to "classicize" by classifying and formalizing a medium that is so young and unpredictable? The photographic essay occupies a strange conceptual space in our understanding of representation, a place where "form" seems both indispensable and disposable. On the one hand, it seems to participate in what Stanley Cavell has described as the tendency of "modernist painting" to "break down the concept

of genre altogether,"[28] as if the medium were not given naturally, but had to be re-invented, re-evaluated in each new instance; this is the tendency I've associated with the mutual "resistance" of photography and writing, the insistence on the distinctive character of each medium, the search for a "purity" of approach that is both aesthetic and ethical. On the other hand, the roots of the photo-essay in documentary journalism, newspapers, magazines, and the whole ensemble of visual-verbal interactions in mass media connect it to popular forms of communication that seem quite antithetical to modernism in their freedom of exchange between image and text and their material ephemerality. Perhaps this is just a way of placing the photographic essay at the crossroads between modernism and postmodernism, understanding it as a form in which the resistance to image-text exchange is (in contrast to painting) most crucial precisely because it has the most to overcome.[29] If this crossroads occupies a real place in our cultural history, it is one we cannot leave unmapped. To take literally the antiformalist rhetoric of the photographic essay would be to empty it of its specific, historical materiality as a representational practice and to neglect those labors of love in which we are enjoined to collaborate.

28. Stanley Cavell, *The World Viewed: Reflections on the Ontology of Film*, enlarged edition (Cambridge, MA: Harvard University Press, 1979), p. 106.

29. I say "in contrast to painting" because the emancipation of painting from language, or at least the rhetoric of emancipation, has dominated the sophisticated understanding of painting for most of this century. For a fuller version of this argument, see chapter 7 above.

IV····Pictures·and·Power

> But it is sensible to begin by asking the beginning questions, why imagine power in the first place, and what is the relationship between one's motive for imagining power and the image one ends up with.
>
> —Edward Said,
> "Foucault and the Imagination of Power"[1]

L et's begin our inquiry into the power of pictures by asking what sort of picture of power we are assuming. I say "picture" instead of "theory" of power, because (following Foucault and others) I don't imagine that we really can theorize power from the outside, and because any effort at theorizing power will necessarily involve some picture of its nature, its effects, its transmission, circulation, and the representative scenes of its exercise (domination and resistance, co-optation and evasive action, violence and suffering).

In a sense, every essay in this book has already been about pictures of power, and the power of pictures. "The Pictorial Turn" attempted to show why contemporary theoretical discourse has found it so difficult, and yet so necessary, to get the question of visual representation under control. "Metapictures" explored the way pictures reflect on themselves, depicting their own powers and their effects on spectators. "Beyond Comparison" introduced a series of redescriptions of the visible and verbal, not merely as instruments of power, but as internally divided force-fields, scenes of struggle indicated by the hybrid term of the "imagetext"—the power of the image understood as the "other"

1. See *Foucault: A Critical Reader,* edited by David Couzens Hoy (New York: Blackwell, 1986), p. 151.

or "slave" to the master's poetic and narrative voice, the power of the image to resist or collaborate with language.

Still, we have not yet attempted to give a picture of power as such, and perhaps no such picture can be given, except in the kind of heterogeneous and dialectical imagetexts we have already seen. Certainly the wrong picture is suggested by models of physical force which hypostatize some homogeneous, subtle fluid called Power and which some people (or systems) simply "have" while others do not.[2] "Power as such," says Foucault, "does not exist" (p. 786). Powerlessness, therefore, is not a mere absence or negation, but a site of action and force in its own right.[3] Foucault suggests as much when he says that one should approach power with the question "how?" rather than "what?" and "give oneself as the object of analysis power relations and not power itself" (p. 788). Power is not something one "has" but a relationship one enjoys or suffers. If we want to understand the power of pictures, we need to look at their internal relations of domination and resistance, as well as their external relations with spectators and with the world.

Foucault offers two basic pictures of power: "that which is

2. I rely here mainly on Foucault's essay, "The Subject and Power," *Critical Inquiry* 8:4 (Summer 1982): 777–95; further page references will be cited in the text. See also David Couzens Hoy, "Power, Repression, Progress: Foucault, Lukes and the Frankfurt School," in *Foucault: A Critical Reader,* pp. 123–47, for a useful account of the intersection between ideological criticism and the Foucauldian critique of power.

3. The unthinkability of absolute powerlessness is, I believe, what lies behind Foucault's statement that "slavery is not a power relationship when man is in chains" (p. 790).

exerted over things" and the ways "certain persons exercise power over others" (p. 786). These contrasting models underlie two of the most durable ways of thinking about the power of pictures, two intertwined traditions I will call "illusionism" and "realism."[4] Illusionism is the capacity of pictures to deceive, delight, astonish, amaze, or otherwise take power over a beholder; in the *trompe-l'œil,* or the special effects of cinema, for instance, the point is to provide a simulation of the presence of objects, spaces, and actions, to trigger a responsive experience in the beholder. Realism, by contrast, is associated with the capacity of pictures to show the truth about things. It doesn't take power over the observer's eye so much as it stands in for it, offering a transparent window onto reality, an embodiment of a socially authorized and credible "eyewitness" perspective. The spectator of the realist representation is not supposed to be under the power of the representation, but to be using representation in order to take power over the world. Seen as a composite imagetext, the realist representation might be understood as a picture accompanied by the tacit legend: "this is the way things are." The legend of illusionism is "this is how things look." Magritte's *Ceci n'est pas une pipe* might be understood as the collision of an illusionist image with a realist text.

4. David Freedberg's *The Power of Images: Studies in the History and Theory of Response* (Chicago: University of Chicago Press, 1989) provides a compendium of "scenes" in which the power of pictures is illustrated. Freedberg considers mainly sexual and religious-magical-superstitious scenes of image-power, declining to engage with political or ideological issues. See p. xxiv: "above all I am conscious of the absence here of an approach to the problem of figurated propaganda and of arousal to political action."

In practice, of course, realism and illusionism are often used interchangeably. Nothing is more common than expressions that praise illusionistic representations for being "realistic" (to call them "illusory" would, in fact, be a sign of incapacity) or expressions that criticize realistic representations as nothing more than plausible illusions, merely an "effect of the real." But even these elisions of realism and illusionism suggest a subtle difference in the terms of praise or dispraise that accompany them and in the metapicture of power relations that underlies them. Illusionism involves power over subjects: it is an action directed at a free subject that has to be addressed, persuaded, entertained, deceived. Realism presents itself as power directed at objects, the kind of power Foucault calls "capacity." It may include representations of subjects, but it addresses them (and its beholders), as it were, "objectively."

An apt illustration of the difference between these two forms of pictorial power is the distinction between spectacle and surveillance.[5] It would make no sense to praise an aerial reconnaissance photograph for its beauty or lifelikeness, and if we commended the "realism" of film simulations of space combat in *Star Wars* we would really be talking about illusionistic spectacle, not about the narrative genre or the documentary status of the film. Taken

5. See Foucault's polemical declaration in *Discipline and Punish*, originally published in French in 1975, translated by Alan Sheridan (New York: Vintage Books, 1979): "Our society is not one of spectacle but of surveillance. . . . We are neither in the amphitheatre nor on the stage but in the Panoptic machine" (p. 217). Foucault's debunking of spectacle strikes me as a moment of narrow-mindedness that has more to do with French intellectual politics than with the real powers of visual culture.

together, spectacle and surveillance epitomize the basic dialectic between illusionism and realism in contemporary visual culture: they might be thought of as the "soft" and "hard" technologies for the formation of subjects in our time, whether we characterize that time as the age of mass culture, triumphant international corporate capitalism, or in familiar rubrics like the postindustrial and the postmodern. Spectacle is the ideological form of pictorial power;[6] surveillance is its bureaucratic, managerial, and disciplinary form.

One way of describing the "pictorial turn" in contemporary visual culture is the convergence of spectacle and surveillance in television news, film, and forms of art that address a public sphere.[7] I'll return to this subject in the final section of this book, but for now my purpose is to focus on theories (that is, pictures) of illusionism and realism. It should be clear that these are not just the names of types of pictures, but types of imagetexts, complex intersections of representation and discourse.[8] The discourse of illusionism seems inevitably to engage the sphere of nature, espe-

6. I am echoing here Guy Debord's classic formulation: "The spectacle is ideology par excellence." See *The Society of the Spectacle* (first published, 1967; Detroit: Black and Red, 1977), par. 215.

7. Jonathan Crary notes the way surveillance and spectacle can "coincide" in *Techniques of the Observer: On Vision and Modernity in the Nineteenth Century* (Cambridge, MA: MIT Press, 1990), p. 18.

8. As heterogeneous imagetexts, there are of course internal power relations between kinds of pictures and the discourses attached to or denied by them. See, for instance, Jean Baudrillard on the way objects in a *trompe-l'œil* "have as it were eliminated the discourse of painting" ("The Trompe-L'œil," in *Calligram: Essays in New Art History from France*, edited by Norman Bryson [New York: Cambridge University Press, 1988]), p. 54.

cially the nature of the spectator understood as a body with sensory, perceptual, and emotional automatisms—"buttons" that may be pushed to activate the individual beholder. Realism, by contrast, aligns itself with the social, the rational, the scientifically skeptical, with the view of an ideal, interchangeable, public spectator understood as normative. The empirical study of illusion tends to engage cognitive science and animal behavior: I illustrate it here in the tradition that links Pliny to Gombrich, more specifically in the practice of "looking at animals looking" in order to get at the nature of the human beholder. The study of realism, on the other hand, intersects with philosophy (where it is also the name of an epistemological tradition) and with aesthetics and the social sciences. I illustrate it here with the attempt of Nelson Goodman to provide a rigorous formal account of realism from the standpoint of a general theory of symbol systems that combines aesthetics with the philosophy of science. Both Goodman and Gombrich cross over these boundaries, of course. Goodman's "irrealism" is densely informed by the assumptions of cognitive science, and Gombrich's characteristic gesture in *Art and Illusion* is to shuttle between realism and illusionism, between pictures understood as mechanisms of power over a real world of objects and as devices to manipulate the senses of beholders. Both theories, I will argue, fail at critical moments, but their failures are all the more interesting for the glimpses they provide of historical turns in the power of pictures.

ILLUSION:
LOOKING AT ANIMALS LOOKING

The following theses are illustrated in this essay:

1. *Illusion is a natural, universal phenomenon, transcending cultural boundaries and historical epochs.*
2. *Illusionism is a specific cultural practice, valued only at certain special historical moments.*
3. *Illusion must be sharply distinguished from illusionism.*
4. *Illusion is to illusionism as*
 forgery is to imitation
 errore *is to* similitude
 delusion is to illusion
 "the real" is to realism
 realism is to surrealism
 ideology is to art
 machine is to (self)conscious being
 animal is to human
5. *Illusionism cannot be sharply distinguished from illusion: surrealism parodies realism; realism mocks the real; forgery is imitation; art is ideology; consciousness is a machine; humans are animals.*
6. *Illusionism is itself an illusion of play, freedom, and mastery of illusion.*
7. *Illusion is possible in all the senses and media. Optical illusion is the fetish of illusion-theory.*
8. *The notion of a theory of illusion is the last illusion of theory.*
9. *Illusion isn't everything; and vice versa.*

Illusion: An Illustration

The problem of aesthetic illusion may be brought into focus by an image that is neither illusory nor aesthetic (figure 69), a joke by cartoonist Roger Bollen that I'm not sure I understand.[1] We are shown

1. The cartoon ran in the *Chicago Tribune,* 17 February 1983.

329

a moment in the conversation of two rather bored looking fishes who are swimming past a highly ornamented lure. " . . . Yep! Funny they don't go for *realism,* though . . . " says the fish on the left. "That wouldn't be *fair!*" replies the fish on the right. The fish on the left is the art critic: he recognizes the lure for what it is, a sculptural representation in a particularly ineffective style (nonrealistic, nonillusionistic). The fish on the right is the moral philosopher. He says that realism wouldn't be "fair," that it would not, I suppose, be "sporting" to make a lure that was too accurate an image of a bait fish.

But what exactly is funny about this scene? Is it just the image of fish as intellectuals? Would it be as funny to reverse the metaphor and depict intellectuals as fish? Or is there something more, something in the content of what they are saying, something which takes the question seriously? Why is it "funny," that is, odd, strange that fishermen "don't go for realism"? What makes this remark truly odd is that, as any fisherman will tell you, they make every effort to go for realism. They don't want to give the fish a sporting chance, a chance to exercise choice, judgment, or intellectual discrimination of the kind we see here. They want the damn fish to bite, and they'll stop at nothing to tempt them—including the fabrication of highly artificial and expensive lures that look more like mobile chandeliers than fish. The baroque creation hanging in front of our two bored fish (who are themselves presented, by the way, with highly unrealistic eyelids) is some fisherman's conception of what he thinks will look realistic to a fish.

Bollen's cartoon is funny, I suspect, because it sends two absolutely contrary messages about visual communication and representational illusion. It says, on the one hand, that realism is universal and natural—that what looks like a fish to human beings will also look that way to fish and that a lure that isn't realistic enough to fool a person will have a tough time fooling a fish. On the other hand, it is saying that realism is absolutely conventional and artificial—that realism is a question of tricks, devices, and other lures and not of any universal standard. What is at issue in realism is how things appear, not how they are. Realism in this view becomes simply one style of representation, functionally related to a goal—in this case, the catching of fish.

Bollen's joke is hard to get, I suspect, because it is on *us* as beholders. It lures us into the trap of a paradox, revealing us to ourselves as caught in contradictory attitudes about images. If we take the "naive realist" view of the image and replace the ornamented lure with a

69. Roger Bollen, *Animal Crackers Cartoon*. Reprinted by permission: Tribune Media Services.

realistic imitation of a bait fish, we are "caught" violating the most ordinary, empirical commonsense lore of fishing—that fish have their own standards of realism, and those standards are not ours. (Try putting a realistic photograph of a worm on a hook and see how many fish bite at it.) If we take the "sophisticated conventionalist" view of the cartoon, we still have to explain why some conventions *work* and others don't. And that question takes us away from our own values and goals, right back into a realm we can only call "nature," a region which seems to impose independent constraints on our conventions.

Looking at Animals Looking

Roger Bollen is not the first to illustrate the paradoxes of pictorial illusionism by portraying animals looking at man-made images. Stories of animals responding to works of art are so widely disseminated that they seem to have a kind of legendary status, occupying a shadowy territory between fact and fiction that is uncannily like the problem of illusion itself. Leonardo da Vinci compiled a number of such stories to support his claim that painting is superior to poetry because it is a "natural" and scientific medium that produces true representa-

tions of the visible world. The proof of painting's "truth" is that it "even deceives animals, for I have seen a picture that deceived a dog because of the likeness to its master . . . likewise I have seen a monkey that did an infinite number of foolish things with another painted monkey."[2] The "truth" in painting is verified by its ability to deceive animals, a power which can also be exercised over human beings. "Men," Leonardo continues, "fall in love with a painting that does not represent any living woman," and they may be "excited to lust and sensuality" by the vivid illusion of lewd scenes. The most potent illusion of all is the ability of images to lure men into idolatry, a power which is unavailable, in Leonardo's view, to textual representation:

> If you, poet, describe the figure of some deities, the writing will not be held in the same veneration as the painted deity, because bows and various prayers will continually be made to the painting. To it will throng many generations from many provinces and from over the eastern seas, and they will demand help from the painting and not from what is written. (I:22)

The paradoxical relation of truth and error in visual images may seem to be unraveled by segregating the separate aspects of the image's activity. The "error," we want to say, is not the painter's, but the beholder's: the dog, not the master, is taken in by the illusion of the master. The monkey may do foolish things with a painted monkey, but it would take a more powerful illusion to make monkeys out of men.

The only problem with this distinction between the human painter's truth and the animal beholder's illusion is that the oppositions it relies on (human/animal; painter/beholder) are quite independent of the distinction between seeing an image truly (that is, "as such") and being "taken in" by an image. Being an artist is no defense against falling for an illusionistic representation, as the Pygmalion myth reminds us. What does seem to be secure, or at least stable, in the relation between pictorial truth and illusion, is its mapping onto a self/other relationship characterized by inequality in power, self-consciousness, or self-control. Leonardo's sequence of examples (dog versus master; monkeys versus men; lustful men versus chaste men) culminates in an implicit social distinction between the cosmopolitan Venetian and his others—the "foreigners" and "provincials" ("from many provinces and from over the eastern seas") who will be taken

2. Leonardo da Vinci, *Treatise on Painting*, translated by A. P. McMahon, 2 vols. (Princeton: Princeton University Press, 1956), I:22.

in by the image and fall into idolatry. The paradoxical weave of truth and illusion is grounded in this structure of alterity: the Self is that which sees, not only the truth *in* an illusion, but that it is to be seen *as* an illusion; the Other is the one *taken in* by the illusion, failing to see it (truly) as an illusion and mistakenly taking it for the reality it (truly) represents.

I hope these examples have convinced you of at least two things: first, that the problem of illusion, aesthetic or otherwise, is not to be settled by a one-sided explanation based on either naturalistic or conventionalist accounts of perception and representation; second, that this problem is deeply interwoven with structures of power and social otherness. The centrality of animals to the examples suggests just how radical this otherness may be, how deeply linked with motives of domination, enslavement, and violence, as indicated by the frequent metaphors of illusionistic "capture" and "taking in." In his classic essay, "Why Look at Animals?" John Berger has argued that the relation of humans and animals is deeply inscribed in the mythical origins of both painting and metaphor: "The first subject matter for painting," he notes, "was animal. Probably the first paint was animal blood. Prior to that, it is not unreasonable to suppose that the first metaphor was animal."[3]

But what is the function of this painting and this metaphor, this doubling of visual and verbal likeness? At a minimum, the dominion of humanity over nature, figured in the animal-versus-human; at a maximum, the dominion of one human over another, expressed by the figure "man-*as*-animal." Animals stand for all forms of social otherness: race, class, and gender are frequently figured in images of subhuman brutishness, bestial appetite, and mechanical servility. Animals have endured, as Berger shows, a history of progressive marginalization which parallels the history of political economy. This reduction of the animal is part of the same process as that by which humans have been reduced to isolated productive and consuming units.

> Indeed . . . an approach to animals often prefigured an approach to man. The mechanical view of the animal's work capacity was later applied to that of workers. F. W. Taylor who developed the "Taylorism" of time-motion studies and "scientific management of industry" proposed that work must be "so stupid" and so phlegmatic that he (the

3. John Berger, *About Looking* (New York: Pantheon Books, 1980), p. 5; further page references will be cited in the text.

worker) "more nearly resembles in his mental make-up the ox than any other type." Nearly all modern techniques of social conditioning were first established with animal experiments. (p. 11)

As figures in scenes of visual exchange, animals have a special, almost magical relation with humanity. Animals can see what we see; they can look us in the eye across a gulf unbridged by language: "a power is ascribed to the animal, comparable with human power, but never coinciding with it. The animal has secrets which, unlike the secrets of caves, mountains, seas, are specifically addressed to man" (p. 3). These secrets become accessible in the moment when the animal is caught in the act of looking at man-made illusions and responding to them as if they were real and natural. This moment provides humanity with a double revelation and reassurance—that human representations are true, accurate, and natural (the animals "agree" and "comprehend" them of their own accord), and that human power over others is secured by mastery of representations (the animals are *forced* to agree, not of their own accord, but automatically).

Most accounts of aesthetic illusion keep these rather atavistic matters at bay by insisting on the radical difference between animal and human responses to images.[4] Even Ernst Gombrich, who uses the conclusions of animal behaviorists extensively in his studies of illusion, always draws up short, denying indignantly that he is "reducing" the problem of illusion to the reaction of a fish snapping at a fly. But there is one writer I know of who is notoriously unembarrassed by the equation of animal and human responses to aesthetic illusion, and that is the Roman historian Pliny, who recorded probably the single most famous anecdote of animals looking at pictures. Parrhasius, a painter in Periclean Athens

> entered into a competition with Zeuxis, who produced a picture of grapes so successfully represented that birds flew up to the stage-buildings; whereupon Parrhasius himself produced such a realistic picture of a curtain that Zeuxis, proud of the verdict of the birds, requested that the curtain should now be drawn and the picture displayed; and when he realized his mistake, with a modesty that did him honor

4. Jacques Lacan's discussion of the mirror-stage, for instance, moves from a description of the behavior of a chimpanzee to that of a human child, but insists on the lack of a symbolic system in the animal. See *The Four Fundamental Concepts of Psychoanalysis,* translated by Alan Sheridan (Hammondsworth, England: Penguin Books, 1979), p. 107.

he yielded up the prize, saying that whereas he had deceived birds Parrhasius had deceived him, an artist.[5]

This scene is often cited as an example of what Norman Bryson calls "the Natural Attitude" toward images, a naive notion of mimesis that Bryson traces from "innocent or Plinian vision" right down to Ernst Gombrich.[6] This naive view of pictorial representation needs to be replaced, in Bryson's view, with a sophisticated, historical account based in semiotic conventionalism ("painting as an art of signs, rather than percepts" [p. xii]) and materialism (painting as a material practice rather than a system of ideal illusions). While I'm basically sympathetic to this agenda, I think it makes a crucial strategic error in bracketing off the tradition which links Pliny to Gombrich as a naive or innocent past to be supplanted by a sophisticated present and in figuring this methodological shift as a move from percepts to signs, idealizations to material practices. I suspect that this shift really isn't possible and that it has mainly a rhetorical function in the arguments of sophisticated commentators. More important, I think the commonplace notion of "Plinian vision" as "innocent" is based on a failure to attend to the nuances of the anecdote of the birds in the context of his *Natural History*.[7]

5. Pliny, *Natural History*, 10 vols., translated by H. Rackham (Cambridge: Harvard University Press, 1952), 9:310–11; [*descendisse hic in certamen cum Zeuxide traditur et, cum ille detulisset uvas pictas tanto successu, ut in scaenam aves advolarent, ipse detulisse linteum pictum ita vertate repraesenta, ut Zeuxis alitum iudicio tumens flagitaret tandem remoto linteo ostendi picturam atque intellecto errore concederet palmam ingenuo pudore, quoniam ipse volucres fefelisset, Parrhasius autem se artificem.*].

6. Norman Bryson, *Vision and Painting: The Logic of the Gaze* (New Haven, CT: Yale University Press, 1983), p. 34; further page references will be cited in the text. Bryson suggests that "the only significant difference between Pliny and Gombrich . . . is that whereas for Pliny the encounter [with visual reality] is continuous, for Gombrich it is intermittent."

7. Indeed, one might say that Pliny's *Natural History* has scarcely been "read" at all, except as a storehouse of anecdotes and bad Latin, or as a "literary monstrosity," in the words of A. Locher. This situation is now beginning to change, at least with regard to the scientific and literary, if not artistic, material in Pliny's text. See Locher's "The Structure of Pliny the Elder's Natural History," in *Science in the Early Roman Empire: Pliny the Elder, His Sources and Influence*, edited by Roger French and Frank Greenaway (Totowa, NJ: Barnes & Noble, 1986), pp. 20–29.

The anecdote is notable for the dignity afforded to those who fall into *errore* (illusion). Unlike Leonardo, for instance, Pliny presents "being taken in" as consistent with a kind of judgment. Zeuxis attributes to the birds a "verdict" (*iudicio*), and when he himself is taken in, he reacts judiciously, accepting defeat gracefully, with a "modesty that did him honor." Although Zeuxis suggests that there is an important difference between deceiving birds and deceiving an artist, there is no radical, incomprehensible gulf between the two deceptions: birds and men participate in the same contest, and the birds deliver a verdict. The difference between animal and human judgment is the difference between the grapes and the curtain: in the one case, the lure is what is depicted, the illusion of grapes presented by the painting; in the other, the lure is precisely what is *not* depicted, what remains invisible in the illusion, forever concealed behind the curtain. Zeuxis does not reach out to feel the curtain, to verify it by touch: he asks for its removal, for the display of the picture beneath. Animals may be taken in by the illusions of humans, but humans are animals capable of taking themselves in. Does this make humans superior or inferior to animals?[8] Zeuxis swells with pride (*tumens*) as he receives the verdict of the birds and yields with a "noble shame" (*concederet . . . ingenuo pudore*) at the discovery of his own error. The relation of artists to animals here is far too complicated to be summarized by the familiar oppositions of "brute" or "mechanical" nature to the self-consciousness of human beings, what Berger calls the "post-Cartesian" view of animals.

The dignity of the birds is consistent with their role as omens and prophetic signs in Roman culture (the word *avis* means "omen" or "portent" as well as "bird"), and Pliny will have them testify to the power of painting several times in his history. The birds not only fly up to Zeuxis' grapes, they try to alight on the roof tiles in Claudius Pulcher's scene-paintings, and they are frightened by the painted serpents of Lepidus. The most impressive display of animal judgment in Pliny is Apelles' triumph as a painter of Alexander the Great's horses. Apelles "had some horses brought and showed them their pictures one by one; and the horses only began to neigh when they saw the horse painted by Apelles" (9:331). This anecdote illustrates, not the

8. Lacan's reading of this fable reinforces the distinction between human and animal, between the *trompe l'œil* and the natural function of the lure. See *The Four Fundamental Concepts of Psychoanalysis*, pp. 111–12, and Mary Ann Doane's excellent discussion in "The Moving Image," *Wide Angle* 7:1 and 2 (1985): 42–57.

deception of horses, but their good judgment, a form of equine connoisseurship responsive to the dignity of the artist's identity as well as his skill. As a member of the Equestrian class, the second rank of Roman aristocracy, Pliny was in a position to understand the dignity of horses, both their own and the kind they confer on men.

I take it as axiomatic that there is no way to disprove these stories: they are presented as fact, but they could very well be folklore. There are animal behaviorists engaged, no doubt, at this very moment in trying to ascertain just what sorts of pictorial illusions will stimulate responses from various kinds of animals, and it wouldn't surprise me to learn that some animals respond to the objects in some pictures as if they were really there. Our only recourse with Pliny is to take the stories as undecidably true and untrue, that is, as rhetorical illusions which, like pictorial ones, inhabit a dialectical realm of illusion*ism*, on the boundary between fact and fiction. Our attention shifts, then, from the question of whether the stories are true, to the question of their function in Pliny's text. Why does he tell these stories? Are they supposed to support a view of the painter's work, as Bryson argues, exclusively oriented toward the "transcendent and immutable given" (p. 5) of nature, a realm that negates "history" (p. 3) and depicts that painter's work as "carried out in a social void" (p. 6)?

I think not. While Pliny suggests that painterly illusion may be *adjudicated* by the natural (in the form of animal testimony), its purpose and history is not determined by nature. Pliny repeatedly emphasizes the social and political function of illusionistic painting, its role in the continuity of the state and the social order. It is easy to forget that Pliny was writing about illusionistic painting as a cultural practice that had fallen into disuse and low esteem in his own time. "Painting," he says, is

> an art that was formerly illustrious, at the time when it was in high demand with kings and nations and when it ennobled others whom it deigned to transmit to posterity. But at the present time it has been entirely ousted by marbles, and indeed finally also by gold. (vol. 9, p. 261)

For Pliny, the chief purpose of illusionistic painting is not the deception of birds or men, but the bequeathing of illustrious "nobility" from one generation to the next through the accurate portrayal of the face:

> The painting of portraits, used to transmit through the ages extremely correct likenesses of persons, has entirely gone out. Bronze shields are

now set up as monuments with a design in silver, with only a faint difference between the figures; heads of statues are exchanged for others, about which before now actually sarcastic epigrams have been current: so universally is a display of material preferred to a recognizable likeness of one's own self. And in the midst of all this people tapestry the walls of their picture-galleries with old pictures, and they prize the likenesses of strangers, while as for themselves they imagine that the honour only consists in the price. . . . Consequently nobody's likeness lives and they leave behind them portraits that represent their money, not themselves. (9:263)

For Pliny, the history of painting is not explained by its relation to the natural, but to the progress of political economy. Illusionism begins at a precise historical moment, at the height of Athenian imperial power. "The first artist to give realistic presentation of objects" is Apollodorus, a contemporary of Pericles. Illusionism declines in Pliny's own lifetime: the emperor Augustus is the last to observe "the dignity of this now expiring art," which has been replaced by what we would now call a fetishism of materials—a new kind of illusionism in which money replaces men. The development of illusionistic painting doesn't simply "reflect" the bygone era of national and imperial greatness; it is the medium or apparatus for reproducing political and social identity in the individual and the collectivity. Pliny continually stresses the public function of art, its role in political propaganda and mass spectacle. "The dictator Caesar . . . gave outstanding public importance to pictures"; Agrippa gives a speech "on the question of making all pictures and statues national property" (p. 279); Hostilius Mancinus wins election to a consulship by "displaying in the forum a picture" of his role in the siege of Carthage (p. 277). The "ungracious Tiberias" and the immoral Nero, by contrast, allow the art to fall into disuse or outright abuse. Nero commissions a portrait of himself on a linen sheet 120 feet high which promptly receives its own natural verdict: it is struck by lightning.

Pliny's sense of the political authority of painting goes well beyond the propagating of noble genealogy or state propaganda. Painting is presented as a restraint and discipline of power as well as an instrument of it, a way of introjecting the master-servant relationship into the sovereign. A painting by Protogenes saves the city of Rhodes from being burned to ground by King Demetrius, and Apelles has "so much power" (p. 325) over Alexander the Great ("who was otherwise of an irascible temper") that he teaches the monarch to "conquer himself" and (in a rather unmagical version of the Pygmalion story)

to give the painter his favorite mistress after she poses as his Aphro-dite. So great is the painter's authority that it can be exercised, finally, without any actual deployment of illusionistic technique. The mere suggestion of the painter's power, as indicated in his characteristic line, mark, or signature, is even more potent than its actual exercise in a finished illusion. The most esteemed painting of Apelles is virtu-ally empty:

> on its vast surface containing nothing else than the almost invisible lines, so that among the outstanding works of many artists it looked like a blank space, and by that very fact attracted attention and was more esteemed than any masterpiece. (9:323)

Given this sort of power over men and monarchs, it is no wonder that it was "forbidden that slaves be instructed" in the art, that it "consistently had the honour of being practised by people of free birth, and later on by persons of station" (9:319).

The relation between master and slave translates into social terms the basic power relations Pliny discovers in the contrast between hu-man and animal responses to painting. Animals are "taken in" by the image, enslaved by it at the same time they are brought closer to humans; they are in a paradoxical state of illusion as *errore* and *iudicio,* a mistake which is simultaneously a true judgment, a slavery which is based in a free, natural judgment. Humans, by contrast, "take in" the image with self-conscious awareness that it is only an image. At rare moments a masterful artist like Parrhasius may "take in" his fellow artist with a *trompe-l'œil;* it is always possible for painting to turn humans into animals, to make them react to an illu-sion like slaves (or animals) to a master. But the proper use of painting among free citizens is as a "liberal science" (*liberalium*), an art of illusion*ism,* not illusion, which frees the beholder's faculties, transmits power to the beholder so that he may "conquer himself," enslave himself. This is what we would call "aesthetic illusion," or (in Murray Krieger's terms) "self-referential illusion."[9]

What tends to be forgotten in accounts of aesthetic illusion that celebrate its freedom and "autonomy" as a cultural practice is the connection between this freedom and social power. "Connection" is too weak a term: the freedom epitomized in the aesthetic illusion is predicated on power over others, just as the truth of the illusion

9. See Murray Krieger, "Literature as Illusion, as Metaphor, as Vision," in *Poetic Presence and Illusion* (Baltimore, MD: Johns Hopkins University Press, 1979), pp. 188–96.

is predicated on its capacity to produce error in others. Illusion and illusionism stand in a dialectical relationship of absolute opposition and mutual mimicry. The opposition of illusionism to illusion is that of human to animal, self-conscious being to machine, master to slave. These relations of power and domination must be continually invoked to reinforce the sense of freedom associated with aesthetic illusion and simultaneously forgotten or repressed so that this freedom can be represented as autonomous, slavery represented as freely chosen. That is why Pliny's stories of the power of illusion are bracketed as "naive" and removed from their context in the history of Greek and Roman politics: they insist on bringing back together what we would like to keep apart—freedom and power, illusionism and illusion, aesthetic "autonomy" and social "discipline." Pliny forces us to read the "natural history" of art, that is, its history as an apparatus of ideology, a history where nature and convention, percept and sign cannot be kept apart.[10]

Our modern Pliny, I want to suggest, is Ernst Gombrich. Gombrich inverts Pliny's priorities: instead of nesting the problem of pictorial illusion inside a densely woven material, social, and cultural history, Gombrich makes the history of pictorial illusion the framework through which all other history may be seen. What the two writers share is the conviction that illusion provides the link between history and nature. Like Pliny, Gombrich has two contradictory accounts of the meaning of pictorial illusion, one based in "nature," cognitive science, and experiments with animals, the other based in a conventionalist rhetoric which treats illusion as a historically specific cultural

10. It is worth noting that Pliny's history not only embeds painting in a social, political history, but in a history of materials and technology as well. At least half of his discussion is devoted to the materials of pigment and painting technology. The history of painting emerges in the midst of a sequence of volumes devoted to the mining of minerals, gems, and rare earths. Alongside Pliny's celebration of painting as the ideological apparatus of Greek and Roman nationalism is a darker story which connects the mining of gold with the degradation of nature and the rise of luxury, a story in which painting figures as simply another wealthy, luxurious object: "We trace out all the fibres of the earth . . . marvelling that occasionally she gapes open or begins to tremble—as if forsooth it were not possible that may be an expression of the indignation of our holy parent! . . . Alas for the prodigality of our inventiveness! In how many ways have we raised the prices of objects! The art of painting has come in addition, and we have made gold and silver dearer by means of engraving! Man has learned to challenge nature in competition!" (9:5).

practice.[11] Unlike Pliny, Gombrich is not explicit about the political and social function of illusionism. In recent writings, however, as Gombrich has reacted more and more strongly against what he sees as the "relativist" and "conventionalist" consensus of contemporary criticism, he has tended to fall back more fully on the one-sided naturalist account and, in the process, to make the ideological implications of his position clearer. In his naturalist guise, Gombrich treats illusionistic images as a special class of representations grounded in biological, wired-in mechanisms of perception that are shared by all cultures and by the higher animals. These images can be more or less sharply distinguished from "conventional" images which approach the condition of language. The two classes of images are exemplified at various times by the difference between Western and Oriental painting, between ancient or primitive and "modern" (that is, from the Renaissance through the nineteenth century) painting, or between photography (the "scientific image") and "hand-made" images like drawings and paintings.

As this list of paired examples suggests (and as Gombrich himself sometimes admits), the nature/convention distinction is a shifting and incoherent one; at best, it serves as a rhetorical trope to mark a distinction of degree between "more" and "less" illusionistic images, with illusionism understood as something like "ease of recognition" of the represented motif. At its "worst," or most insidiously effective level, this trope reinforces a host of ideological oppositions that pit Western-ness, modernity, and scientific truth against the primitive, the non-Western, and the superstitiously archaic. The mastery of "illusion*ism*" in Gombrich's view, is directly proportional to the overcoming of "illusion" in the sense of false belief. Ultimately, this mastery over images is the basis for control over others—the creation of deceptive appearances in the *trompe l'œil,* the perfection of a panopticon

11. See my essay, "Nature and Convention: Gombrich's Illusions," in *Iconology: Image, Text, Ideology* (Chicago: University of Chicago Press, 1986), pp. 75–94. Murray Krieger also discusses the "two Gombrichs," an early "skeptical humanist" who treats pictorial illusion in terms of convention and a later "positive scientist" who privileges natural, biological explanations. See "The Ambiguities of Representation and Illusion: An E. H. Gombrich Retrospective," *Critical Inquiry* 11:2 (December 1984): 181–94. My view is closer to Norman Bryson's thesis of a single Gombrich whose argument "is in open contradiction with itself," (*Vision and Painting,* p. 33) from first to last, but I see Gombrich's deepest loyalties invested in the naturalistic account from the first, and I don't find the contradictions "open," in the sense of being transparent, or easily disentangled.

of surveillance and espionage, the deployment of effective "decoys" and "lures" in advertising, the instantaneous and effortless reproduction of visual reality in the service of voyeuristic gratification (pornography occasionally surfaces as Gombrich's clinching example of the natural image).[12]

What this rather schematic recapitulation cannot capture is the remarkable rhetorical agility which permits Gombrich to carry off this argument, nesting it within other claims and positions that qualify and contradict it in myriad ways. The "shifting" of the nature-convention distinction, for instance, over a whole range of opposed examples (images and texts, photographs and paintings) prevents it from occupying a fixed ground from which it might be dislodged: any example of the "natural image" one finds in Gombrich will, within a few pages, be transformed into a relatively conventional image. Alongside Gombrich's argument for the natural, illusionistic image is an equally powerful and equally compelling argument for the conventionality of all image-making, an argument which stresses the arbitrary making of "schematisms" as a precondition for any "matching" of images against visual appearances, which emphasizes the reliance of pictorial production and consumption on habits and conventions (pictures are made out of other pictures, not out of "reality"), and which appeals to analogies with language to explain the nature of pictures. These, in fact, are the arguments which made Gombrich famous, giving him a claim to be the Saussure of image theory, the creator of a "linguistics of the visual field." To this title we might now add, the Pliny of modern art history, the natural historian of the visual field. If Pliny's is a gloomy Tory history, lamenting the loss of an art that guarantees the continuity of the Roman republic, Gombrich's is a Whig history of scientific, liberal progress, the emancipation of Western civilization from barbarism. That Gombrich's accounts of illusion constantly hearken back to his experiences in World War II as a decoder and interpreter for British Intelligence, using his skills against the Nazi barbarians, is both the clinching rhetorical instance and the historical starting point for his work.

Let me conclude by returning to the theses with which I opened this essay. I cannot expect to have demonstrated any of them in this brief account, but I hope at least to have illustrated their sense.

The first two theses claim that illusion is to illusionism as nature

12. See "Image and Code: Scope and Limits of Conventionalism in Pictorial Representation," in *Image and Code,* edited by Wendy Steiner (Ann Arbor: University of Michigan Press, 1981), pp. 11–42.

is to culture: illusion is something built into the very conditions of sentience and extends from areas of animal behavior such as camouflage and mimicry right into *trompe-l'œil* and ultimately, I want to argue, into the universal structure of ideology or false consciousness. This is illusion as *error*, delusion, or false belief. Illusion*ism*, by contrast, is playing with illusions, the self-conscious exploitation of illusion as a cultural practice for social ends. We have a whole vocabulary of oppositions for keeping illusion and illusionism rigorously distinct from one another; at the same time, we have (as the fourth thesis argues) a whole set of metaphors and practices which tend to collapse them into one another: the phrase "aesthetic illusion" is one such conflation, since (on the logic of strict distinction) the phrase should really be "aesthetic illusion*ism*." The most dramatic form of this collapse is the one which suggests (as per thesis 6) that "illusionism is itself an illusion" in its pretence of freedom without power, its construction of an autonomous realm of play beyond illusion.

The visual fetishism of illusionism is, I hope, clear from the examples of Leonardo, Pliny, and Gombrich. There is nothing in theory to deny that illusion is possible in all the sensory, perceptual, and cognitive modes and that illusionism may be practiced in any medium or system of signs. We have produced, in fact, almost perfect aural illusions in laser disk recordings; phonography is capable of much more perfect simulacra than photography, or even holography. Yet it seems fair to say that aural fetishism is a relatively rare disease, confined to a few audiophiles, while visual fetishism in a culture of television, propaganda, and advertising is endemic, not to say an epidemic in advanced industrial societies.

How can we intervene critically, therapeutically in what is widely perceived as the contemporary epidemic of illusion, the virtual collapse of all distinctions between the aesthetic and the nonaesthetic, the play of what Baudrillard has called "simulacra," which undermine all distinction between illusion and illusionism? Not, my last thesis wants to suggest, by constructing a "theory of illusion" which claims to stand free of the phenomenon it criticizes. The postulation of this sort of theory in experimental psychology is what preserves the delusion that we might finally (as Gombrich puts it) find the "keys to the locks of our senses" by opening up the bodies of animals and probing their perceptual apparatus. (Recent experiments have involved such practices as injecting radioactive and electromagnetic dyes into animal nervous systems to trace the patterns of nerve impulses; "re-wiring" the visual cortex to the ears, and the aural cortex to the eyes of rats; stimulating the brain tissue of chimpanzees to produce hallucina-

tions.) On the side of philosophy and "critical theory," the notion, as Jean-François Lyotard puts it, of a "theoretical-critical *genre* . . . which claims as its object to tell the truth and to dissipate illusions, is a particular case of those genres we usually term literary."[13] Its rhetoric of truth, transparency, and verism is just that, a rhetoric, an art, and not a natural fact guaranteed by its (illusory) self-representation as beyond illusion. The question is whether the understanding of theory as rhetoric, as illusion*ism*, can be taken as an enabling discovery, one which returns us to our positions in the world of illusion, as propagators of ideology who play continually across the boundaries of illusion and illusionism. This is a game for which the rules are now being invented. One rule might be that reality is ruled out: the only weapon against illusion is illusionism. Another might be that we have to learn once more how to look at animals. But perhaps most fundamental would be the rule stated as my final thesis: illusion isn't everything; and vice versa.[14]

13. Jean-Françoise Lyotard, "Theory as Art: A Pragmatic Point of View," in *Image and Code,* edited by Wendy Steiner, p. 71.

14. I would like to thank Bob Kaster, Lauren Berlant, Joel Snyder, and Arnold Davidson for their help with this essay.

REALISM, IRREALISM, AND IDEOLOGY: AFTER NELSON GOODMAN

Then there is the story of the two detectives in the Chicago Police Department. One was a naive realist who believed literally in the copy theory of representation. The other was a sophisticated irrealist who believed in the relativity and arbitrariness of representation. Both detectives, it seems, had to be fired from the force: the realist, because he didn't see any need to arrest a suspect if he already had a mug shot; the irrealist, because once he had a mug shot, he started arresting everyone in sight.

Nelson Goodman's theories of representation have been useful primarily because his relatively neutral or value-free characterizations of symbol types provide a way of measuring the highly charged associations of value in traditional theories. Goodman's distinction between images and texts, for instance, as respectively dense and differentiated systems, offers a clarifying respite from metaphysical distinctions like space and time or nature and convention.[1] The differences between symbolic types become a relative matter, embedded in questions of function, context, and habit, and cease to be a question of essences or absolute categories.

I've always felt, however, that there was a certain price to be paid in the elaboration of what Goodman has called "a neutral comparative study" of artistic media and symbol systems.[2] This essay will try

1. See "Pictures and Paragraphs: Nelson Goodman and the Grammar of Difference," in *Iconology* (Chicago: University of Chicago Press, 1986), pp. 53–74. I am grateful for the advice of Ted Cohen, William Brown, Jay Schleusener, and Joel Snyder on many of the issues in this essay.

2. Nelson Goodman and Catherine Z. Elgin, *Reconceptions in Philosophy & the Other Arts & Sciences* (Indianapolis: Hackett, 1988), p. 31, hereafter

to assess what that price is. I want to ask, first, exactly what is Goodman excluding under the rubric of value? How rigorous are the exclusions, and to what extent are aesthetic, ethical, or political values reintroduced as aspects of an expanded epistemology? How does the neutrality of Goodman's method enable or disable it for inquiries into historical and ideological issues? To what extent do Goodman's self-imposed limits create difficulties, not just in its extension beyond those limits, but in conceptual issues internal to his project?

The main focus for this critique will be Goodman's accounts of realism. My argument will be that realism constitutes an especially vexing problem for Goodman's theory, precisely because it occupies the unstable boundary between what lies inside and outside the scope of that theory. A critique of realism is absolutely fundamental to the internal integrity of Goodman's theory, and yet it seems to resist the kind of systematic account he is able to produce for other problems in symbolism. "Realism, like reality," Goodman concludes, "is multiple and evanescent, and no one account of it will do."[3] The question, then, is whether this negative result "will do" for the problem of realism. My suggestion is that it won't do and that a more satisfactory account of realism requires a breaching of Goodman's self-limitation to a "neutral comparative study" along with a broaching of the issues of value, interest, and power that he attempts to suspend. My conclusion will take something like the form of the following analogy: the issue of realism is to the prospect of a theory of symbols what the problem of ideology is to project of a unified epistemology.

The first question to consider is the scope of Goodman's project, what lies inside and outside the domain of his inquiry. There are three basic subject areas that Goodman routinely excludes from his system:

cited as "R" with page numbers. I have not attempted to distinguish in the following pages between the positions (or words) of Goodman and Elgin in *Reconceptions*. I take their positions to be, in practice, indistinguishable, and I may occasionally have labeled a passage as written by Goodman when in fact the primary responsibility for its composition was Elgin's. For more general remarks on "comparative methods" and interartistic comparison, see chapter three of this volume.

3. Nelson Goodman, "Realism, Relativism, and Reality," *New Literary History* 14 (1982–83): 269–72. The best survey of the varieties of realism is still Roman Jakobson's classic 1921 essay, "On Realism in Art," in *Language in Literature*, edited by Krystyna Pomorska and Stephen Rudy (Cambridge, MA: Harvard University Press, 1987), pp. 19–27. I am grateful to Tracy Fernandez for calling this piece to my attention.

values, knowledge, and history. But these are not, I think, excluded in the same way. Values (aesthetic, ethical) are marginalized or subordinated only as a temporary tactic. Although *Languages of Art* may begin with a disclaimer that it will "touch only incidentally on questions of value and offer no canons of criticism" (p. xi), it concludes with a section on the "question of merit" that offers a canon of criticism: "symbolization . . . is to be judged fundamentally by how well it serves the cognitive purpose" (p. 258).[4] This conclusion suggests that aesthetic value has not been abandoned, just shifted into the domain of epistemology. But this shift can't be properly appreciated without noting a related shift in the notion of epistemology itself. The "cognitive" is moved in Goodman's system from the realm of what he calls "knowing" to "understanding." Goodman sees knowledge (and its related notions of "certainty" and "truth") as supplanted in his system by understanding, "adoption" (of provisional terms and accounts), and "rightness" (R, p. 165). This exclusion is not provisional, but fundamental, absolute, and final. Goodman sees himself as overturning a long and deeply entrenched tradition of epistemological realism that draws strength from various alliances in aesthetics and symbol theory ("copy theories" of representation) and commonsensical notions about the world. Although Goodman occasionally engages in rearguard skirmishes with radical skepticism, solipsism, and limitless relativism, situating himself in a middle territory between absolutism and absolute relativism, his main energy is directed against realist epistemology and its cognates in symbol theory. His theory of symbols, in fact, is simply the first phase in a threefold project which aims to reconstitute, not merely our understanding of symbols, but "the very constitution of what is referred to"—the "world" or "worlds" constructed by symbols and, finally, the "conception of philosophy" itself (R, p. 164).

Goodman's exclusion of history from his philosophy is, I think, comparable to Saussure's exclusion of diachronic considerations of linguistic change from the study of language.[5] Like Saussure, Good-

4. Nelson Goodman, *Languages of Art* (Indianapolis: Hackett Publishing Company, 1976). Further references will be cited in the text as "LA."

5. Perhaps the more apt comparison here would trace Goodman's exclusions to the tradition of systematic pragmatism at Harvard associated with C. S. Peirce and C. I. Lewis. Goodman shares especially Lewis's combination of interests in symbolic logic and epistemology and his professional disdain for popular or "public" philosophy. See Bruce Kuklick, *The Rise of American Philosophy* (New Haven, CT: Yale University Press, 1977), p. 561.

man wants a synchronic, systematic map of the fundamental rules and types that operate in all symbolic behavior, in any language, culture, or moment in history: "I am thus concerned with structures rather than origins . . . My subject is the nature and varieties of reference, regardless of how or when or why or by whom that reference is effected."[6] He is not interested in the process of change and treats it with perfunctory formulas of habituation and novelty: conventions become established for the manipulation of symbols; systems acquire authority through habitual use. But human curiosity and love for novelty prevent any particular symbol system from prevailing forever: "practice palls," and some new system that offers "revelation" takes its place. The important thing is that we can never get beyond some symbol system or other, and they all, without exception, require formalizable "routes of reference" (not to be confused with genetic, historical "roots" of reference): that is, systems of notation, conventions of depiction, alphabets, scripts, characters, and other units of significance.

Goodman does for symbols in general, then, what Saussure did for language: transforms them into the objects of a universal science. His decision to begin *Languages of Art* with the problem of representation and depiction, rather than with language, was in this respect, a wonderfully cagey move to outflank the competing paradigm of semiotics, the other "universal science of signs." By starting with the *picture* as the entry point for this science, Goodman took on precisely the kind of sign which had proved irritatingly anomalous for semiotics. As Jonathan Culler noted some time ago, "study of the way in which a drawing of a horse represents a horse is perhaps more properly the concern of a philosophical theory of representation than of a linguistically based semiology."[7] Goodman notes that the word "lan-

6. Nelson Goodman, "Routes of Reference," in *Of Mind and Other Matters* (Cambridge, MA: Harvard University Press, 1984), p. 55.

7. Jonathan Culler, *Structuralist Poetics: Structuralism, Linguistics, and the Study of Literature* (Ithaca, NY: Cornell University Press, 1975), pp. 16–17. I don't mean to say, incidentally, that semiotics has nothing to say about pictures, or more generally "icons"; in fact, it has a great deal to say. But much of what it says takes its interest precisely from the friction between the properties of iconicity and the paradigms of language. This friction—the feeling, for instance, that icons may lie partly outside the science of semiotics, that they may be "other" to language, linked to instinct, the unconscious, the body, or other pre- or nonlinguistic domains, is precisely what makes semiotics attuned to problems of history and value in pictorial representation in a way that Goodman may not be.

guages" in the title of *Languages of Art* is only a "vernacular" conve-
nience for what should properly be called "symbol systems." The
"vernacular" here is also the prevailing jargon of semiotics, in which
language provides the basic model or at least "relay" for all symbolic
functions.[8] Goodman uses this vernacular to situate his theory in the
proper competitive relation with semiotics (though he never names it)
and then immediately retracts the term to indicate his rather different
starting point.

We may summarize Goodman's three exclusions then as tactical,
absolute, and strategic. Values (at least aesthetic values) are excluded
only temporarily, finally to be relocated in the cognitive; ethical and
political values, one presumes, would also be ultimately relocated in
the cognitive and would grow out of Goodman's picture of human
subjects as freely choosing between visions, versions, and systems.
Knowledge, truth, and certainty, by contrast, must forever be ex-
cluded as absolute error. Realism is wrong and irrealism is right.

History, by contrast, offers another way of being right, but it lies
beyond the scope of Goodman's project. All Goodman offers on this
front is a binary model of structural change: the static maintenance
of the familiar and the disruptive appearance of the novel. This pat-
tern governs Goodman's understanding of the historical position of
his own work, as well as the transformations of symbol systems.
Irrealism is simultaneously disruptive and familiar: "I have repeatedly
had to assail authoritative current doctrine and fond prevailing faith.
Yet I claim no outstanding novelty for my conclusions . . . most of
my arguments and results may well have been anticipated by other
writers" (LA, p. xii). Realism is not just wrong, it is historically obso-
lete, superseded by the rightness of irrealism, which is not just Good-
man's original invention, but the expression of a new consensus:
"Nowadays" the "traditional ideologies and mythologies of the arts
are undergoing deconstruction and disvaluation, making way for a
neutral comparative study" (R, p. 31). Although Goodman is gener-
ally critical of deconstruction, which he sees as an unlimited relativ-
ism, incapable of discerning rightness, he recognizes it as part of the
context which enables his own work.[9] Irrealism overturns "dogma,"

8. See Roland Barthes, *Elements of Semiology,* translated by Annette
Lavers and Colin Smith (1968; rpt., New York: Hill and Wang, 1977),
pp. 10–11.

9. In Goodman's view, the "freedom" associated with deconstruction "is
bought at the price of inconsequence. Whatever may be said counts as a right
interpretation of any work" (R, p. 45). Goodman labels his own position

349

"prevailing faith," "myth," and "ideology," yet it also participates in a new, emergent consensus. It provides, we may say, both a cognitive revelation and a new set of habitual conventions and commonplaces.[10]

It is no criticism of Goodman's work to say that he is more interesting when he is constructing his own positive formalism than when he strays into the territory of history and value. I'm not suggesting that his work is damaged by these exclusions, that he should have paid more attention to these questions. On the contrary, my suggestion is that the less Goodman says about these things, the better. The question is whether he can avoid saying things about them, whether there are forces at work within Goodman's own account of the field of representation that tend to defeat any attempt to construct a "neutral comparative study." Insofar as irrealism "supplants" realism, the answer is clearly no. Like realism, irrealism must overturn superstition and ideology, provide stable cognitive and symbolic categories, and offer revelations of new understanding. Most fundamentally, irrealism, like realism, has to explain everything. The formal theory of symbol systems cannot be bracketed off as a special, limited project, but must take in the totality of cognitive universes. Since Goodman regards the world and cognition as completely mediated by symbol systems, the "languages of art" do not have an ornamental or supplementary relation to epistemology: the new epistemology is constituted by the aesthetic, the semiotic, and the symbolic. "My relativism," he says, "does not stop with representation and vision and realism and resemblance but goes through to reality as well."[11]

Goodman's attack on epistemological realism, then, is inextricably connected with his critique of representational realism, specifically, his well-known assault on resemblance, illusion, and informational accuracy as criteria for aesthetic forms of realism. Since these criteria have been dismissed from the domains of cognition and representation as such, it is not surprising that they would have no place

"constructive relativism" and sees it as a "third view" that supplants both "absolutism" (or realism) and deconstructive "relativism," occupying a synthetic middle position. "Deconstruction" is thus only "a prelude to *reconstruction*" (R, p. 45), a passing phase of radical skepticism.

10. It will not escape the alert reader that irrealism's double face as consensual and innovative is a mirror image of Goodman's own account of realism.

11. Nelson Goodman, "Realism, Relativism, and Reality," *New Literary History* 14 (1982–83): 269; further page references will be cited in the text with the abbreviation "RRR."

in the subdomain of *realistic* representation. Goodman treats realism in *Languages of Art* as a "minor question" (p. 34). It comes up, I suppose, just because realistic representation would seem, to common sense, exactly the place where issues of resemblance, illusion, and information might recur, even if they had been dislodged from a more general account of representation. Representation—standing for, denoting, depicting, even "acting for"—can occur in so many patently nonrealistic ways, that common sense might be able to accept Goodman's antirealist account of it, while holding out a special place for realism as an exceptional kind of representation. This is the possibility Goodman needs to block. Realism may be a "minor question," but it would be a major embarrassment to his whole theory if it were allowed to sustain its own account of itself, as a privileged mode of representation that reaches out to the truth of the world, of nature, or the way we see. The relation between realism and irrealism is one of total war. Goodman can't be content, therefore, to simply dismiss realism; he has to have an account of it as a recognizable, conventional mode of representation within his system that will be more powerful than the account given by the realists themselves.

The account of realism in *Languages of Art* might be called "hyperconventional." Realism "depends upon how stereotyped the mode of representation is, upon how commonplace the labels and their uses have become" (p. 36). It is not absolute, but "relative"

> determined by the system of representation standard for a given culture or person at a given time. Newer or older or alien systems are accounted artificial or unskilled. For a Fifth-Dynasty Egyptian the straightforward way of representing something is not the same as for an eighteenth-century Japanese. (p. 37)

All representations are conventional in the sense that they depend upon symbol systems that might, in principle, be replaced by some other system. It looks as if realism is simply the most conventional convention,[12] the most customary custom. "We usually think of paint-

12. All representation is, of course, "conventional" in Goodman's terms, insofar as it depends on symbolic schemes, systems, and rules for reference that are not "given" by nature, but invented by people. Realism is simply the "familiar," or "standard," or "straightforward," or "traditional" mode of representation. Strictly speaking, then, convention is not a matter of degree. I am lapsing here into the vernacular sense of the conventional as the customary or habitual. Goodman flirts with this same lapse in the footnote to page 37 in *Languages of Art*, when he offers to substitute "conventional" for

ings as literal or realistic if they are in a traditional European style of representation" (LA, p. 37) but, Goodman warns, we need to realize that this judgment is "egocentric" (not to say ethnocentric) and that there are other realisms, based in other styles, visions, and constructions of "the real."

There is, however, one class of exceptions to this account of realism, a class that goes directly against Goodman's notion of "standard" realism. "*Most of the time* . . . the traditional system is taken as standard; and the . . . realistic or naturalistic system is simply the customary one" (LA, p. 38; emphasis added). But sometimes "shifts in standard" occur; a "departure from a traditional system" may introduce a "new degree of realism." In a later expansion of this point, Goodman associates this sort of realism with what he calls "revelation."

> Practice palls; and a new mode of representation may be so fresh and forceful as to achieve what amounts to a revelation. This was true for standard Western perspective when it was invented during the Renaissance, and no less true for modes that broke away from that system, such as the Oriental mode when rediscovered by late nineteenth century French painters. (RRR, p. 169)

I see two problems with this account. The first is that it fails to say anything specific to realism. The criteria for realism—that it be the "standard," "familiar," or "habitual" form of representation—are so capacious that many nonrealistic forms of representation would seem to be included. Rococo and mannerist painting, for instance, both employ stylistic and iconographic features that were "standard" and "familiar" in their time (the term "mannerist," in fact, is usually employed to label representational modes that are *excessively* habitual). But neither style counted as "realistic" in its own time. Goodman's own example of "the straightforward way of representing something" for "a Fifth-Dynasty Egyptian" would seem more apt as a counterexample. Egyptian painting is certainly standardized, but does that make it realistic? Cubism is now a familiar, standard style of Western painting, but no one calls it "realistic." One might as well argue that since allegorical and romantic narrative forms were familiar and standard in the Middle Ages, they were the realism of the day.

"traditional" and then draws back: "but 'conventional' is a dangerously ambiguous term: witness the contrast between 'very conventional' (as 'very ordinary') and 'highly conventional' or 'highly conventionalized' (as 'very artificial')."

Indeed, Goodman's sense of realism is so capacious that it looks as if it could apply to a single individual ("the system of representation standard for . . . a *person*"), a formulation that suggests the possibility of a private realism. Custom and habit and standardization would seem at best to be *necessary* conditions for realism (as for any enduring mode of representation), but not sufficient conditions. To conclude, as Goodman does, that "realism is a matter of habit" is to say nothing special about realism.

The second problem is Goodman's bifurcated account of realism as "most of the time" familiar and traditional, but "sometimes" novel and revelatory. Goodman can have it both ways only by introducing a specification that lies outside his own synchronic formalism, the dimension of time and history. Realism is the familiar at time T_1; it is the unfamiliar at time T_2. These temporal dimensions, moreover, are not simply homogeneous, quantifiable measures of chronology. T_1 is a long time, something like a period, an era, or an epoch. T_2 is a short time, a moment or a critical event in history.[13] As long as Goodman is talking about representation more generally, he doesn't need these mini-narratives. He can be content with a synchronic mapping of the "routes of reference" and ignore the genetic "roots" while mounting a formidable attack on copy theories of representation and their realistic connotations. As long as Goodman is attacking realism he is fine; when he has to provide a positive account of it, however,

13. The obvious (perhaps the *only*) example that fulfills all these conditions is artificial perspective. It begins (or at least represents itself as beginning) in revelation *ex novo* at a specific moment (Alberti's *De Pictura*, 1435) and lives on in routine and continued revelation. It becomes a standard mode of representation not just for artists, but for engineers, scientists, photographers, and surveyors, and it even becomes understood as an equivalent for natural, universal visual experience (an argument made familiar by Gombrich). Its "standardization" is sustained, not just by traditional practices and habits, but by rational measurement and scientific method (in this sense, it might be distinguished from the representational standards of Byzantine painting, which endured with little variation for hundreds of years and certainly made strong claims to be a "revelation" of "the real" in some form, but grounded its claims in religious tradition rather than scientific method). Perspectival realism clinches its hold on "the real" by becoming the key principle in the apparatus of mass, global visual communication (film, photography, and television) in the twentieth century. I owe this point to discussions with Rob Nelson of the Art Department of University of Chicago. See also Martin Jay, "Scopic Regimes of Modernity," in *Vision and Visuality,* edited by Hal Foster (Seattle, WA: Bay Press, 1988), pp. 3–23.

his theory transgresses its own boundaries. Were it not for the intrinsic interest of these vulnerable moments, one would be tempted to say that Goodman would have been better off never to write the section on realism in *Languages of Art* or the essay on "Realism, Relativism, and Reality." Or rather, one could wish for an explanation of why a positive account of realism, one that would explain realism to the realists better than their own account, is rigorously excluded from his system. The short way to do this would have been to consign realism to the dustbin of history. A longer route would have required that Goodman show why realism, as distinct from a general theory of representation, is strictly unformalizable within a synchronic system.

That Goodman, with all his rigor and self-consciousness about limitations, domains, and scope, could not resist the temptation to project his theory beyond its proper domain is perhaps testimony to the insatiability of theorizing as a rhetorical mode. The move from *Languages of Art* to *Ways of Worldmaking* indicates, in the very terms of the titles, something of this totalizing ambition. By the end of Goodman's most recent book, the limited attempt to produce a comparative theory of symbols has become a global project:

> We work *from* a perspective that takes in the arts, the sciences, philosophy, perception, and our everyday worlds, and *toward* better understanding of each through significant comparison with the others. . . . The present *third* phase starts from the realization that the prevailing conception of philosophy is hopelessly deficient when all fields of cognition, symbols of all kinds, and all ways of referring are taken into account. (R, p. 164)

The sound of "all" casts a pall over Goodman's practice, but it does not, I think, vitiate the insights of his theory in a more limited domain. Nothing I have said really contests Goodman's demolition of the copy theory of representation; the negative force of his critique remains as formidable as ever.[14] What we need at this point is a positive account of realism that registers the force of Goodman's critique without extending it beyond its proper domain.

14. In a reply to this essay, Catherine Elgin reads my argument as a claim that "indifference to history vitiates Goodman's aesthetics." My own view is that this indifference to anything but a formal notion of the historical is precisely what gives Goodman's work its distinctive power. See Elgin's "What Goodman Leaves Out," *Journal of Aesthetic Education* 25:1 (Spring 1991): 89–96, and my rejoinder, "Reply to Catherine Elgin," *Journal of Aesthetic Education* 25:4 (Winter 1991): 137–39.

Let us return, first, to Goodman's critique of the copy theory of representation. The key move in this critique is the debunking of resemblance as either a necessary or sufficient condition for representation. Goodman argues that many things resemble each other that don't represent each other, and vice versa: "no degree of resemblance is sufficient to establish . . . reference" by itself. "Nor is resemblance *necessary* for reference" (LA, p. 5). In place of the phenomenon of resemblance, Goodman treats representation as simply a form of denotation, a use of something to stand for something else. "Denotation" is thus the core of representation, a practical activity of using things to refer to other things, and this practice is independent of resemblance. I can use the saltshaker on my table to represent, that is, to denote, a man or a mountain, and this usage is quite independent of any prior condition of resemblance.

But Goodman's exclusion of resemblance from his account of representation, like so many of his exclusions, is not so absolute as it might seem. Resemblance (and the related notion of illusion or "deceptiveness") re-enter the picture once a representational practice has been inaugurated: "Resemblance and deceptiveness, far from being constant and independent sources and criteria of representational practice are to some degree products of it" (LA, p. 39). Although Goodman seems here to be reiterating the exclusion of resemblance, he is actually making a startling concession that is elaborated in the accompanying footnote:

> Neither here nor elsewhere have I argued that there is no constant relation of resemblance; judgments of similarity in selected and familiar respects are, even though rough and fallible, as objective and categorical as any that are made in describing the world. (p. 39)

The only time that resemblance (and perhaps illusion) could fail to be crucial to a representational practice would be prior to its institution. As long as the saltshaker isn't being used to represent anything, its resemblance to any possible referent (except possibly other saltshakers) is invisible and irrelevant. But as soon as we use the saltshaker to represent a man or a mountain, considerations of resemblance begin to surface. We start to think of the top as "like" a head, the sides as resembling a body; or we imagine a tiny climber struggling up the slippery, precipitous slopes. The placement of resemblance as a product rather than a precondition of representation loses much of its radicality when we realize that, even within Goodman's own system, there is no world or worlds of any sort prior to representation. All realities, experiences, cognitions (including the experience of like-

ness) are products of representational practices. Representation and resemblance and illusion are always already with us, late and soon.[15]

That does not mean that realism is always with us. Realism emerges in this modified account as a use of representation by resemblance to say how things are. Realism is thus representation plus a belief system, and the beliefs may refer either to the representational mode or to what it represents. That is why (for the proper belief system) a picture of a unicorn may be realistic and denote something real. For another system (our own) it might simply be a realistic unicorn picture and denote absolutely nothing. The saltshaker may be a long way from realistically representing a man, but that distance cannot be measured by an account of its formal features of referentiality or by an assessment of its familiarity or novelty.[16]

It is tempting to suppose that realism might be located in degrees of resemblance produced by representation. Goodman's notion that representational systems are "dense," "replete," and "continuous," relatively saturated with significant features (in contrast to languages, scripts, and notations), might be thought to offer a continuum between relatively schematic representations (saltshaker as man) and relatively "dense" representations (a photograph of a man which offers infinitely more information about his visual appearance). But realism is not just a formal matter of elaborating further discriminations of resemblance; we can paint eyes on the saltshaker and give it arms and legs without *necessarily* moving toward realism. The move from representation to realism is something like the move from denotation ("this is that") to a certain kind of assertion: the saltshaker has to be used to say "this is how things are" or "this is the way a man really looks." "Representations," as Ian Hacking has argued, "are not in

15. A more formal way to express the irrepressible return of resemblance into Goodman's system is to note that his argument that resemblance is not a "necessary" condition for representation may not be successful. While there are plenty of counterexamples to refute the notion that resemblance is a *sufficient* condition (think of all the things that resemble other things without representing them), it is hard to think of a counterexample for the converse proposition: whenever x represents y, x resembles y. Since Goodman insists that *every* x resembles every y in some respect, this must also be true in the special case of a representational relationship. I owe this point to Ted Cohen.

16. More precisely, an assessment of "familiarity or novelty" would require attention to those "roots of reference" that Goodman has excluded— how or why or when or to whom something is familiar or novel. See p. 348 above, and Goodman's *Of Mind and Other Matters*, p. 55.

general intended to say how it is. They can be portrayals or delights. . . . Pictures are seldom, and statues almost never used to say how things are."[17] Truth, certainty, and knowledge are *structurally connoted* in realistic representation: they constitute the ideology or automatism necessary for it to construct a reality. That is why realism is such an apt vehicle for spreading lies, confusion, and disinformation, for wielding power over mass publics, or for projecting fantasy. The great achievements of modern technologies of representation— propaganda, advertising, surveillance—are scarcely conceivable without modes of realistic representation. Idolatry, in fact, might be regarded as a form of realism *avant le lettre:* the idol is understood as a representation whose likeness guarantees the real presence of the god it represents. When the idolater becomes convinced that the represented god will "have no other gods before it," the special requirements of realism are on the way to being met.

From the standpoint of the philologist, all pre–nineteenth-century forms of realism are *avant le lettre.* As Raymond Williams points out, the term emerges as a label for certain kinds of pictorial and literary representation only in the nineteenth century.[18] But if we relax the philologist's insistence on the literality of realism and attend to the canonical precedents in Western theories of representation, we can go back much further. Western forms of realism have generally grounded their authority in nature and science, not religion. Pliny's account of "verism" in Greek and Roman painting treats it as a technique verified by the responses of animals (the birds flying at Zeuxis' grapes, most famously). But Pliny (as we have seen in the preceding chapter) makes it clear that the purpose of realism is not simply power over nature; verism is a tool of civic and political life, a way of assuring the continuity of the citizen aristocracy by preserving the likenesses of noble individuals and passing them on to succeeding generations.[19] Alberti links realism to perspective by way of the science of optics, but (like Pliny) he regards the truth of visual representation as merely instrumental for a social purpose—the presentation of vivid *historiae,* dramatic scenes of human action. Unlike Pliny, who treats verism as a set of traditional techniques and practices that are in danger of being

17. Ian Hacking, *Representing and Intervening* (Cambridge: Cambridge University Press, 1983), p. 138.

18. Raymond Williams, *Keywords: A Vocabulary of Culture and Society,* rev. ed. (New York: Oxford University Press, 1985), s.v. "Realism."

19. See chapter 10, "Illusion: Looking at Animals Looking."

lost, Alberti regards his realism as a rigorous method based on a scientific theory of vision: "we are not writing a history of painting like Pliny," says Alberti, "but treating of the art in an entirely new way."[20] But Alberti's new science of representation, even in its optical foundations, is a political science as well. The famous "visual pyramid" of light rays that constitutes the visual and perspectival field is an image of the ideal political order, a sovereign "centric ray" surrounded on all sides by its "ministers": "this ray alone is supported in their midst, like a united assembly, by all the others, so that it must rightly be called the leader and prince of rays" (p. 45).

The common thread of realist movements in Western painting might, in fact, be identified as the employment of naturally or scientifically authorized representations for social purposes. Nineteenth-century "social realism" in literature and art is perhaps the most explicit example, as (in a quite different way, and with reference to a different science) is "socialist realism." We now live in a time of hyperrealism, in which the technical mastery of illusion and realism is so complete that it offers itself as an aesthetic object in its own right or puts itself at the service of totalizing fantasies. Irrealist epistemology has made its peace with illusionistic technologies of representation, and the result is exemplified best by the multiple ways of world-making offered to the choice of the consumer in the contemporary theme park. At Disney World, for instance, one can travel inside the human body, through outer space, or survive a North Sea storm while never leaving the air-conditioned comfort of Florida. Disney World's wave pool advertises itself as "better than a day at the beach," and its relentless search for a more perfect reality has recently brought it to the attention of the environmentalists. Disney World has been killing off the native Florida buzzards (among other things) in the expansion of its "wilderness" park.

The new terms of the debate between realism and irrealism are dramatized vividly in *Jurassic Park,* a recent novel (and movie) about a theme park in which real, living dinosaurs have been artificially produced by cloning traces of DNA.[21] At one point in the novel, a debate is staged between the park's geneticist, Dr. Henry Wu, and John Hammond, the entrepreneur who has conceived of the park in

20. Leon Battista Alberti, *On Painting and On Sculpture,* edited and translated by Cecil Grayson (London: Phaidon Press, 1972), p. 63.

21. Michael Crichton, *Jurassic Park* (New York: Ballantine Books, 1990); further page references will be cited in the text.

the first place. Hammond is the showman, the P. T. Barnum of *Jurassic Park;* Wu is the scientist who controls the technology behind the scenes. We would expect Hammond to want dinosaurs that obey the rule of illusion—that is, that conform to what spectators expect, that gratify their prejudices, no matter what dinosaurs were *really* like. We would expect Wu to want realistic dinosaurs, not just convincing illusions; a scientist should want to make dinosaurs that correspond as closely as possible to what they were, what they must have been, given the objective constraints of genetics, environment, etc. And yet the debate is staged precisely to reverse these positions. The scientist wants to perfect the dinosaurs, to make them safe for a modern theme park, to make them slower, more stupid, more tractable, more in keeping with our stereotype of creatures destined for extinction. His reasoning is surely sound. First, he points out that "nobody really knows what" the dinosaurs were "really like" (p. 121). When Hammond objects that docile, domesticated dinosaurs "wouldn't be real," Wu replies: "But they're not real now. . . . That's what I'm trying to tell you. There isn't any reality here" (p. 122). The dinosaurs that have been cloned in Dr. Wu's lab are totally "artificial" creatures already. "The DNA of the dinosaurs was like old photographs that had been retouched, basically the same as the original, but in some places repaired and clarified." The image and reality they present are already a product of manipulation: they are palpable, living beings whose relation to "real" dinosaurs is already within a regime of illusion, so that the only question is what illusion we happen to want to present to ourselves, what image will be both safe and attractive to the consumer. Wu is the irrealist who is content to collapse the distinction between realism and illusionism, who believes that realisms are freely chosen ways of world making, that the world and its representations are made not given.

John Hammond, by contrast, has the eagerness and fatality of the realist. Science has made it possible to clone dinosaurs from traces of ancient DNA. The process has produced some creatures that look right and turn out to act in ways more in keeping with the accounts of contemporary paleontology (they are warm-blooded creatures closer to birds than to reptiles). Besides, Hammond is in a hurry to make his theme park operational. The present crop of dinosaurs is not only realistic enough; it is the reality at hand, and the investors are waiting to see a real profit.

The interesting thing about this debate, aside from the reversal of expected positions, is that it stages the oppositions between irrealism and realism as wholly contained within a framework of consumption

and display. Nowhere in this debate is it possible to ask whether it is a good idea to clone dinosaurs in the first place, much less to present them as commodified images in a theme park. The debate is completely contained within the assumptions of specular (and speculative) capitalism. What we display, what we visually produce and consume, may be debatable from a standpoint like "product safety" (a debate rather like the endless and pointless squabbles about whether television and movie violence "causes" violence in the streets), but the specular economy itself cannot be critiqued. It can only be "regulated" or "de-regulated." The public "debate" about *Jurassic Park* the movie is thus mainly about whether children should be allowed to see it, not what it means that adults have produced a film whose special effects for recreating dinosaurs cost "more money . . . than on funding all scientific research on dinosaurs undertaken to date."[22]

Dr. Wu and John Hammond epitomize what might be thought of as the postmodern re-positioning of the venerable debate between irrealism, constructivism, and relativism, and various forms of representational and epistemological realism. It is as if P. T. Barnum were to debate Charles Darwin with all of their assumptions about reality inverted. Wu is the iconoclastic showman, the master of illusions and realisms: he is happy to smash all superstitious notions of "real" resemblance and necessary correspondence between representations and what they represent. For him, the theme park is an infinitely malleable way of world-making. His position reaches its logical extension in the view of Jurassic Park's systems engineer "that the entire world was increasingly described by the metaphor of the theme park" (p. 138).

In *Languages of Art,* Goodman describes his theory of representation as an "iconoclasm," and we may now be in a position to understand the implications of this label. The "icons" that Goodman wants to smash are, at the most general reach of his system, epistemological and representational realisms. At the more specific and technical level of formalizing the concept of representation, the enemy is *resemblance* or, as the semioticians would say, "iconicity." But Goodman is no more capable of eliminating resemblance from his picture of representation than he is of eliminating realism from his account of cognition. Like realism, resemblance is exiled from the system only to come back

22. Pat Dowell, *In These Times* (28 June 1993), p. 33. It hardly needs to be said that Steven Spielberg's *Jurassic Park* eliminates nearly all traces of political or economic debate and confines the narrative strictly to the service of spectacle and speculation.

as its central problem. As with the perfectly engineered cloning of dinosaurs, "real resemblance" has a way of asserting—and reproducing—itself.[23] Goodman's own formal notion of the pictorial as the "undifferentiated" symbol recalls him, by antithesis, to the shattered icon: "Can it be that—ironically, iconically—a ghost of likeness, as nondifferentiation, sneaks back to haunt our distinction between pictures and predicates" (R, p. 131). Like most iconoclasts, Goodman supposes that his critique will take us into a realm of freedom from superstition, ideology, and atavistic beliefs in "natural" or privileged modes of representation: "Representation is thus disengaged from perverted ideas of it as an idiosyncratic physical process like mirroring, and is recognized as a symbolic relationship that is relative and variable" (LA, p. 43). Recognition of the relativity and variability of symbols will, in Goodman's view, overcome the perverse "mirror stage" of realism and liberate us into a cognitive pluralism where "the choice among systems is free" (LA, p. 40).

In the cognitive politics of irrealism, then, understanding rather than truth is what will make us free. Irrealism is a liberalism, however, whose notion of freedom is still quite ambiguous. Is freedom of choice among systems, symbols, and versions an ideal to be achieved by the irrealist critique? A fact about cognition and representation? Or a pragmatic consensus achieved by contemporary forms of relativism and skepticism? The answers to all these questions, at least as provided by Goodman's writing, is simply "yes." Irrealist freedom plays at least three roles: as critical ideal, it motivates the iconoclastic overturning of traditional idols of realism; as a "fact" about "the mind," it aligns irrealism with the authority of cognitive science; as historical consensus, it continues the long love affair between American philosophy (especially the Harvard tradition that goes back to Peirce and William James) and the liberal individualism of American political ideology—a tradition we might call "transcendental pragmatism."[24]

Irrealism's tripartite self-representation as utopian ideal, scientific fact, and historical consensus suggests that, like most ideologies, it is systematically ambivalent about its own "certainty," while relatively certain about its "rightness." This chameleon status is not a weakness,

23. One of the key elements in Jurassic Park's biotechnology is to maintain control of the dinosaurs by cloning all of them as females, thus preventing uncontrolled reproduction. Naturally, this enforced sterility-by-resemblance is the first thing to break down.

24. The term is Ian Hacking's, applied to Hilary Putnam in *Representing and Intervening*.

however; on the contrary, it is precisely what gives irrealism rhetorical power. Any one of irrealism's self-representations would, taken independently, raise questions. Is it a fact that "the mind" freely chooses how it will characterize everything from sensations to worlds? (R, pp. 5–6). Would an irrealist utopia in which this claim were true be desirable? Is American liberalism really the end of history and ideology and the gateway into a postrealist era of freedom? My own view is that the *only* version of irrealism that makes sense is the utopian, iconoclastic one. This is the authentic critical core of irrealism, its power as a negative critique of realism and as a positive, ahistorical account of representational systems. When irrealism strays beyond these boundaries into pronouncements on history, knowledge, and value, it gains rhetorical power at the expense of internal consistency. It becomes, in short, just another ideology, just another realism. Irrealism has a more important role to play, not as a philosophy that "supplants" realism, but as a therapeutic thorn in its side, a way of keeping realism honest. Realism, for its part, cannot be content to make peace with irrealism. That route offers nothing better than the liberality and "free choice" of consumer fantasies exemplified by the new world order of the theme park. Those are real monsters at the gates of *Jurassic Park*.

V····Pictures·and·the·Public·Sphere

How should we picture the public sphere and the place of visual representation in it? The most comprehensive modern reflection on the public sphere is provided by Jurgen Habermas, who imagines it as a utopian "ideological template" that has survived from Hellenic Greece to the present day.[1] The public sphere is "the sphere of private people come together as a public" (p. 27), "a realm of freedom and permanence" in which public opinion may be formed through the operations of uncoerced reason and free discussion: "only in the light of the public sphere did that which existed become revealed, did everything become visible to all" (p. 4). The specific, concrete model (what Habermas calls the "type of representative publicness") of the public sphere changes, of course, with different social formations. For the Greeks, it was located in the marketplace, the court, or in war or games and was strictly separated from the regime of the *oikos* or private household with its women, children, and slaves; in medieval Germany it was divided between the commons (*publica*) and the feudal court, the sphere of "lordly" authority (*publicus*) (p. 6). While Habermas notes that "sociologically" a public sphere (in the sense of "a separate realm distinguished from the private" [p. 7]) did not exist under feudalism and monarchical absolutism, he notes what might be called

1. Jurgen Habermas, *Structural Transformation of the Public Sphere*, translated by Thomas Burger and Frederick Lawrence (Cambridge, MA: MIT Press, 1989); further page references will be cited in the text.

"hyper-publicity" in the emphasis on the public display of lordly power and the staging of ecclesiastical authority.

Habermas's account of the emergence of the "bourgeois public sphere," the Enlightenment model of a literate, freethinking public, and of its endangerment by the emergence of mass culture, the sphere of "commercial industrial publicity," is too well known to retrace here. All I wish to note at this point are two consistent features in Habermas's "ideological template"—the emphasis on visual representation and uncoerced discussion. The template of the public sphere might be described as a theatrical/architectural imagetext, an openly visible place or stage in which everything may be revealed, everyone may see and be seen, and in which everyone may speak and be heard. The public sphere, in short, is a kind of utopian counterpart to the pictures of power we have just been contemplating. It imagines a place outside the realm of power and special interests, a place of freedom from power. If power is depicted by figures of coercion, domination, and resistance, the public sphere is imagined as a scene of free conversation. Foucault's panopticon of total surveillance is matched by Habermas's forum or civic plaza, with its spectacle of free public access.

The convergence of these two forms of visual culture was imagined with vivid precision in the figure of the telescreen in George Orwell's *1984*. The telescreen is a two-way medium, broadcasting political propaganda (most notably the spectacular images of war "news" to stir up hate against the enemy) while simultaneously serving as an instrument of public surveillance.

Combining the panopticon and the public spectacle, the telescreen effectively eliminates the boundary between the public and private spheres. Forms of resistance to this culture of total publicity are staged as futile efforts to retreat into a nonexistent privacy or into archaic refuges (the proletarian quarter and the countryside). It is not just that Winston Smith's efforts at rebellion against Big Brother are finally defeated. They are ultimately revealed as having been illusory all along. Smith's "resistances"—his retreat to a private corner of his apartment to write in his secret diary, his flight from the city to engage in a sexual rendezvous with Julia— are finally revealed as having been "staged" as a spectacle for Party surveillance.

The telescreen is a figure for the convergence of pictorial power and publicity under a totalitarian police state, a Stalinist dystopia. It leaves open a host of questions about our own situation in the advanced industrial democracies of the late twentieth century after the Cold War. What is the relation between power and publicity in the actual world of triumphant capitalism and international corporate culture? What is the role of art and image-making in a public sphere that is mainly constituted by forms of mass spectacle and the mediatization of experience—the world as theme park? What is the relation between spectacle and surveillance in a "New World Order" of televisual war and public melodrama? What forms of resistance are likely to be efficacious in an era when traditional oppositions (avantgarde versus mass culture, art versus kitsch, private versus public) no longer seem to have cultural or political leverage?

These questions are certainly not original with me. They might be described, in fact, as the canonical questions about visual culture in the postmodern era, the questions that have been central both to Frankfurt School critical theory and to the French critique of the "scopic regime" and the "society of the spectacle."[2] If there is any originality in the answers that emerge in the final two essays of this book, it would not come from any original "methods" that dictate these questions. The concepts of the metapicture and the imagetext, for instance, are simply crystallizations of what has become common sense in postmodern picture theory. What has changed, and what might offer a new, if as yet unsystematized insight, is the specific cultural and historical situation in which all of these essays have been written. I'm thinking here of the momentous historical shift in the late 1980s that has brought the postmodern era to an end and brought the pictorial turn into focus. The children of postmodernism matured in the nuclear, Cold War era; their metapicture of visual media evolved within narratives of paranoia and melodrama. The critical unveiling of "hidden persuaders," subliminal messages, and ideological codes was (and remains) a primary task of critical theory. But what do we make of an era when the persuaders are not hidden, the messages are overt, and ideology is both everywhere and nowhere? What do we say about a televisual spectacle like the video-

2. These two concepts are principally associated with Michel Foucault and Guy Debord respectively. Despite their differences, I associate these two figures with a continuing tradition of resistance to and critique of the visual, in contrast to Jean Baudrillard, whose work seems finally to preempt all dialectical negations of the regime of images.

tape of the Rodney King beating? Most critical commentators on media found themselves responding to this image with a rhetoric of pictorial transparency and realism.[3] All the skills for deciphering the imagetext, the disclosure of hidden strata of visual/verbal "layering," seemed irrelevant in the face of this spectacle. The "textualizing" of this image was, in fact, mainly supplied by the police defense lawyers, who subjected the image-track to frame-by-frame analysis and supplied multiple layers of interpretation, tacit dialogue, and implicit scripting.

The Rodney King videotape is only one example of this kind of breakthrough into transparency in recent media representations. The live images of dead bodies pulled from a bomb shelter in Baghdad "broke through" the screen/spectacle of high-tech, low-resolution images offered by CNN's Gulf War coverage. As in the Rodney King videotape, the main textualizing was provided by government "spin doctors"; the president's press secretary even confessed that it was difficult to counteract an image with words. Indeed, the new "transparency" of the media is not just to be located in these moments of breakthrough, when a large public is convinced that the spectacle it is witnessing is the truth, when illusionism and realism coincide. The television coverage of the Anita Hill/Clarence Thomas hearings collapsed the distinction between news and melodrama, surveillance and spectacle. The

3. The first attempt to prosecute the police officers who beat Rodney King was hampered by its naive trust and reliance on the transparency of the video, its "self-evident" authority. The second prosecution succeeded largely because the prosecutors realized the need to supplement the videotape with King's own testimony.

transparency of Anita Hill's honesty (and Clarence Thomas's mendacity) broke through all the narrative and textual codes that were interposed by the media and Thomas's media "handlers." Although Thomas won the short-term political struggle, the longer-range impact—the effect, for instance, of this spectacle in remobilizing a women's public sphere—may well be more significant.[4]

The new transparency of the image is also visible in the foregrounding of mediation itself. On one side this means that the transparency is an effect produced by a sense of randomness, improvisation, and accident. The Rodney King video betrays all of the signs of the amateur, accidental cameraman, not of professional image-making. On the other side, even the smooth illusionism of professional image/text suturing has become transparent in its way. The coverage of the Persian Gulf War was largely about the coverage itself. Media "personalities" were everywhere, and the institutions of mediation (cameras, control rooms, telestrators, intertitles, framing, scheduling) were placed on display as never before. Tom Engelhardt was right to call it "total television" and to contrast it with the coverage of Vietnam: "Vietnam . . . was not (as is so often said) our first television war, but our last nontelevision one in its inability either to adhere to precise scheduling or achieve closure."[5] The new transparency is a dialectical effect of total television: the effect of the real produced by

4. See the discussion by Patricia Mellencamp in *High Anxiety* (Bloomington: Indiana University Press, 1992), pp. 68–70.

5. *Nation*, 11 May 1992: 613–30.

random, unscripted, unofficial, and unauthorized images (live images of dead bodies) depends on it.

Perhaps we have moved into an era when the point about pictures is not just to interpret them, but to change them. The following pair of essays is an exploration of some contemporary imagetext-events in public art, film, and television that attempt to break through and change the codes of contemporary visual culture. They also, in my view, signal the end of postmodernism, with its corrosive, hermeneutic irony about pictures. The films I discuss (*Do the Right Thing* and *JFK*) are notable, if not for their "transparency," for a certain frankness about their rhetorical address to the spectator, an explicitness about social/political intervention, and (especially in *JFK*) a kind of crudity and naivete in narrative construction. The contexts in which I place them (battles over "public art" in the late eighties; the unveiling of the New World Order of total television and mass destruction in 1991) are meant not just to provide a background for the "reading" of these films but to suggest the changing character of visual culture in the wake of postmodernism, both the threat of a kind of "soft" form of global corporate fascism (the much-heralded victory of capitalism) and the hope for new and critical pictures of the public sphere.

THE VIOLENCE OF PUBLIC ART:
DO THE RIGHT THING

I n May, 1988, I took what may well be the last photograph of the statue of Mao Tse Tung on the campus of Beijing University (figure 70). The thirty-foot monolith was enveloped in a bamboo scaffolding "to keep off the harsh desert winds," my hosts told me with knowing smiles. That night, workers with sledgehammers reduced the statue to a pile of rubble, and rumors spread throughout Beijing that the same thing was happening to Mao statues on university campuses all over China. One year later, most of the world's newspaper readers scanned the photos of Chinese students erecting a thirty-foot styrofoam and plaster "Goddess of Democracy" (figure 71) directly facing the disfigured portrait of Mao in Tiananmen Square despite the warnings from government loudspeakers: "This statue is illegal. It is not approved by the government. Even in the United States statues need permission before they can be put up."[1] A few days later the newspaper accounts told us of army tanks mowing down this statue along with thousands of protesters, reasserting the rule of what was called "law" over a public and its art.

The Beijing Massacre, and the confrontation of images at the central public space in China, is full of instruction for anyone who wants to think about public art and, more generally, of the whole relation of images, violence, and the public sphere.[2] "Even in the United States" political and legal control is exerted, not only over the erection of public statues and monuments, but over the display of a

1. See Uli Schmetzer, *Chicago Tribune*, 1 June 1989, p. 1.

2. For an excellent discussion of the way the events in China in June 1989 became a "spectacle for the West," overdetermined by the presence of a massive publicity apparatus, see Rey Chow, "Violence in the Other Country: Preliminary Remarks on the 'China Crisis,' June 1989," *Radical America* 22 (July–August 1989): 23–32. See also Wu Hung, "Tiananmen Square: A Political History of Monuments," *Representations* 35 (Summer 1991): 84–117.

70. Statue of Mao Tse Tung at Beijing University.

wide range of images, artistic or otherwise, to actual or potential publics. Even in the United States, the "publicness" of public images goes well beyond their specific sites or sponsorship: "publicity" has, in a very real sense, made all art into public art. And even in the United States, art that enters the public sphere is liable to be received as a provocation to or an act of violence.

This juxtaposition of the politics of American public art with the monumental atrocities of Tiananmen Square has struck some readers as deeply inappropriate. Zhang Longxi has argued that it is a "rather casual use of the Chinese example," one that "seems to trivialize the momentum of a great and tragic event" and "verges on endorsing the Chinese government's view" while failing to understand the "true meaning of that phrase"—"even in the United States"—"coming out

372

71. Goddess of Democracy in Tiananmen Square in China. AP/ Wide World Photos.

of government loudspeakers."[3] My aim, of course, is not to endorse the Chinese government's massacre of its people, but to see what might be learned from its manner of legitimating that massacre. The government's verbal pretensions of legality and public civility coupled with the most transparent visual representations of brutal violence effectively dismembered and disarticulated the smooth suturing of the television news imagetext. But the spectacle does more than undermine the phrase, revealing it as a cynical alibi for state repression; it also puts the phrase into a new orbit of global circulation and connects it, albeit anachronistically and a-topically, with other public spectacles of monumental violence and violence against monuments. "Even in the U.S. . . . " comes home to roost, as it were, and the

3. Zhang Longxi, "Western Theory and Chinese Reality," *Critical Inquiry* 19:1 (Autumn 1992): 114.

question is how. This sort of juxtaposition and circulation is what it means to live in a society of spectacle and surveillance, the world of the pictorial turn. Zhang Longxi is right to worry that such specular linkages risk trivializing great and tragic events. But the ability to differentiate and connect the trivial and the tragic, the insignificant and the monumental, is precisely what is at issue in the critique of art, violence, and the public sphere. Above all, the relations of literal and figurative violence, of violence by and against persons, and violence by and against images, can only be measured at the risk of trivializing the monumental and vice versa.

Our own historical moment in the United States has seemed especially rich in examples of public acts and provocations that cross the boundaries between real and symbolic violence, between the monumental and trivial. The erosion of the boundary between public and private spheres in a mediatized, specular society is what makes those border crossings possible, even inevitable. Recent art has carried the scandals previously associated with the cloistered spaces of the art world—the gallery, the museum, and the private collection—into the public sphere. And the public, by virtue of governmental patronage of the arts, has taken an interest in what is done with its money, no matter whether it is spent on traditional public art—in a public place as a public commission—or on a private activity in a private space that just happens to receive some public support or publicity. The controversy over Richard Serra's *Tilted Arc* sculpture in a public plaza in New York City marks one boundary of this phenomenon. Serra's is a traditional work of public art; it provoked another engagement in what Michael North has called the "tiresome battle, repeated in city after city . . . whenever a piece of modern sculpture is installed outdoors."[4] But now the battle has moved indoors, into the spaces of museums and art schools. The privacy of the exhibition site is no longer a protection for art that does symbolic violence to revered public figures like the deceased mayor of Chicago or to public emblems and icons like the American flag or the crucifix.

The erosion of the boundary between public and private art is accompanied by a collapsing of the distinction between symbolic and actual violence, whether the "official" violence of police, juridical, or

4. Michael North, *The Final Sculpture: Public Monuments and Modern Poets* (Ithaca, NY: Cornell University Press, 1985), p. 17. *Tilted Arc* is "traditional" in its legal status as a commission by a public, governmental agency. In other ways (style, form, relation to site, public legibility) it is obviously nontraditional.

legislative power or the "unofficial" violence in the responses of private individuals. Serra's *Tilted Arc* was seen as a violation of public space, was subjected to actual defacement and vandalism by some members of the public, and became the subject of public legal proceedings to determine whether it should be dismantled.[5] The official removal of an art student's caricature of Mayor Washington from the School of the Chicago Art Institute involved, not just the damaging of the offensive picture, but a claim that the picture was itself an "incitement to violence" in black communities. A later installation at the same school asking *What Is the Proper Way to Display the American Flag?* was construed as an invitation to "trample" on the flag. It immediately attracted threats of unofficial violence against the person of the artist and may ultimately serve as the catalyst not simply for legislative action but for a constitutional amendment protecting the flag against all acts of symbolic or real violence. The response to Andres Serrano's *Piss Christ* and the closing of the Mapplethorpe show at the Corcoran Gallery indicate the presence of an American public, or at least of some well-entrenched political interests, that is fed up with tolerating symbolic violence against religious and sexual taboos under the covers of "art," "privacy," and "free speech" and is determined to fight back with the very real power of financial sanctions.[6] The United States is nowhere near to sending tanks to mow down students and their statues, but it has recently endured a period when art and various partial publics (insofar as they are embodied by state power and "public opinion") have seemed on a collision course.

The association of public art with violence is nothing new. The fall of every Chinese dynasty since antiquity has been accompanied by the destruction of its public monuments, and the long history of political and religious strife in the West could almost be rewritten as a history of iconoclasm. The history of communism, from Eisenstein's *October* to CNN's coverage of the collapse of the Soviet Union, has been largely framed by images of the demolition of public monuments. There is also nothing new about the violent opposition of art to its public. Artists have been biting the hands that feed them since antiq-

5. For an excellent account of this whole controversy and the decision to remove *Tilted Arc*, see *Public Art/Public Controversy: The Tilted Arc on Trial*, edited by Sherrill Jordan et al. (New York: American Council for the Arts, 1987).

6. On the neoconservative reactions against controversial forms of state-supported art in the late 1980s, see Paul Mattick, Jr., "Arts and the State," *Nation* 251:10 (1 October 1990): 348–58.

uity,[7] and even the notion of an "avant-garde" capable of scandalizing the bourgeoisie has been dismissed, by a number of critics, to the dustbin of history. The avant-garde, in Thomas Crow's words, now functions "as a kind of research and development arm of the culture industry."[8] Oppositional movements such as surrealism, expressionism, and cubism have been recuperated for entertainment and advertising, and the boldest gestures of High Modernism have become the ornaments of corporate public spaces. If traditional public art identified certain classical styles as appropriate to the embodiment of public images, contemporary public art has turned to the monumental abstraction as its acceptable icon. What Kate Linker calls the "corporate bauble" in the shopping mall or bank plaza need have no iconic or symbolic relation to the public it serves, the space it occupies, or the figures it reveres.[9] It is enough that it serve as an emblem of aesthetic surplus, a token of "art" imported into and adding value to a public space.

The notorious "anti-aesthetic" posture of much postmodern art may be seen, in its flouting of the canons of High Modernism, as the latest edition of the iconoclastic public icon, the image which affronts its own public—in this case, the art world as well as the "general" public. The violence associated with this art is inseparable from its *publicness,* especially its exploitation of and by the apparatuses of publicity, reproduction, and commercial distribution.[10] The scandalousness and obtrusive theatricality of these images holds up a mirror to the nature of the commodified image and the public spectator ad-

7. G. E. Lessing notes that beauty in visual art was not simply an aesthetic preference for the ancients but a matter of juridical control. The Greeks had laws against caricature, and the ugly "dirt painters" were subjected to censorship. See Lessing's *Laocoon: An Essay upon the Limits of Poetry and Painting,* translated by Ellen Frothingham (1766; New York: publisher, 1969), pp. 9–10.

8. Thomas Crow, "Modernism and Mass Culture in the Visual Arts," in *Pollock and After: The Critical Debate,* edited by Francis Frascina (New York: Harper and Row, 1985), p. 257.

9. See Kate Linker's important essay, "Public Sculpture: The Pursuit of the Pleasurable and Profitable Paradise," *ArtForum* 19 (March 1981): 66.

10. Scott Burton summarizes the "new kind of relationship" between art and its audience: "it might be called public art. Not because it is necessarily located in public places but because the content is more than the private history of the maker" (quoted in Henry Sayre, *The Object of Performance* [Chicago: University of Chicago Press, 1989], p. 6).

dressed by advertising, television, movies, and "Art" with a capital A. If all images are for sale, it's hardly surprising that artists would invent public images that are difficult (in any sense) to "buy." Postmodern art tries, among other things, to be difficult to own or collect, and much of it succeeds, existing only as ruined fragments, or photographic "documentation." Much of it also "fails," of course, to be unmarketable and thus "succeeds" quite handsomely as an aesthetic commodity, as Andy Warhol's work demonstrates. The common thread of both the marketable and the unmarketable artwork is the more or less explicit awareness of "marketability" and publicity as unavoidable dimensions of any public sphere that art might address. "Co-optation" and "resistance" are thus the ethical maxims of this public sphere and the aesthetic it generates.

The violence associated with this art may seem, then, to have a peculiarly desperate character and is often directed at the work itself as much as its beholder. Sometimes a self-destructive violence is built into the work, as in Jean Tinguely's self-destroying machine sculpture, *Homage to New York*, or Rudolf Schwarzkogler's amputation of his own penis, both of which now exist only in photographic documentation.[11] More often, the violence suffered by contemporary art seems simultaneously fateful and accidental, a combination of misunderstanding by local or partial publics and a certain fragility or temporariness in the work itself. The early history of Claes Oldenburg's monumental *Lipstick* at Yale University is one of progressive disfigurement and dismantling. Many of the works of Robert Smithson and Robert Morris are destroyed, existing now only in documents and photographs. The openness of contemporary art to publicity and public destruction has been interpreted by some commentators as a kind of artistic aggression and scandal-mongering. A more accurate reading would recognize it as a deliberate vulnerability to violence, a strategy for dramatizing new relations between the traditionally "timeless" work of art and the transient generations, the "publics," that are addressed by it.[12] The defaced and graffiti-laden walls that Jonathan

11. See Sayre, *The Object of Performance*, pp. 2–3.

12. For a shocking example of an artist's misrepresentation of these issues, see Frederick E. Hart, "The Shocking Truth about Contemporary Art," *The Washington Post*, 28 August–3 September 1989, national weekly edition, op-ed. section. It hardly comes as a surprise that Hart is the sculptor responsible for the figural "supplement" to the Vietnam Veterans' Memorial, the traditional monumental figures of three soldiers erected in the area facing the Memorial.

Borofsky installs in museum spaces are a strategy for reconfiguring the whole relation of private and public, legitimate and "transgressive" exhibition spaces. Morris's 1981 proposal to install the casings of nuclear bombs as monumental sculpture at a Florida VA hospital was both a logical extension of a public sculpture tradition (the public display of obsolete weapons) and a deadpan mimicry of the claim that these weapons "saved American lives" in World War II.[13]

The question naturally arises: Is public art inherently violent, or a provocation to violence? Is violence built into the monument in its very conception? Or is violence simply an accident that befalls some monuments, a matter of the fortunes of history? The historical record suggests that if violence is simply an accident that happens to public art, it is one that is always waiting to happen. The principal media and materials of public art are stone and metal sculpture not so much by choice as by necessity. "A public sculpture," says Lawrence Alloway, "should be invulnerable or inaccessible. It should have the material strength to resist attack or be easily cleanable, but it also needs a formal structure that is not wrecked by alterations."[14] The violence that surrounds public art is more, however, than simply the ever-present possibility of accident—the natural disaster or random act of vandalism. Much of the world's public art—memorials, monuments, triumphal arches, obelisks, columns, and statues—has a rather direct reference to violence in the form of war or conquest. From Ozymandias to Caesar to Napoleon to Hitler, public art has served as a kind of monumentalizing of violence and never more powerfully than when it presents the conqueror as a man of peace imposing a Napoleonic code or a *pax Romana* on the world. Public sculpture that is too frank or explicit about this monumentalizing of violence, whether the Assyrian palace reliefs of the 9th century B.C., or Morris's bomb sculpture proposal of 1981, is likely to offend the sensibilities of a public committed to the repression of its own complicity in violence.[15] The very notion of public art as we receive it is inseparable from what Jurgen Habermas has called "the liberal model of the

13. See Robert Morris, "Fissures," unpublished manuscript, Guggenheim Museum Archives; also see chapter 8.

14. Lawrence Alloway, "The Public Sculpture Problem," *Studio International* 184:948 (October 1972): 124.

15. See Leo Bersani and Ulysse Dutoit, "The Forms of Violence," *October* 8 (Spring 1979): 17–29, for an important critique of the "narrativization" of violence in Western art and an examination of the alternative suggested by the Assyrian palace reliefs.

public sphere," a pacified space distinct from economic, private, and political dimensions. In this ideal realm disinterested citizens may contemplate a transparent emblem of their own inclusiveness and solidarity and deliberate on the general good, free of coercion, violence, or private interests.[16]

The fictional ideal of the classic public sphere is that it includes everyone; the fact is that it can only be constituted by the rigorous exclusion of certain groups—slaves, children, foreigners, those without property, and (most conspicuously) women.[17] The very notion of the "public," it seems, grows out of a conflation of two very different words, *populo* (the people) and *pubes* (adult men). The word *public* might more properly be written with the "l" in parentheses to remind us that, for much of human history political and social authority has derived from a "pubic" sphere, not a public one. This seems to be the case even when the public sphere is personified as a female figure. The famous examples of female monuments to the all-inclusive principle of public civility and rule of law—Athena to represent impartial Athenian justice, the Goddess of Reason epitomizing the rationalization of the public sphere in revolutionary France, the Statue of Liberty welcoming the huddled masses from every shore—all presided over political systems that rigorously excluded women from any public role.[18]

Perhaps some of the power associated with the Vietnam Veterans' Memorial in Washington, D.C., comes from its cunning violation and inversion of monumental conventions for expressing and repressing

16. Habermas first introduced this concept in *Structural Transformation of the Public Sphere*, translated by Thomas Burger and Frederick Lawrence (Cambridge, MA: MIT Press, 1989). First published in German in 1962, it has since become the focus of an extensive literature. See also Habermas's short encyclopedia article, "The Public Sphere," translated by Sara Lennox and Frank Lennox, *New German Critique* 1, no. 3 (Fall 1974): 49–55, and the introduction to it by Peter Hohendahl in the same issue, pp. 44–48. I owe much to the guidance of Miriam Hansen and Lauren Berlant on this complex and crucial topic.

17. See Joan Landes, *Women and the Public Sphere in the Age of the French Revolution* (Ithaca, NY: Cornell University Press, 1988), p. 3.

18. Rey Chow notes the way the "Goddess of Democracy" in Tiananmen Square replicates the *"King Kong* syndrome," in which the body of the white woman sutures the gap between "enlightened instrumental reason and barbarism-lurking-behind-the Wall," the "white man's production and the monster's destruction" (Chow, "Violence in the Other Country," p. 26).

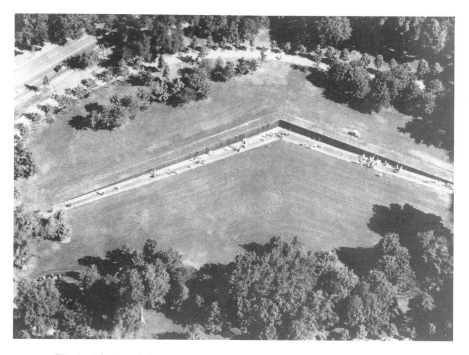

72. Aerial view of the Vietnam Veterans' Memorial. Photo by Richard Hofmeister, Smithsonian Institution's Office of Printing and Photographic Services. From *Reflections on the Wall: The Vietnam Veterans Memorial* (Harrisburg, PA: Stackpole Books, 1987).

the violence of the pub(l)ic sphere (figure 72). The VVM is anti-heroic, anti-monumental, a V-shaped gash or scar, a trace of violence suffered, not (as in the conventional war memorial) of violence wielded in the service of a glorious cause.[19] It achieves the universality of the public monument, not by rising above its surroundings to transcend the political, but by going beneath the political to the shared sense of a wound that will never heal, or (more optimistically) a scar that will never fade. Its legibility is not that of narrative: no heroic episode such as the planting of the American flag on Iwo Jima is memorialized, only the mind-numbing and undifferentiated chronology of violence

19. See Charles Griswold, "The Vietnam Veterans' Memorial and the Washington Mall: Philosophical Thoughts on Political Iconography," *Critical Inquiry* 12, no. 4 (Summer 1986): 709. Griswold reads the VVM as a symbol of "honor without glory."

and death catalogued by the 57,000 names inscribed on the black marble walls. The only other legibility is that of the giant flat "V" carved in the earth itself, a multivalent monogram or initial that seems uncannily overdetermined. Does the "V" stand for Vietnam? For a pyrrhic "Victory"? For the Veterans themselves? For the Violence they suffered? Is it possible, finally, to avoid seeing it as a quite literal anti-type to the "pubic sphere" signified in the traditional phallic monument, the Vagina of Mother Earth opened to receive her sons, as if the American soil were opening its legs to show the scars inscribed on her private parts?

Even as this monument seems to invert the symbolic valences of the traditional war memorial, however, it reinscribes them at a more subtle level. The privates of Mother Earth are all men (Frederick Hart's "supplement" to the VVM, a traditional sculptural group of three male GIs, makes this exclusion of women visible). And although the authorship of the VVM design by a Chinese-American woman is sometimes adduced to explain its pacifist form, the ethnicity of Maya Lin seems mainly an ironic footnote to a memorial that (unsurprisingly) has no place for the suffering of the Vietnamese. If the VVM is a successful work of public art, it is not because it manages to "heal" the wounds of the past or to re-open them with forms of critical violence: it succeeds only in keeping the space between these possibilities open, in the way an indelible scar provokes an indefinite series of narratives and counternarratives.[20]

It should be clear that the violence associated with public art is not simply an undifferentiated abstraction, any more than is the public sphere it addresses. Violence may be in some sense "encoded" in the concept and practice of public art, but the specific role it plays, its political or ethical status, the form in which it is manifested, the identities of those who wield and suffer it, is always nested in particular circumstances. We may distinguish three basic forms of violence in the images of public art, each of which may, in various ways, interact with the other: (1) the image as an *act* or *object* of violence, itself doing violence to beholders, or "suffering" violence as the target of vandalism, disfigurement, or demolition; (2) the image as a *weapon*

20. These issues, and a suggestion that the "healing" provided by the VVM may have as much to do with nationalist amnesia and historical revisionism as with critical commemoration, are discussed by Marita Sturken in "The Wall, the Screen, and the Image: The Vietnam Veterans' Memorial," *Representations* 35 (Summer 1991): 118–42. See also chapter 8 above for Robert Morris's remarks on the VVM.

of violence, a device for attack, coercion, incitement, or more subtle "dislocations" of public spaces; (3) the image as a *representation* of violence, whether a realistic imitation of a violent act, or a monument, trophy, memorial, or other trace of past violence. All three forms are, in principle, independent of one another: an image can be a weapon of violence without representing it; it may become the object of violence without ever being used as a weapon; it may represent violence without ever exerting or suffering it. In fact, however, these three forms of violence are often linked together. Pornography is said to be a representation of and a weapon of violence against women which should be destroyed or at least banned from public distribution.[21] The propaganda image is a weapon of war which obviously engages with all three forms of violence in various ways, depending on the circumstances. The relation of pornography to propaganda is a kind of displaced version of the relation of "private" to "public" art: the former projects fetishistic images confined, in theory, to the "private sphere" of sexuality; the latter projects totemistic or idolatrous images directed, in theory, at a specific public sphere.[22] In practice, however, private "arousal" and public "mobilization" cannot be confined to their proper spheres: rape and riot are the "surplus" of the economy of violence encoded in public and private images.

These elisions of the boundary between public and private images are what make it possible, perhaps even necessary, to connect the sphere of public art in its "proper" or traditional sense (works of art installed in public places by public agencies at public expense) to film, a medium of public art in an extended or "improper" sense.[23] Although film is sometimes called the central public art of the twentieth century, we should be clear about the adjustments in both key terms—"public" and "art"—required to make this turn. Film is not a "public art" in the classic sense stipulated by Habermas; it is deeply entangled with the marketplace and the sphere of commercial-industrial public-

21. See Catharine Mackinnon, *Feminism Unmodified* (Cambridge, MA: Harvard University Press, 1987), especially pp. 172–73 and 192–93.

22. For more on the distinction between totemism and fetishism, see my "Tableau and Taboo: The Resistance to Vision in Literary Discourse," *CEA Critic* 51 (Fall 1988): 4–10, and the discussion in chapter 8, pp. 260, 266, 269–70, 278.

23. See Miriam Hansen, *Babel and Babylon: Spectatorship in American Silent Film* (Cambridge, MA: Harvard University Press, 1991), p. 7: "On one level, cinema constitutes a public sphere of its own. . . . At the same time cinema intersects and interacts with other formations of public life. . . . "

ity that replaces what Habermas calls the "culture-debating" public with a "culture-consuming" public.[24] We need not accept Habermas's historical claim that the classic public sphere (based in the "world of letters") was "replaced by the pseudo-public or sham-private world of culture consumption" to see that its basic distinction between an ideal, utopian public sphere and the real world of commerce and publicity is what underwrites the distinction between public art "proper" and the "improper" turn to film, a medium that is neither "public" nor "art" in this proper (utopian) sense.

This juxtaposition of public art and commercial film illuminates a number of contrasting features whose distinctiveness is under considerable pressure, both in contemporary art and recent film practice. An obvious difference between public art and the movies is the contrast in mobility. Of all forms of art, public art is the most static, stable, and fixed in space: the monument is a fixed, generally rigid object, designed to remain on its site for all time.[25] The movies, by contrast, "move" in every possible way—in their presentation, their circulation and distribution, and in their responsiveness to the fluctuations of contemporary taste. Public art is supposed to occupy a pacified, utopian space, a site held in common by free and equal citizens whose debates, freed of commercial motives, private interest, or violent coercion, will form "public opinion." Movies are beheld in private, commercial theaters that further privatize spectators by isolating and immobilizing them in darkness. Public art stands still and silent while its beholders move in the reciprocal social relations of festivals, mass meetings, parades, and rendezvous. Movies appropriate all motion and sound to themselves, allowing only the furtive, private rendezvous of lovers or of auto-eroticism.

The most dramatic contrast between film and public art emerges in the characteristic tendencies of each medium with respect to the representation of sex and violence. Public art tends to repress violence, veiling it with the stasis of monumentalized and pacified spaces, just as it veils gender inequality by representing the masculine public sphere with the monumentalized bodies of women. Film tends to express violence, staging it as a climactic spectacle, just as it foregrounds gender inequality by fetishizing rather than monumentalizing the female body. Sex and violence are strictly forbidden in the public site,

24. Habermas, *The Structural Transformation of the Public Sphere*, pp. 159–60.

25. The removal of *Tilted Arc* is all the more remarkable (and ominous) in view of this strong presumption in favor of permanence.

and thus the plaza, common, or city square is the favored site for insurrection and symbolic transgression, with disfiguration of the monument a familiar, almost ritual occurrence.[26] The representation of sex and violence is licensed in the cinema and it is generally presumed (even by the censors) that it is re-enacted elsewhere—in streets, alleys, and private places.

I have rehearsed these traditional distinctions between film and public art not to claim their irresistible truth but to sketch the conventional background against which the relations of certain contemporary practices in film and public art may be understood—their common horizon of resistance, as it were. Much recent public art obviously resists and criticizes its own site, and the fixed, monumental status conventionally required of it; much of it aspires, quite literally, to the condition of film in the form of photographic or cinematic documentation. I turn now to a film that aspires to the condition of public art, attempting a similar form of resistance within its own medium and holding up a mirror to the economy of violence encoded in public images.[27]

········

In May of 1989 I tried unsuccessfully to attend an advance screening of Spike Lee's Do the Right Thing at the University of Chicago. Students from the university and the neighborhood had lined up for six

26. The fate of the Berlin Wall is a perfect illustration of this process of disfiguration as a transformation of a public monument into a host of private fetishes. While the Wall stood it served as a work of public art, both in its official status and its unofficial function as a blank slate for the expression of public resistance. As it is torn to pieces, its fragments are carried away to serve as trophies in private collections. As German reunification proceeds, these fragments may come to signify a nostalgia for the monument that expressed and enforced its division.

27. By the phrase "economy of violence," I mean, quite strictly, a social structure in which violence circulates and is exchanged as a currency of social interaction. The "trading" of insults might be called the barter or "in-kind" exchange; body parts (eyes, teeth notably) can also be exchanged, along with blows, glares, hard looks, threats, and first strikes. This economy lends itself to rapid, runaway inflation, so that (under the right circumstances) an injury that would have been trivial (stepping on someone's sneakers, smashing a radio) is drastically overestimated in importance. As a currency, violence is notoriously and appropriately unstable.

hours to get the free tickets, and none of them seemed interested in scalping them at any price. Spike Lee made an appearance at the film's conclusion and stayed until well after midnight answering the questions of the overflow crowd. This event turned out to be a preview not simply of the film, but of the film's subsequent reception. Lee spent much of the summer answering questions about the film in television and newspaper interviews; the *New York Times* staged an instant symposium of experts on ethnicity and urban violence; and screenings of the film (especially in urban theaters) took on the character of festivals, with audiences in New York, London, Chicago, and Los Angeles shouting out their approval to the screen and to each other.

The film elicited disapproval from critics and viewers as well. It was denounced as an incitement to violence and even as an *act* of violence by viewers who regarded its representations of ghetto characters as demeaning.[28] The film moved from the familiar commercial public sphere of "culture consumption" into the sphere of public art, the arena of the "culture-debating" public, a shift signaled most dramatically by its exclusion from the "Best Picture" category of the Academy Awards. As the film's early reception subsides into the cultural history of the late eighties in the United States, we may now be in a position to assess its significance as something more than a "public sensation" or "popular phenomenon." *Do the Right Thing* is rapidly establishing itself not only as a work of public art (a "monumental achievement" in the trade lingo), but as a film *about* public art.[29] The film tells a story of multiple ethnic public spheres, the violence that circulates among and within these partial publics, and the tendency of this violence to fixate itself on specific images—symbolic objects, fetishes, and public icons or idols.

28. Murray Kempton's review (*New York Review of Books*, 28 September 1989), pp. 37–38, is perhaps the most hysterically abusive of the hostile reviews. Kempton condemns Spike Lee as a "hack" who is ignorant of African-American history and guilty of "a low opinion of his own people" (p. 37). His judgment of Mookie, the character played by Spike Lee in the film, is even more vitriolic: Mookie "is not just an inferior specimen of a great race but beneath the decent minimum for humankind itself" (p. 37).

29. One of the interesting developments in the later reception of *Do the Right Thing* has been its rapid canonization as Spike Lee's "masterpiece." Critics who trashed the film in 1989 now use it as an example of his best, most authentic work in order to trash his later films (most notably *Malcolm X*) by contrast.

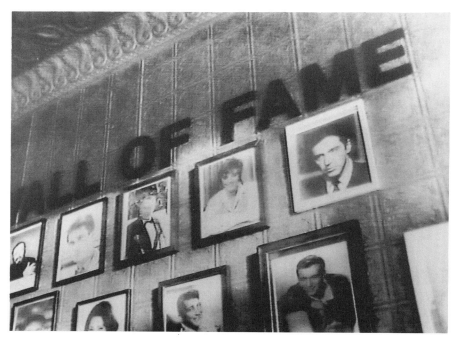

73. Sal's "Wall of Fame" in Spike Lee's *Do the Right Thing.*

The specific public image at the center of the violence in *Do the Right Thing* is a collection of photographs, an array of signed publicity photos of Italian-American stars in sports, movies, and popular music framed and hung up on the "Wall of Fame" in Sal's Famous Pizzeria at the corner of Stuyvesant and Lexington Avenues in Brooklyn (figure 73). A young bespectacled man named "Buggin' Out" (who is the closest thing to a "political activist" to be found in this film) challenges this arrangement, asking Sal why no pictures of black Americans are on the wall (figure 74). Sal's response is an appeal to the rights of private property: "You want brothers up on the Wall of Fame, you open up your own business, then you can do what you wanna do. My pizzeria. American-Italians only up on the wall." When Buggin' Out persists, arguing that blacks should have some say about the Wall since their money keeps the pizzeria in business, Sal reaches for a baseball bat, a publicly recognizable emblem of both the American way of life and of recent white-on-black violence. Mookie, Sal's black delivery boy (played by Spike Lee) defuses the situation by hus-

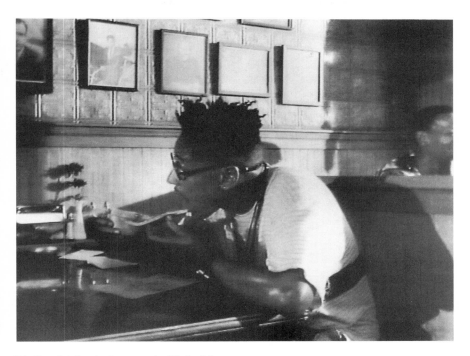

74. Buggin' Out looks up at the Wall of Fame.

tling Buggin' Out out of the pizzeria. In retaliation, Buggin' Out tries, quite unsuccessfully, to organize a neighborhood boycott and the conflict between the black public and the private white-owned business simmers on the back burner throughout the hot summer day. Smiley, a stammering, semi-articulate black man who sells copies of a unique photograph showing Martin Luther King and Malcolm X together, tries to sell his photos to Sal (who seems ready to be accommodating) but is driven off by Sal's son Pino. Sal is assaulted by another form of "public art" when Radio Raheem enters the pizzeria with his boom box blasting out Public Enemy's rap song, "Fight the Power." Finally, at closing time, Radio Raheem and Buggin' Out re-enter Sal's, radio blasting, to demand once again that some black people go up on the Wall of Fame. Sal smashes the radio with his baseball bat, Raheem pulls Sal over the counter and begins to choke him. In the riot that follows, the police kill Radio Raheem and depart with his body, leaving Sal and his sons to face a neighborhood uprising. Mookie throws a garbage can through the window of the pizzeria, and the mob loots

and burns it. Later, when the fire is burning down, Smiley enters the ruins and pins his photograph of King and Malcolm (figure 75) to the smoldering Wall of Fame.

Sal's Wall of Fame exemplifies the central contradictions of public art. It is located in a place that may be described, with equal force, as a public accommodation and a private business. Like the classic liberal public sphere, it rests on a foundation of private property which comes into the open when its public inclusiveness is challenged. Sal's repeated refrain throughout the film to express both his openness and hospitality to the public and his "right" to reign as a despot in his "own place" is a simple definition of what his "place" is: "This is America." As "art," Sal's wall stands on the threshold between the aesthetic and the rhetorical, functioning simultaneously as ornament and as propaganda, both a private collection and a public statement. The content of the statement occupies a similar threshold, the hyphenated space designated by "Italian-American," a hybrid of particular ethnic identification and general public identity. The Wall is important to Sal not just because it displays famous Italians but because they are famous *Americans* (Sinatra, DiMaggio, Liza Minelli, Mario Cuomo) who have made it possible for Italians to think of themselves as Americans, full-fledged members of the general public sphere. The Wall is important to Buggin' Out because it signifies exclusion from the public sphere. This may seem odd, since the neighborhood is filled with public representations of African American heroes on every side: a huge billboard of Mike Tyson looms over Sal's pizzeria; children's art ornaments the sidewalks and graffiti streaks subversive messages like "Tawana told the truth" on the walls; Magic Johnson T-shirts, Air Jordan sneakers, and a variety of jewelry and exotic hairdos make the characters like walking billboards for "Black pride"; and the sound-world of the film is suffused with a musical "Wall of Fame," a veritable anthology of great jazz, blues, and popular music emanating from Mister Señor Love Daddy's storefront radio station, just two doors away from Sal's.

Why aren't these tokens of black self-respect enough for Buggin' Out? The answer, I think, is that they are only tokens of self-respect, of black pride, and what Buggin' Out wants is the respect of whites, the acknowledgment that African-Americans are hyphenated Americans too, just like Italians.[30] The public spaces accessible to blacks in the film are *only* public and that only in the special way that the

30. I am indebted to Joel Snyder for suggesting this distinction between self-respect and acknowledgment.

sphere of commercial-industrial publicity (a sphere which includes, of course, movies themselves) is available to blacks. They are, like the public spaces in which black athletes and entertainers appear, rarely owned by blacks themselves; they are reminders that black public figures are by and large the "property" of a white-owned corporation—whether a professional sports franchise, a recording company, or a film distributor. The public spaces in which blacks achieve prominence are thus only sites of publicity or of marginalized arts of resistance, the disfiguring of public spaces epitomized by graffiti, not of a genuine public sphere they may enter as equal citizens. The spaces of publicity, despite their glamour and magnitude, are not as important as the humble little piece of "real America" that is Sal's Pizzeria, the semiprivate, semipublic white-owned space, the threshold space that supports genuine membership in the American public sphere. The one piece of public art "proper" that appears in the film is an allegorical mural across the street from Sal's, and it is conspicuously marginalized; the camera never lingers on it long enough to allow decipherment of its complex images. The mural is a kind of archaic residue of a past moment in the black struggle for equality, when "Black Pride" was enough. In *Do the Right Thing* the blacks have plenty of pride; what they want, and cannot get, is the acknowledgment and respect of whites.

The film is not suggesting, however, that integrating the Wall of Fame would solve the problem of racism, or allow African Americans to enter the public sphere as full-fledged Americans. Probably the most fundamental contradiction the film suggests about the whole issue of public art is its simultaneous triviality and monumentality. The Wall of Fame is, in a precise sense, the "cause" of the major violence in the narrative, and yet it is also merely a token or symptom. Buggin' Out's boycott fails to draw any support from the neighborhood, which generally regards his plan as a meaningless gesture. The racial integration of the public symbol, as of the public accommodation, is merely a token of public acceptance. Real participation in the public sphere involves more than tokenism: it involves full economic participation. As long as blacks do not own private property in this society, they remain in something like the status of public art, mere ornaments to (or disfigurations of) the public place, entertaining statues and abstract caricatures rather than full human beings.

Spike Lee has been accused by some critics of racism for projecting a world of black stereotypes in his film: Tina, the tough, foul-mouthed sexy ghetto babe; Radio Raheem, the sullen menace with his ghetto blaster; "Da Mayor," the neighborhood wino; "Mother

Sister," the domineering, disapproving matriarch who sits in her window all day posed like Whistler's mother. Lee even casts himself as a type, a streetwise, lazy, treacherous hustler who hoards his money, neglects his child, and betrays his employer by setting off the mob to destroy the pizzeria. But it is not enough to call these stereotypes "unrealistic"; they are, from another point of view, highly realistic representations of the public *images* of blacks, the caricatures imposed on them and (sometimes) acted out by them. Ruby Dee and Ossie Davis, whom Lee cast as the Matriarch and the Wino, have a long history of participation in the film proliferation of these images, and Dee's comment on the role of black elders is quite self-conscious about this history: "When you get old in this country, you become a statue, a monument. And what happens to statues? Birds shit on them. There's got to be more to life for an elder than that."[31] The film suggests that there's got be more to life for the younger generation as well, which seems equally in danger of settling into a new image-repertoire of stereotypes. It is as if the film wanted to cast its characters as publicity images with human beings imprisoned inside them, struggling to break out of their shells to truly participate in the public space where they are displayed.

This "breaking out" of the public image is what the film dramatizes and what constitutes the violence that pervades it. Much of this violence is merely trivial or irritating, involving the tokens of public display, as when an Irish yuppie homesteader (complete with Larry Bird t-shirt) steps on Buggin' Out's Air Jordans; some is erotic, as in Tina's dance as a female boxer, which opens the film; some is subtle and poetic, as in the scene when Radio Raheem breaks out of his sullen silence, turns off his blaster, and does a rap directly addressed to the camera, punctuating his lines with punches, his fists clad in massive gold rings that are inscribed with the words "Love" and "Hate." Negative reactions to the film tend to obsessively focus on the destruction of the pizzeria, as if the violence against property were the only "real" violence in the film. Radio Raheem's murder is regularly passed over as a mere link in the narrative chain that leads to the climactic spectacle of the burning pizzeria. Spike Lee has also been criticized for showing this spectacle at all; the film has routinely been denounced as an incitement to violence or at least a defense of rioting against white property as an act of justifiable violence in the black community. Commentators have complained that the riot is

31. Quoted in Spike Lee and Lisa Jones, *Do the Right Thing: A Spike Lee Joint* (New York: Simon and Schuster, 1989), caption to pl. 30.

insufficiently motivated, or that it is just there for the spectacle, or to prove a thesis.[32] In particular, Spike Lee has been criticized for allowing Mookie's character to "break out" of its passive, evasive, uncommitted stance at the crucial moment, when he throws the garbage can through the window.

Mookie's act dramatizes the whole issue of violence and public art by staging an act of vandalism against a public symbol and specifically by smashing the plate glass window that marks the boundary between public and private property, the street and the commercial interest. Most of the negative commentary on the film has construed this action as a political statement, a call by Spike Lee to advance African-American interests by trashing white-owned businesses. Lee risks this misinterpretation, of course, in the very act of staging this spectacle for potential monumentalization as a public statement, a clearly legible image readable by all potential publics as a threat or model for imitation. That this event has emerged as the focus of principal controversy suggests that it is not so legible, not so transparent as it might have seemed. Spike Lee's motives as writer and director—whether to make a political statement, give the audience the spectacle it wants, or fulfill a narrative design—are far from clear. And Mookie's motivation as a character is equally problematic: at the very least, his action seems subject to multiple private determinations—anger at Sal, frustration at his dead-end job, rage at Radio Raheem's murder—that have no political or "public" content. At the most intimate level, Mookie's act hints at the anxieties about sexual violence that we have seen encoded in other public monuments. Sal

32. Terrence Rafferty ("Open and Shut," review of *Do the Right Thing*, in *The New Yorker*, 24 July 1989) makes all three complaints. Rafferty (1) reduces the film to a thesis about "the inevitability of race conflict in America"; (2) suggests that the violent ending comes only from "Lee's sense, as a filmmaker, that he needs a conflagration at the end"; and (3) compares Lee's film unfavorably to Martin Scorsese's *Mean Streets* and *Taxi Driver*, where "the final bursts of violence are generated entirely from within." What Rafferty fails to consider is (1) that the film explicitly articulates theses that are diametrically opposed to his reductive reading (most notably, Love Daddy's concluding call "My People, My People," for peace and harmony, a speech filled with echoes of Zora Neale Hurston's autobiography); (2) that the final conflagration might be deliberately staged—as is so much of the film—*as a stagey, theatrical event* to foreground a certain requirement of the medium; (3) that the psychological conventions of Italian-American neorealism with their "inner" motivations for violence are among the issues under examination in *Do the Right Thing*.

has, in Mookie's view, attempted to seduce his sister, Jade (whom we have seen in a nearly incestuous relation to Mookie in the opening scene), and Mookie has warned his sister never to enter the pizzeria again (this dialogue staged in front of the pizzeria's brick wall, spray-painted with the graffiti message, "Tawana told the Truth," an evocation of another indecipherable case of highly publicized sexual violence). Mookie's private anxieties about his manhood ("Be a man, Mookie!" is his girlfriend Tina's hectoring refrain) are deeply inscribed in his public act of violence against the public symbol of white domination.

But private, psychological explanations are far from exhausting the meaning of Mookie's act. An equally compelling account would regard the smashing of the window as an ethical intervention. At the moment of Mookie's decision the mob is wavering between attacking the pizzeria and assaulting its Italian American owners. Mookie's act directs the violence away from persons and toward property, the only choice available in that moment. One could say that Mookie "does the right thing," saving human lives by sacrificing property.[33] Most fundamentally, however, we have to say that Spike Lee himself "does the right thing" in this moment by breaking the illusion of cinematic realism and intervening as the director of his own work of public art, taking personal responsibility for the decision to portray and perform a public act of violence against private property. This choice breaks the film loose from the *narrative* justification of violence, its legitimation by a law of cause and effect or political justice, and displays it as a pure effect of *this* work of art in this moment and place. The act makes perfect sense as a piece of Brechtean theater, giving the audience what it wants with one hand and taking it back with the other.

We may call *Do the Right Thing* a piece of "violent public art," then, in all the relevant senses—as a representation, an act, and a weapon of violence. But it is a work of *intelligent* violence, to echo the words of Malcolm X that conclude the film. It does not repudiate

33. This interpretation was first suggested to me by Arnold Davidson, who heard it from David Welberry of the Philosophy Department at Stanford University. It received independent confirmation from audiences to this paper at Harvard, California Institute of the Arts, Williams College, University of Southern California, UCLA, Pasadena Art Center, the University of Chicago's American Studies Workshop, the Chicago Art History Colloquium, and Sculpture Chicago's conference on "Art in Public Places." I wish to thank the participants in these discussions for their many provocative questions and suggestions.

the alternative of nonviolence articulated by Martin Luther King in the film's other epigraph (this is, after all, a film, a symbolic and not a "real" act of violence); it resituates both violence and nonviolence as strategies within a struggle that is simply an ineradicable fact of American public life. The film may be suffused in violence, but unlike the "Black Rambo" films that find such ready acceptance with the American public, it takes the trouble to differentiate this violence with ethically and aesthetically precise images. The film exerts a violence on its viewers, badgering us to "fight the power" and "do the right thing," but it never underestimates the difficulty of rightly locating the power to be fought or the right strategy for fighting it. A prefabricated propaganda image of political or ethical correctness, a public monument to "legitimate violence" is exactly what the film refuses to be. It is, rather, a monument of resistance, of "intelligent violence," a ready-made assemblage of images that reconfigures a local space— literally, the space of the black ghetto, figuratively, the space of public images of race in the American public sphere. Like the Goddess of Democracy in Tiananmen Square, the film confronts the disfigured public image of legitimate power, holding out the torch of liberty with two hands, one inscribed with *Hate*, the other with *Love*.

We may now be in a position to measure the gap between the tragic events of spring 1989 in China and the impact of a Hollywood film that just happened to be released at the same moment. The gap between the two events, and the images that brought them into focus for mass audiences, may seem too great for measurement. But it is precisely the distance between the monumental and the trivial, between violence in the "other country" and our own, that needs to be assessed if we are to construct a picture, much less a theory, of the circulation of visual culture in our time. The Goddess of Democracy imaged a short-lived utopian and revolutionary monument that seems to grow in stature as it recedes in memory. It brought briefly into focus the possible emergence of a democratic, civil society in a culture and political order that has endured the violence of state repression for centuries. *Do the Right Thing* deploys its utopian, revolutionary rhetoric on a much smaller stage (a street in Brooklyn), and its challenge to established power is much more problematic and equivocal. If the Goddess claimed to symbolize the aspirations of a majority, an all-inclusive public sphere, Spike Lee's film articulates the desperation of a minority, a partial public, calling on the majority to open the doors to the public sphere promised by its official rhetoric. The violence in *Do the Right Thing* may be local, symbolic, even "fictional" in contrast to the Tiananmen Square massacre, but it refers unequivo-

cally to the widespread, unrelenting, and very real violence against African Americans in the United States, both the direct physical violence of police repression instantiated by Radio Raheem's murder and the long-term economic violence perpetrated by the white majority.

Perhaps the most obvious contrast between the Goddess and *Do the Right Thing* is the sense (doubtless inaccurate)[34] that the former is an image of revolutionary "purity," the latter a highly impure image-repertoire of compromises, trade-offs, and sell-outs. The harshest criticism that has been made of Spike Lee is the claim that he is merely another "corporate populist," franchising his own celebrity as a star and director, trading in his progressive principles for advertising contracts with the Nike Corporation.[35] The advantage of this *ad hominem* attack is that it saves a lot of time: one needn't actually look at *Do the Right Thing* (or at Spike Lee's witty, ironic commercials for Nike), because one already knows that he is a capitalist.

On the other hand, if one is willing to grant that corporate capital constitutes the actual, existing conditions for making movies with any chance of public circulation, then one actually has to look at the work and assess its value.[36] *Do the Right Thing* makes abundant sense as

34. The "purity" of the Goddess of Democracy is surely compromised by the mixture of sources and motives that went into its production and effect. As Wu Hung notes, "it was not a copy" of the Statue of Liberty, and yet it "owed its form and concept" to "other existing monuments"—most notably the image of "a healthy young woman," specifically "a female student"—to stand for a new concept of the public sphere ("Tiananmen Square: A Political History of Monuments," p. 110). The students' motives, moreover, ranged from revolutionary idealism to "mere" reform of government corruption and the hope for opportunities in more open exchanges with capitalist economies. Some observers, no doubt, saw the statue as an appeal to the true spirit of Maoism beneath the disfigured portrait.

35. This charge is made by Jerome Christensen in "Spike Lee, Corporate Populist," *Critical Inquiry* 17:3 (Spring 1991): 582–95. A more detailed rejoinder is provided in my "Seeing *Do the Right Thing*," in the same issue, pp. 596–608.

36. One of the more astonishing claims of Christensen's essay is its treatment of Lee's filmmaking as "the most advanced expression of the emergent genre of corporate art" (p. 589), a development in which "films . . . are rapidly being transformed into moving billboards for corporate advertising" (p. 590). This "emergence" and "transformation" will be news to film historians who have traced the links between corporate advertising and filmmaking to the earliest days of the industry. See Miriam Hansen on the commodification of the teddy bear in early cinema in her "Adventures of Goldilocks:

a film *about* corporate populism, a critique of the effects of capital in a multi-ethnic American community. The film shows what it is like to live in a community where no utopian public image or monument is available to symbolize collective aspirations, a community where personal identity is largely constituted by commodity fetishism—from Air Jordan sneakers to Magic Johnson jerseys to designer jewelry and elephantine boom boxes.

The meaning of these fetishes, however, is not confused with the labeling of them as fetishistic. They are treated critically, with irony, but without the generalized contempt and condescension generally afforded to "mere" fetishes. Radio Raheem's blaster is as important to him as Sal's pizzeria (and the Wall of Fame) is to him. Both are commercial objects *and* vehicles for the propagation of public statements about personal identity. Even the image in the film that comes closest to being a sacred, public totem, the photograph of King and Malcolm X shaking hands, has been turned by Smiley into a commodity. The affixing of this image, with all of its connotations of love and hate, violence and nonviolence, to the smoldering remains of the Wall of Fame, is the closest the film comes to the sort of apotheosis achieved by the Goddess of Democracy as she faced the disfigured portrait of Mao.

If *Do the Right Thing* has a moral for those who wish to continue the tradition of public art and public sculpture as a utopian venture, a "daring to dream" of a more humane and comprehensive public sphere, it is probably in the opening lines of the film, uttered by the ubiquitous voice of Love Daddy: "Wake up!" Public art has always dared to dream, projecting fantasies of a monolithic, uniform, pacified public sphere, a realm beyond capitalism and outside history. What seems called for now, and what many contemporary artists wish to provide, is a *critical* public art that is frank about the contradictions and violence encoded in its own situation, one that dares to awaken a public sphere of resistance, struggle, and dialogue. Exactly how to negotiate the border between struggle and dialogue, between the argument of force and the force of argument, is an open question, as open as the two hands of the Goddess of Democracy or the two faces of revolution in Smiley's photograph.

Spectatorship, Consumerism, and Public Life," *Camera Obscura* 22 (January 1990): 51–71, and Jane Gaines, *Contested Culture: The Image, the Voice, and the Law* (Chapel Hill, NC: University of North Carolina, 1991), especially her analysis of commodity "tie-ups"—"the consumer goods and services that have been linked with the release of motion pictures" (p. xiii).

75. AP/Wide World Photo of Martin Luther King, Jr., and Malcolm X.

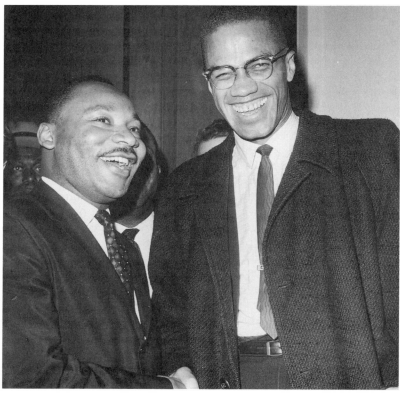

Violence as a way of achieving racial justice is both impractical and immoral. It is impractical because it is a descending spiral ending in destruction for all. The old law of an eye for an eye leaves everybody blind. It is immoral because it seeks to humiliate the opponent rather than win his understanding; it seeks to annihilate rather than to convert. Violence is immoral because it thrives on hatred rather than love. It destroys community and makes brotherhood impossible. It leaves society in monologue rather than dialogue. Violence ends by defeating itself. It creates bitterness in the survivors and brutality in the destroyers. [Martin Luther King, Jr., "Where Do We Go from Here?" *Stride toward Freedom: The Montgomery Story* (New York: 1958), p. 213]

I think there are plenty of good people in America, but there are also plenty of bad people in America and the bad ones are the ones who seem to have all the power and be in these positions to block things that you and I need. Because this is the situation, you and I have to preserve the right to do what is necessary to bring an end to that situation, and it doesn't mean that I advocate violence, but at the same time I am not against using violence in self-defense. I don't even call it violence when it's self-defense, I call it intelligence. [Malcolm X, "Communication and Reality," *Malcolm X: The Man and His Times*, edited by John Henrik Clarke (New York, 1969), p. 313]

FROM CNN TO *JFK*

am old enough to remember a time when going to the movies meant going to see the newsreels too. Perhaps that is why the juxtaposition of CNN and *JFK* makes so much sense to me. I've never been able to get over the idea that the news is just another kind of movie, and vice versa. That *JFK* is, at least in part, a movie about television news and that CNN's coverage of the 1991 war in the Persian Gulf was filled with echoes of war movies also makes the linkage feel appropriate. But CNN and *JFK* belong together in a historical proximity as well, as the framing media events of a very strange year in American cultural history. 1991 began, for American spectators, with the most heavily publicized war in American history and ended with a cinematic re-enactment of the Kennedy assassination, the most highly publicized event in what *JFK* represents as a secret war for control of America's national destiny. Between CNN's Operation Desert Storm and *JFK*'s "Operation Mongoose" fall the media shadows of what are now called America's "Culture Wars." These are the ongoing battles for the ideological soul of America played out in the convergence of television news and melodrama. Pitched battles of the sexes and races were staged with unprecedented intensity in such media "events" as the Clarence Thomas/Anita Hill hearings and the David Duke campaign. Conspiracy theories detailed the infiltration of American higher education by "politically correct" militants and lamented the takeover of the art world by feminists, homosexuals, and ethnic minorities. In short, for Americans who watch television news, 1991 was a year of war and publicity—not just the publicizing or representing of war, but the waging of war by means of publicity and representation. Oliver Stone's *JFK* is the perfect cinematic coda to such a year.

I don't wish to dwell here on the numerous and obvious differences between movies and television news, though this is a subject of considerable interest, or to rehearse the well-documented ways in which American television was "censored" and manipulated by the

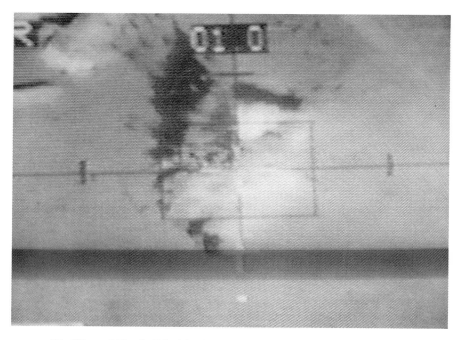

76. "Ground Zero": Television image transmitted from the nose of a "Smart Bomb," photograph by Nadine L. McGann from CNN's *Operation Desert Storm.*

military or "distorted the truth" about the Persian Gulf War.[1] I want instead to compare two melodramatic scenarios that captured the imagination of American spectators in 1991 and to analyze the impact of these representations on public discourse. The Kennedy assassination and Operation Desert Storm are both widely perceived as major turning points in American history, the one signaling the beginning of the Vietnam era, the other marking the transition between the end of the Cold War and the unveiling of George Bush's "New World

1. For an excellent account of bias in American television coverage of this event, see William Hoynes, "War as Video Game: Media, Activism, and the Gulf War," in *Collateral Damage,* edited by Cynthia Peters (Boston: South End Press, 1992), pp. 305–26. For a critique of the basic opposition between "impartiality" and "bias" as the relevant terms for the analysis of television news, see Ian Connell, "Television News and the Social Contract," *Screen* 20:1. Connell rejects, as I do, the "conspiracy theory" of television news coverage in favor of an ideological analysis that stresses the collaboration between popular mythology, vested interests, and journalistic professionalism.

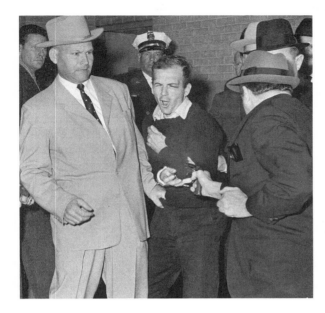

77. *Dallas, November 24, 1963*, photograph by Bob Jackson of the assassination of Lee Harvey Oswald by Jack Ruby.

Order." Both events were also turning points in the history of American television, with each reaching unprecedented numbers of viewers. CNN's public relations office estimated that one billion people in one hundred and eight nations watched their coverage of the Gulf War.[2] The Kennedy assassination drew transfixed viewers into an instant international community of shock and mourning, while Operation Desert Storm elicited responses of horror, anxiety, and fascination at the spectacle of a war that combined the latest in high-tech electronic communications and weaponry. Appropriately emblematic for the convergence of war, representation, and the public spectacle are the famous image-sequences transmitted from the noses of the smart bombs descending on their targets (figure 76), taking a dazzled American public directly into the heart of mass destruction. The corresponding moment in the television reportage of the Kennedy assassination would be, I suppose, the moment when Jack Ruby shot Lee Harvey Oswald during a live television broadcast (figure 77).

These two images typify many of the differences between CNN's Desert Storm and Stone's *JFK*, purely at the level of representational

2. Major General Perry Smith, *How CNN Fought the War* (New York: Birch Lane Press, 1991), p. xi.

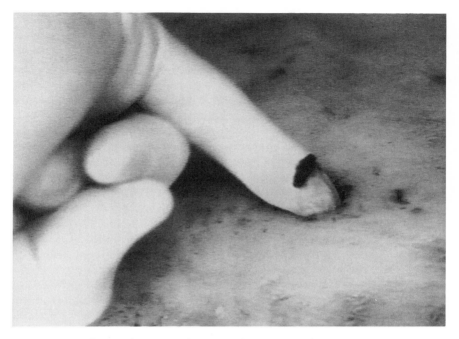

78. *JFK* frame enlargement of surgeon's finger in wound.

style. The Desert Storm image is abstract, like a display in a video game. It represents a war of aerial reconnaissance and electronic mapping, one in which bodies (except for the endangered bodies of heroic media personalities) rarely appear. The Oswald image is bodily, visceral, and intimate; its endangerment was realized in the instantaneous transmission of a close-up pistol shot to the gut. It is a perfect piece of raw material for a film that relentlessly explores the human body and assaults the body of the spectator. Stone's aim is not so much to make us see as to *feel* the physical reality of Kennedy's skull being shattered by rifle fire. We are even forced to watch the President's autopsy, including the spilling of his brains from the skull cavity and the insertion of a surgeon's finger into an open wound (figure 78).

Now one might object that these are simply differences in the objective content of two drastically different historical events, the assassination of a single individual and the waging of a massive military campaign. To this I can only reply that it would have been possi-

400

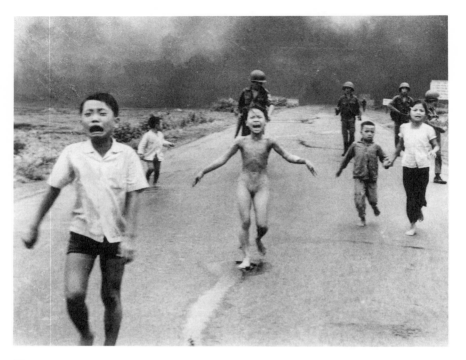

79. *Trang Bang, June 1972*, photograph by Nick Ut. Associated Press photo. AP/ Wide World Photos.

ble to represent both these events in very different ways. The Kennedy assassination can be (and has been) represented as a remote, abstract event whose physical reality can never be recaptured, a product of forces that will remain forever invisible and untouchable, even unknowable and insignificant. Mass warfare can be (and has been) represented in immediate and palpable ways on both film and television. Oliver Stone's *Platoon*, for instance, is notorious for the way it conveys the physical reality of combat. In this respect it is in keeping with what might be thought of as the dominant style of Vietnam's television representation. Vietnam was, above all, represented as a war about the human body. To remember Vietnam is to remember the television coverage of body counts and innumerable flag-draped caskets, of massacres, atrocities, and mass burials, and of singular images like the naked Vietnamese girl with her flesh aflame with napalm (figure 79) and the dismembered American soldiers returning home.

The abstract image provided for television by the remote, robotic sensors of a "smart bomb," then, is not just an accidental feature of the way this war was fought, but a crucial element in its overall narrative construction. A major objective in the presentation of the Persian Gulf War to the American public was the erasure of the human body from the picture. General Schwarzkopf announced at the very outset that there would be no "body counts" or "body bags" in this war. Instead, we had the euphemism of "human remains pouches" and the strict refusal to enumerate casualties, especially Iraqi casualties, which to this very day have received no official estimate from the Pentagon. The closest thing to a "crisis" in the public acceptance of Operation Desert Storm occurred when CNN's Peter Arnett broke the rule against showing bodies, transmitting images of Iraqi civilians killed by one of our "smart" bombs. Senator Simpson of Wyoming promptly labeled Arnett an Iraqi "sympathizer," and NBC military analyst Harry Summer suggested that he might be guilty of treason.[3] Military and political leaders were instantly dispatched to the major television talk shows to provide spin control with euphemisms about "collateral damage" and (in the case of the late Senator Tower) outright denial that the bodies even existed. Even the "veiled" representation of our own war dead was prohibited in this war. Media coverage of military funerals or the unloading of flagdraped caskets was strictly censored. This was a war without bodies or tears for the American public, but one filled, at the same time, with a sense of danger, paranoia, and spectacular violence.[4]

The reasons for the censorship on representations of the body are not difficult to grasp. Schwarzkopf rejected the body count on aesthetic grounds, as a tasteless, ghoulish, and demoralizing way of keeping score. But the more fundamental reason was to construct Operation Desert Storm as at once the antithesis and antidote to Vietnam. It is common military wisdom that the Vietnam War was lost because it lost the support of the American public. And the loss of public support is generally traced to the media coverage of the war. Vietnam is sometimes called the first "television war": it brought home to the American public harrowing images of mutilated human bodies in

3. See Smith, *How CNN Fought the War,* p. 32. The criticism even extended to Ted Turner, who was quickly labeled "Baghdad Ted," an appropriate consort for his new girlfriend, "Hanoi Jane."

4. The other moment when CNN received negative responses from its viewers was when it showed the press conferences of captured U.S. pilots, who had their faces covered with bruises from being beaten.

overwhelming numbers. CNN and the American media in general collaborated fully in the project of evoking while erasing all reminders of Vietnam by eliminating, as completely as possible, all traces of the human body. This control of the representation of the war was just as crucial to its "success" as control of the battlefield. Vietnam had shown us that American wars are won or lost on the home front, so the war of publicity was given at least as much attention as the military operation itself.

A more comprehensive account of this public relations war would take note, not only of its negative work—the erasure or "unwriting" of the Vietnam scenario—but also its attempt to provide a positive alternative story line. The main source of images and narrative materials for this positive construction was the American mythology of World War II, preserved in newsreels, photos, and (of course) the movies, from (say) *The Desert Fox* to *Patton*. The media heroes of the Gulf War were the war correspondents in Baghdad with their code of fearless professionalism and their rumpled Banana Republic clothing (*Doonesbury* missed a wonderful opportunity to dispatch Roland Hedley to the scene). Robert Wiener, the executive producer of CNN Baghdad, makes it clear in his memoir that the Gulf War was both a financial bonanza for CNN and a career-making opportunity for ambitious journalists.[5] CNN's video summary of Operation Desert Storm is "dedicated," not to those who fought in the war, but "to the brave men and women of CNN." Hunter Thompson praises Wiener as "a hero and living monument to the balls and best instincts of our trade." Wiener, unsurprisingly, never utters a critical word about the policy that led the United States into this war and never questions the assumption that his position at "ground zero" amounts to transparent access to the truth about the war.[6] The only moment of skepticism about CNN Baghdad's access to "history as it happens" is expressed in a joke by Wiener's cameraman, Mark Biello, who characterizes the CNN team as "first to go, last to know."[7]

Operation Desert Storm was thus a kind of utopian replay of

5. Robert Wiener, *Live from Baghdad: Gathering News at Ground Zero* (New York: Doubleday, 1992).

6. Thompson's words appear in a blurb on the dust jacket of Wiener's book. One can only imagine what a "monument to the balls . . . of our trade" would look like. Wiener is, as we might expect, totally contemptuous of the "scribblers" (print journalists) who flee the action, and his own prose has the feel of a Tom Swift boy's novel, jazzed up with ample profanity.

7. Wiener, *Live from Baghdad*, p. 3.

World War II, fulfilling all the fantasies of victory through over-whelming air superiority, reported by heroic reincarnations of Ed Murrow, pitted against an enemy portrayed as Hitler reincarnate, a Satanic father of lies threatening the mother of all battles. I don't mean to deny, of course, that Saddam Hussein was (and still is) an evil, vicious, and dangerous tyrant. I only want to note that his characterization as Hitler, as the Butcher of Baghdad, as a man whose very name on American lips elicits echoes of sodomy and sadism, has more to do with the strategies of a public relations war than it does with any political or historical analysis of the real aims and consequences of our war in the Middle East. The main function of this caricature was reductive and emotional—to simplify the issues to a straightfor-ward moral choice, to whip up war fever and mass hatred against the enemy, and to make rational debate and opposition to the war seem like an act of treason.

The "Saddam as Hitler" card was, in short, a very effective weapon in the publicity war on the home front, as effective in its use of propaganda images as Bush's playing of the race card with the "Willie Horton" ads of the 1988 presidential campaign. It allowed the vast majority of the American public to celebrate without qualms the spectacle of mass destruction of unwilling Iraqi conscripts in Ku-wait and of innocent civilians in Iraq. It allowed that public to see the restoration of an undemocratic oligarchy in Kuwait as a moral act of liberation. Most notably, it has permitted, at least so far, a kind of blissful amnesia about the strange outcome of a World War II scenario in which Hitler remains in power, his Gestapo and elite mili-tary units remain intact, and he continues to massacre ethnic minori-ties within his borders. It turns out that "our Hitler" has a new role to play now in American foreign policy: he is a regrettably necessary force for stability and order in the region or perhaps a convenient scapegoat for any U.S. president who needs a lot of foreign adventur-ism to bolster his standing in the public opinion polls, a possibility that has not been lost on Bill Clinton.

There is no use, I think, in wasting energy in moral indignation over the cynical exploitation of publicity in war. The Bush administra-tion did nothing unusual in manipulating the war of representation; what was unusual was how well the job was done, how perfectly the media collaborated in the selling of a presidential war to a skeptical public and the suppressing of every sign of protest. There is also no use in complaining about CNN's exploitation of the war as the occa-sion for a massive journalistic coup that fixed the eyes of the world on the "story" as represented by a single network. CNN did nothing

unusual in making the war into a ratings bonanza. The specific role of CNN in the media war was, as their air war consultant, Major General Perry Smith points out, exactly analogous to the Air Force's role in the Gulf. After the first few days CNN "achieved total air superiority over the networks."[8] It provided saturation bombing of the American public with instant analysis by over sixty military experts and a steady stream of State Department officials. It offered "balanced" debates of the issues between far right hawks like John Tower and moderate hawks like John Mearsheimer and rigorously excluded the views of anti-war representatives. CNN's aim was, as General Smith puts it, "not just to beat the competition but to blow it away" (p. 7), and it succeeded in every way. General Smith's book is called "How CNN *Fought* the War," not how it "reported" the war. Indeed, this may well be the first time a major American television news network has so openly collaborated with the propaganda machine of the U.S. military. Peter Arnett, it seems clear in retrospect, was mainly useful in creating the illusion of controversy and immediacy and as a symbolic figure in the melodrama of American paranoia and endangerment.[9]

.

If Operation Desert Storm showed us how the strategic use of media could convert a divided, skeptical, even resistant public into compliant spectators to a high-tech massacre, *JFK* showed that it is still possible for a single movie to administer the equivalent of shock treatment to a numbed, overstimulated public that seems to be reaching a saturation point in its receptiveness to war melodramas, whether public or private, foreign or domestic. This is not to suggest that *JFK* has accomplished anything remotely approaching the propaganda coup achieved by Operation Desert Storm. On the contrary, as propaganda, *JFK* has had very mixed success. The most discernible immediate ef-

8. See General Smith, *How CNN Fought the War*, p. 6.

9. CNN's subsequent release of videotape "highlights" of its war coverage ("Desert Storm," from Turner Home Entertainment), consolidates the work of erasure performed by CNN's live coverage. This condensed version eliminates almost all trace of protest against the war and contains the whole story in a narrative frame constructed around George Bush's career (his historic "gamble" in the Gulf) and Saddam Hussein's *eye*, which is treated, by the miracle of video graphics, as the frame for a ninety-second run-through of Arab "history" and "grievances."

fect has been a curious unanimity among critics and pundits across the political spectrum that this is an extremely bad movie—vulgar, crude, and tasteless as a piece of filmmaking and almost totally fraudulent as a piece of historical representation. Aside from that, *JFK* seems to be a commercial success, drawing large audiences (especially of young people who have no memory of the assassination) who emerge from this film, not simply convinced that Kennedy was killed by the CIA, but engaged in arguments, asking questions, sometimes even talking to their parents about this event. The film has carved out, in short, a tiny and perhaps ephemeral space of public discussion, not only about the assassination, but about the whole meaning of the Kennedy presidency and the implications of the widespread belief that Kennedy was killed by a conspiracy hatched in the U.S. intelligence community.

The narrative work of *JFK* is rather like that of Desert Storm. It manages to unwrite one scenario (the Warren Commission's story of Lee Harvey Oswald "acting alone" for personal, private, and unknowable reasons) and to put in its place an alternate script: that Lee Harvey Oswald was a "patsy" who was set up with an elaborately constructed "communist sympathizer" dossier to divert attention from the real assassins, who were in the employ of the CIA. This complex secret narrative is framed and motivated by a larger story: that the CIA, the U.S. intelligence community, and the whole range of interests summarized by Eisenhower's "military-industrial complex" saw Kennedy as a threat to their increasing dominance over America's Cold War economy. In particular, the fear was that Kennedy was "soft on communism," that he might withdraw from Vietnam and strike a deal with Castro and Khrushchev. Although the actual conspiracy may have been quite small, involving so-called "rogue elements" of the CIA, the conspiracy of consent, of plausible deniability, of silence and acquiescence, is virtually endless. It goes all the way up to Earl Warren and Lyndon Johnson. It continues to the present day in the unbroken wall of secrecy that is permitted to stand around the covert activities of the CIA and in the continued cooperation of major organs of U.S. journalism (*Time-Life, The Washington Post, The New York Times,* the major television networks) in trying to put the assassination behind us.

What exactly is wrong with this narrative? How is it likely to lead a gullible American public astray, and how can it be prevented from having this effect? Four basic kinds of arguments have been made against *JFK*. The first is *ad hominem*. It ignores the story and discredits the storyteller. Oliver Stone is denounced as a power-mad

Hollywood baron, a crude, vulgar filmmaker who will stop at nothing to coerce or pander to his audience. ("I think people who sell sex have more principle"—George Lardner, *Washington Post*, 19 May 1991.)[10] Jim Garrison, the New Orleans District Attorney whose narrative is the basis for *JFK*, is denounced as a mad publicity hound who lost his case in court.[11] Or the entire cottage industry of assassination research is ridiculed for its fascination with musty trivia, its paranoid obsession with unraveling the conspiracy. The second argument might be called macrohistorical. It disputes the large claims about the forces arrayed against Kennedy, denies that he would have withdrawn from Vietnam, and denounces Stone's attempt to revive the Camelot myth, with JFK as the fallen prince of peace. This argument rapidly turns *ad hominem*, getting into nasty stories about Kennedy's mob ties and sex life.[12] Or it takes the high road and declares the assassination a historical irrelevancy: "Whether J.F.K. was killed by a lone assassin or by a conspiracy has as much to do with the subsequent contours of American politics as if he had tripped over one of Caroline's dolls and broken his neck in the White House nursery" (Alexander Cockburn, *The Nation*, January 6/13, 1992, p. 6). The third argument

10. 19 May 1991, "Outlook," D1, 4. Lardner, who covers "national security issues" for the *Washington Post* and enjoys a cozy relationship with U.S. intelligence is quoting Harold Weisberg's opinion on Stone as a prostitute. Lardner's review was the first "pre-emptive strike" in the journalistic attack on *JFK*. His review appeared almost six months before the movie was released and was based on a script of the film "obtained by Harold Weisberg."

11. Garrison's own version of the publicity issue is that he tried, unsuccessfully, to keep his investigation confidential, but found this increasingly difficult in the face of media attention. For Garrison's side of the media assault on his investigation, see *On the Trail of the Assassins* (New York: Warner Books, 1988), chapter 13.

12. See, for instance, Christopher Hitchens in *The Nation*, 3 February 1992, p. 114. Hitchens dismisses the idealization of Kennedy as "dated" and "reactionary." He does, however, concede that the tarnishing of the ideal doesn't eliminate the probability of a conspiracy. It just alters the moral to be drawn from the story: "the fact that Kennedy was a howling little shit doesn't prove that there wasn't a plot to do him in. Indeed, like many a godfather before him, he may have been slain by precisely the same forces that he himself set in motion." The specific question of Kennedy's intentions concerning Vietnam has generally been regarded as closed by professional historians (JFK would have escalated just as Johnson did; the assassination changed nothing). John Newman's *JFK and Vietnam* (New York: Warner Books, 1992), has, however, reopened this whole question.

is microhistorical. It punctures holes in the details, brings up contra-dictory testimony, offers alternative hypotheses. It tends to trail off into indeterminacy: we'll never know who did it, or why ("Nearly three decades of mostly independent, non-official examination of the event have turned up virtually no answers."—Terrence Rafferty, *The New Yorker,* 13 January 1992, p. 73).[13]

The fourth and final argument is the cinematic/aesthetic. Unlike the others, it at least acknowledges that *JFK* is a film, a work of imagination and not a historical documentary. But it finds the film vulgar and coercively rhetorical. It resents the film's treating its view-ers like children, playing a relentless game of "show and tell" to reinforce every point. It regards the scenes of the autopsy and the relentless dwelling on the body as in bad taste. It finds the treatment of the private lives of both Garrison and the conspirators an unbear-able tissue of cliches and stereotypes (Garrison is portrayed as a decent, normal family man whose domestic bliss is disturbed by a bunch of perverted, homosexual right-wing plotters). The coercive-ness of the film, its appeal to nostalgic, populist myths of American innocence, and its exploitation of homophobia (the unconscious basis of paranoia, according to Freud) have led some reviewers to associate *JFK* with "fascist" aesthetics.[14] Alexander Cockburn's review summa-rizes this point: "in its truly fascist yearning for the 'father-leader' taken from the children-people by conspiracy, it [*JFK*] accurately catches the crippling nuttiness of what passes amid some sectors of the left . . . as mature analysis and propaganda."[15]

Cockburn is half right on two fronts. First, he should have added that this sort of nuttiness passes for "analysis" on the Right as well as on the Left. Second, while he may be right that *JFK* is "immature" as political or historical analysis, he is certainly in strange territory with his suggestion that it is not "mature . . . propaganda." Propa-ganda by its very nature sorts very oddly with notions of analytic maturity; its point is persuasion and the production of emotional

13. Cp. Dan Rather, in CBS's umpteenth "white paper" on the assassina-tion, now provoked by *JFK,* moralizing about the heavy burden of uncertainty that heroic journalists must bear, in contrast to the comforts of certainty and conviction enjoyed by conspiracy theorists.

14. Dave Kehr suggests that "as frequently as the film invokes the dark threat of fascism, Stone seems unaware of the totalitarian tendencies in his own style, which remains one of physical intimidation and cheap emotional appeals" (*Chicago Tribune,* Friday, 20 December 1991, Section 7, p. 8).

15. Alexander Cockburn, *The Nation,* 6–13 January 1992, p. 6.

effects, not cool, mature judgment. If maturity means power and effec-
tiveness then *JFK* is certainly mature—though not nearly so polished
and effective as the potent fantasies of good versus evil that structured
media representations of Operation Desert Storm. Like the managers
of the Persian Gulf's media war, Stone realized that a simple, compre-
hensive moral narrative was required. He saw that emotional shock
would best be produced by intimate, bodily re-enactments of the key
events, just as the media managers of Desert Storm realized that physi-
cal alienation and detached spectacle would best serve the purposes
of anesthetizing the American public from the consequences of a high-
tech massacre. Stone's idealization of Kennedy and demonization of
the conspirators rests on the same assumptions about audience re-
sponse that produce the figure of "Saddam/Hitler" and the heroic
"liberation" of Kuwait. These are mature calculations based in an
assessment of the subject matter, the audience, and the economic reali-
ties of filmmaking. *JFK* is, like the media management of Operation
Desert Storm, a propaganda film that uses representation as a weapon
in the war for the hearts and minds of the American public.

Having said that, a number of qualifications need to be registered.
The first, and most obvious, is that the propaganda power of *JFK* is
pretty much limited to what the film can accomplish with its sounds
and images. In contrast to the media managers of Operation Desert
Storm, Oliver Stone does not have a host of "spin doctors" and "me-
dia assets" to call on;[16] he does not have a political party, or a national
security state, or a vast military apparatus at his disposal. When critics
on the Right and the Left throw the word "fascist" at *JFK*, they would
do well to keep in mind that the fascist filmmakers of Nazi Germany
were mainly working for the state, propagating racist myths that
would make mass destruction of innocent people acceptable to an
anesthetized public.

A second qualification has to do with the actual effects that can
be empirically attributed to the film. As we have seen, the main effect
of television's Desert Storm coverage was the transformation of a
divided, skeptical American public into a consensus of passive accep-
tance and image consumption. By contrast, the main effect of Oliver

16. Stone does have, of course, the usual publicity apparatus that accom-
panies the distribution of a major Hollywood film, and Cockburn (*The Na-
tion*, p. 7) speaks darkly of the "conglomerate" backing the film. Much more
important to the public impact of the film, however, has been the "free adver-
tising" supplied by the barrage of hostile reviews and the treatment of the
film's release as a potentially dangerous event in American public culture.

Stone's movie has been the provocation of controversy and debate. Complaints that the film will mislead the unwary, gullible American public seem quite at odds with its actual reception. When the film was released, the cover of *Newsweek* promised to show us "Why Oliver Stone's New Movie Can't Be Trusted."[17] One year before, *Newsweek* devoted a similar cover story to "How the New High Tech Weapons Will Save Lives." While it is good to be reminded that we should trust in our weapons (and in *Newsweek*), I have yet to meet anyone who claims to "trust" *JFK* as history or to feel comfortable with it as a film. On the contrary, the movie seems to arouse suspicion about its own credibility and to create a kind of massive discomfort, a vague anxiety which may be partly a consequence of the political horror it unveils and the private fantasies it links to that horror. While the film is certainly *designed* by its director to produce an effect of conversion and conviction in an audience that is treated as malleable and child-like, it contains elements that actually work against its own power as propaganda and have the effect of transferring power to its audience.

The empowerment of the spectator begins at the most microscopic level of editing and montage. Many reviewers complain of the "dizzying barrage" of images (Vincent Canby, *New York Times*) that assaults the spectator, but this response is as much a testimony to spectatorial resistance as to a passive "trust" of the images. Spectators nurtured on MTV (the "children" to whom Oliver Stone addresses his movie), moreover, are much less likely to find the "barrage" of images overwhelming. For the alert, visually literate spectator, the dazzling image sequences offer a challenge to discriminate different levels of representation and narrative authority. The rapid transitions from original visual documents (photographs, file footage of television broadcasts, simulations of the Zapruder home movie) to dramatic re-enactments, to courtroom models and diagrams, to subjective memories, to real locations, to the faces of actors, fictional characters, and historical personages caught in reactions create a dense weave of narrative and argument that invites sorting and differentiation, even as it seems to overwhelm the viewer. Even the casting, which from the standpoint of "director's intention" is clearly meant to enhance the film's authority with the presentation of recognizable stars like Jack Lemmon, Ed Asner, Gary Oldham and John Candy, has a curiously equivocal effect. One reviewer argues that the casting "hilariously compromises the film's credibility—simply because the star personas immediately eclipse the real-life figures they are supposed to be

17. 23 December 1991.

playing. One leaves 'JFK' with the confused impression that Johnny La Rue and the Odd Couple have set up Sid Vicious as the fall guy for Lou Grant."[18]

This slippage between intentional design and actual effect, between rhetorical coercion and solicitation of resistance is clear in the scene in which Donald Sutherland delivers a long monologue to Kevin Costner on the Mall in Washington, D.C., the great monuments to the republic arrayed around them. Sutherland as a mysterious "Mr. X" lays out the full scope of the conspiracy for the wide-eyed innocence of Costner's Garrison, his verbal account regularly overlaid with visual materials—historical footage of the Warren Commission, the Joint Chiefs of Staff, and Lyndon Johnson, all intercut with grainy black and white simulated documentary footage that purports to show high-level military officers engaged in conspiracy deep inside the Pentagon. Are we to take these images as illustrations of the speaker's voice, what Donald Sutherland as Mr. X is "remembering" as he speaks? In some cases, yes (certainly, where Sutherland himself appears), but in some cases they clearly go beyond what Mr. X could have observed. Are they then to be taken as what Jim Garrison, the listener, imagines as he hears Mr. X's narrative? Or are they to be taken as the visual narrative provided by the film itself, the views of an omniscient, all-powerful storyteller who is equivalent, for all practical purposes, to Oliver Stone's directorial "point of view"? The answer, I think, is that the images shift through all these levels of authority and that these shifts do as much to undercut as to reinforce the viewer's trust in the film's authority. Since so many of the "original" and "authentic" visual documents and physical evidence associated with the assassination (photos of Oswald, of the Warren Commission, of Dealey Plaza, of the Kennedy autopsy) are of dubious authenticity, or ambiguous in their meaning, or still hidden in secret archives, or already familiar "public" property, the notion of a secure and uniform visual authority, a clear boundary between history and imagination, is exactly what slips away from the film in spite of (perhaps because of) its best efforts to control all the visual information. Oliver Stone is right to call his film a "myth": the term is appropriate to describe both its truth claims and its melodramatic narrative structure.

The film's double effect of seizing and losing its grip on visual authority is nowhere clearer than in its treatment of the trial of Clay Shaw, which ends, after all, with his acquittal and ignominious defeat

18. Dave Kehr, "Born on Nov. 22," *Chicago Tribune*, Friday, 20 December 1991, Section 7.

for Jim Garrison's (and the film's) case for a conspiracy. The visual materials that show Clay Shaw in the company of key conspirators are clearly designed to make us skeptical about the rightness of the verdict, but they do not make us skeptical about the appropriateness of the jury's judgment, given what they are shown. And they do not constitute anything like "proof" that Clay Shaw was a key figure in the assassination. They merely re-awaken the suspicions that led Garrison into a trial he knew would probably fail, not only because of the suspicious death of a key witness, but because the jury would have had to believe a story so appalling that it defies credibility.

JFK actually represents the moment when Garrison's narrative undoes itself, by showing the response of the spectator to whom it matters most within the film. This is the reaction shot that shows Clay Shaw breaking into a relaxed smile as he listens to Garrison reach the highest levels of the conspiracy. Shaw's smile tells us that he knows he's safe. Garrison (and Oliver Stone and the film itself) have gone too far; no one will believe that Lyndon Johnson and Earl Warren were "accomplices after the fact." And if no one will believe in the Big Plot, then the little plotters have a place to hide and a motive for silence as well. When Garrison quotes Hitler on the effectiveness of the Big Lie as the cover-up for the Big Plot, we know that the game is up. Skepticism, suspicion, doubt—all the intellectual resources that might resist the Big Lie and the Big Plot—are crippled by the taint of paranoia, their attention turned from reality and history back onto the mind of the skeptic. The public accusation becomes evidence of a private neurosis. Statements about the world become symptoms of inner states, and the omnivorous interpretative strategies of conspiracy theory are consumed by the equally omnivorous hermeneutics of the psyche. Garrison cannot even pronounce the name of the ultimate meaning of his story out loud: the unspeakable secret of American politics must be whispered to the courtroom in a single word. That word is "fascism."

Fascism is a powerful word for terminating public discussion in an American context. We have seen it applied in its most traditional form in the representations of Desert Storm as a war against Hitler and in a formalistic and decontextualized way in the attacks on *JFK* as fascist filmmaking. Garrison uses it to describe the conspiracy as a military coup d'etat and to suggest further that the wider structure of industrial, military, and media interests amount, when coupled with a passive, apathetic citizenry, to a new cultural formation called American fascism. This may not seem so far-fetched when one reflects that a month before *JFK*'s release a publicly declared member of the

American Nazi Party received fifty-five percent of the white vote for governor of Louisiana, Jim Garrison's home state.

But the film's account of fascism is less concerned with its public face than with the shadow world of privacy and sexuality that lies behind it. At least one-third of *JFK* is concerned with these private matters, which are dismissed as excrescences, even by viewers who generally applaud the public, political narrative. There are real questions as to what Garrison's "family romance" is doing in this film and how it relates to the world of perverse sexuality associated with the conspirators. The most straightforward answer is rhetorical: Oliver Stone's reductive moralistic narrative requires that a straight, normal, decent American family man go up against a seamy underworld of perverse sexuality, an underworld that ranges from the pornographic ambience of Jack Ruby's nightclub to the aristocratic, homosexual sado-masochism of Clay Shaw's New Orleans mansion. By casting Kevin Costner, who has become a film icon of decent, indigenous American values, embodying baseball and sentimental "Native Americanism," as Jim Garrison, Stone erases the problematic image of the real New Orleans district attorney and sets him against antagonists (Joe Pesci as David Ferrie, Tommy Lee Jones as Clay Shaw) who are associated with uncontrollable violence and murder.[19] The sexual subplot may be nothing more than a propaganda device, eliciting traditional American family values, and traditional American homophobia, to suggest that the evil that kills Kennedy is not just a secret, conspiratorial malevolence, but a private, inner corruption that infects the American nuclear family, disrupting the bonds between fathers and children, husbands and wives.

This subplot, with its suggestion that the real moral struggle is between a homosexual cabal and the traditional American family, is certainly embarrassing in its crudity and naivete, and it is one of those blemishes that leads Norman Mailer to call *JFK* "one of the worst great movies ever made."[20] The question I want to raise is whether the "worst" parts of *JFK* are separable from its "greatness," or at least (since I'm not really sure it is a great movie) whether they are separable from what gives it its special power. My sense is that the film's blemishes are all of a piece: the looniness of its left-wing idealization of Kennedy requires an equally loony staging of right-wing

19. I'm thinking specifically here of Joe Pesci's role in Martin Scorsese's *Goodfellas* and Jones's role as Gary Gilmore, the murderer of *Executioner's Song*.

20. Norman Mailer, *Vanity Fair*, February 1992, p. 126.

homophobia; the crudity of its public narrative requires a corresponding crudity in the private sphere. Both stories focus relentlessly on the body, on the one hand as a private and sexualized region and, on the other, as the "body politic" in the form of the president's shattered corpse. The darkest moment in this relentless equation between public and private bodies occurs when Jim Garrison, still in shock from witnessing Robert Kennedy's assassination on television, is finally able to make love to his at last sympathetic wife. The hyperactive perversity of the prostitutes in Jack Ruby's night club and the Sadean fantasies of Clay Shaw's parlor are finally overmatched by the overtones of necrophilia at the heart of the bourgeois marriage bed.

There is one point, in fact, when it seems as if the film is employing the private subplot as an explicit parody of the main plot. This occurs in the scene when Garrison, after a fight with his wife about his neglect of the family, sits down with his children on the front porch swing and explains to them that Daddy has to work late because he is trying to keep America a country where children can grow up in freedom. Like the public "scenes of instruction" (Mr. X's briefing and Garrison's summation speech), this display of didacticism violates every rule of film rhetoric. It tries to persuade by telling rather than showing, and (even more damaging for a successful propaganda film) it *shows* the act of telling as a sentimentalized scene of parental instruction. As propaganda, this is a very dubious strategy. Effective propaganda must seem modern and up-to-date in its rhetoric, and it must conceal, not parade, its own exertion of pedagogical force. The echoes of Norman Rockwell and Frank Capra in this scene do as much to alienate as to engage its audience.

I'm not suggesting that Oliver Stone gets credit for being "ironic" about his own authoritarian film style in this movie: *JFK* seems to me a much more remarkable achievement, a genuinely "naive" work of cinematic art.[21] Oliver Stone's special talents as a director have found,

21. See Friedrich von Schiller's famous distinction between "naive" and "sentimental" forms of art as the difference between primitive and mythical works, on the one hand, and ironic and self-reflexive works, on the other. One could argue that CNN's achievement was the sentimentalizing of the Gulf War in Schiller's sense: that is, CNN continually foregrounded the mediated character of the war, staging it (as General Smith's memoirs suggest) as a war of the networks in which it was achieving "air superiority" and treating it as a television commodity to be marketed with devices borrowed from the dramatic mini-series (titles like "Countdown to Confrontation") and from sports (notably the "telestrators" or "John Madden machines" that allowed

in the Kennedy assassination, the perfect subject at the perfect histori-
cal moment. The "authoring" of the effects I'm talking about is as
much to the credit of the national audience of Stone's film (including
its hostile reviewers) as it is to any directorial agency. My sense is
that an American audience knows itself, for better and for worse, in
JFK: it encounters a projection of its own national fantasy in the
film's intersection of private and public bodies.[22] What it does not
encounter, and what prevents this from being a fascist film, is a clear
embodiment of the evil it seeks to exorcise. There is no "Saddam/
Hitler" figure to focus audience hatred and distract it from the erasure
of real bodies elsewhere. The hostility evoked by *JFK*, therefore, tends
to be displaced (and misplaced) onto its director (Oliver Stone, the
power-hungry fascist), onto its principal actor (even the most fervent
admirers of *JFK* will want to insist that Kevin Costner is the worst
actor in the world), or onto JFK himself (the sexual transgressor,
arch-cold-warrior, and crony of mobsters, hiding inside the body of
the handsome prince).

But none of these figures, clearly, is adequate to the specter of
conspiracy that the film presents, a new form of fascism that cannot
be demonized in the person of a determinate villain or idealized in a
heroic father-leader. *JFK*'s fascism is faceless and bodiless, a systemic
feature of the New World Order outlined by Eisenhower in 1959 and
unveiled in Operation Desert Storm in 1991: a new version of the
"military-industrial complex" that has now added the persuasive ap-
paratus of the American mass media to its arsenal. A hopeful reading
of contemporary history would lead us to think that this new "soft"
form of global domination by multinational capital, communications,
and security will finally produce a New World Order of peace and
international cooperation. In the same week that *JFK* was released,

visual analysis of aerial photography). The fact that the central figures of the
television war were not the actual combatants but correspondents in Banana
Republic garb (CNN's video is "dedicated to the brave men and women" of
the network) is crucial to its modernity and self-reflexivity—and thus to its
success as propaganda. *JFK,* by contrast, is, while filled with sentimentality,
itself completely unsentimental: it has no irony toward its own authority and
regards itself as a pedagogical device for children. It is a work of naivete, we
might say, in a sentimental age, a piece of myth-making in a postmodern era.
I owe this point to conversations with Jim Chandler.

22. I'm employing the notion of "national fantasy" here in the sense sug-
gested by Benedict Anderson in *Imagined Communities* and its specific appli-
cation to the United States by Lauren Berlant in *Anatomy of National Fantasy.*

Time magazine anointed Ted Turner as its "Man of the Year," declaring him to be the "Prince of the Global Village" for his revolutionizing of television news and praising CNN as a "beacon of freedom" that will force "despotic governments to do their bloody deeds, if they dare, before a watching world."[23] *Time* did not bother to mention that its parent corporation owns a controlling interest in Turner Communications. It also failed to include the massacre in the Persian Gulf among the "bloody deeds" shown to a "watching world."

Ted Turner, however, is a no more appropriate candidate for paranoid fantasies than Oliver Stone. Despite his megalomania and his heroic ambitions to "take over and save us all" (p. 39), Turner gets even less credit for the specific effects of CNN than Stone does for *JFK*. Like Stone, he is, in his own words, merely "the right man in the right place at the right time." The critical questions, then, are not about persons, but about places, times, and the kind of "rightness" or coherence they disclose. I've suggested that CNN and *JFK* serve as acronymic frames for a certain moment in cultural space-time that, for lack of a better phrase, I'll simply call "America, 1991." The task of cultural criticism in this place and time is far from clear. The great temptations are melodrama and paranoia, and I can't say that I've avoided them in this essay, nor do I have any clear sense of how they are to be avoided. The path of criticism can no longer be imagined, as it once was, to be the high road toward a utopian realm of truth or toward the conservation of a secure cultural legacy. Criticism has no choice but to work through the conditions it is given, to question the rightness of its own place and time. When "history as it happens" in the movies and the news takes the form of melodramas that induce paranoia in their audiences, we have to remember that even melodramas have their uses, and even paranoids have their enemies.

23. *Time*, 6 January 1992, p. 25.

SOME PICTURES OF REPRESENTATION

He is no longer quite sure whether he must draw a picture of indigenous theory, or construct a theory of indigenous reality.

— Claude Lévi-Strauss, *Introduction to the Work of
Marcel Mauss* (1950)

A book called "picture theory" should, I suppose, end with a picture of the whole argument, a visible architectonic that would diagram the relation of all the parts and leave the reader with a grid to be filled in with infinite detail. Unfortunately, I have no such picture to offer. This book has instead been compiled in something like the manner of a photograph album. It is a collection of snapshots of specific problems indigenous to representation, addressed on particular occasions, at a definite historical moment that I have called the end of postmodernism, the era of the "pictorial turn." If the book has a unity, it has been in its insistence on staying for the many answers to its few simple questions: What is a picture? What is the relation of pictures and language? Why are these questions of any practical or theoretical interest?

The list of new theoretical concepts and terms in this book is deliberately short and unoriginal. It begins with the "metapicture" and ends with the "imagetext," concepts that have been harvested from the current crop of new work in art history and the study of visual culture. This terminological economy is partly a result of my conviction that we already have an overabundance of metalanguages for representation and that no "neutral" or "scientific" vocabulary (semiotics, linguistics, discourse analysis) can transcend or master the field of representation. Instead, I've offered reflections on the ordinary languages of picture theory, the indigenous vernaculars of verbal and visual representation. My hope is that these terms will make up in

scope and power what they lack in novelty and quantity. The scope of the imagetext, for instance, is not confined to visual representation, but extends to language as well. The pictorial turn is not just about the new significance of visual culture; it has implications for the fate of reading, literature, and literacy. This means that literary studies cannot simply "add on" the study of film, television, and mass culture to its list of courses without changing the whole map of the discipline, and it cannot stabilize its new relation to art history and visual culture with paradigms of structural comparison. The very concept of culture as a relation between texts and readers endures a sea-change when it encounters its "significant other," the image/spectator as a "resident alien" in its own household.

The power of these concepts is, as I have suggested many times in this book, largely negative. They are part of a de-disciplinary effort whose ultimate outcome cannot yet be pictured. If I were compelled to imagine the shape of a new disciplinary formation that might emerge from efforts to theorize pictures and picture theory, it would have a thoroughly dialogical and dialectical structure, not in the Hegelian sense of achieving a stable synthesis, but in Blake's and Adorno's sense of working through contradiction interminably. The power of the metapicture is to make visible the impossibility of separating theory from practice, to give theory a body and visible shape that it often wants to deny, to reveal theory as representation. The power of the imagetext is to reveal the inescapable heterogeneity of representation, to show that the body we give to theory is an assemblage of prostheses and artificial supplements, not a natural or organic form. At a time when culture (and related notions of social "difference" and "identity") is taking on renewed force as the master-concept for the humanities and social sciences, it may be useful to have a conceptual counterweight that emphasizes analysis of the formal, structural heterogeneity of representation, that examines cultural formations as contested, conflicted forms of mediation.

I've employed the term "representation" throughout this book as a general term to cover the work of imagetexts and metapictures. Perhaps the best place to conclude, then, is with some pictures of representation itself and its claim on beholders. I offer three "snapshots," admittedly unfocused and speculative, of three basic questions about representations: (1) what lies outside representation? (2) why are we so anxious about it? (3) what is our responsibility toward it? I realize that the last two questions beg the question of who the "we" is that is anxious, the "our" that has responsibilities, and part of my effort here will be to sketch in that collective identity.

418

Outside Representation: Some Wrinkles

What is beyond representation, different from it, antithetical or other to it? Attempts to give a positive answers to this question often return to the specular/iconic prototypes of representation and locate the alternative in forms of discourse (Foucault's neo-Kantian divide between the "seeable and the sayable"), textuality (Nelson Goodman's division between the "articulate" and the "replete," the semiotic division between the symbolic and the indexical/iconic), or the pragmatist distinction between "representation" and "action" (cp. Ian Hacking's "representing and intervening"). Equally important, however, is the tradition which offers an uncompromisingly negative answer: that is, *nothing* lies outside representation. This is the tradition of the aesthetic sublime, which posits a realm of absolute negation, of radical otherness and unknowability. The sublime, located in pain, death, transcendence, and the unknowable, is precisely the unrepresentable.

But suppose we thought of representation, not as a homogeneous field or grid of relationships governed by a single principle, but as a multidimensional and heterogeneous terrain, a collage or patchwork quilt assembled over time out of fragments. Suppose further that this quilt was torn, folded, wrinkled, covered with accidental stains, traces of the bodies it has enfolded. This model might help us understand a number of things about representation. It would make materially visible the structure of representation as a trace of temporality and exchange, the fragments as mementos, as "presents" re-presented in the ongoing process of assemblage, of stitching in and tearing out. It might explain why representation seems to "cover" so many diverse things without revealing any image of totality, other than the image of diversity and heterogeneity. It might help us to see why the "wrinkles" and differences in representation, its suturing together of politics, economics, semiotics, and aesthetics, its ragged, improvised transitions between codes and conventions, between media and genres, between sensory channels and imagined experiences are constitutive of its totality. The theory of representation appropriate to such a model would have to be a pragmatic, localized, heterogeneous, and improvisatory totality. That is, it would understand itself as an act of representation (in Ian Hacking's sense of theory as interpretation, description, or explanation), but also (in a violation of Hacking's model) as an intervention, an experiment, an interpretation of the world that amounts to a change in the world. What lies "beyond" representation would thus be found "within" it (as the "black hole" of the image is found within the ekphrastic text) or along its margins.

The Exile of Representation

Why are we so anxious about representation? It serves, on the one hand, as an indispensable and inaugural concept, not just for aesthetics and literary theory, but for semiotics, epistemology, and certain forms of political theory; and yet it also seems like a stumbling block, a crude, almost superstitious or regressive concept that brings up atavistic notions like "imitation," "copy" or "correspondence" theories of truth, and mechanical notions of political empowerment. A great deal of modern philosophy has been devoted to the expulsion of representation from its discourse. The paradigmatic examples of representation—pictures, images, and other "specular/iconic" symbols—are routinely treated as pariahs to be banished, idols to be smashed by a clearheaded iconoclastic critique.

But suppose we thought about representation, not in terms of a particular kind of object (like a statue or a painting) but as a kind of activity, process, or set of relationships? Suppose we de-reified the *thing* that seems to "stand" before us, "standing for" something else, and thought of representation, not as that thing, but as a process in which the thing is a participant, like a pawn on a chessboard or a coin in a system of exchange? This would bring us back to the notion of representation as something roughly commensurate with the totality of cultural activity, including (1) that aspect of political culture which is structured around the transfer, displacement, or alienation of power—from "the people" to "the sovereign," the state, or the representative, from God to father to son in a patriarchal system, from slave to master in an absolutist polity, or (2) culture understood as an economy, a system of exchanges and transfers of value, or (3) culture understood as a utopian imaginary encountering a pragmatic reality, as in the collision of the ideal public sphere (the paradisal scene of total visual and verbal transparency) and the actuality of mass mediation. Representation understood, then, as relationship, as process, as the relay mechanism in exchanges of power, value, and publicity: nothing in this model guarantees the directionality of the structure. On the contrary, it suggests an inherently unstable, reversible, and dialectical structure. The relation of the representation to what it represents, for instance, may transfer power/value to the representation and drain it from the represented, but inherent in such an understanding would be the assumption that the power/value quotient originates with the represented, that it has been (temporarily) alienated, transferred, and may always be taken back. If "presentation" is a giving, a gift, a transfer of wealth and power,

"re-presentation" is always a giving back, a present returned or (in what used to be called "Indian Giving," a parody of potlatch) a *taking* back of the present. In representations, as in dreams, begin responsibilities—the political responsibility entailed in the representative/represented relationship; the mutual obligations of the donor and debtor in exchange, what Derrida calls "economimesis." If taxation without representation is tyranny, representation without taxation is irresponsibility.

Representation and Responsibility

What is the relation between representation and responsibility? The traditional answer is that they are deeply implicated with one another: there is a kind of *correspondence* between them, a mutual resonance, a co-responsiveness. The good or true representation is "responsible" to what it represents and to whom it represents it. "Responsible representation" is a definition for truth, both as an epistemological question (the accuracy and faithfulness of a description or a picture to what it represents) and as an ethical contract (the notion that the representor is "responsible for" the truth of a representation and responsible *to* the audience or recipient of the representation). The terms co-respond at every level: representation is a form, an act of taking responsibility; it is itself a *response,* in the musical sense, an answering echo to a previous presentation or representation. Responsibility, for its part, cannot exist apart from representation. It takes the form of a pledge, warrant, or promise, a representation of how things are or will be. Responsibility is representation, and vice versa.

This means, of course, that a break or gap between responsibility and representation is not only a possibility, but a structural necessity for their mutual functioning, for their co-respondence. Representation can, must be irresponsible; responsibility can, must be unrepresentable. The lie, the fiction, the false oath, the error, the failure of correspondence, the playful, irresponsible representation, the unspoken promise, the invisible constitution—all these are not only possible within the polity of representational responsibilities, they are its necessary supplement. There would be no meaning to the notion of "responsible representation" if this were a tautology, if representations were automatically responsible, if responsibilities could be confirmed, affirmed by representations alone.

Art, culture, and ideology explore and exploit the gap between representation and responsibility. For art, the traditional (that is,

modernist) account of this gap is focused on self-reference: representation is responsible only to itself, to its own laws of form, genre, affect, its own playful necessity. Toward everything else, art must be rigorously irresponsible. Culture and ideology constitute the field within which this irresponsible game called art is played. There the laws of form, genre, and affect co-respond with power/knowledge relations, with historical forms of social stratification, with domination, mystification, propaganda, etc.

What, then, is our responsibility with respect to representation? This is the basic question that I want to raise. But of course all the key words in the question must first be defined. What is representation? What is responsibility? What is their relation? And (above all) who is the "we" that has some responsibility toward representation? The answer that "everyone" is responsible certainly follows from the notion that nothing lies outside representation, and this could be construed in ethical, political, or even the public terms of national identity (the "citizen" as "representative").

But let's assume for the moment that "we" are the people who make professional, public statements about representation, who are socially authorized and legitimated as scholars, critics, theorists of culture. The question, then, has to do with our professional responsibility, as teachers and scholars, toward representation. Our responsibility toward representation is relatively well defined. We know it to be *interpretation:* attentive, careful, loving reading of texts and images; learned, critical responsiveness to their meanings; and eloquent testimony to their power. Making sense of representations and publishing that sense, proclaiming it publicly as truth: that is our profession, a definition of our professional responsibility.

Of course, we do lots of other things: we theorize about the nature of representation. We differentiate it from and within other major cultural categories like narrative, performance, or discourse. We argue about which representations ought to be attended to, which are valuable, central, which marginal, useless, or despicable. We historicize it, analyze it, clarify and reify it. We are relentlessly skeptical, suspicious, and anxious about its power over us. We argue about whether we can get outside it, to reality itself, to some unmediated vision. Some of us—writers, artists—actually make "it," actually produce representations. And even the humblest historical scholar, patiently annotating the sacred text or icon, knows this work to be part of representation, itself an act of representation, and thus subject to all sorts of constraints and responsibilities—a professional ethics, as

it were. We could say that representation is our responsibility; we are its keepers, its professional caretakers. We make professional statements—that is, representations about representations.

It may sound like I'm substituting the word "representation" here for something like "culture" or at least "cultural forms." In a sense I am. The word "culture" is so mystified and loaded with honorific connotations that it instantly paralyzes the faculties. "Representation" is more neutral, and (if it's thought of as a kind of stand-in for "culture") it suggests the constructed, artificial character of forms of life, in contrast to the organic, biological connotations of "culture." Culture-as-representation helps to remind us that culture itself is a fractured concept, a suturing of convention and nature and not a homogeneous terrain. It also provides an analytic model for cultural forms, one which emphasizes semiotic, aesthetic, epistemological, and political relationships embedded in these forms. It leads us to ask not merely what these forms "mean," but what they *do* in a network of social relations: who or what represents what to whom with what, and where and why? Most important, it automatically raises the question of responsibility and raises it for us as a professional issue.

If representation automatically raises the question of responsibility, however, it does not answer it. We may know that we have responsibilities toward representation, even that they involve interpretation. But what sort of interpretation? And does interpretation exhaust our responsibilities? Are there claims on us that go beyond interpretation?

I don't think we can answer these questions abstractly or categorically. We must address them to the concrete conditions of our moment, to the ways in which representation is currently at work in our culture. This, of course, is a massive undertaking. It would involve, first, an assessment of our own epoch in the history of representation, a taking stock of issues such as hyperrepresentations and the hyperrealities produced by them. There seems little doubt that we are now undergoing a revolution in the technologies of representation that makes possible the fabrication of realities on an unprecedented scale. At the same time, we know that this type of revolution has occurred before, that it appeared previously in the inventions of writing and printing and engraving and mechanical reproduction, and that our interpretation of the present is always in danger of replicating previous narratives with their nostalgia for a lost authenticity understood as responsible representation.

Nevertheless, we must think our present in relation to these narra-

tives. The most salient comparisons, to my mind, would be drawn from Europe in the 1930s, when a "New World Order" called fascism began to employ the latest in representational technologies to produce, in Walter Benjamin's words, an "aestheticizing of politics." I don't mean to be melodramatic in invoking the specter of fascism; only to recall that the massive production of political hallucinations, the whipping up of war hysteria, and the formation of socially acceptable forms of race hatred and the mass destruction of populations is central to the work of representation under fascism. Whatever else we might want to say about our cultural moment in the United States, we would have to acknowledge the fact of a many-faceted "culture war" that is being waged on the fronts of ethnic and gender politics and (most directly for us) on the terrain of educational policy. I wrote these words at the end of a year in which our government managed to represent the systematic destruction of the most advanced, literate Arab society in the Middle East, the massacre of untold thousands of people, and the lingering death from disease and malnutrition of the survivors, as a "just war" against fascism. It was a year in which the high point of ethnic politics was the fracturing of the African American community over the Clarence Thomas/Anita Hill confrontation, a strategy that showed an American president how to play the "race card" and the "gender card" in a single trick, while weakening even further the judicial and legislative branches of government. It was a year in which a member of the Ku Klux Klan and American Nazi Party was able to represent his past as "intolerance" and garner forty percent of the vote for the governorship of Louisiana, including fifty-five percent of the white vote, and to begin being taken seriously as a national candidate. For us, the professional interpreters of culture, it was the year of the "political correctness" campaign, which represented the broad mainstream of humanities education in the United States as hopelessly dominated by "tenured radicals" preaching doctrines of nihilism, authoritarianism, and subversive forms of anti-American, anti-Western values.

What is our responsibility toward these representations? To begin with, we must see them as related to one another and to us. Although some of them may be "beyond our control," they are certainly not outside of our field. In the case of the political correctness campaign, it is precisely our field that is in question. The new legitimations of racism and sexism are mediated by representations about which we have considerable expertise. And the representation of war and mass destruction in narratives that simultaneously erase the memory of

Vietnam and replace it with a fantasy replay of World War II should activate our responsibilities as preservers of the historical record and of cultural memory. In short, though we probably cannot change the world, we can continue to describe it critically and interpret it accurately. In a time of global misrepresentation, disinformation, and systematic mendacity, that may be the moral equivalent of intervention.

Index

Index